P. Signac

Henri-Matisse

F. Lautrec

Bonnard

E. Vuillard

Rouault

H. Rousseau

Manet

Utrillo.V.

Picasso

Maurice Denis

P. Gauguin

IMPRESSIONISM AND POST- IMPRESSIONISM

IMPRESSIONISM AND POST-IMPRESSIONISM

The Hermitage, Leningrad,
the Pushkin Museum of Fine Arts, Moscow,
and the National Gallery of Art, Washington

With introductions by

Marina Bessonova and William James Williams

WINGS BOOKS/New York • Avenel, New Jersey
in association with
Hugh Lauter Levin Associates, Inc./New York
Aurora Art Publishers/Leningrad

Soviet selection by Marina Bessonova and Albert Kostenevich.

The publishers wish to thank all of those involved with the publication of this volume. In Leningrad, we are thankful to the managing editor, Irina Freshko; the designers, Ildus Farrakhov and Evgeny Bolshakov; and the translator, Yuri Pamfilov. In New York, we would like to thank the editors, Harkavy Publishing Service and Donald Goddard; the designer, Philip Grushkin; and the typesetter, A&S Graphics. We are especially grateful to the printer and binder of this book, Toppan Printing Company, Tokyo.

This edition is published by Wings Books, distributed by Outlet Book Company, Inc., a Random House Company, 40 Engelhard Avenue, Avenel, New Jersey 07001, by arrangement with Hugh Lauter Levin Associates, Inc.

Random House
New York • Toronto • London • Sydney • Auckland

Manufactured in Japan

Library of Congress Cataloging-in-Publication Data

Impressionism and post-impressionism : the Hermitage, Leningrad, the
 Pushkin Museum of Fine Arts, Moscow, and the National Gallery of
 Art, Washington / with introductions by Marina Bessonova and William
 James Williams.
 Reprint. Originally published: New York : Hugh Lauter Levin
 Associates : Leningrad : Aurora Art Publishers, c1986.
 Includes index.
 ISBN 0-517-66562-X
 1. Impressionism (Art)—France. 2. Paintings, French.
 3. Painting, Modern—19th century—France. 4. Post-impressionism
 (Art)—France. 5. Painting, Modern—20th century—France.
 6. Painting—Russian S.F.S.R. 7. Painting—Washington (D.C.)
 8. Gosudarstvennyi Ėrmitazh (Soviet Union) 9. Gosudarstvennyi muzei
 izobrazitel'nykh iskusstv A.S. Pushkina. 10. National Gallery of
 Art (U.S.) I. Bessonova, Marina. II. Williams, William James,
 1942- . III. Gosudarstvennyi Ėrmitazh (Soviet Union)
 IV. Gosudarstvennyi muzei izobrazitel'nykh iskusstv A.S. Pushkina.
 V. National Gallery of Art (U.S.)
 ND547.5.I4I4475 1989
 759.4—dc19 88-37985
 CIP

ISBN 0-517-66562-X
10 9 8 7 6 5 4 3

Contents

PUBLISHERS' NOTE

THIS VOLUME is a product of international cooperation. It has been created by a Soviet publishing company, Aurora Art Publishers, and an American publishing company, Hugh Lauter Levin Associates, Inc., working together on every aspect of publication, from conception and editorial planning to design and production.

It is fitting that the subject is Impressionism and Post-Impressionism, developments in the history of art that were neither Russian nor American but which have immense popularity in both countries. And it is pertinent that Russian and American collectors, critics, and artists were some of the most enthusiastic early supporters of the French avant-garde, with the result that their work is magnificently represented in the museum collections of both nations.

We have published this volume as an expression of the communal and universal ties that bind the American and Soviet people. In book form, it is possible to create a permanent "exhibition" of paintings that are usually thousands of miles apart. This exhibition, then, is one expression of our common interest in art, in culture, in knowledge, and in peaceful coexistence. Let us hope that the same spirit can be applied to all our relationships.

As you read and look at this book, appreciate the great paintings that are brought together in one volume for the first time. Appreciate also the identity of purpose and sensibility that makes such a project possible.

AURORA ART PUBLISHERS HUGH LAUTER LEVIN ASSOCIATES, INC.
Boris Kutkov Hugh L. Levin

Impressionism and Post-Impressionism in

the National Gallery of Art, Washington

THE AMERICAN AND FRENCH REVOLUTIONS of the late 1700s unleashed a furious series of political rebellions that, by changing the nature of Western civilization, also profoundly affected the role of art in a changing society. Painters who once relied on commissions from the court or Church found themselves suddenly without patrons. On the other hand, the artists who had sold through dealers discovered a vastly increased market as an affluent upper-middle-class arose in the emerging republics and democracies.

Unfortunately, these merchants and industrialists usually lacked the cultivated heritage necessary to appreciate the allegorical subject matter and technical virtuosity which had appealed to the aristocrats. Insecure about their education, these newly rich patrons relied upon journalist critics and state jurors to establish standards of cultural excellence. The old royal academies of art, reborn as bureaucratic agencies, became the chief arbiters of acceptable taste. An insidious cycle of repression developed as the academies' faculties sought to perpetuate and transmit their own value systems to the next generation. Conformity became the order of the day. Naturally, many younger, more innovative painters rebelled against the rule of this establishment.

In the ensuing tug-of-war between conservative and liberal artistic factions, one of the principal methods of academic control was to judge the entries in government-sponsored exhibitons of recent art. Such shows in France were called *Salons,* after a room in the Louvre Palace where court painters had formerly displayed their creations. Salons became the main forum—indeed, about the only avenue—for presenting artists' works to the press and to potential patrons. Among the hundreds of entries competing for attention at the Salon of 1870 were Berthe Morisot's *The Mother and Sister of the Artist* and Pierre-Auguste Renoir's *Odalisque,* painted after the exotic fashion of Eugène Delacroix, leader of the Romantic painters. Through such exposure, these young artists, who already had participated in previous Salons, received encouragement and advice.

However, if a work violated conventional expectations, it created a sensation. In the 1864 Salon, for example, Edouard Manet's *Incident in a Bullfight* suggested the isolation of death by juxtaposing a huge foreground bullfighter against a far-distant arena where spectators watch helplessly. This radical design aroused scathing derision and newspaper caricatures. Piqued by the criticism, Manet cut the canvas in two. The lower portion is the National Gallery's *Dead Toreador,* while the upper, bullring section is now in the Frick Collection in New York.

Winning a medal at a nineteenth-century Salon ensured professional success. Conversely, jury

rejection of a submitted entry constituted aesthetic banishment. So many pictures were rejected by the conservative jury at the 1863 Salon that the emperor, Napoleon III, sponsored a concurrent exhibit so the public could compare the officially acceptable pieces to the refused paintings in a Salon des Refusés. This secondary show provided an immensely popular pastime, that of jeering and snickering.

To circumvent the academic juries, wealthier artists could mount independent exhibitions. Gustave Courbet, a Realist painter of daily life, for instance, submitted a number of works to the 1855 World's Fair in Paris. The entrance committee accepted his nature paintings but rejected his thematic pictures. Courbet thereupon defied tradition by building his own pavilion outside the fair grounds. Even though his broad, painterly style impressed the elderly Delacroix, few others bothered to attend. Courbet repeated the experiment with greater success in 1867, hanging all his canvases separately from the exposition. Edouard Manet followed Courbet's lead during the 1867 World's Fair, erecting his own gallery to house a retrospective of his paintings, including *The Old Musician* and *Still Life with Melon and Peaches.* Erecting one's own gallery and privately printing a catalogue obviously required financial means far beyond those of most artists. However, the independent exhibitions by Courbet and Manet inspired the idea for a group show by avant-garde painters.

Scientific discoveries paralleled the social upheavals affecting nineteenth-century art. In 1839, for example, Louis Daguerre in Paris and William Henry Fox Talbot in London demonstrated their separate inventions of photographic cameras. Photography soon freed painters and printmakers from the necessity of making mere records of people, places, and events. No longer having to copy nature, some artists ventured into the realm of personal expression. Photography also introduced a fresh vision into European art. The camera lens produced cropped compositions and oblique sight lines, novel designs which were studied and replicated by artists.

In the same year the camera was invented, 1839, a chemist at Gobelins' tapestry studio published the first accurate explanation of color perception. While developing dyes for textiles, Michel Eugène Chevreul ascertained that there are three primary hues—red, yellow, and blue—from which all other colors may be mixed. Chevreul's arrangement of hues into a "color wheel" not only elegantly demonstrated a complex scientific idea but also presented artists with a workable theory of pigment mixture. The American physicist Ogden Rood and the German scientist Hermann von Helmholtz made further contributions through their studies in optics.

In 1841, the American scientist-artist John Rand patented folding tin tubes to hold spoilable oil paints. Prior to this invention, any oil painter who wanted to work outdoors had to mix the needed pigments and then siphon them into either glass vials, which break, or animal bladders, which leak. Rand's paint tubes permitted an entire studio to fit into a briefcase and be carried outdoors conveniently. Soon, as one wag quipped, the countryside held more landscapists than farmers.

Eugène Boudin, who was among the more adventurous of these artists, taught his pupil Claude Monet the importance of painting scenes outdoors, "in the light, in the air, just as they are." Painting *en plein air* was born. Monet quickly introduced his friends Renoir, Sisley, and Bazille to the concept of recording only what is visible at given distances under specific lighting conditions. In the evenings at Parisian cafés, the young artists excitedly, sometimes heatedly, exchanged ideas about their recent discoveries.

On December 27, 1873, these outdoor painting sessions and café discussions culminated in the formation of the Société Anonyme des Artistes Peintres, Sculpteurs, Graveurs. They held their first group exhibition the following spring in the sales gallery of Nadar, an experimental photographer and dealer in modern art. Canvases now in the National Gallery that figured in that epoch-making show were Camille Pissarro's *Orchard in Bloom, Louveciennes,* Renoir's life-sized *The Dancer,* Morisot's *The Mother and Sister of the Artist,* and *The Harbor at Lorient.* Several art reviewers at the time confused the young Impressionist Claude Monet with the already well-known Realist Edouard Manet, who, in fact, always aspired to official recognition and purposely avoided this anti-Salon rebellion.

The month-long exhibit, opening on April 15, 1874, included a view by Claude Monet of dawn over a foggy harbor, *Impression: Sunrise.* Louis Leroy, a painter and art critic, wrote a satirical review which popularized the term "Impressionist," coined by conservative critics. Although Monet did not

object, many others felt that the term was too simplistic; Edgar Degas, for example, referred to himself as an *indépendant,* working apart from the Salon establishment. In all, the so-called Impressionists gave eight exhibitions irregularly from 1874 to 1886. Although there were fifty-five painters, half entered merely a single show. Most of the painters represented in this book participated at least once. Pierre Bonnard, Edouard Vuillard, and Henri de Toulouse-Lautrec, however, were too young, and Vincent van Gogh's brief career occurred too late. The only artist participating in every one of the eight exhibitions was Camille Pissarro, affectionately nicknamed "Papa" for his even temperament and calming influence.

By the 1880s, however, several of the initial Impressionists had reacted against purely visual painting and verged from an objective impression of nature. The inspirations behind such changing tastes included James McNeill Whistler's "art for art's sake" aesthetic theories as well as recent imports from Japan of woodblock prints with strong patterns and dramatic perspectives.

Some painters, such as Georges Seurat and Paul Cézanne, sought to introduce a solid compositional structure into their work. Others, like Van Gogh and Paul Gauguin, ventured into self-expression through stylized designs and color symbolism. Because many of these artists had exhibited in the Impressionists' shows but went on to develop other styles afterward, they were labeled "Post-Impressionists" by the English critic Roger Fry when he sponsored a modern French exhibition in London in 1910. Most of the Post-Impressionists were already dead and so could not react to Fry's terminology. Moreover, within three years, Gauguin's *Words of the Devil* would hang beside canvases by Pablo Picasso, Henri Matisse, and Wassily Kandinsky at New York's controversial Armory Show of 1913. Thus, Post-Impressionism and early twentieth-century modernism arrived in America simultaneously.

In many ways, the words "Impressionism" and "Post-Impressionism" are too limiting and simplistic. All these artists had been schooled in the conventional, academic tradition of precise detailing and enamel-like surfaces. Breaking with the idealized subject matter of the Salons, they embarked on careers as Realists who recorded the actual conditions of daily life. Then, each worked for a while as an Impressionist, objectively capturing the effects of varying light. After their Impressionist phases, most of these avant-garde painters turned to the individual Post-Impressionist experiments that helped to found twentieth-century abstraction. The National Gallery's collection is varied enough in chronological periods to demonstrate the stylistic evolution of most of these artists.

By the time he painted *Bazille and Camille,* for instance, Claude Monet was already abandoning the dark palette of Realism for the brighter highlights of *plein air* painting. The 1865 canvas shows his fiancée, Camille Doncieux, and his best friend, the artist Frédéric Bazille, caught in sunbeams that pierce through the foliage of the forest of Fontainebleau. (The refreshingly candid picture is, incidentally, a life sketch for Monet's immense but now fragmented *Luncheon on the Grass,* for which the Pushkin Museum has the overall compositional study.) *Woman with a Parasol* of 1875 depicts Camille again, now as Monet's wife and the mother of his son Jean; the picture was exhibited at the second Impressionist group show. In style, it is mature Impressionism with complex harmonies of complementary colors and a radiant glow of yellow-green grass reflecting off Madame Monet's elbow. When Monet painted his *Rouen Cathedral* series in 1893–1894 and *Waterloo Bridge* series in 1904 (works from the same sequences are in the Soviet museum), he had moved beyond Impressionist spontaneity. In these, color schemes are deliberately selected to play against each other in the same manner that a musician composes "variations on a theme" by changing the key or tempo of a particular passage.

Interestingly enough, Edouard Manet, whose Realist paintings had influenced Claude Monet to create the twenty-foot-long *Luncheon on the Grass,* was himself influenced by the younger artist. Inspired by Monet's method of working outdoors on the spot, Manet painted his first *plein air* picture in 1873, *Gare Saint-Lazare,* near the Parisian railroad depot. A decided change occurred in Manet's style: compare the traditional, dark backgrounds of Manet's works from the 1860s, such as *The Tragic Actor,* with the bright colors in *Ball at the Opera* of 1873. Even though the men are attired in black formal dress, the scene sparkles under the gaslights. Its sense of immediacy is heightened by the composition that crops several figures at the frame's edge.

Renoir, too, evolved dramatically. His *Diana,* rejected by the 1867 Salon jury, recalls the thick

brushstrokes and neutral hues of the older Realist, Courbet. Five years later, *Pont Neuf, Paris,* one of Renoir's few cityscapes, gleams with the strong sunshine and free brushwork of Impressionism. After a trip to Italy in 1881, Renoir decided to adopt the tighter draftsmanship of Renaissance masters. *Girl with a Hoop,* for instance, uses precise details to attract attention to the child's face and hands in an otherwise dreamy fog of pastel tints. This is a commissioned portrait of Marie Goujon, daughter of a French senator; the companion portrait of her brother Etienne now resides in the Hermitage. The 1893 *Bather Arranging Her Hair* might be termed a Post-Impressionist composition, with its reliance upon firm contours and a calculated scheme of browns and greens.

Just as Renoir went through a late Post-Impressionist phase, so Gauguin underwent early development as an Impressionist. Gauguin's *Brittany Landscape* of 1888 reveals in its variegated colors the teachings of Pissarro. But the brushstrokes are clearly arranged into vertical and horizontal cross-hatchings that presage Gauguin's later interest in deliberate design principles. The change in his style was so abrupt it must be called a revolution rather than an evolution. Only one year later, his *Self-Portrait* uses bold outlines and flat color areas derived, in part, from his study of medieval stained glass windows and cloisonné enamels. A private joke, the personal symbolism represents Gauguin as both the Messiah—with halo—and the Devil—with the forbidden fruit—who led a colony of poets and painters in Brittany. Resolving to leave the hypocritical conventionality of Europe, Gauguin departed for Tahiti on June 8, 1891. The National Gallery has a well-rounded selection of Gauguin's famous Polynesian scenes.

Cézanne's development is so complex that, for convenience, art historians divide it into four periods. During the late 1860s, he worked in the Romantic manner of dark tones and thick paint that characterize *The Artist's Father.* (Monsieur Cézanne reads the radical newspaper for which Emile Zola, Paul's boyhood friend, was the art critic.) During the mid-1870s, Cézanne painted in an Impressionist mode, evidenced by the fresh colors of *The House of Père Lacroix.* This landscape of 1873, created under the influence of Pissarro, is one of only a handful of pictures that Cézanne ever signed and dated. His Constructive period of the late 1870s to mid-1880s replaced Impressionism's ephemeral qualities with the logical design seen in the patterned brushstrokes of *Houses in Provence.* Finally, by about 1887, Cézanne attained his Synthetic period in which, regardless of the subjects' natural appearances, colors are balanced as hot against cold and shapes are contrasted as curves against angles. Apparent in such pieces as *Still Life with Peppermint Bottle,* this Synthetic phase of pure "art for art's sake" was to inspire the later Cubist movement.

Post-Impressionism spawned several independent movements around the turn of the century. In the 1890s, Pierre Bonnard and Edouard Vuillard banded together with several other artists to form *Les Nabis,* from the Hebrew for "prophets." The Nabis generally chose intimate scenes rendered with exquisite, subdued colors. And, in 1905, Henri Matisse and Georges Rouault found their vividly hued pictures branded as the work of *Les Fauves,* "the wild beasts." Often, the Fauves expressed an optimism and joy of life with strong colors and bold textures inspired by the works of Van Gogh and Gauguin. With their continued reliance upon recognizable subject matter, the Nabis and the Fauvists may be considered offshoots of Post-Impressionism that endured well into the twentieth century.

Oddly enough, the very first modern French paintings to be seen in the United States were not shipped here from Europe but were created in the New World. Edgar Degas, whose mother was an American Creole, visited his younger brothers, Louisiana cotton merchants, during the winter of 1872–1873. While in New Orleans, Degas painted several family portraits. In *Madame René de Gas,* pastel tints and vacant spaces effectively convey the blindness of his sister-in-law Estelle. Degas took this memento back to France, where his first sale to an American patron—the earliest known by any Impressionist—was about to take place.

In 1873, even before she met Degas, the American painter Mary Cassatt had persuaded a lady friend to purchase one of his pastel drawings from a Parisian dealer's window. Cassatt's companion soon married H.O. Havemeyer, a New York merchant called "the sugar king," who became a major donor of French Impressionism to American museums. Cassatt's social status as the daughter of a prominent Pennsylvania banker allowed her to exert a subtle influence on her wealthy peers, such

as the Havemeyers and Whittemores. Although paramount in her impact upon America's late nineteenth-century collectors, Cassatt was not alone. Two other famous expatriate painters, James McNeill Whistler and John Singer Sargent, also urged Americans to buy modern paintings.

Tycoons in the United States are often considered cultural usurpers. To counteract this dubious heritage, they sometimes surround themselves with symbols of prestige: costly antiques and rare Old Masters. While partially true, this stereotype ignores the millionaires who embody the spirit of their own financial success by embracing the equally fresh outlook of modern artists.

The first opportunity to purchase Realist and Impressionist paintings in the United States came on September 3, 1883, when an industrial trade fair opened in Boston. In its Foreign Exhibition hung Manet's *The Tragic Actor,* a stark portrait of Philibert Rouvière costumed in his celebrated role as Hamlet. Many of these fifty-seven French paintings belonged to Paul Durand-Ruel, a dealer with galleries in Paris and New York. Durand-Ruel later sold this Manet to George Vanderbilt, whose widow gave it to the National Gallery as one of the earliest avant-garde pictures ever seen on this side of the Atlantic. Durand-Ruel also created America's second sales exhibition, a huge selection of some 300 pictures, in New York in April and May of 1886—just when the last Impressionist group show was being held in Paris.

The first Impressionist to have a one-man show in the United States was Monet, in New York in 1891 and the next year in Boston. *Morning Haze,* a sparkling evocation of dew near Monet's home at Giverny, undoubtedly appeared in one or both of these exhibits because it belonged to the New York art entrepreneur who organized them. By 1893, at Chicago's immense World's Columbian Exposition, modern French paintings like Edouard Manet's *Dead Toreador* clearly dominated the art exhibits. This Manet, which three decades earlier had scandalized Paris, was purchased by Peter A. B. Widener, a Philadelphia railroad magnate with one of the country's best collections of Old Masters. Widener's daring demonstration of avant-garde taste set an important precedent for other American patrons. The trickle of French pictures crossing the ocean soon became a flood. Long before the founding of the National Gallery of Art in 1937, innumerable Impressionist paintings had been donated to or purchased by museums all over the United States.

A particularly noteworthy Atlantic crossing occurred in 1880, when two young Pittsburgh financiers, Henry Clay Frick and Andrew William Mellon, traveled together on their first European trips; both became avid art collectors. Mellon retired from business to become Secretary of the Treasury from 1921 to 1932 and to serve as Ambassador to Great Britain in 1932 and 1933. During his career in the District of Columbia, Mellon decided to create a national art gallery; in fact, he purchased many pictures with the specific intention of giving them away and never hung them in his home. Although rivals for the attention of art dealers, Mellon and Frick remained the closest of friends. Had Frick not died in 1919, he might have joined his collection, now a New York landmark, to Mellon's in forming a museum in Washington.

On March 24, 1937, Congress accepted Mellon's amazing offer of his superb Old Master paintings and statues, an endowment fund, and a building large enough to house the gallery's growing acquisitions for several generations to come. The architect, John Russell Pope, specialized in museums and monuments; the National Archives and the Jefferson Memorial are among his other creations in Washington, D.C. The severe classical edifice he designed for Mellon was, upon completion, the world's largest marble building. Regrettably, neither founder nor architect saw his dream come true; Mellon and Pope both died a few months after the groundbreaking.

The most recent item in Andrew Mellon's collection was a richly colored Venetian scene of the 1840s by J. M. W. Turner, the English Romantic landscapist. When asked whether he intended to add Impressionism, Mellon answered, "No, I hope others, who know this school better than I do, will contribute such works to the National Gallery." Little did he realize that his son and daughter would assemble two of the world's best Impressionist collections.

When the National Gallery of Art opened on March 17, 1941, it did not possess any nineteenth-century French paintings. Three months later, Duncan Phillips, a member of the initial Board of Trustees, gave *Advice to a Young Artist,* by the political caricaturist Honoré Daumier. The subject matter optimistically forecast growth for the new museum, and the canvas bore the distinction of

having once been owned by Daumier's close friend and mentor, Jean-Baptiste Camille Corot. The generosity of this act was extraordinary because the picture could have graced the donor's own family gallery in Washington, D.C.—The Phillips Collection—founded in 1918 as America's first museum of contemporary art.

Soon, thirty-three modern paintings, borrowed from the Phillips, Dale, and Whittemore families, accompanied this sole Daumier. The modern French paintings actually in the gallery's possession increased markedly the year after the inauguration. Before he died, Andrew Mellon had an inkling that Joseph Widener might add his treasures to the National Gallery; this occurred in 1942. Widener donated his Old Master paintings, sculptures, and decorative arts in memory of his father, Peter Widener, who had bought Manet's *Dead Toreador* so early on. Degas' *The Races* reflects the family's passion for thoroughbreds. And the Wideners' progressive tastes showed in Renoir's *The Dancer,* which, delightful as it appears today, received vicious critical attacks at the first Impressionist show. Thus, although the National Gallery's Impressionist holdings were initially small, they already contained works of historic importance.

In 1956, the gallery acquired Manet's *Gare Saint-Lazare.* Its donor, Horace Havemeyer, gave the canvas in honor of his mother, Mrs. Havemeyer, the first American patron known to buy an Impressionist picture. From 1958 to 1960, Agnes and Eugene Meyer, publishers of *The Washington Post,* gave Manet's *Still Life with Melon and Peaches* and four Cézannes, among them *The Sailor* and *Le Château Noir*.

During the gallery's first two decades, twenty donors built up a collection of forty-five French paintings from the latter half of the 1800s. The Wideners and Meyers contributed exactly one-third of this group; the remaining thirty works came from eighteen other benefactors. A listing of these early benefactors reads like a "Who's Who" of publically spirited American families. More Impressionist works were on view, however, than the gallery actually owned. Since the fall of 1941, for example, Manet's *The Old Musician* and Renoir's *A Girl with a Watering Can* had been hanging on loan from Chester Dale. As he lent more and more pictures, new display spaces supplemented the initial three rooms for modern art. In 1958, Dale gave the gallery its first Monet, *Morning Haze.*

A self-made millionaire, Dale began as a Wall Street messenger boy and quickly emerged as a major investor. His interest in art began after he married Maud Murray, an amateur painter who studied in Paris. His acumen at art collecting soon matched his sharpness in the stock market; he shrewdly bought a partnership in the Galerie Georges Petit, a major Parisian dealership. Thereby an art agent himself, Dale not only knew beforehand which works of established artists might be coming up for sale but also eliminated dealers' percentage fees. Maud and Chester Dale acquired works from contemporary painters, too, such as Henri Matisse and Pablo Picasso.

Dale's death in 1962 revealed the National Gallery of Art to be the recipient of his entire collection. Eighty-eight paintings from his Manhattan apartment joined the 152 pictures already on loan. Virtually every major Impressionist and Post-Impressionist was represented, as were the current Parisian painters.

With such a broad survey in a such concentrated field, the Dale bequest formed a foundation upon which the National Gallery's future additions of late nineteenth- and early twentieth-century art will rest.

In 1966, the gallery celebrated its twenty-fifth anniversary with a special exhibition drawn exclusively from the holdings of the founder's two children: French Paintings from the Collections of Mr. and Mrs. Paul Mellon and Mrs. Mellon Bruce, displaying 247 pictures from the mid-nineteenth to early twentieth centuries. Nearly half these loans subsequently passed to the gallery.

The gallery outgrew its original facilities for display and scholarship far more rapidly than anticipated. Paul Mellon and Ailsa Mellon Bruce then agreed to finance an expansion program. Ms. Bruce, like her father, passed away without seeing the project fulfilled, two years before the 1971 groundbreaking. Her brother, Paul Mellon, supervised the design and construction of the present East Building, which opened on June 1, 1978. The architect, I. M. Pei, brilliantly conquered the problem of a trapezoidal site by erecting a dramatic polygonal structure.

Ailsa Mellon Bruce had served the National Gallery as an anonymous benefactor. Her personal

taste accounts for her 1955 purchase of Captain Edward Molyneux's collection, seen three years earlier in a National Gallery loan show. A British couturier with a Parisian dress salon, Molyneux devoted his connoisseurship to acquiring intimate Impressionist canvases, including Berthe Morisot's *The Harbor at Lorient,* Van Gogh's *Farmhouse in Provence, Arles,* Bonnard's *Two Dogs in a Deserted Street,* and Vuillard's *Child Wearing a Red Scarf.* Most of the Molyneux pictures were too tiny to compete with the West Building's vast rooms. So, for a decade after Mrs. Bruce's bequest, the gallery stored these charming works. Installed for the new building's inauguration, Small French Paintings instantly became a public favorite.

Space limitations prevented the display of other French pictures, too. In 1972, W. Averell Harriman, former Governor of New York and Ambassador to the Soviet Union, gave twenty-three paintings in memory of his late wife, who had directed her own modern art dealership in New York until 1942. She acquired many of the picutres in her husband's memorial bequest, twelve of which are Realist or Post-Impressionist. One, Cézanne's *Battle of Love,* a vividly powerful interpretation of a classical theme, once belonged to Renoir. Gauguin's *Words of the Devil* illustrates the temptation of the "ancient Eve" which the artist mentioned in a letter to the Swedish author, August Strindberg. (This Tahitian Eden also demonstrates Gauguin's fascination with particular motifs: the tree in the forest is the same one seen on the beach in his *By the Sea.*)

Recent additions continue to augment the collection. John Hay Whitney, the publisher of the New York *Herald Tribune* and, like Andrew Mellon, an Ambassador to Great Britain, passed away in 1982. His bequest will help to fill gaps or amplify strengths of the gallery's holdings. *Coast near Antibes,* for instance, is the National Gallery's first work by Post-Impressionist Henri-Edmond Cross. In his Riviera landscape, Cross exaggerated Georges Seurat's luminous points of light into a stylized pattern of emphatic dots.

Paul Mellon, the founder's son and his successor on the Board of Trustees, supports the National Gallery and several other educational institutions. Allowing no fanfare to trumpet his donations, he has transferred pictures on long-term loan to the gallery bit by bit. Although Cézanne's *The Artist's Father* did receive a public announcement, the astute visitor could spot additions only by noticing that paintings had acquired, overnight, plaques on their frames.

On January 28, 1983, however, Mr. and Mrs. Paul Mellon made so significant a gift that the gallery did announce the acquisition of ninety-three works, including twenty-six canvases by the Impressionists and Post-Impressionists. Among the rarest is Frédéric Bazille's *Negro Girl with Peonies,* finished just months before the twenty-eight-year-old painter was killed in action in the Franco-Prussian War. Bazille left only sixty pictures, and the gallery had possessed only one other work by him. A formative figure in the rise of Impressionism, he was Monet's best friend when portrayed in the latter's *Bazille and Camille.*

The National Gallery's rapid rise as a world-class museum of Old Masters and modern art must be credited to over 500 philanthropists, whose benevolence, starting in 1941 with one canvas by Daumier, has provided the National Gallery of Art with its breathtaking sweep of nearly 300 Impressionist and Post-Impressionist pictures.

William James Williams

Impressionism and Post-Impressionism in The Hermitage, Leningrad, and the Pushkin Museum of Fine Arts, Moscow

SOVIET COLLECTIONS of French paintings and drawings of the late nineteenth and early twentieth centuries are considered to be among the world's finest. They are composed chiefly of works from the celebrated private collections of two Moscow connoisseurs, Sergei Shchukin and Ivan Morozov, who associated closely with French artists and critics. In purchasing works by then unrecognized French painters, they relied largely on intuition and help from their long-standing contacts with such Paris dealers as Durand-Ruel, Druet, Vollard, Bernheim-Jeune, and, later, Kahnweiler. Contemporary French paintings that the Russian collectors bought, though underestimated in the country of their origin, met with critical acclaim in Moscow and were integrated into Russian artistic culture.

Today, towards the close of the twentieth century, we can appreciate fully the tremendous role European dealers played in promoting the innovative ideas of the French avant-garde. Each combined his profession of *marchand* with serious art studies; they were, in effect, the first serious critics of modern European painting. The names of Paul Durand-Ruel, a staunch advocate of Impressionism, of Ambroise Vollard, who discovered Cézanne and Rouault and urged Picasso to create a remarkable series of etchings, and of Daniel Kahnweiler, who was the first to assess the unique significance of the Cubist experiments of Picasso and Braque, are of paramount importance for the history of modern art in Europe.

A major contribution to its development was also made by art collectors. The Morozov and Shchukin brothers created oases of modern French culture in Moscow, in the very heart of Russia. The parallel efforts of these progressive intellectuals were a phenomenon of far-reaching consequence for modern painting. Canvases by French artists that had found their way into Russia, Germany, Great Britain, and the United States played a key role in the emergence of national schools of avant-garde art.

The year 1897 was an important date in Sergei Shchukin's collecting activities: his attention was drawn in that year to Claude Monet's landscapes exhibited at Durand-Ruel's gallery. Their pictorial merits won Shchukin's sincere admiration, and Monet became his favorite artist for many years to

come. One after another, he bought several brilliant canvases from Monet's famous series of *Haystacks, Cliffs, Views of Rouen Cathedral* and *Water Lilies*. In 1904, he purchased a smaller version of *Luncheon on the Grass (Le Déjeuner sur l'herbe)*, which is now at the Pushkin Museum of Fine Arts in Moscow. (Only separate portions of the larger canvas have survived.) In 1899, he evidently persuaded his brother Piotr to buy from Durand-Ruel Monet's *Lady in the Garden,* which Piotr later presented to him. Shchukin's collection of Monets attracted numerous art lovers; artists came from Paris to see it.

Shchukin also built an extensive collection of other Impressionist paintings. In 1898, for example, Durand-Ruel acquired for him Camille Pissarro's *Place du Théâtre-Français, Spring.* Later, Shchukin bought a picture from Pissarro's well-known series, *Avenue de l'Opéra.* A separate room in Shchukin's gallery was allocated to Renoir. Through Durand-Ruel, a number of superb Renoir canvases were acquired for Piotr Shchukin and later found their way into Sergei Shchukin's gallery. They included *Nude, Lady in Black* and *Girls in Black.* Incidentally, all the Degas pastels that presently grace the Pushkin Museum in Moscow—his *Blue Dancers* and the remarkable *Dancer Posing for a Photographer,* among others—come from Sergei Shchukin's collection.

In the early years of the twentieth century, Shchukin's interest was focused on Post-Impressionism. He bought three brilliant pictures by Van Gogh, namely *Portrait of Dr. Rey, Ladies of Arles (Reminiscence of the Garden at Etten),* and *Lilac Bush.* In 1904, he bought from Durand-Ruel the celebrated Cézanne painting, *Pierrot and Harlequin,* upon which the Pushkin Museum justly prides itself today. Other Cézanne pictures, such as *Self-Portrait, Landscape at Aix (Mont Sainte-Victoire)*—one of the artist's later works—and *The Smoker,* came from the collection of Ambroise Vollard. Shchukin also owned a superb portrait by Cézanne, *Lady in Blue.* The Moscow collector also became an enthusiastic admirer of Gauguin's Polynesian pictures and bought sixteen canvases by that master. He was conscious of the decorative aspect of Gauguin's pictures and appreciated his complex, at times indecipherable, imagery, selecting such intriguing compositions as *The Ford (The Flight), Sunflowers, Gathering Fruit, The King's Wife, Her Name Is Vairaumati,* and *Bé Bé (The Nativity).*

However important all of Shchukin's above-mentioned acquisitions may have been, he is most famous for his collection of Matisses. Before World War I, when Matisse was hardly known in French art circles, the Moscow patron was the young artist's chief buyer. He owned most of Matisse's pre-Fauve paintings that are reproduced in this volume. In 1904, he brought to Moscow the still life, *Crockery on a Table.* In fact, one might say that Shchukin discovered Matisse; after 1908, he began to buy his work regularly. At about this time, he first met the artist in Paris, and in 1911, Matisse accepted Shchukin's invitation to visit Moscow. In Shchukin's drawing room, Matisse personally hung all the twenty-one canvases then in his host's possession. It was this room that the collector used to call his "fragrant garden."

At their first meeting, Shchukin commissioned two large panels, *The Dance* and *Music,* intended to decorate the entrance hall of his Moscow house. These are justly considered to be Matisse's central works of 1910. At that time—Matisse had yet to paint the panels for the Barnes Foundation in Merion Station, Pennsylvania, in the U. S.—the Shchukin gallery was the only one in the world to contain examples of the artist's monumental and decorative work.

During the same years, Shchukin began to collect the work of the young Picasso, another great innovator whose genius came into full bloom on French soil. Enlisting the services of Daniel Kahnweiler, a prominent dealer and theoretician of modern art, Shchukin bought a large number of Picasso's works from his Blue, pre-Cubist, and Cubist periods. Kahnweiler sold to Shchukin such early Picasso masterpieces as *Old Jew and a Boy, The Embrace, The Visit (Two Sisters), Portrait of the Poet Sabartés,* and *The Absinthe Drinker.* Shchukin had fifty-one Picassos, including (apart from his early works) a number of Cubist canvases, ranging from the *Nudes* of the transitional period to examples of Synthetic Cubism and collage. In the room which he allotted to his Picassos, Shchukin also installed some primitive African sculptures of the kind that the artist himself admired.

Shchukin's last acquisitions were of some pictures by Le Douanier Rousseau. This alone demonstrates his bold, diverse tastes, for the works of Rousseau, who died in obscurity in 1910, had just begun to gain renown among the avant-garde of the French artistic milieu.

Equally celebrated among the Moscow collectors were the Morozov brothers. Mikhail Morozov was an art and literary critic and the first Russian to buy French paintings produced during the latter half of the nineteenth century. From 1890, he developed an interest in the Impressionists and their precursors. In the late 1890s, he bought from Sergei Shchukin Edouard Manet's *The Bar,* a beautiful study painted with a striking freshness. His subsequent acquisitions included Monet's landscape, *Poppy Field,* and Renoir's well-known, full-length *Portrait of the Actress Jeanne Samary.* In 1898, the Paris music-hall star Yvette Guilbert toured Moscow. Yvette's singing enchanted Morozov, and having caught sight of her portrait by Toulouse-Lautrec in the Bernheim-Jeune Gallery in Paris, he bought it on the spot. Between 1900 and 1903, he bought Gauguin's Tahitian composition, *Landscape with Two Goats,* and Van Gogh's canvas, *Seascape at Saintes-Maries.* Morozov's collecting ardor was unfortunately cut short by his untimely death in 1903.

Mikhail Morozov inspired his younger brother, Ivan, with his enthusiasm for painting. In the summer of 1903, Ivan Morozov acquired Sisley's *Frosty Morning in Louveciennes* from Durand-Ruel, thus starting his collection. He then purchased more Sisley landscapes, notably *River Banks at Saint-Mammès.*

The peak of Ivan Morozov's collecting activities was reached in 1907–1908. By that time, he had acquired Pissarro's *Ploughland,* a canvas displayed at the exhibition of the Société Anonyme des Artistes Peintres, Sculpteurs, Graveurs in 1874, the first of the famous Impressionist exhibitions. Of the several pieces bought before 1907, Renoir's study for the *Portrait of the Actress Jeanne Samary,* from the collection of the sitter's husband, is especially noteworthy. In addition to the Impressionists, the acquisitions of those years included works by Van Gogh, Gauguin, Cézanne, Signac, and Bonnard. Van Gogh's well-known painting *The Red Vineyard at Arles* was acquired on Valentin Serov's suggestion. At about the same time, Morozov purchased his first Gauguins, *Landscape with Peacocks, Café at Arles,* (one of the artist's early masterpieces), and *Woman Holding a Fruit.* Morozov owned eighteen superb works by Cézanne, an artist he held in special esteem. These included the celebrated early *Girl at the Piano, Still Life with Peaches and Pears,* and such late works as *Mont Sainte-Victoire* and *Great Pine near Aix.* His acquisition of several excellent Monets—*Le Boulevard des Capucines,* decorative panels with views of the garden at Montgeron, and the wonderful townscape *Waterloo Bridge: Effect of Mist*—further enriched his collection. Morozov also bought some lovely Renoirs—the landscape *Bathing on the Seine, La Grenouillère, In the Garden: Under the Trees of the Moulin de la Galette,* and the captivating *Girl with a Fan.*

In 1906, at the Salon des Indépendants and in the house of Baron Cochin in Paris, the Russian collector first saw decorative compositions by Maurice Denis. He knew that Denis admired Cézanne, so he made a point of introducing himself. They soon met at the latter artist's suburban studio, where Morozov bought several Cézannes, as well as works of Denis. Later, he asked Denis to decorate the large music salon in his Prechistenka house in Moscow.

Bonnard's well-known triptych *The Mediterranean* was also commissioned by Morozov and hung in the vestibule of his house. As the result of several more commissions, Morozov came to possess a collection of Bonnard's paintings produced between 1905 and 1910.

Between 1911 and 1912, Morozov acquired, through Vollard, Matisse's early still life, *The Bottle of Schiedam.* By this time the Moscow collector had met the artist and, like Sergei Shchukin, already held him in high esteem. In his letters Matisse repeatedly invited Morozov to visit his atelier and gave him valuable advice on what to buy. Ivan Morozov bought only three Picassos—*Harlequin and His Companion, Girl on a Ball,* and *Portrait of Ambroise Vollard.* Today we are fully aware of their importance in the artist's oeuvre.

Unlike the temperamental Sergei Shchukin, who was prone to hazardous choices and to swift change, Ivan Morozov judiciously desired to possess only outstanding works of art. This difference was reflected in their respective galleries. While Shchukin's house afforded a sanctuary to budding Moscow artists, who always animatedly discussed the pictures exhibited, the Morozov gallery in the Prechistenka Street (now No. 21, Kropotkin Street) was open only to a select coterie of connoisseurs. Morozov built a veritable museum of modern French art, in which he invested heavily. He spent annually as much money on acquisitions as only state-subsidized museums could afford in those days.

Among other prominent Russian collectors of French art was the landscape painter Ilya Ostroukhov. He owned the pastel, *Woman at Her Toilette,* by Degas. The Moscow collectors' circle likewise included the Riabushinsky brothers, Mikhail and Nikolai, both bankers. Mikhail Riabushinsky's collection contained, for instance, Pissarro's *Boulevard Montmartre, Afternoon Sun.*

The Moscow collectors' activities were cut short at the outbreak of World War I. After the October 1917 Revolution, the collections of Sergei Shchukin and Ivan Morozov were nationalized and their galleries opened to the public. The Shchukin collection in Znamensky Lane received the official name of the First Museum of Modern Western Painting, and the Morozov collection formed the Second Museum of Modern Western Painting. In 1923, both galleries were merged into the State Museum of Modern Western Art, and all the pictures were amassed in the former Morozov house. Boris Ternovetz, a prominent art historian and sculptor, was appointed the museum's curator. He did much to establish regular contacts with art collectors and museums in Western Europe.

Between 1923 and 1930, the art museums of Moscow and Leningrad were reorganized and their stocks redistributed in order to arrange exhibitions on a truly scholarly basis and to fill the lacunae in the collections of each; the Hermitage had little in the way of late nineteenth- and early twentieth-century Western European art, while the Moscow museums had few Old Masters. So the Hermitage sent to Moscow 460 paintings and in turn received numerous paintings by Monet, Pissarro, Sisley, Cézanne, Van Gogh, Gauguin, Matisse, Picasso, and other artists from the above-mentioned Museum of Modern Western Art in Moscow. The latter was closed in 1948, and its holdings—comprising the Shchukin and Morozov collections—were split up between the Pushkin Museum and the Hermitage.

This book presents a wide selection of Impressionist and Post-Impressionist paintings in Soviet museums, encompassing a period of revolutionary discoveries in art from the late 1860s and early 1870s to the onset of the twentieth century. The authors believe 1905—the year in which Cézanne produced his last paintings and Fauvism emerged—to have been the watershed in the development of French art; yet, no movement should be presented in strict chronological sequence, and for this reason this volume also includes works by Denis, Bonnard, and Vuillard done during the 1910s. This was the most productive period for the Nabis, although they were organized as a group in the 1880s. The decorative series of Denis and Bonnard illustrate the logical culmination of a basic tendency characteristic of Post-Impressionism, which was a transitional movement: an integrated, decorative monumentality based on the harmony of pure color and linear pattern. Pictorially, however, Post-Impressionism betrays an obvious debt to the style-forming principles of the Art Nouveau movement and Symbolist poetry—thus it cleaves more to the nineteenth century. The paintings of Henri Rousseau may also go beyond the chronological limits of this volume, for they do not always permit accurate dating. The heritage of this unique painter should, in the authors' opinion, be considered *in toto.*

The museums of Leningrad and Moscow possess a number of remarkable Impressionist landscapes—*Bathing on the Seine, La Grenouillère,* and *In the Garden: Under the Trees of the Moulin de la Galette* by Renoir, *Le Boulevard des Capucines* by Monet, *Village on the Seine, Villeneuve-la-Garenne* and *Frosty Morning in Louveciennes* by Sisley. All were done by the young painters in the 1870s, when they had their first exhibitions, and have a special appeal. The artists have left to posterity truthful, heartfelt representations of what is no longer to be seen—sailboats on the Seine, open-air dance floors in the heart of Paris and vineyards of its suburbs, the semi-rustic Montmartre, such favorite public places as La Grenouillère, and the bustle of fin-de-siècle urban life. This "lost world" springs back to life on Impressionist canvases.

The same ambiance is characteristic of the portraits produced in the 1870s and the early 1880s. Such brilliant Renoir canvases as *Portrait of the Actress Jeanne Samary* or *Girl with a Fan* proclaim the Impressionist approach to portraiture, which aimed to capture the fleeting moods and inimitable facial expressions of the charming sitters. More than any other artist, Renoir delighted in the atmosphere of happiness, youthful exuberance, and friendliness that then reigned in Montmartre, as seen in *In the Garden.* His portrayals of young women radiate a *joie de vivre* and strike the viewers with

their fresh, dazzling colors; this is especially true of the Hermitage pictures, *Girl with a Fan* and *Lady in Black.* During the same stage in his career, Renoir painted portraits aimed to please the official critics of the Salons. The Hermitage *Portrait of the Actress Jeanne Samary* provides some insight into this approach.

By the mid-1880s Renoir had reached a critical point. Now a master of delicate tonal values, adept at conveying an ethereal atmosphere and the trembling reflections of sunlight, he now rejected blurred contours, striving towards a clear and well-delineated form. He developed a classical style known as *style aigre.* This period is represented in Soviet collections by the Hermitage painting, *Child with a Whip.*

The landscapes of Alfred Sisley, in contrast to other Impressionists, require a long and close scrutiny. He was never preoccupied with the theory of color or the problems of visual perception. His landscapes seek above all to convey a mood. Although his oeuvre contains a great variety of landscape motifs, he did not combine them into series as did Monet and Pissarro. His individual style underwent no dramatic changes, though in the mid-1880s he began to employ broader, more dynamic brushwork, abandoning his former, fragmented spatial delineation. This new manner is evident in such works as *Windy Day at Veneux, River Banks at Saint-Mammès,* and *The Skirts of the Fontainebleau Forest.*

The early landscapes of Camille Pissarro reveal influences of Corot and Daubigny. The sensitive and poetic treatment of nature in the landscapes of the Barbizon painters was compatible with Pissarro's own lyrical talent. In 1874, Pissaro and Monet were among the initiators of the first Impressionist exhibition, where Pissarro displayed five landscapes, including *Ploughland.* A dedicated Impressionist who helped to organize and who took part in all the Impressionist exhibitions, Pissarro never tired of perfecting his pictorial techniques. In the 1890s, Pissarro produced his famous series of Paris and Rouen views. This period is represented in this volume by two excellent canvases from Soviet collections, both of which convey the throbbing rhythm of urban life that the Impressionists always tried to capture in their work. His *Boulevard Montmartre,* with its continuous stream of passers-by, is flooded by midday sunshine breaking through the spring clouds, and *Place du Théâtre-Français* is alive with the freshness of spring foliage and the joyful bustle of the crowd.

The work of Claude Monet is amply represented in Soviet collections. In such landscapes of the 1870s as *The Pond at Montgeron* and *Le Boulevard des Capucines,* Monet came close to transcending the isolated character of easel painting. He aimed at an integration of painting with other visual arts. This tendency is best illustrated by *The Pond at Montgeron.* In the years that followed, Monet produced not only paintings remarkable for their meticulous brushwork and diverse texture, but also pictures conceived in a more generalized manner, akin to decorative panels: *The Rocks of Belle-Ile* and *Cliffs at Etretat* may serve as examples.

In 1883, the artist settled in Giverny. The Hermitage collection contains one of his earliest views of Giverny, in which the haystack in the foreground also serves as the starting point for a deep, panoramic composition. The Pushkin Museum's *Haystack at Giverny* and The Hermitage's *Poppy Field,* while reflecting different fleeting states of light, are notable for the intensity of their blues, greens, and reds; each scene is filled with sunshine.

The series dedicated to Rouen Cathedral was painted in the 1890s. Two pictures from this series which are in the Pushkin Museum present the façade of the cathedral at different times of day. They both abound in the most delicate gradations of tonal values.

In the early years of the twentieth century, Monet's landscapes become highly decorative. Forms lose their configuration; objects melt into the enveloping haze. The distinctive features of Monet's late period found their most complete expression in his views of London. In *Waterloo Bridge: Effect of Mist,* the outlines of the bridge and of the Houses of Parliament are barely discernible in the thick mist, whose effect is conveyed with great skill.

Edgar Degas, with his acute powers of observation and interest in contemporary reality, stood close to the Impressionists; he employed bright, pure colors and introduced a number of bold compositional devices. He preferred to portray subjects in motion, and he spent hours with his sketchbook or camera at the racetrack, at ballet rehearsals, and in backstage areas. By depicting figures with

an unexpected foreshortening, or by presenting in one picture several figures in different postures, he sought to convey the dynamic rhythm of contemporary life. The gestures and facial expressions he portrayed reflect the psychology of a transitional epoch. Degas is represented in Soviet museums by pictures of racehorses, dancers, and women at their toilette. In one of his pastels, *Exercising Racehorses,* Degas imparts a distinctive character to the movement of each horse and rider, creating a rhythmic whole. Like his other pictures of horse races, this pastel radiates an optimistic mood redolent of Impressionist landscapes.

All the Soviet-owned works by Degas reproduced in this volume were done after 1880, except for the unique Moscow piece, *Dancer Posing for a Photographer,* dating back to the 1870s. In place of the typical furnishings of a photographer's studio, Degas chooses as the backdrop a window opening out onto Parisian rooftops. The soft, silvery light streaming from outside seems to envelop both the interior and the dancer in an ethereal haze. This fusion of an outdoor scene with an interior creates one of the most expressive effects achieved in modern painting before Matisse.

In such famous pastels as *Blue Dancers,* where the artist has brought together all his favorite ballet gestures and movements, we see a dance that departs wonderfully from the classical ballet. Degas' pastels of nudes at their toilette form, as the artist himself said, "a suite of naked women, bathing, washing, drying themselves, rubbing themselves down, combing their hair or having it combed." Among the pastels that Moscow collectors acquired, *Woman Combing Her Hair* is conspicuous for its high artistic merit.

Any account of late nineteenth-century art would be incomplete if it failed to describe the works of Cézanne, Van Gogh, and Gauguin in Soviet museums.

A genuine masterpiece from Cézanne's early period is the Hermitage *Girl at the Piano,* a version of the non-extant *Overture to Tannhäuser.* In it we have a difference in scale between the figures and a disintegration of the stagelike, closed-in space, even to the point of replacing it by an alternating sequence of parallel flat objects.

Starting in the 1880s, Cézanne explored the problem of constructing a solid volume, an integrated spherical space, within the limits of still life and landscape. In his experiments in landscape the artist aimed to convey a unity of nature's forces. He strove to attain a harmony between the diagonally arranged, receding perspective and the flat surface of the canvas. The spatial relationships in another landscape, *The Aqueduct,* obey the same laws; here the effect of depth is enhanced by the different scaling of the objects and, at the same time, is offset by color modeling along the vertical plane. In the *Mont Sainte-Victoire* landscapes these compositional devices serve to produce a truly cosmic image. The Cézannes in the Soviet collections enable art historians to trace all the stages the artist went through to achieve this objective.

The Moscow and Leningrad museums display several Cézanne pictures containing portrayals of people. His *Smokers* series best reveals his understanding of humanity's part in Creation. Like the Renaissance artists, he succeeded in immortalizing his contemporaries. To fuse humanity with nature, to make the human figure the compositional pivot of the universe, was something that Cézanne undertook only in his late period. The small Pushkin Museum study, *Bathers,* is important because it demonstrates his first efforts along these lines.

The several Van Goghs in Soviet museums—from the earliest pictures painted in Arles to the last ones, done just before the artist's death in Auvers—are indisputable masterpieces.

In 1888, Van Gogh moved from Paris to Arles, in Provence, where he began to work with feverish speed for several hours every day and produced a great number of pictures distinguished by a highly individual manner unlike that of the Paris Impressionists. He painted in oils directly onto canvas, using no preliminary charcoal sketches. The vigorous dabs in *Seascape at Saintes-Maries* provide a good example of his manner. He was able to complete a picture in one sitting, to infuse it with an inner emotion, and to inject a dynamic quality into the most trivial of motifs.

In the autumn of 1888, Gauguin came to Arles. Under his influence, as well as that of Bernard's and Anquetin's experiments with Cloisonnism (thus termed because of the resemblance to cloisonné enamels), Van Gogh painted several pictures of women walking. Of these works, done in a synthetic manner, the Hermitage *Ladies of Arles (Reminiscence of the Garden at Etten)* is the most famous. How-

ever, the artist's independent and violent nature clashed with the well-ordered rationale of Cloisonnism, so that in the foreground of this picture we see a chaotic conglomeration of paints squeezed out of tubes onto the canvas—which merge, viewed from a distance, into a flowerbed.

A striking contrast to the well-balanced stylization of Cloisonnism is provided by Van Gogh's *The Red Vineyard at Arles,* a gem of the Arles period. It is a picture filled with explosive, flaming reds and incandescent sunlight—and pervaded with the foreboding of tragedy. It is the cry of an artist aware that he is doomed to complete isolation. Shortly thereafter, Van Gogh violently quarrelled with Gauguin and had a nervous breakdown; he cut off his ear lobe and had to be taken to the Arles hospital. Félix Rey, the doctor who took care of him there, looks at us from a Moscow portrait.

The period of Van Gogh's confinement to the Saint-Remy asylum is illustrated in Soviet museums by two major works revealing the antinomy of his world outlook: *Lilac Bush* and *The Convict Prison.* Whereas the latter picture symbolizes distress and despair, the *Lilac Bush* is perceived as a triumphant paean to divine nature and the beauty of Creation; it embodies the spiritual vigor of the human mind. If in *Seascape at Saintes-Maries* the brushwork betrays a youthful fervor and temperament, in *Lilac Bush* each stroke comes from the impulsive, inspired hand of a painter who unravelled the mystery of artistic creation. One of Van Gogh's last masterpieces, *Landscape at Auvers after the Rain,* stands out for its truly cosmic vision. When the artist's life was ending and his personal world was confined to the asylum, his art seemed to embrace a time–space continuum of unprecedented scope.

The earliest Gauguin to be found in Soviet museums is *Café at Arles,* painted in 1888 when the artist was staying with Van Gogh. All other Gauguin paintings from the extensive Morozov and, particularly, Shchukin collection stem from the artist's first and second Tahitian periods. *Conversation,* painted shortly after Gauguin arrived in the Polynesian islands, bears the stamp of his immediate impressions and marks a partial return to Impressionism, with its verisimilitude, its generalization of motifs, its preservation of depth and distant planes, and its reflections of light. The same can be said of the famous picture, *Woman Holding a Fruit (Where Are You Going?),* which shows a Tahitian woman holding a fruit reminiscent of a water vessel.

During his first stay in Tahiti, Gauguin already avoided overly informative portrayals, trying to grasp the essence of nature as an orderly system. In the Pushkin Museum's picture, *Are You Jealous?,* the Tahitian women are depicted on the bank of a pool; however, earth and water are completely schematic, reduced to tense patches of color. In Gauguin's view, the pictorial plane was a *substance,* capable of generating an infinite number of forms; it was an active field of force incorporating the structures of all the objects depicted, one to which they may return to become a plane once again. Gauguin made this discovery in Pont-Aven, and in Tahiti this Synthetic technique was renewed. It enabled him to control the play of natural forces and the splendor of an exotic environment (seen, for instance, in his *Landscape with Peacocks* and *Pastorales Tahitiennes*), a splendor so fragrant and spellbinding that the European can easily fall victim to its poisonous charms. On the other hand, the Synthetic style produced the unusual tenor of the landscape, its break with the forms and color combinations so familiar to the European eye. Gauguin transformed Tahitian scenery into the symbol of another reality, the artist's imagination, the land of "sweet dreams". And he made Oceania even more exotic than it really was.

In the course of his second stay in Tahiti, Gauguin produced works of profound content; here, he sought the Promised Land. The deliberately simple Tahitian scenes, such as *Bé Bé (The Nativity)* and *The Great Buddha,* evoke religious motifs. In several Gauguin paintings, *The King's Wife, Gathering Fruit,* and *The Month of Mary,* we see strange plants reminiscent of buds—symbols of fertility, of the Earth itself, fecund and reproductive, yet doomed to death. The sinister image of Death in the guise of a horseman is seen in *Gathering Fruit* and recurs in *The Ford* (or *The Flight*), painted two years before the artist's own death and reflecting the last stage in his life—his flight from Tahiti to the island of Dominica. *Gathering Fruit* is one of the three pictures that the artist conceived as parts of a fresco; the other two, *Where Do We Come From? What Are We? Where Are We Going?* and *Preparations for a Feast (Faa Iheihe)* are now in the Museum of Fine Arts in Boston and the Tate Gallery in London.

By virtue of their manifold meaning, Gauguin's works are akin to nineteenth-century art in general and European Symbolism in particular. Yet, despite the affinity of themes and subjects, Gauguin and the Symbolists spoke two different languages. In contrast to the latter's sophisticated mode of expression, Gauguin preferred the vivid tongues of primitive peoples with their full-blooded imagery. In the painting *Her Name Is Vairaumati,* the Maori myth of the god Horo meeting the beautiful Vaïraumati is depicted twice. The genuine mythological characters are represented in a Polynesian wood carving that is visible in the background, but the artist's Tahitian inscription refers to the young woman seated on a bright carpet: she is Vaïraumati, mother of the human race, but she is also a *vahine,* a woman of easy virtue.

In analyzing Gauguin's work one should not concentrate exclusively on the overriding nature of its decorative color and unrestrained play of form. Indeed, these aspects conceal the representational and conceptual fabric.

Neo-Impressionism is represented in Soviet collections by Paul Signac and Henri-Edmond Cross. Their landscapes should not be regarded as dead and dry schemes. With their dots of color distributed over the surface in a strictly balanced manner, they delight the eye by their contrasting play, conveying the light-and-air medium. Signac's painting, *Harbor at Marseilles,* is restrained and delicate, radiating a poetic enchantment. Although the name of Cross is often overshadowed by such leading figures of Divisionism as Seurat and Signac, such pictures as *Around My House* and *View of Santa Maria degli Angeli near Assisi* demonstrate the refined taste and consummate artistry of this consistent Divisionist.

The autodidact artist Henri Rousseau stands apart in turn-of-the-century French painting. Along with Cézanne, Van Gogh, and Gauguin, Rousseau epitomized one of the main trends in twentieth-century art—a tendency towards the primitive. Rousseau's highly distinctive style, marked by a clarity of form and color and reinforced by the seemingly frozen postures and facial expressions, enabled him to impart an aura of eternity to everyday life.

The Pushkin Museum owns a genuine Rousseau masterpiece: the double portrait of Guillaume Apollinaire and Marie Laurencin, which the painter entitled *The Poet and His Muse.* One must look hard to recognize the woman, herself an artist, who was the poet's source of inspiration. Rousseau portrays her as if in the crooked mirror of civilization, bewildered and lost in the bustle of the twentieth century. The landscape elements in this picture are more than mere decorations. The gillyflowers, taken from a botanical atlas, build a kind of hedge in front of the Poet and the Muse; full of life, their stems seem to grow visibly, their leaves straining outwards and their flower clusters assuming gigantic proportions. This is the image of an animated world filled with inspiration, the flowers symbolizing the poet's immortal soul. One of Rousseau's most significant works, the portrait treats a great theme that is common to all humanity.

The collection of paintings by the young Matisse allows art scholars to trace his evolution from his earliest efforts, reminiscent of the Old Masters, to his first Fauve canvases. During his artistic career, Matisse was infatuated with the Impressionists, as is evidenced by his still life *Blue Jug* and *Corsican Landscape: Olive Trees.* Yet, on the whole, his early works betray close links with Cézanne and Van Gogh—for instance, *Blue Pot and Lemon* and *Fruit and Coffeepot.* Prior to 1900, Matisse stayed within the mainstream of Post-Impressionism. However, his still lifes of crockery, done at the beginning of this century, reveal areas of active color as well as flattened volumes designated by merely two or three free-flowing strokes and patches of color, as in *Dishes and Fruit.* The landscape, *Luxembourg Gardens,* shows the influence of Gauguin's Tahitian canvases.

Whereas Matisse's early efforts may be designated as preparatory, an impetuous evolution culminating in the creation of *The Dance* and *Music,* the young Picasso's Blue and Rose periods (1901–1905) are to be placed at once in the domain of modern art. Such Picasso masterpieces from Soviet collections as *Old Jew and a Boy* and *Girl on a Ball* signify the end of Post-Impressionism and are part of the stylistic idiom of today. Such canvases as *The Absinthe Drinker, The Embrace,* and *Harlequin and His Companion* closely relate to Gauguin, Toulouse-Lautrec, and Munch, while *The Embrace, Old Jew and a Boy,* and *Girl on a Ball* refer to the concepts of Spanish and French Symbolists—that is, to the nineteenth century. Despite the daring structure of his works of this period, they man-

ifest Picasso's undying faith in humane ideals and in the possibility of bettering humanity and the social environment by means of art. Picasso's Blue and Rose periods constitute a brilliant chapter in the searchings and achievements of modern French art.

The Impressionist and Post-Impressionist paintings in The Hermitage and the Pushkin Museum—from Boudin to Picasso—are a unique collection of masterpieces tracing the development of modern art. They are a treasure of the people of the Soviet Union and of the world.

Marina Bessonova

IMPRESSIONISM AND
POST- IMPRESSIONISM

EUGENE BOUDIN
1824–1898

EUGÈNE BOUDIN was born at Honfleur, the son of a harbor pilot. From adolescence he worked in an art supplies shop in Le Havre and drew in his spare time. The artists who visited the city, in particular Corot, Isabey, Troyon, and Millet, gave him valuable help and advice. The municipality of Le Havre granted him a three-year scholarship to study in Paris. Boudin first exhibited at the 1859 Salon and then at the 1863 Salon des Refusés. After his return to Le Havre, he spent many summers on the farm of Saint-Siméon, in the environs of Honfleur, with a group of landscape painters including Jongkind, Bazille, and Claude Monet. This group is often called the School of Saint-Siméon, as distinct from the Barbizon School.

Boudin traveled widely in Normandy and Brittany and visited Holland, Belgium, and Venice. Wherever he went, he invariably painted harbor and beach scenes with numerous strolling figures. He was fascinated by towns and seaside resorts of France—Camaret-sur-Mer, Bordeaux, Deauville, Trouville—with their humid climate and shimmering, diffused light.

In the 1850s, Boudin met Claude Monet and did much to help the young painter find his true artistic self. In the 1860s, he frequently met Edouard Manet and worked with him in Boulogne and Deauville. In the 1870s, the Impressionists, in their turn, began to exert an influence on Boudin. His landscapes of that period are filled with a constantly changing iridescent light; his palette grows lighter and the brushstrokes assume the aspect of soft, blurred patches of color.

In 1874, Boudin took part in the first Impressionist exhibition. He also frequently exhibited with the Impressionists later, at Durand-Ruel's galleries in Paris and New York.

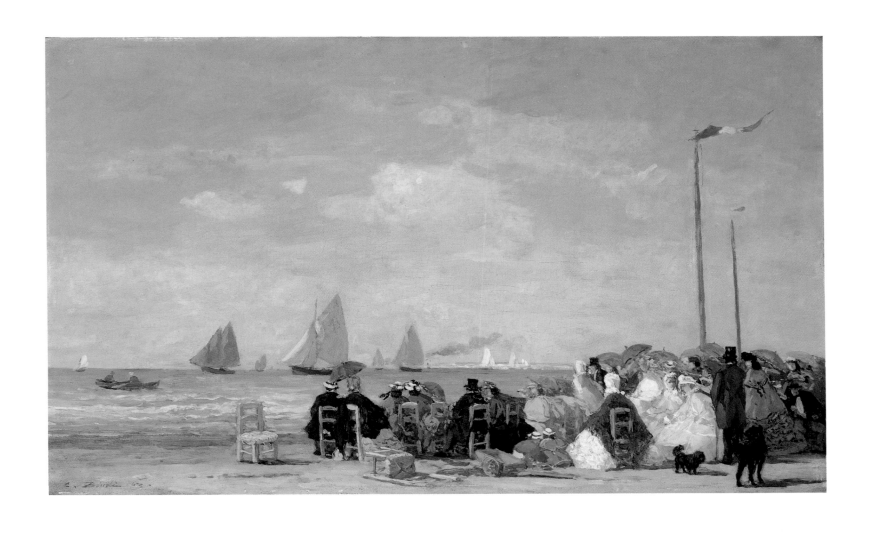

Beach Scene at Trouville

1863. Oil on wood. 34.9 × 57.8 cm. (13¾ × 22¾ in.)
Collection of Mr. and Mrs. Paul Mellon, National Gallery of Art, Washington

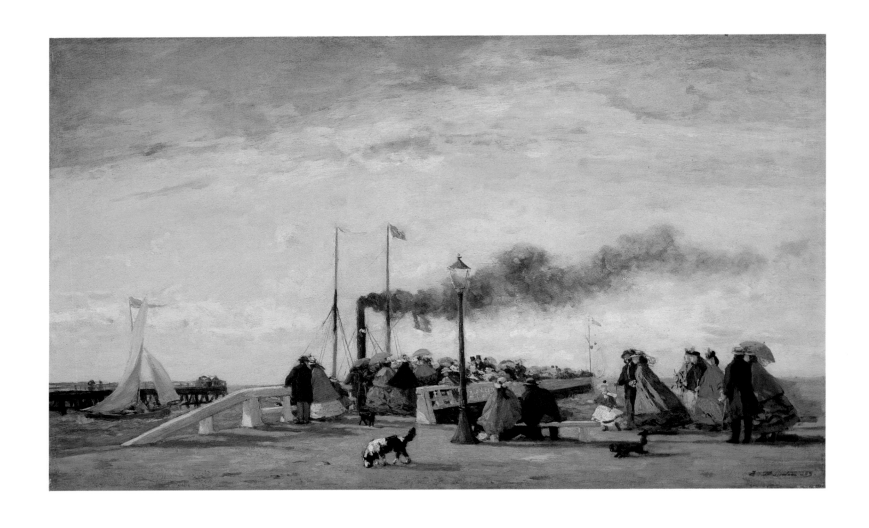

Jetty and Wharf at Trouville

1863. Oil on wood. 34.6 × 57.8 cm. (13⅝ × 22¾ in.)
Collection of Mr. and Mrs. Paul Mellon, National Gallery of Art, Washington

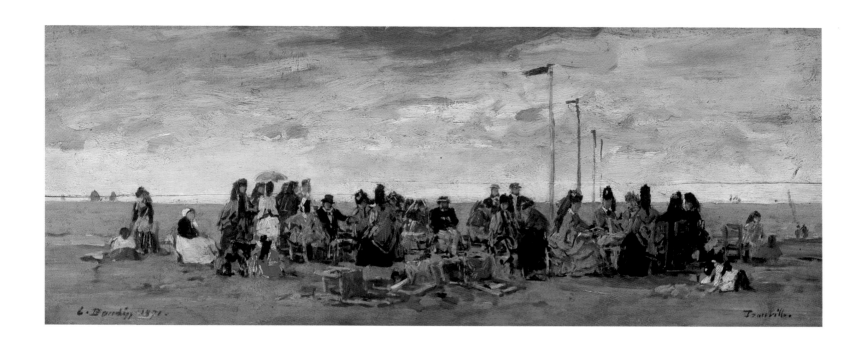

On the Beach, Trouville

1871. Oil on panel. 19 × 46 cm. (7½ × 18⅛ in.)
The Pushkin Museum, Moscow

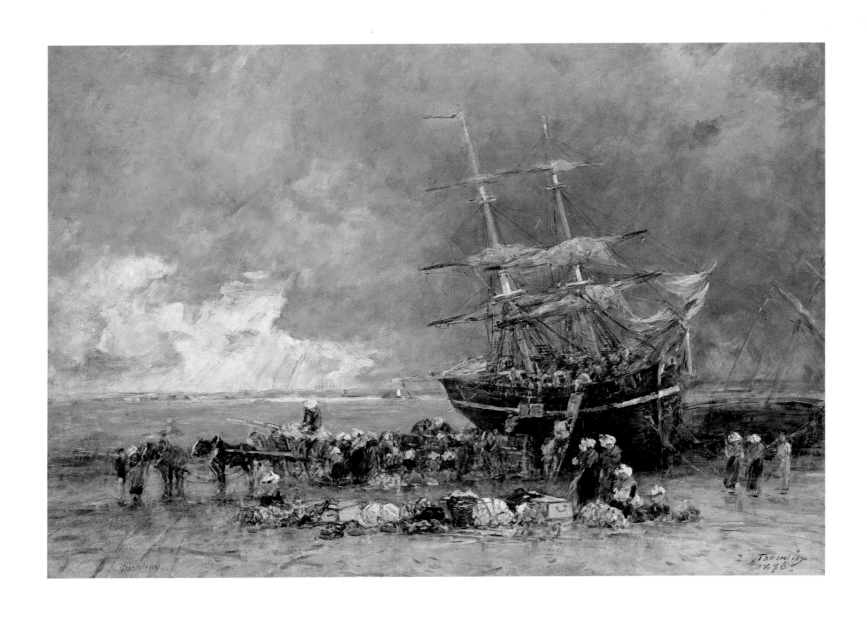

Return of the Terre-Neuvier

1875. Oil on canvas. 73.5 × 100.7 cm. (29 × 39⅝ in.)
Chester Dale Collection, National Gallery of Art, Washington

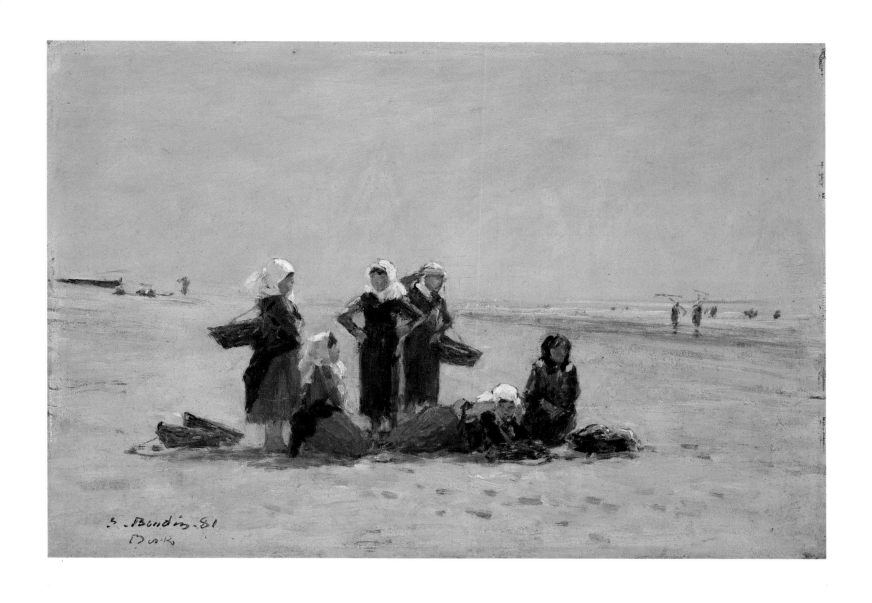

Women on the Beach at Berck

1881. Oil on wood. 24.8 × 36.2 cm. (9¾ × 14¼ in.)
Ailsa Mellon Bruce Collection, National Gallery of Art, Washington

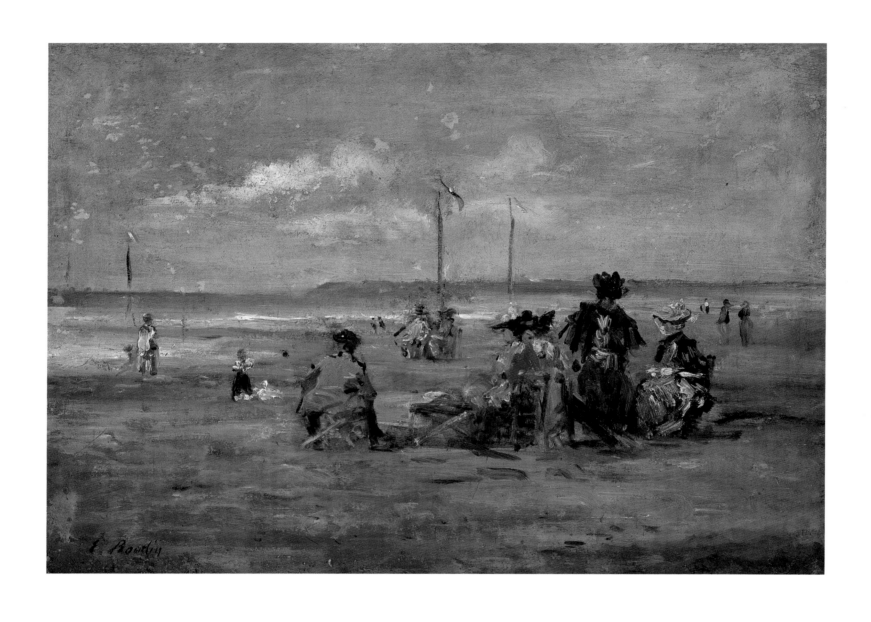

Beach Scene

Late 1880s–early 1890s. Oil on panel. 23.5 × 33 cm. (9¼ × 13 in.)
The Hermitage, Leningrad

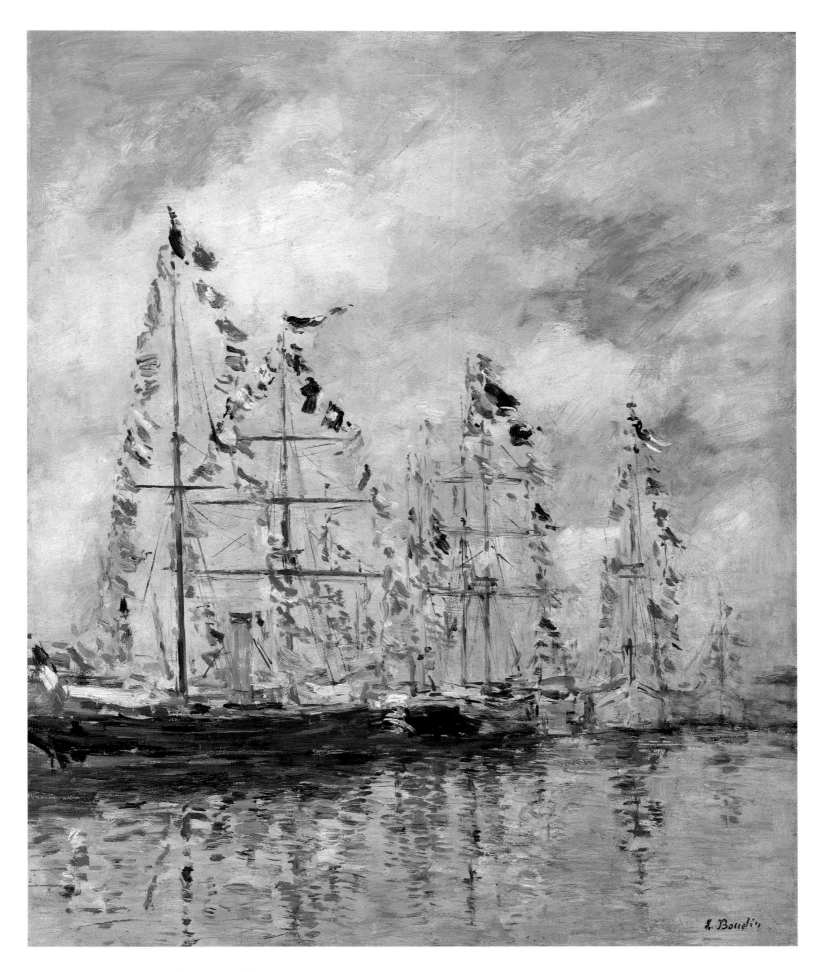

Yacht Basin at Trouville-Deauville

c. 1895/96. Oil on wood. 45.8 × 37.1 cm. (18 × 14⅝ in.)
Ailsa Mellon Bruce Collection, National Gallery of Art, Washington

EDOUARD MANET
1832–1883

BORN IN PARIS, Edouard Manet was the son of a prominent official in the Ministry of Justice. As a compromise between his own early interest in art and his father's desire that he pursue a career in law, Manet joined the Navy in 1848. Failing the entrance examination for the Naval Training School a year later, he was finally permitted to study painting.

At the Ecole des Beaux-Arts, Manet remained a pupil of Thomas Couture for six years, despite the later's stultifying, academic approach. His real teachers were to be found in the Louvre, and he was particularly drawn to such non-French masters as Velázquez, Goya, Rembrandt, Giorgione, and Titian.

Though traditional and conservative in his desire to be accepted by the official art establishment and the Salon, Manet soon found himself a hero of the young vanguard in Paris. After several rejections by the Salon, he did, in fact, achieve acclaim with his entries of 1861. But his submissions of 1863 and 1865, *Déjeuner sur l'herbe* and *Olympia*, respectively, were received with derision and anger by critics and public, who objected to Manet's frank treatment of female nudity, his supposed irreverence toward ancient and honored themes, and his fresh, direct color and brushstrokes. The controversy aroused by these paintings only enhanced Manet's standing among poets, critics, and artists of the avant-garde, such as Baudelaire, Duranty, Monet, and Degas.

Even as a leading figure for the younger generation of Impressionist painters, the elegant, sophisticated Manet remained supremely independent and never exhibited with the group, preferring to take his rather dim chances with the Salon. He was, however, closely associated with several members of the Impressionist circle and was deeply influenced by their sparkling, light-filled canvases, particularly those of Claude Monet and Berthe Morisot, who became his sister-in-law. In his later years, Manet painted more intimate and casual landscapes, portraits, street and café scenes, and still lifes, but with the sure feeling for structure and immediacy for which he was always known.

Manet was finally honored by the Salon in the last two years of his life. After his death, the Ecole des Beaux-Arts organized an extensive memorial exhibition of his work in 1884, and in 1890 a public subscription was raised to buy *Olympia* from the artist's widow, though the painting was not accepted by the Louvre until 1907.

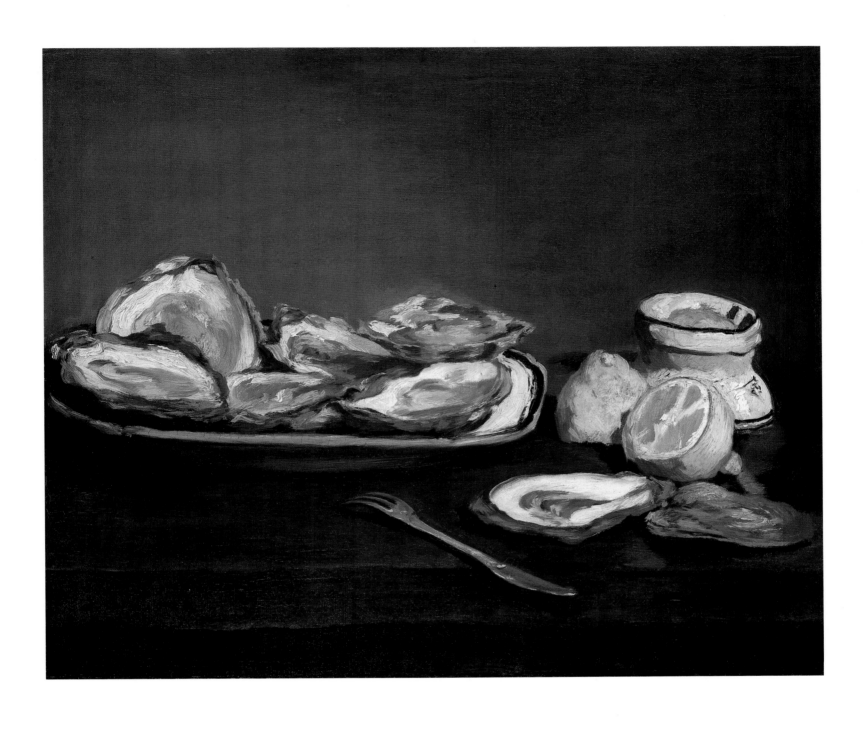

Oysters

1862. Oil on canvas. 39.1 × 46.7 cm. (15⅜ × 18⅜ in.)
Gift of the Adele R. Levy Fund, National Gallery of Art, Washington

The Old Musician

1862. Oil on canvas.
187.4 × 248.3 cm. (73¾ × 97¾ in.)
Chester Dale Collection,
National Gallery of Art, Washington

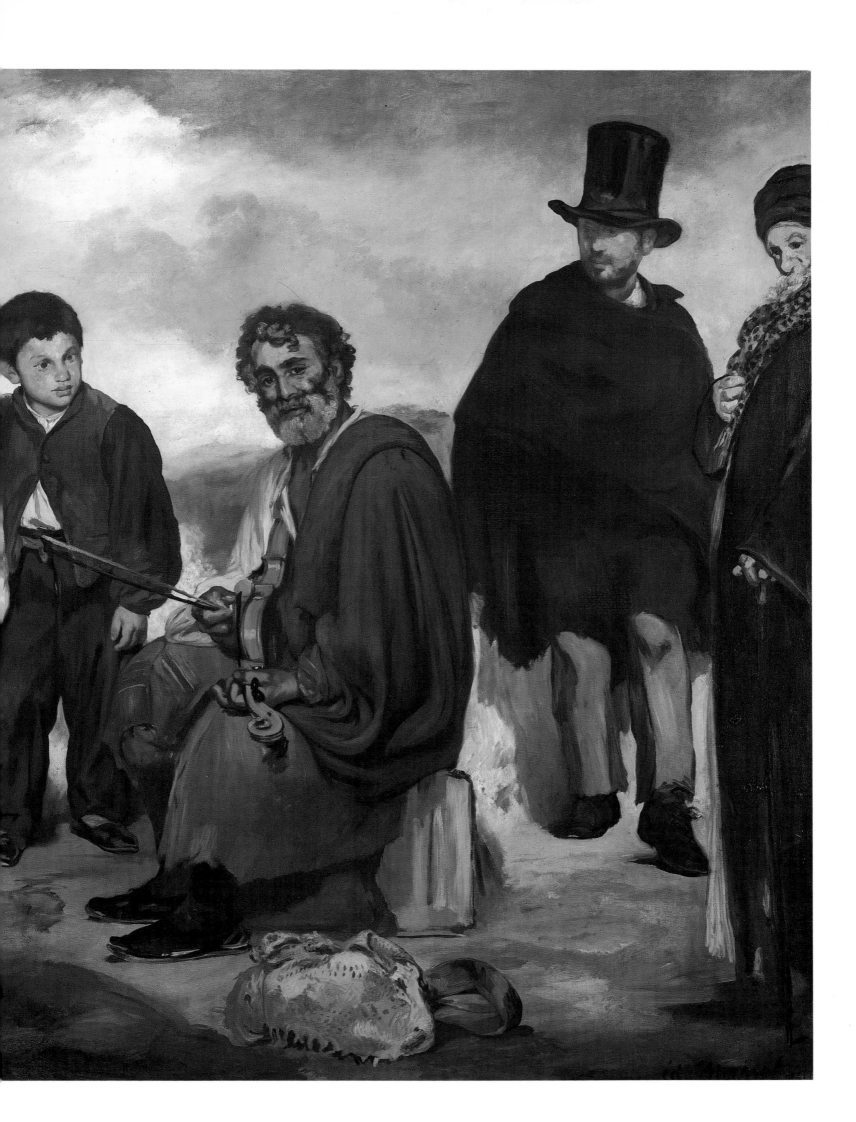

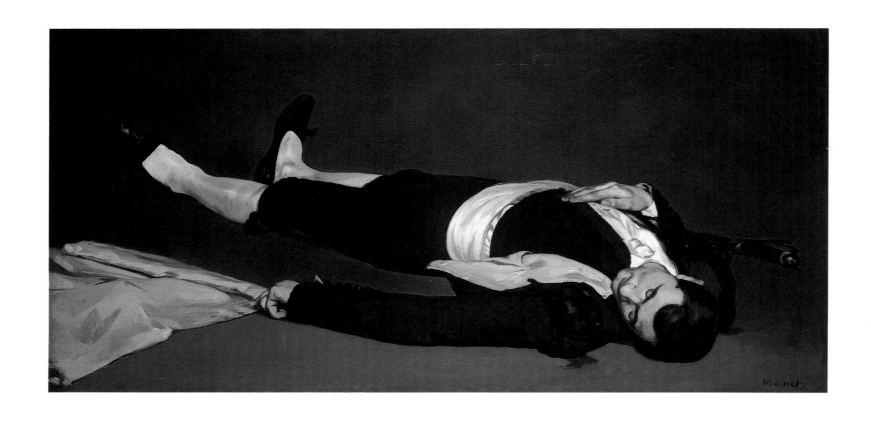

The Dead Toreador

Probably 1864. Oil on canvas. 75.9 × 153.3 cm. (29⅞ × 60⅜ in.)
Widener Collection, National Gallery of Art, Washington

OPPOSITE:

The Tragic Actor (Rouvière as Hamlet)

1865/66. Oil on canvas. 187.2 × 108.1 cm. (73¾ × 42½ in.)
Gift of Edith Stuyvesant Gerry, National Gallery of Art, Washington

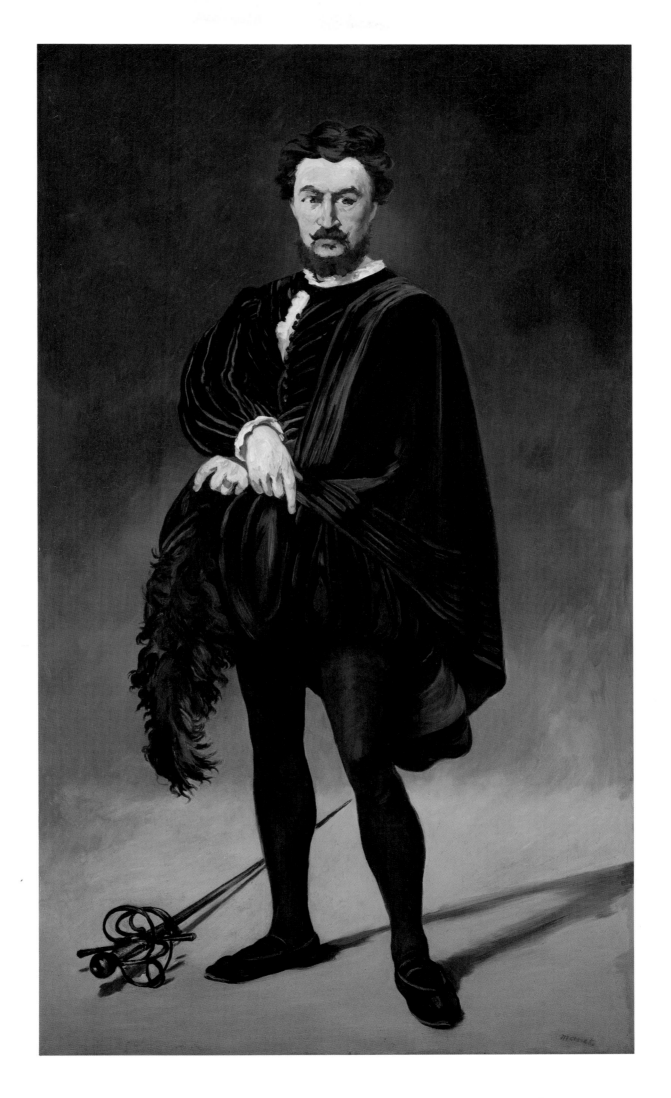

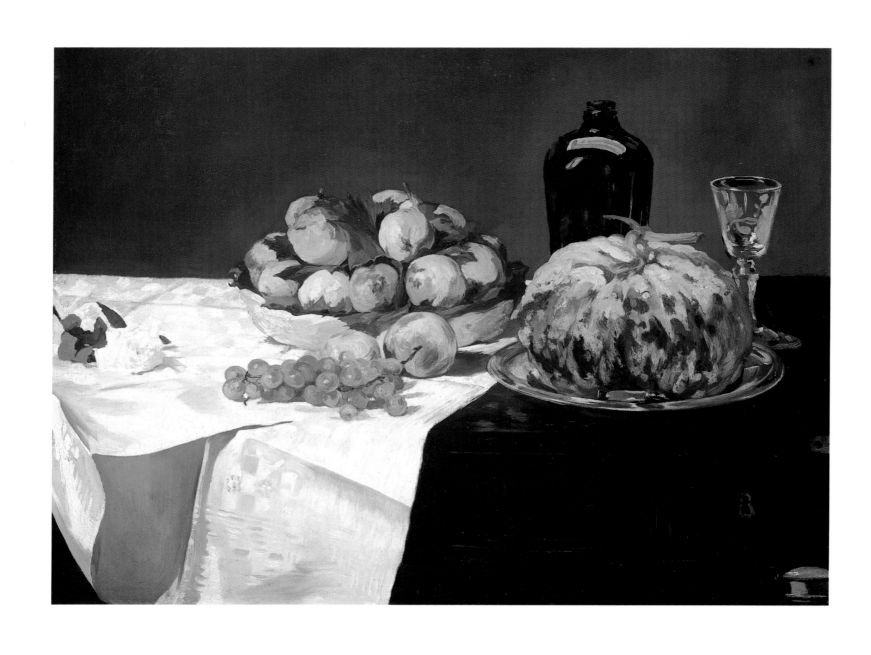

Still Life with Melon and Peaches

c. 1866. Oil on canvas. 69 × 92.2 cm. (27⅛ × 36¼ in.)
Gift of Eugene and Agnes Meyer, National Gallery of Art, Washington

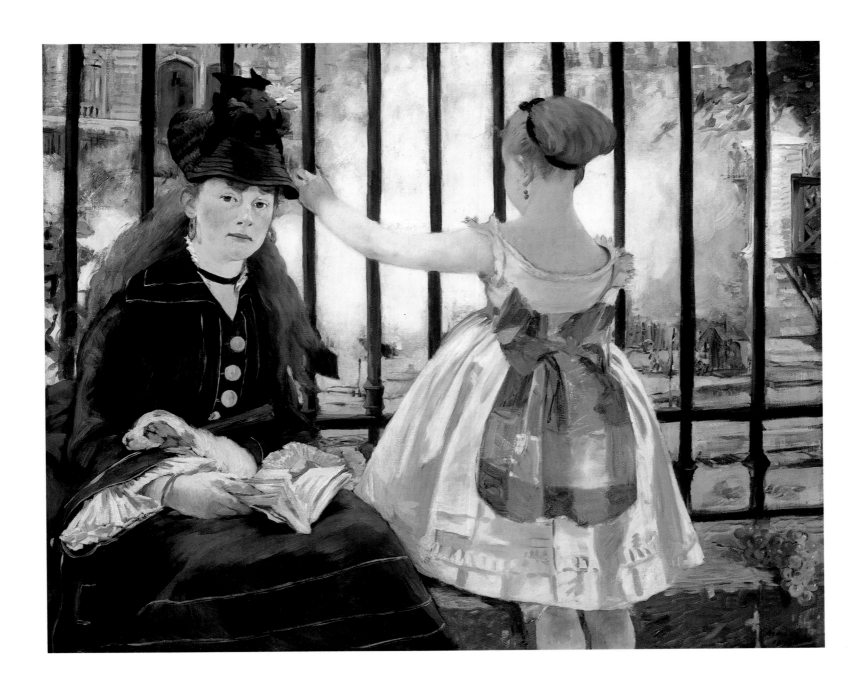

Gare Saint-Lazare

1873. Oil on canvas. 93.3 × 114.5 cm. (36¾ × 45⅛ in.)
Gift of Horace Havemeyer in memory of his mother,
Louisine W. Havemeyer, National Gallery of Art, Washington

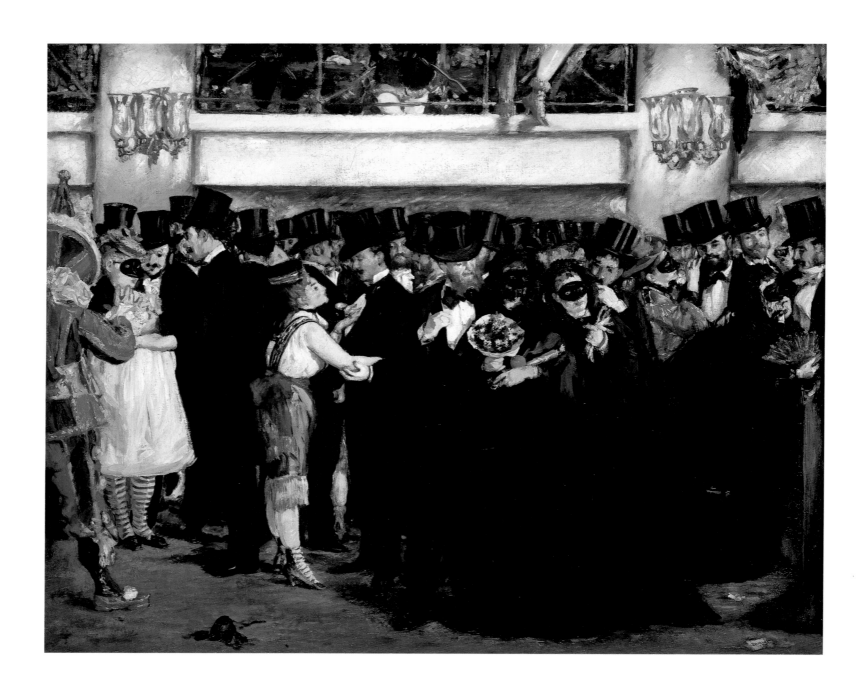

Ball at the Opera

1873. Oil on canvas. 59 × 72.5 cm. (23¼ × 28½ in.)
Gift of Mrs. Horace Havemeyer in memory of her mother-in-law,
Louisine W. Havemeyer, National Gallery of Art, Washington

OPPOSITE:

The Plum

c. 1877. Oil on canvas. 73.6 × 50.2 cm. (29 × 19¾ in.)
Collection of Mr. and Mrs. Paul Mellon, National Gallery of Art, Washington

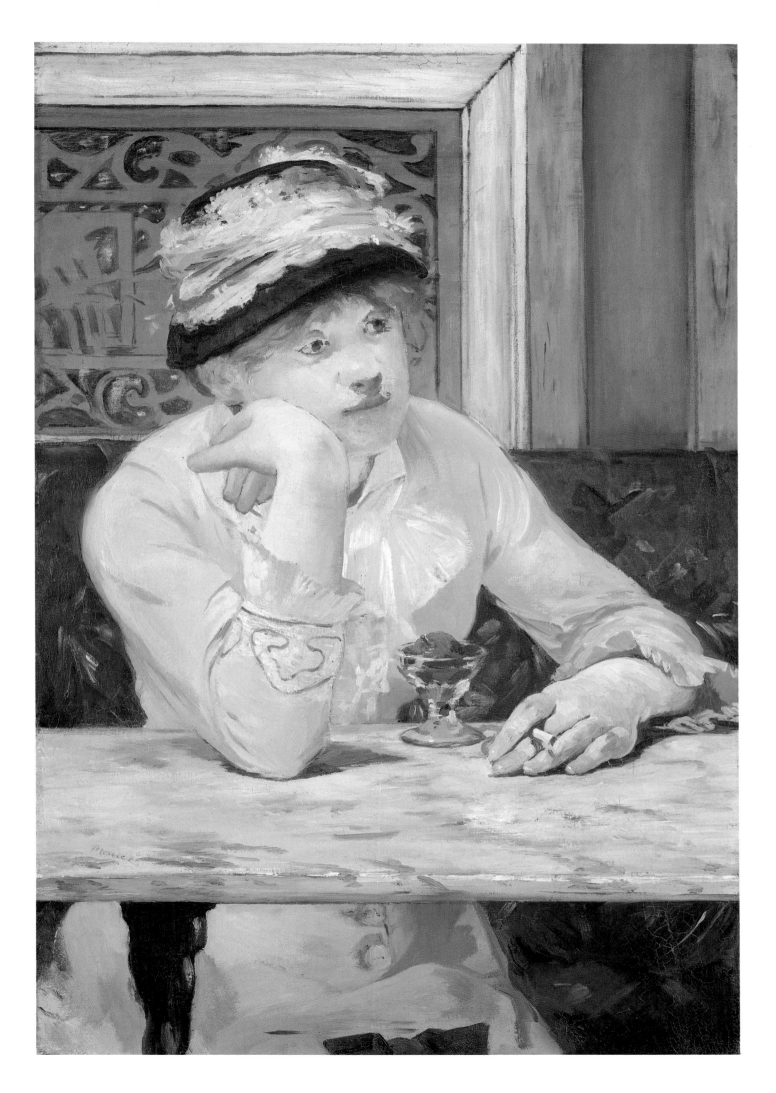

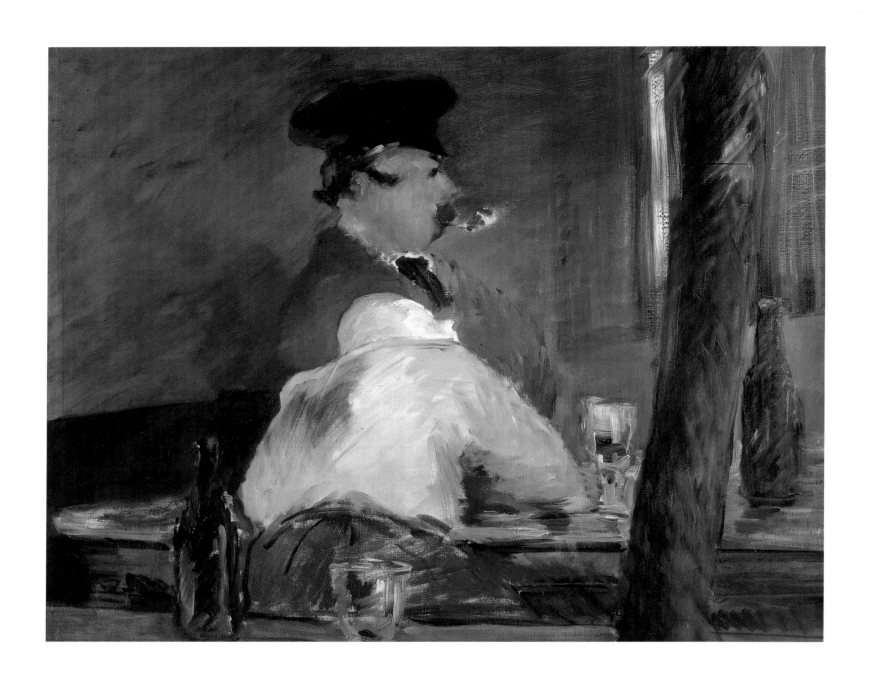

The Bar (Le "Bouchon")

c. 1878–79. Oil on canvas. 72 × 92 cm. (28⅜ × 36¼ in.)
The Pushkin Museum, Moscow

OPPOSITE:

Madame Michel-Levy

1882. Pastel and oil on canvas. 74.4 × 51 cm. (29¼ × 20⅛ in.)
Chester Dale Collection, National Gallery of Art, Washington

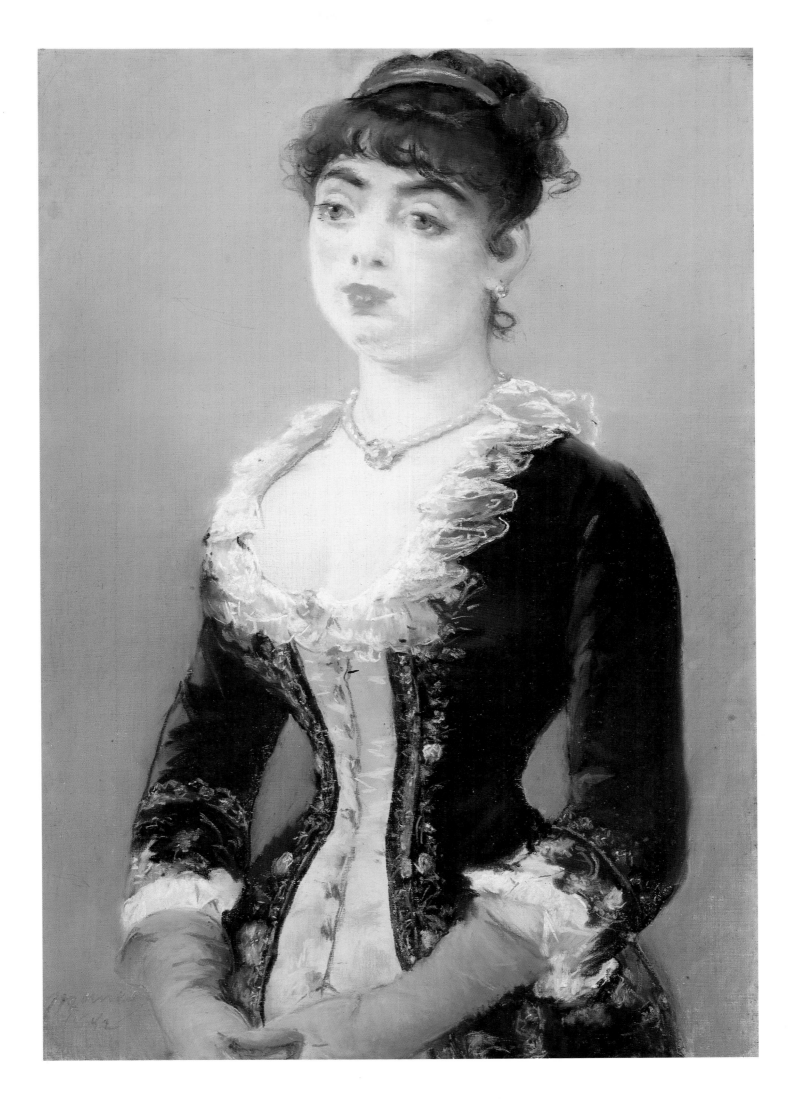

Berthe Morisot

BERTHE MORISOT
1841–1895

BERTHE MORISOT was born in Bourges, the daughter of a high government official. She moved with her family to Paris in 1852 and began her studies in drawing and painting in 1856 with Chocarne and then, more profitably, with Guichard. She subsequently sought out Corot and began working under his guidance in 1861. By 1864, her work was already being accepted by the Salon, and she continued to show there until 1874.

Morisot's friendship with Edouard Manet, who already admired her work, began in 1868, and they were to influence each other over the next decade. In 1874, she married Edouard's brother Eugène. Manet was one avenue of introduction to the Impressionists, but he vigorously opposed Morisot's decision to give up the Salon and exhibit only with

these reviled artists of her generation. She showed nine paintings in the first Impressionist exhibition in 1874 and was a mainstay of their exhibitions in the years after.

Morisot's radiant, open landscapes and interiors with women contributed significantly to the movement, and were even admired outside the Impressionist camp. But in her distinctive manner, Morisot often abjured atmospheric effects for more solid, even expressionistic uses of brushstroke and line, particularly in her later work. During her lifetime, she frequently achieved higher prices than her male colleagues, by whom she was generally admired. She remained a focal point for artists, poets, and critics associated with Impressionism throughout her life.

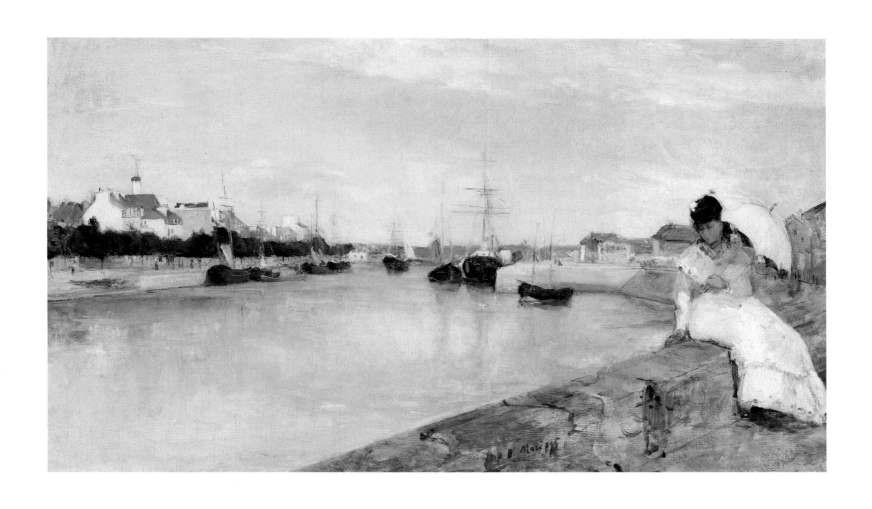

The Harbor at Lorient

1869. Oil on canvas. 43.5 × 73 cm. (17⅛ × 28¾ in.)
Ailsa Mellon Bruce Collection, National Gallery of Art, Washington

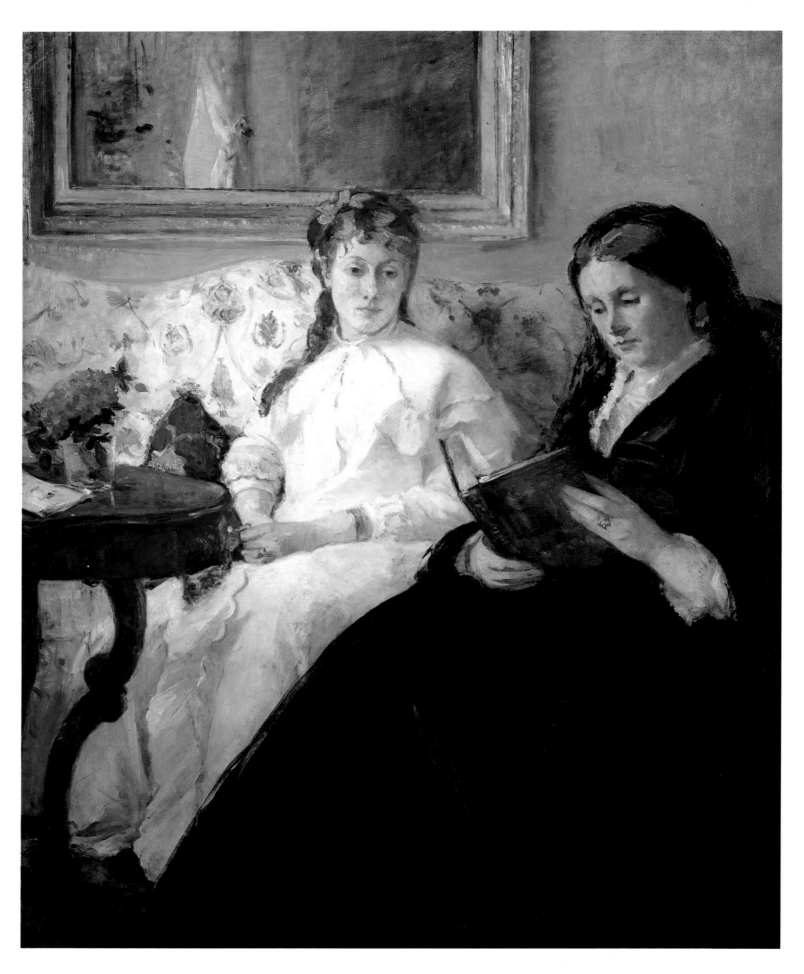

The Mother and Sister of the Artist

1869–70. Oil on canvas. 101 × 81.8 cm. (39½ × 32¼ in.)
Chester Dale Collection, National Gallery of Art, Washington

The Artist's Daughter with a Parakeet

1890. Oil on canvas. 65.6 × 52.4 cm. (25¾ × 20⅝ in.)
Chester Dale Collection, National Gallery of Art, Washington

CLAUDE MONET
1840–1926

CLAUDE MONET spent his childhood in Le Havre. In his youth he painted caricature portraits and exhibited them in the art supplies shop in which Eugène Boudin worked at the time. Boudin persuaded the young Monet to become a landscape painter. After finishing his military service in Algeria, Monet attended the Académie Suisse and there made the acquaintance of Pissarro and Cézanne. Later, in 1862, he entered the Atelier Gleyre, where he met Bazille, Renoir, and Sisley. In the 1860s, the young artists frequented the Café Guerbois, a place often visited by Emile Zola and Edouard Manet. An important turning-point in Monet's artistic career came in 1869, when he and Renoir painted La Grenouillère, a floating restaurant at Bougival. The canvases they produced marked the emergence of a new artistic movement, Impressionism.

During the Franco-Prussian War of 1870–71, Monet lived in London and was introduced to Paul Durand-Ruel, an art dealer who did much to popularize Impressionist works. In 1874, in an atmosphere of increasing hostility on the part of official artistic circles, Monet and his friends formed a group and exhibited on their own for the first time.

By then they had found many supporters and admirers.

The following years witnessed the flourishing of Impressionism. Monet took part in the group's exhibitions of 1874, 1876, 1877, 1879, and 1882. In those years he created such masterpieces as *La Gare Saint-Lazare* and *La Rue Montargueil*. However, his canvases found very few buyers. He went to live where life was less expensive, at Argenteuil from 1873 to 1878, at Vétheuil from 1879 to 1881, at Poissy in 1882, and at Giverny from 1883 until his death. In the late 1880s, his painting began to attract the attention both of the public and critics. Fame brought comfort and even wealth. During that period, the artist was engrossed in painting landscapes in series, recording different light effects at different times of day. In 1899, Monet first turned to the subject of water lilies, the main theme of his later work. Fourteen large canvases of his *Water Lilies* series, started in 1916, were bequeathed by him to the State. In 1927, shortly after the artist's death, these canvases were placed in two oval rooms of the Musée de l'Orangerie in the Tuileries Gardens.

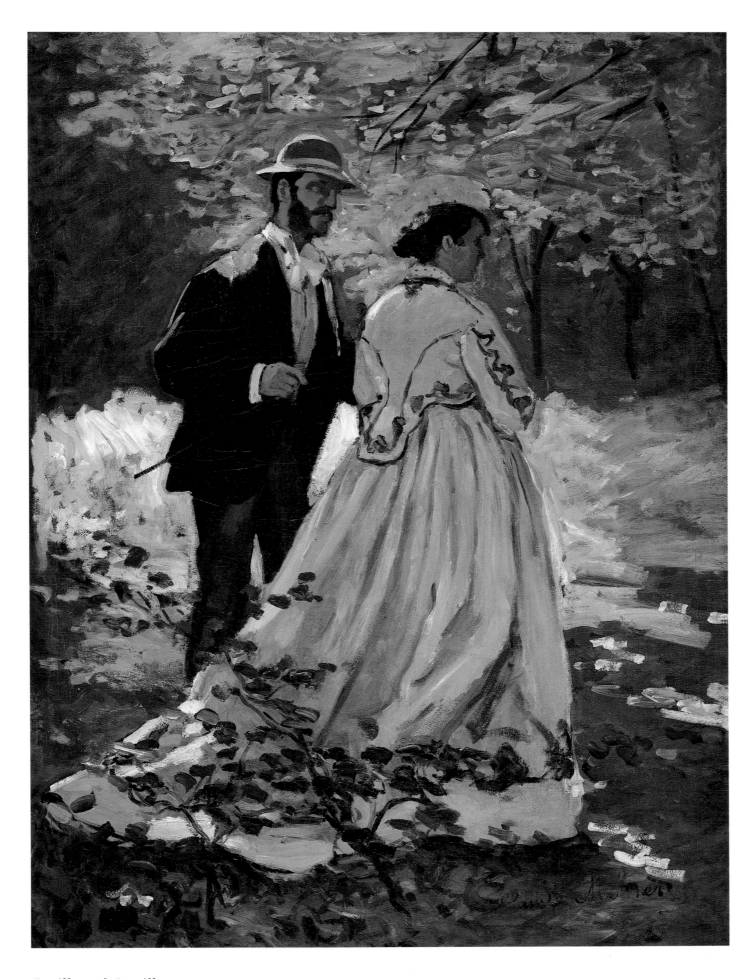

Bazille and Camille

1865. Oil on canvas. 93 × 69 cm. (36⅝ × 27⅛ in.)
Ailsa Mellon Bruce Collection, National Gallery of Art, Washington

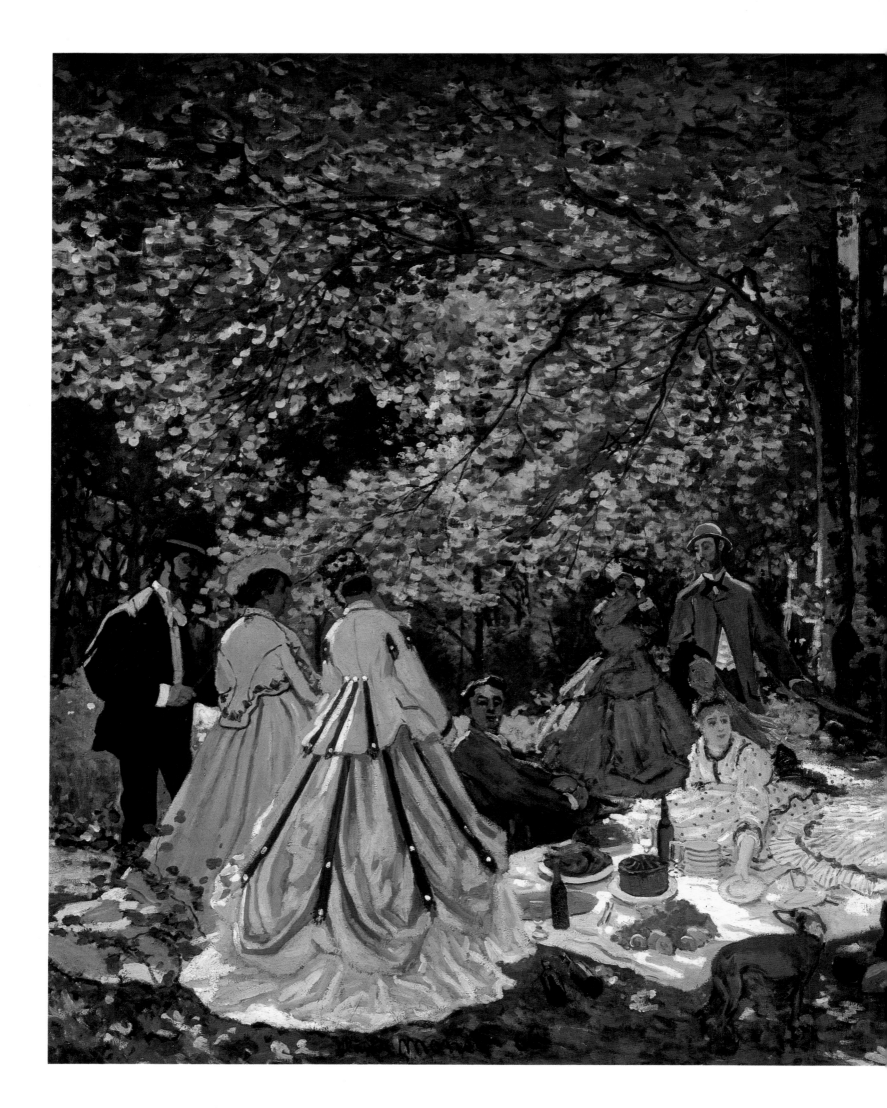

Luncheon on the Grass

1866. Oil on canvas. 130 × 181 cm.
(51¼ × 71¼ in.)
The Pushkin Museum, Moscow

The Cradle—Camille with the Artist's Son Jean

1867. Oil on canvas. 116.8 × 88.9 cm. (46 × 35 in.)
Collection of Mr. and Mrs. Paul Mellon, National Gallery of Art, Washington

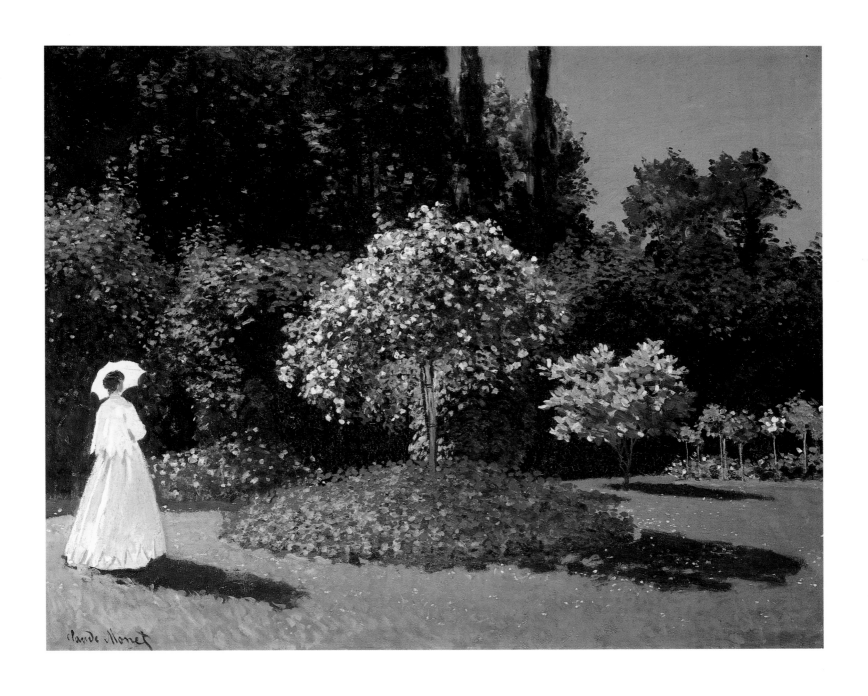

Lady in the Garden at Sainte-Adresse

c. 1867. Oil on canvas. 80 × 99 cm. (31½ × 39 in.)
The Hermitage, Leningrad

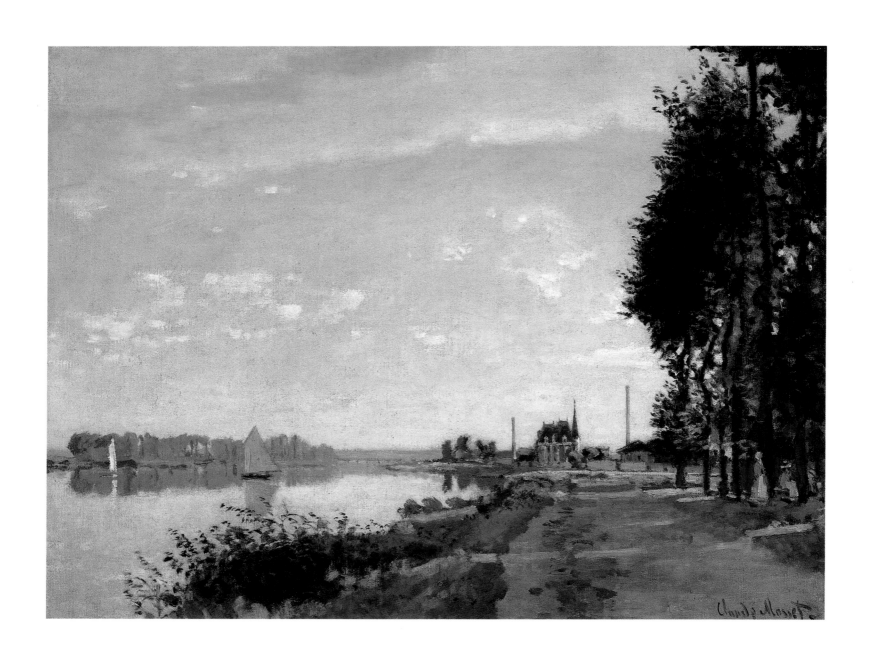

Argenteuil

c. 1872. Oil on canvas. 50.4 × 65.2 cm. (19⅞ × 25⅝ in.)
Ailsa Mellon Bruce Collection, National Gallery of Art, Washington

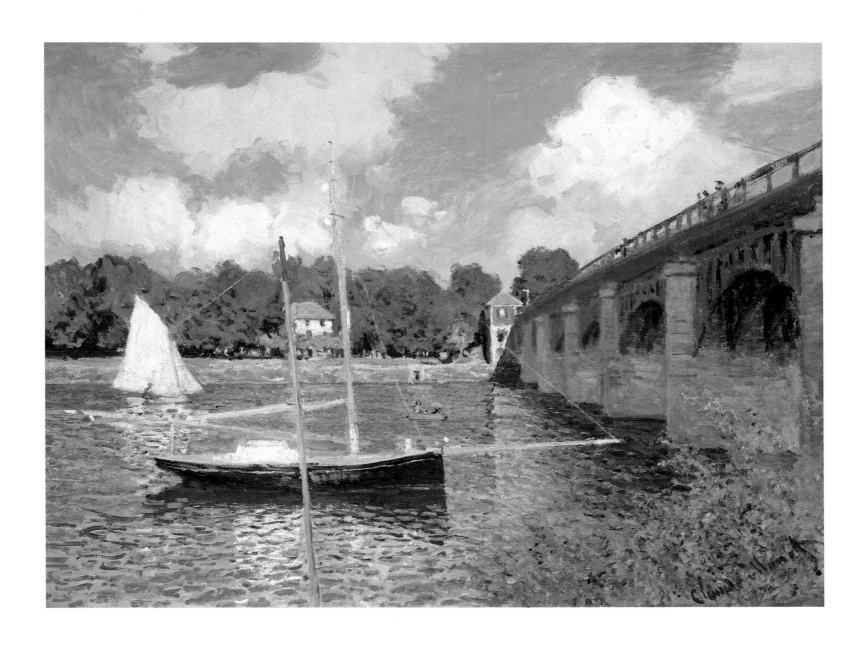

The Bridge at Argenteuil

1874. Oil on canvas. 60 × 79.7 cm. (23⅝ × 31⅜ in.)
Collection of Mr. and Mrs. Paul Mellon, National Gallery of Art, Washington

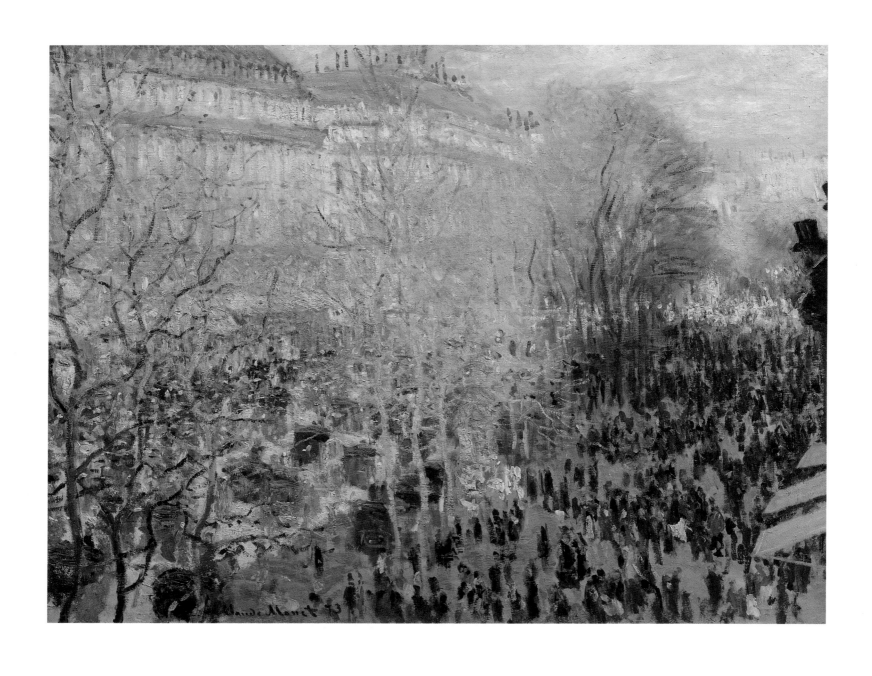

Le Boulevard des Capucines

1873. Oil on canvas. 61 × 80 cm. (24 × 31½ in.)
The Pushkin Museum, Moscow

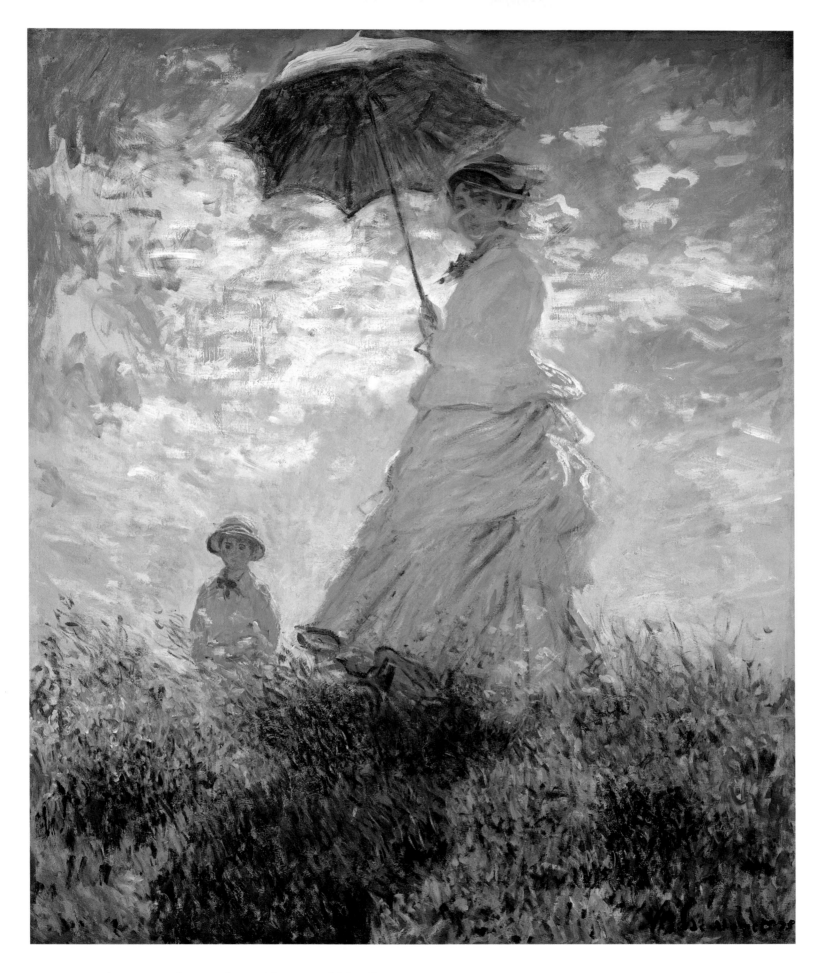

Woman with a Parasol—Madame Monet and Her Son

1875. Oil on canvas. 1 × 81 cm. (39⅜ × 31⅞ in.)
Collection of Mr. and Mrs. Paul Mellon, National Gallery of Art, Washington

The Pond at Montgeron

c. 1876–77. Oil on canvas. 172 × 193 cm. (67¾ × 76 in.)
The Hermitage, Leningrad

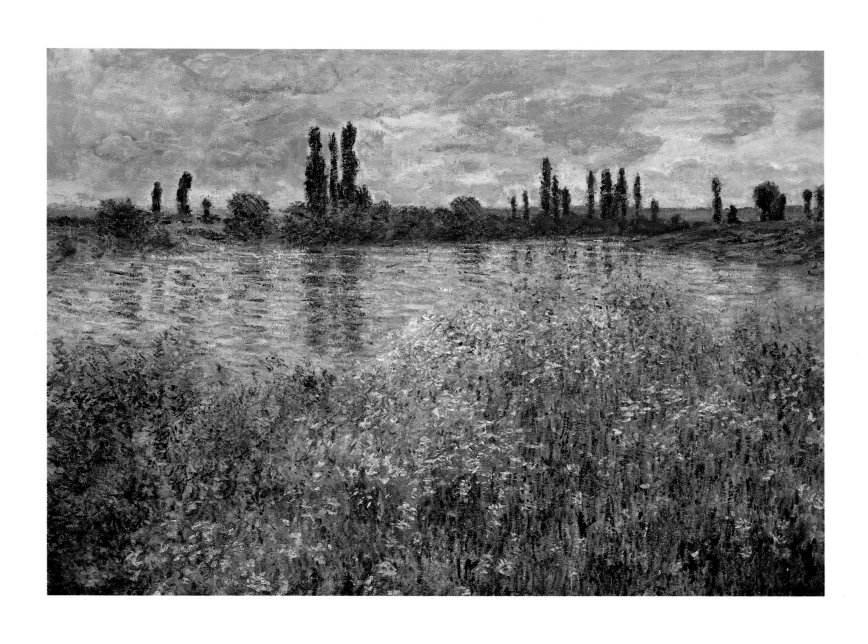

Banks of the Seine, Vétheuil

1880. Oil on canvas. 73.4 × 100.5 cm. (28⅞ × 39⅝ in.)
Chester Dale Collection, National Gallery of Art, Washington

Woman Seated under the Willows

1880. Oil on canvas. 81.1 × 60 cm. (31⅞ × 23⅝ in.)
Chester Dale Collection, National Gallery of Art, Washington

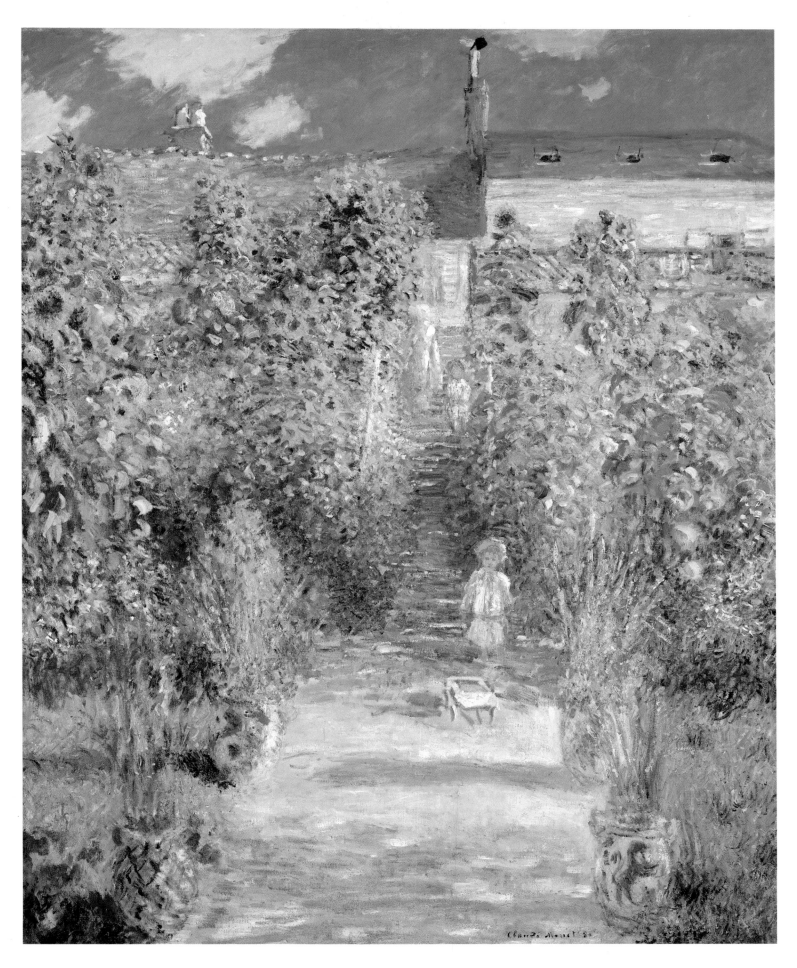

The Artist's Garden at Vétheuil

1880. Oil on canvas. 151.4 × 121 cm. (59⅝ × 47⅝ in.)
Ailsa Mellon Bruce Collection, National Gallery of Art, Washington

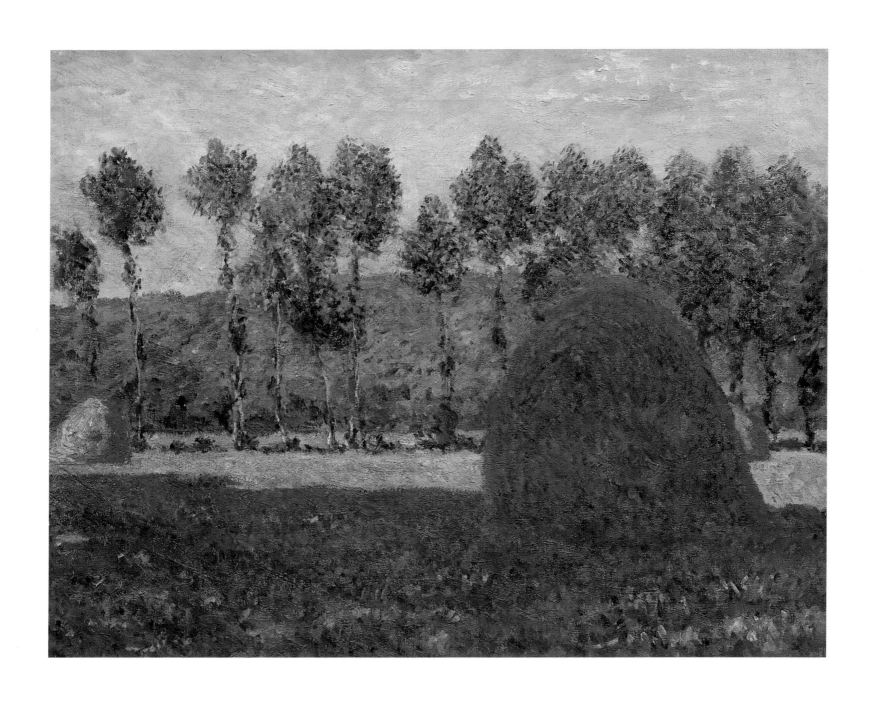

Haystack at Giverny

c. 1884. Oil on canvas. 64.5 × 81 cm. (25⅜ × 31⅞ in.)
The Pushkin Museum, Moscow

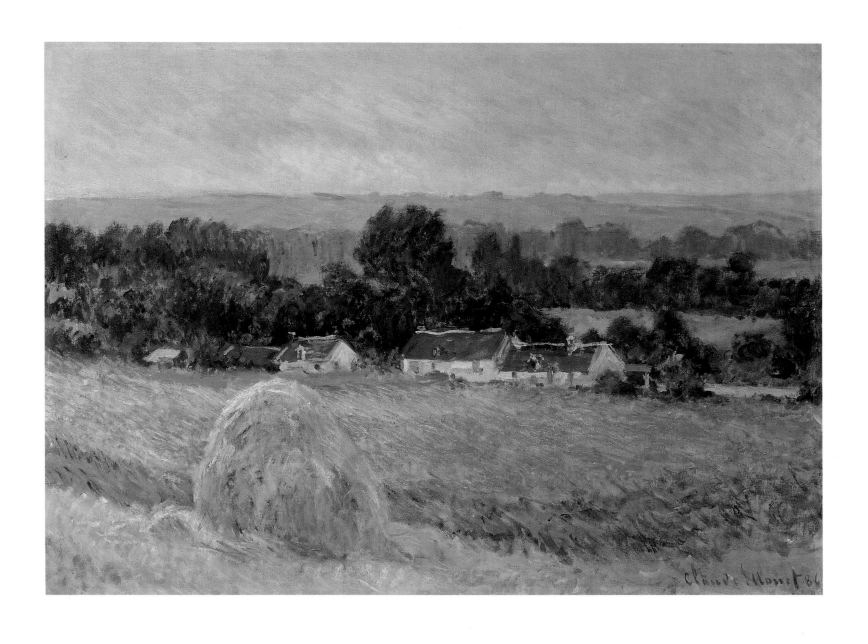

Haystack at Giverny

c. 1886. Oil on canvas. 61 × 81 cm. (24 × 31⅞ in.)
The Hermitage, Leningrad

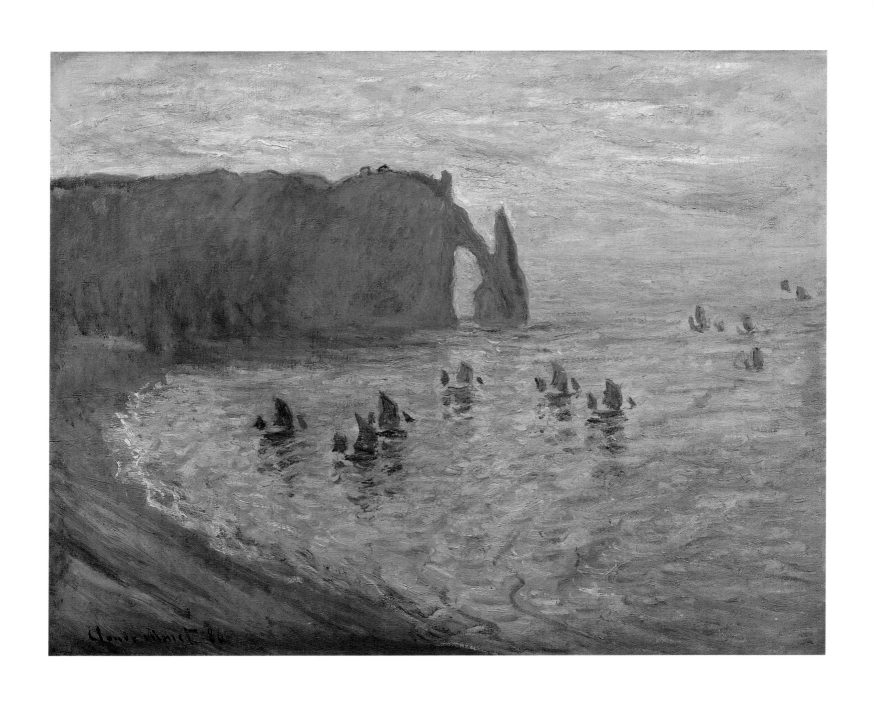

Cliffs at Etretat

1886. Oil on canvas. 66 × 81 cm. (26 × 31⅞ in.)
The Pushkin Museum, Moscow

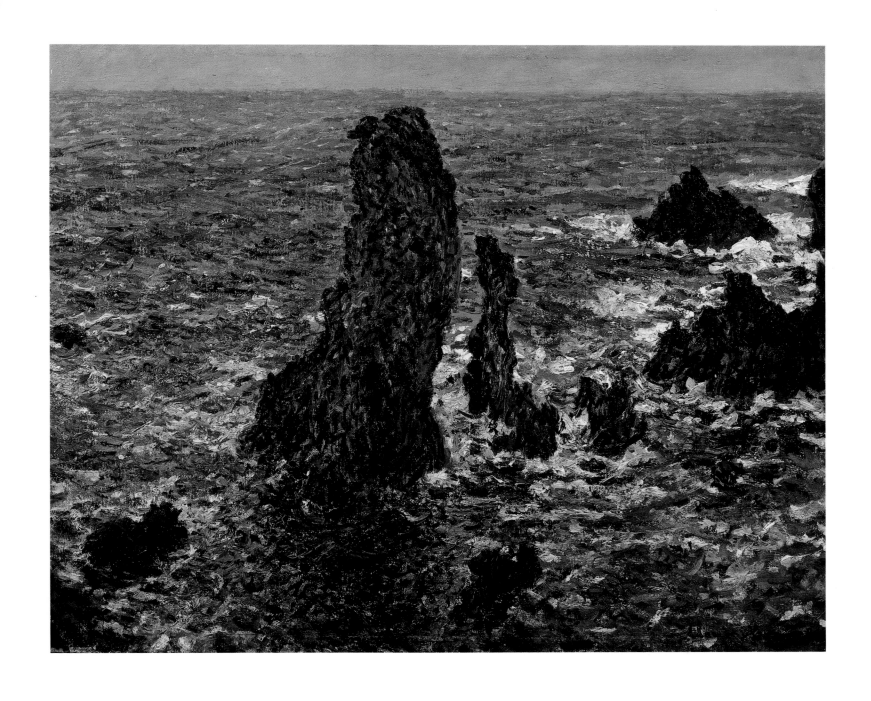

The Rocks of Belle-Ile

1886. Oil on canvas. 65 × 81 cm. (25⅝ × 31⅞ in.)
The Pushkin Museum, Moscow

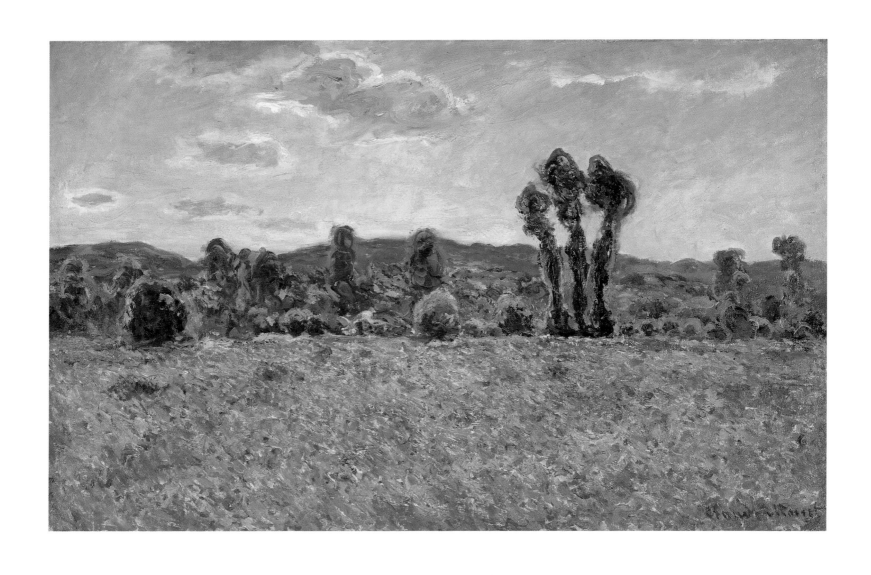

Poppy Field

c. 1887. Oil on canvas. 59 × 90 cm. (23¼ × 35½ in.)
The Hermitage, Leningrad

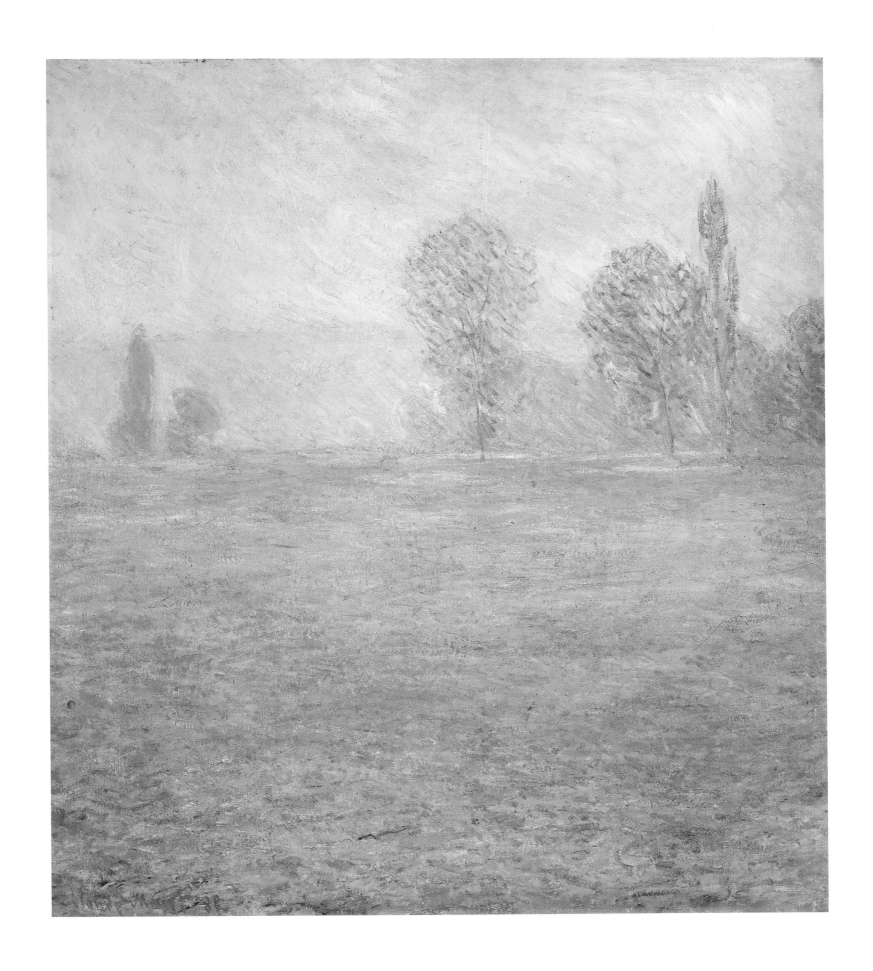

Meadows at Giverny

1888. Oil on canvas. 92 × 80 cm. (36¼ × 31½ in.)
The Hermitage, Leningrad

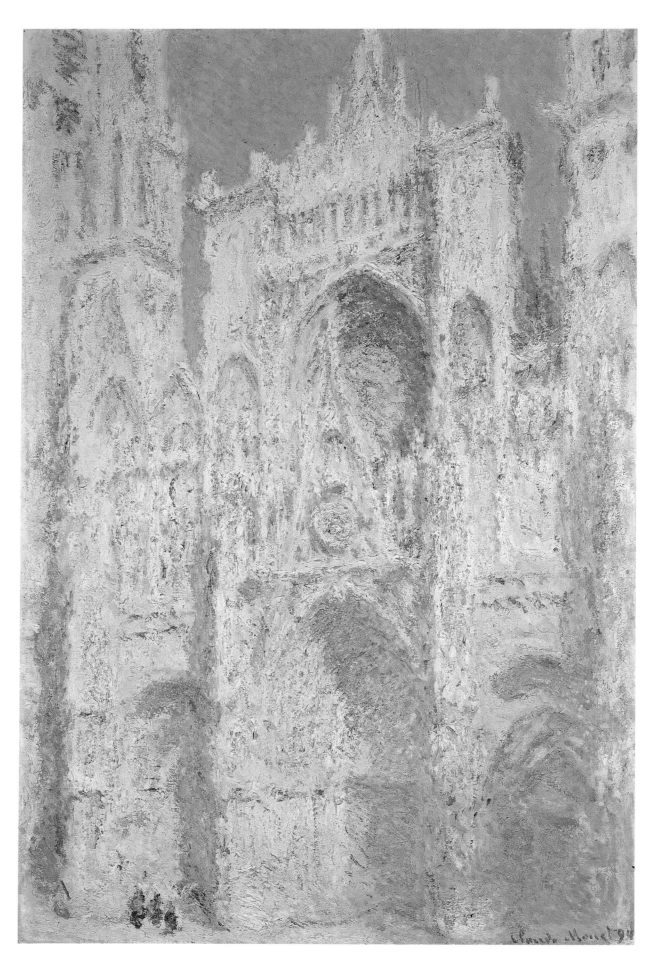

Rouen Cathedral, West Facade, Sunlight

1894. Oil on canvas. 100.2 × 66 cm. (39½ × 26 in.)
Chester Dale Collection, National Gallery of Art, Washington

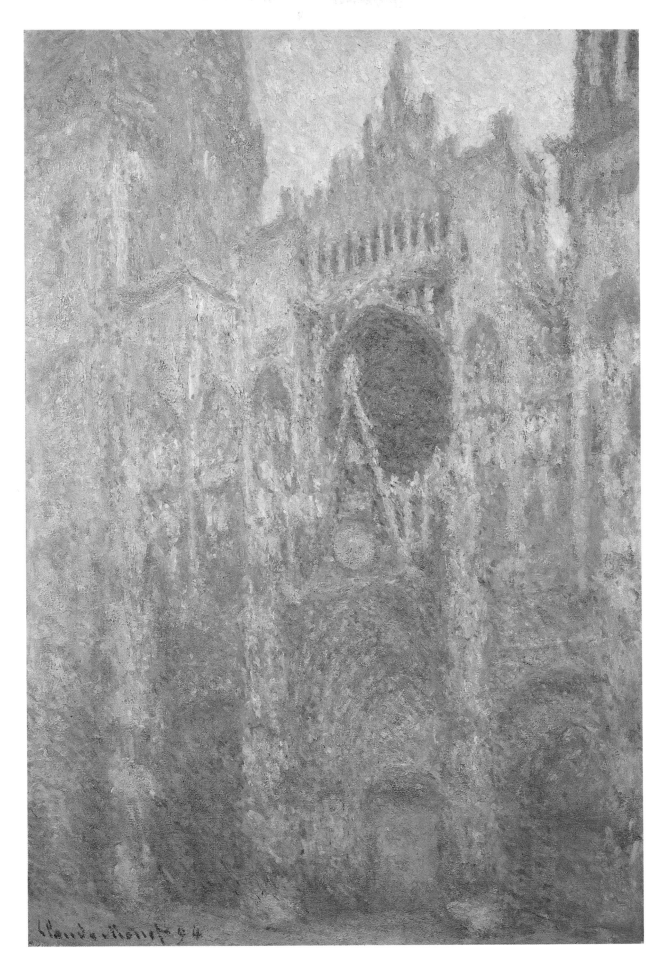

Rouen Cathedral, West Facade

1894. Oil on canvas. 100.4 × 66 cm. (39½ × 26 in.)
Chester Dale Collection, National Gallery of Art, Washington

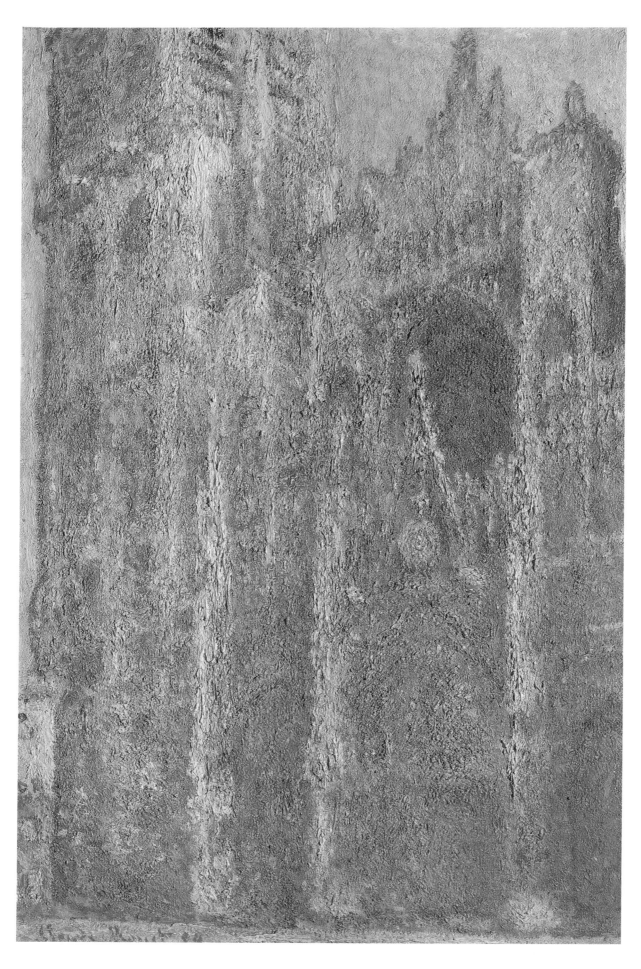

Rouen Cathedral at Noon

1894. Oil on canvas. 101 × 65 cm. (39¾ × 25⅝ in.)
The Pushkin Museum, Moscow

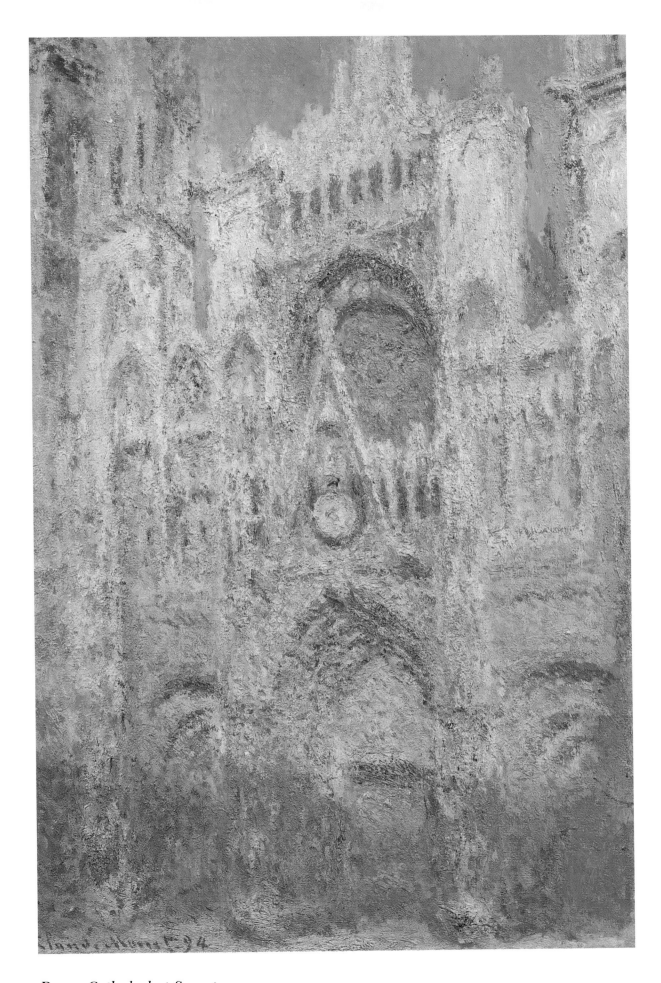

Rouen Cathedral at Sunset

1894. Oil on canvas. 100 × 65 cm. (39⅜ × 25⅝ in.)
The Pushkin Museum, Moscow

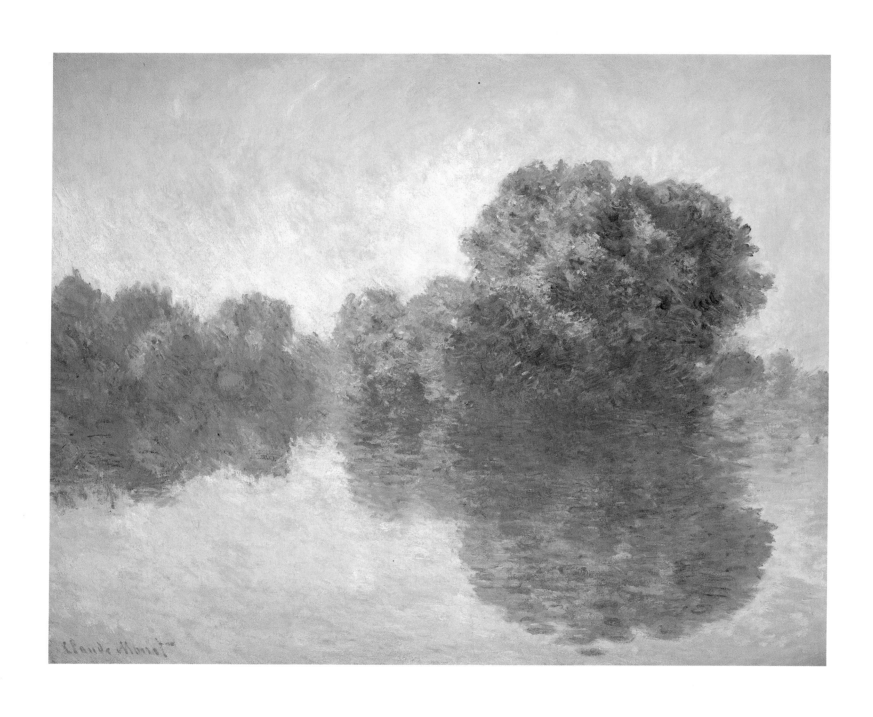

Morning Haze

1888. Oil on canvas. 74 × 92.9 cm. (29⅛ × 36⅝ in.)
Chester Dale Collection, National Gallery of Art, Washington

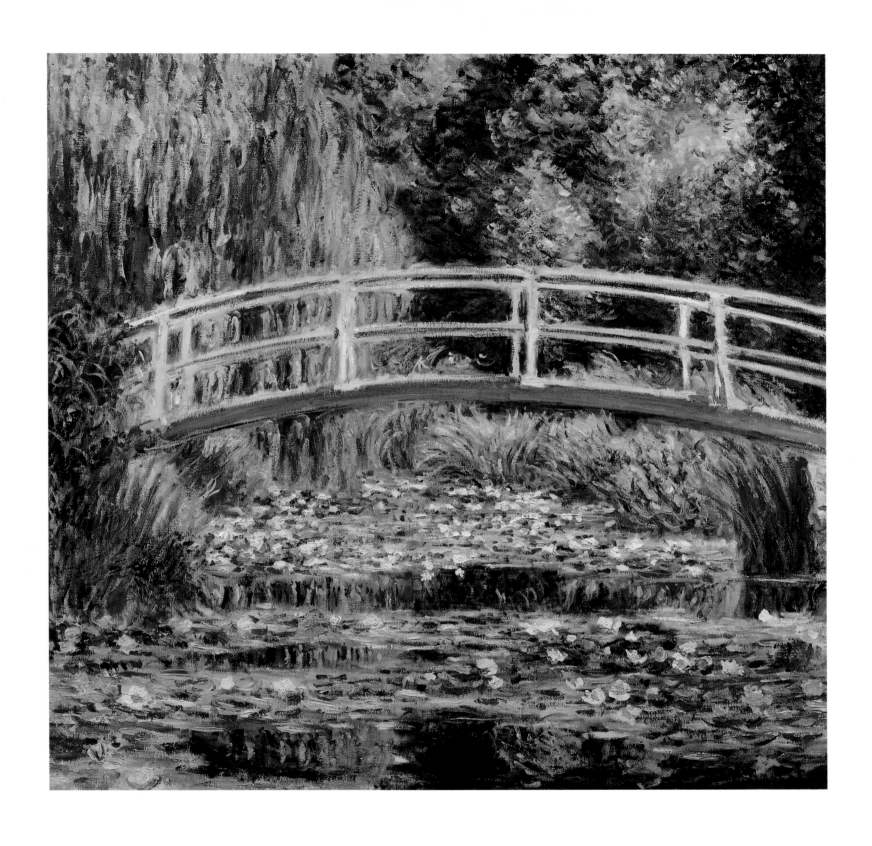

White Water Lilies

1899. Oil on canvas. 89 × 93 cm. (35 × 36⅝ in.)
The Pushkin Museum, Moscow

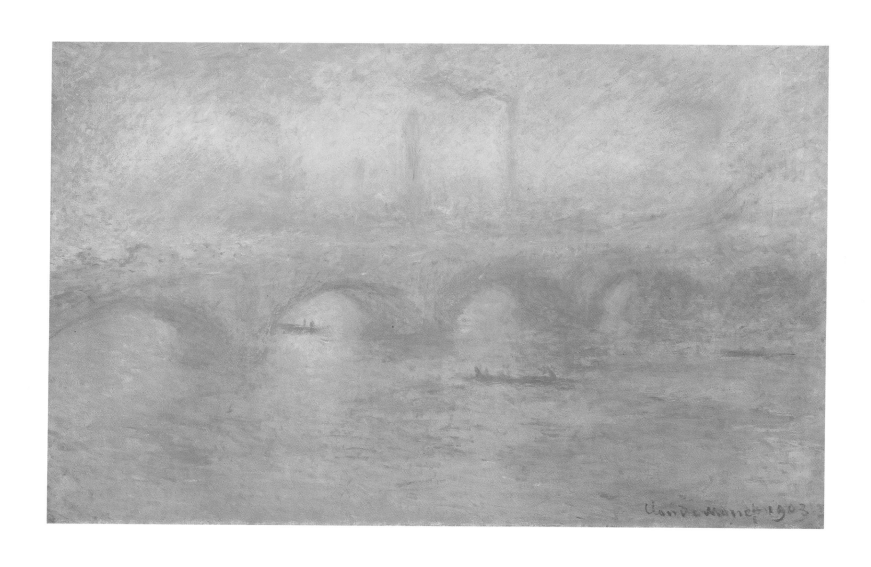

Waterloo Bridge: Effect of Mist

1903. Oil on canvas. 65 × 100 cm. (25⅝ × 39⅜ in.)
The Hermitage, Leningrad

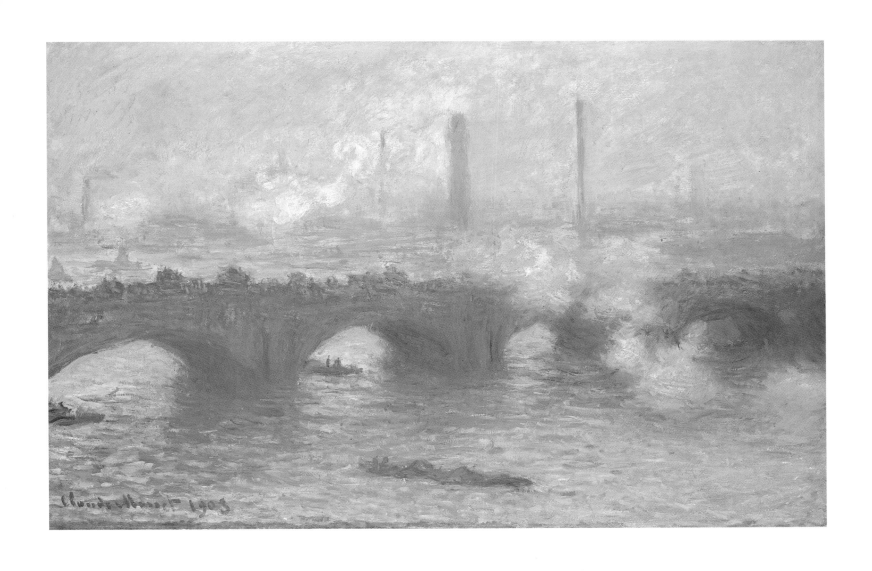

Waterloo Bridge, Gray Day

1903. Oil on canvas. 65.1 × 100 cm. (25⅜ × 39⅜ in.)
Chester Dale Collection, National Gallery of Art, Washington

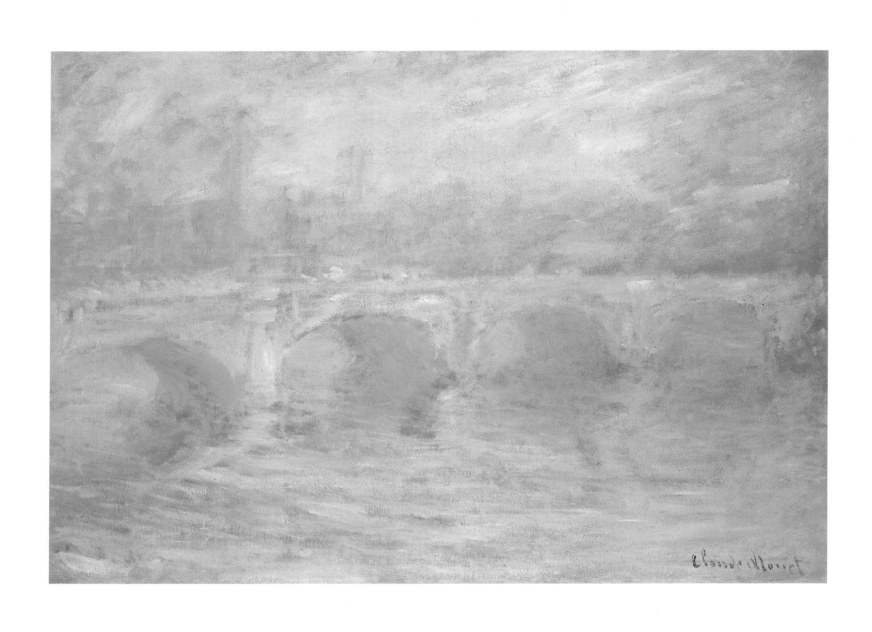

Waterloo Bridge, London, at Sunset

1904. Oil on canvas. 65.5 × 92.7 cm. (25¾ × 36½ in.)
Collection of Mr. and Mrs. Paul Mellon, National Gallery of Art, Washington

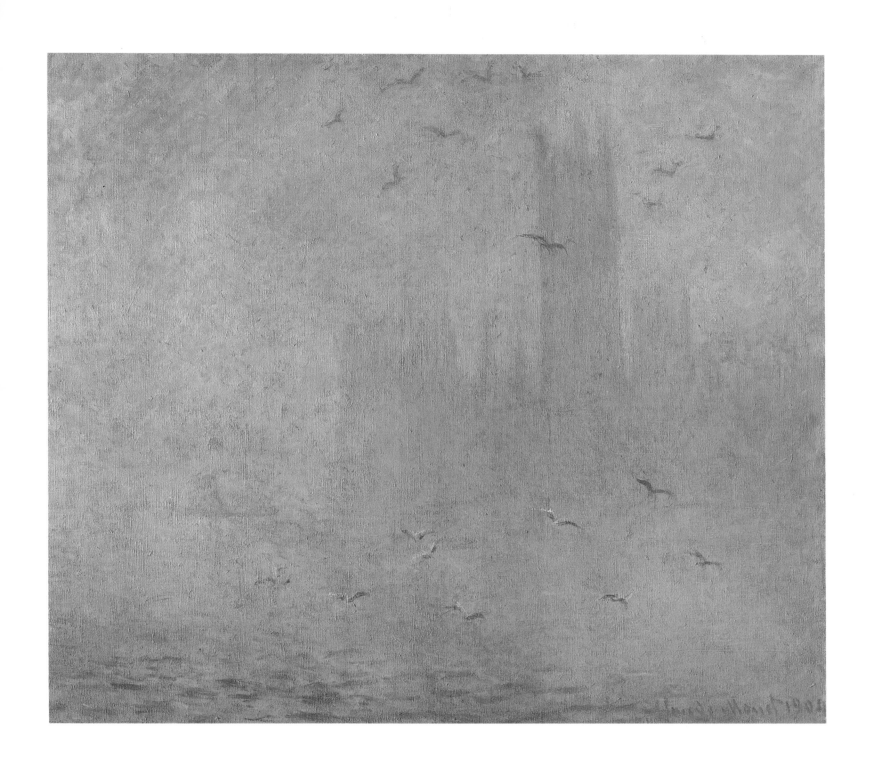

Seagulls. The Thames in London. The Houses of Parliament

1904. Oil on canvas. 82 × 92 cm. (32¼ × 36¼ in.)
The Pushkin Museum, Moscow

CAMILLE PISSARRO
1830–1903

CAMILLE PISSARRO spent his childhood and youth at Saint-Thomas in the Antilles, where he studied painting under the Danish landscapist Melbye. Despite the insistence of his father, who was a businessman, Pissarro refused to make a career in commerce and went to Paris in 1855. There he entered the Académie Suisse and was initially influenced by Corot. He first exhibited at the Salon of 1859 and participated in the Salon des Refusés of 1863. At that time, Pissarro made the acquaintance of Manet, Whistler, and Cézanne, and later met Gleyre's pupils, Monet, Sisley, and Bazille. During the Franco-Prussian War, Pissarro lived in London, where he met Monet and was introduced to Paul Durand-Ruel. After his return to France, he worked with Cézanne at Pontoise between 1872 and 1874 and took part in all the eight Impressionist exhibitions. His continual struggle to provide for his family of six children sometimes forced him to take up odd jobs, such as fan-painting.

In 1885, Pissarro began working in the style called "Divisionism" and sent his works to Divisionist exhibitions. In 1890, however, he gave up Divisionism and returned to the freer handling of his original manner. In 1885, he settled in the village of Eragny near Gisors; during the last years of his life, he often left it to stay for long periods in Paris, Rouen, and Dieppe, where he painted town views from hotel windows. Pissarro did not live to see his art gain recognition and acclaim.

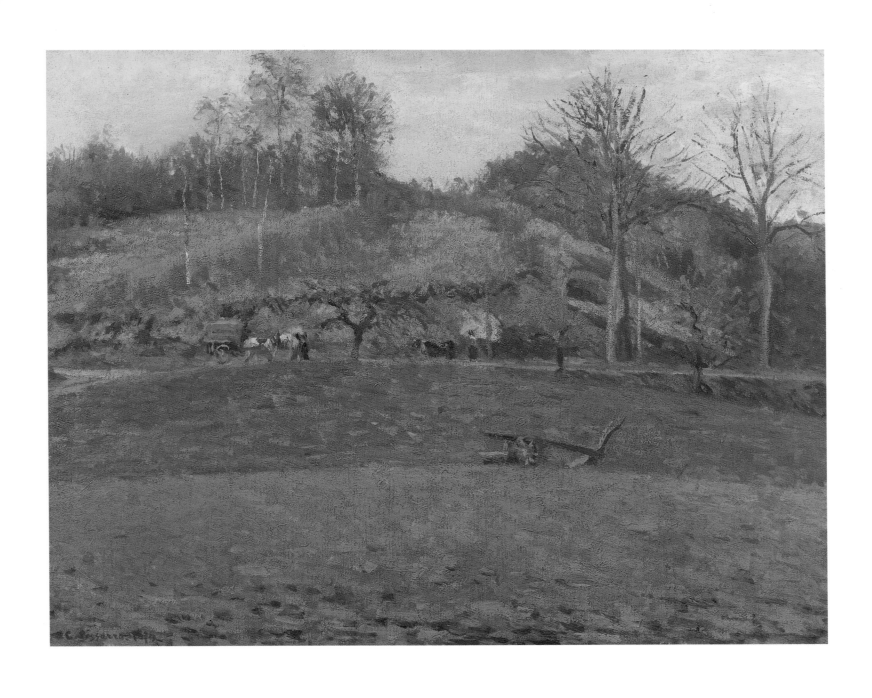

Ploughland

1874. Oil on canvas. 49 × 64 cm. (19¼ × 25¼ in.)
The Pushkin Museum, Moscow

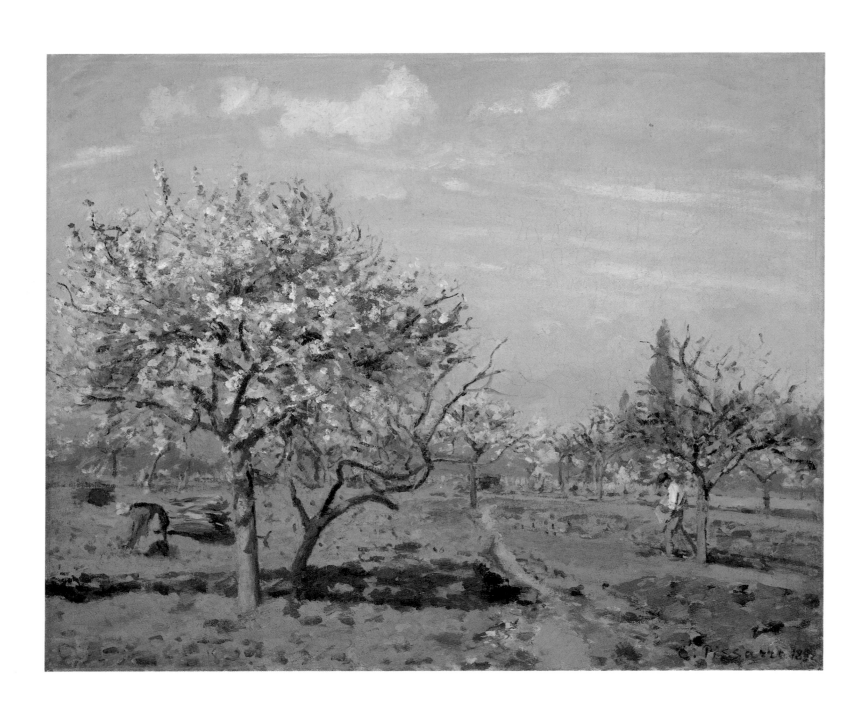

Orchard in Bloom, Louveciennes

1872. Oil on canvas. 45 × 55 cm. (17¾ × 21⅝ in.)
Ailsa Mellon Bruce Collection, National Gallery of Art, Washington

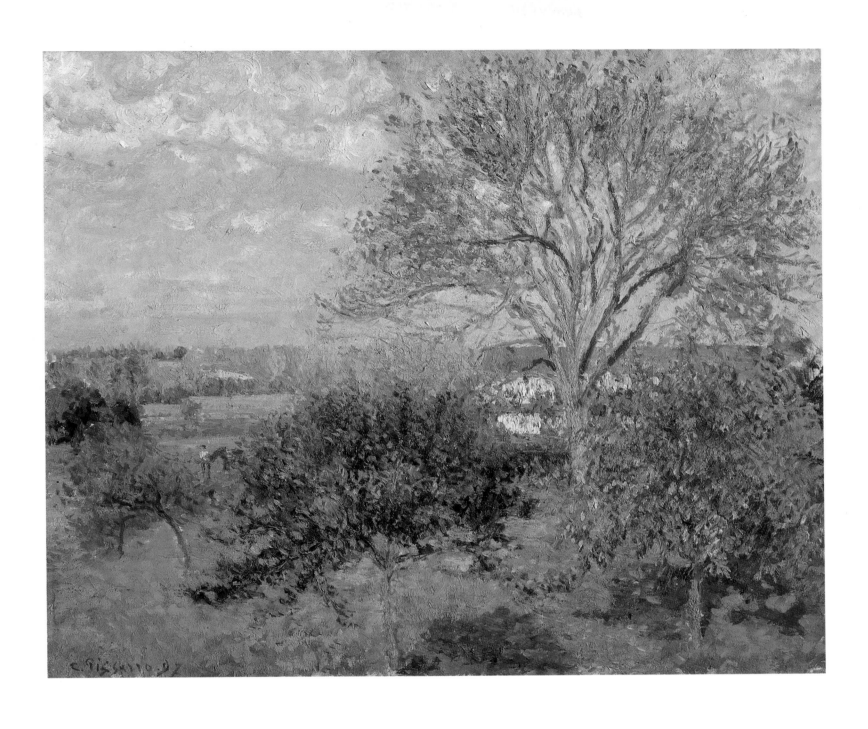

Autumn Morning at Eragny

1897. Oil on canvas. 54 × 65 cm. (21¼ × 25⅝ in.)
The Pushkin Museum, Moscow

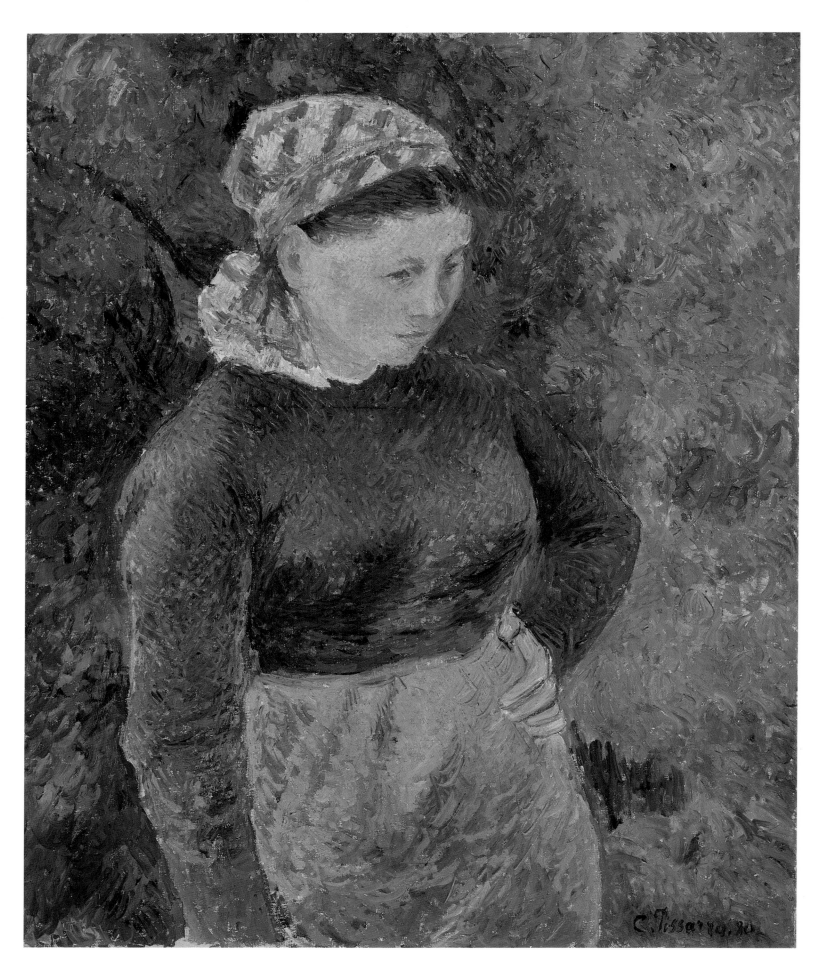

Peasant Woman

1880. Oil on canvas. 73.1 × 60 cm. (28¾ × 23⅝ in.)
Chester Dale Collection, National Gallery of Art, Washington

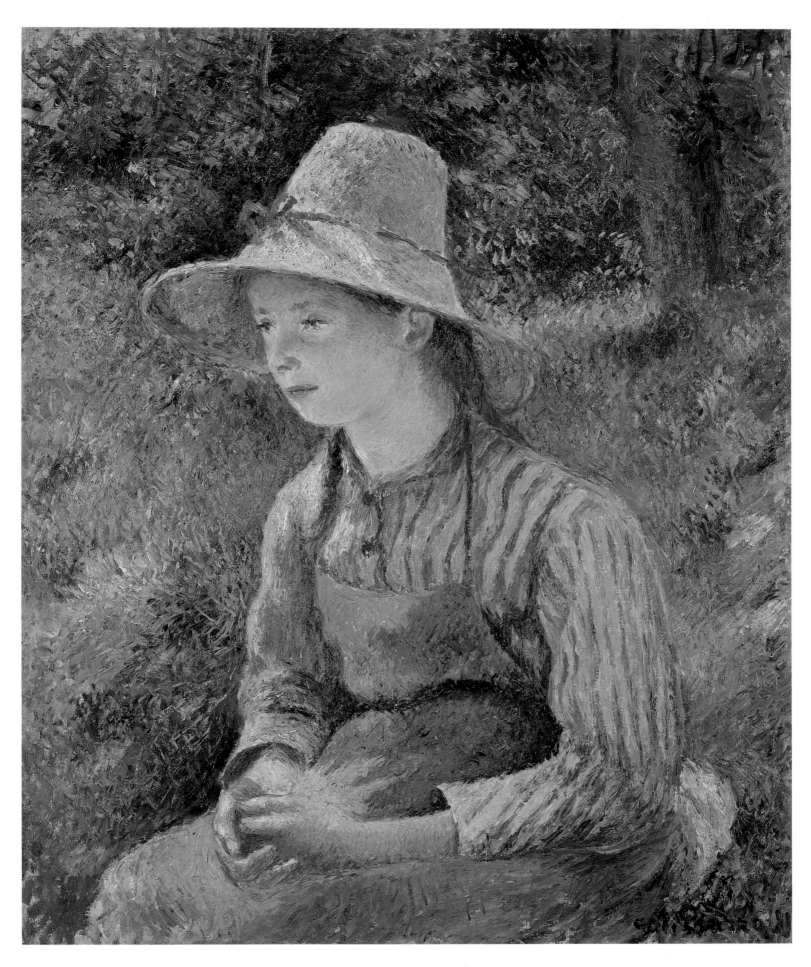

Peasant Girl with a Straw Hat

1881. Oil on canvas. 73.4 × 59.6 cm. (28⅞ × 23½ in.)
Ailsa Mellon Bruce Collection, National Gallery of Art, Washington

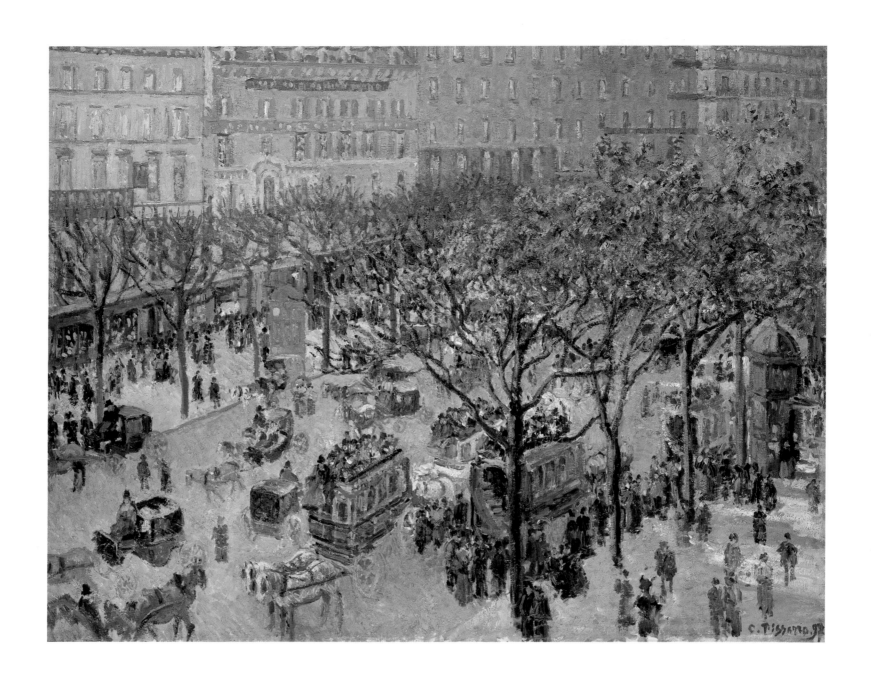

Boulevard des Italiens, Morning, Sunlight

1897. Oil on canvas. 73.2 × 92.1 cm. (28⅞ × 36¼ in.)
Chester Dale Collection, National Gallery of Art, Washington

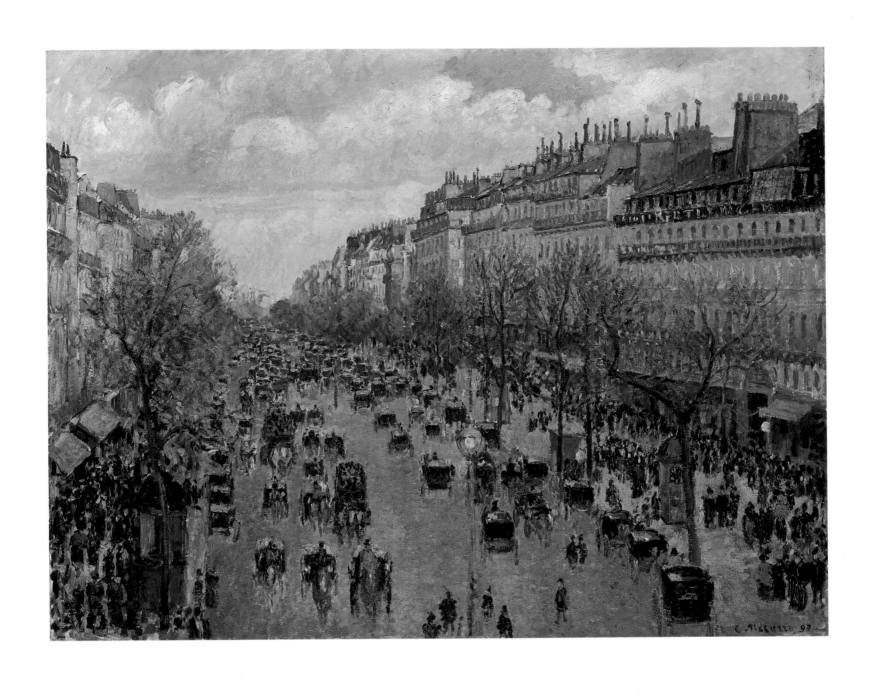

Boulevard Montmartre, Afternoon Sun

1897. Oil on canvas. 73 × 92 cm. (28¾ × 36¼ in.)
The Hermitage, Leningrad

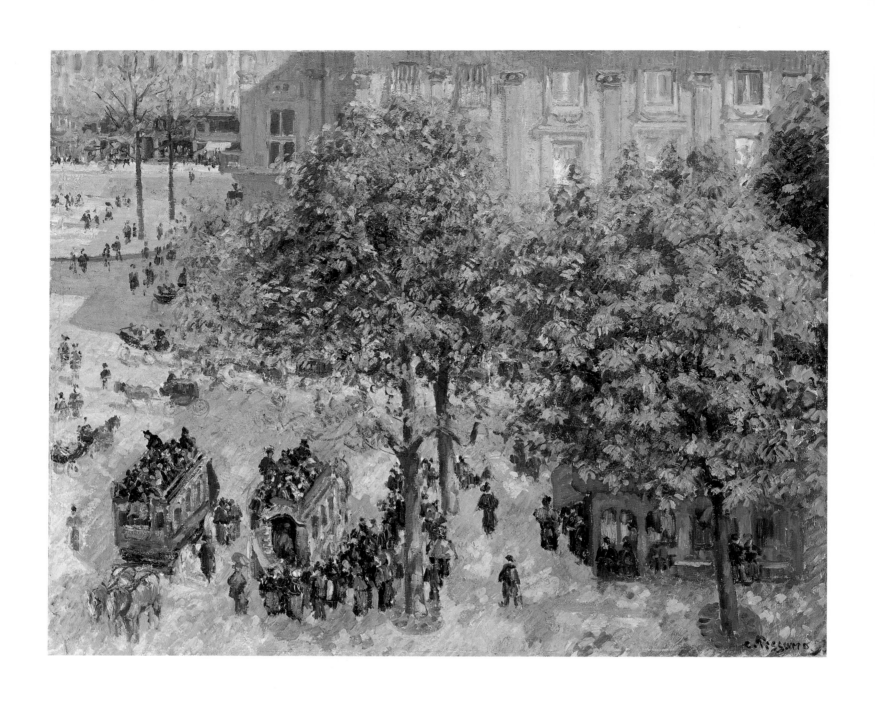

Place du Théâtre-Français, Spring

1898. Oil on canvas. 65.5 × 81.5 cm. (25⅝ × 32 in.)
The Hermitage, Leningrad

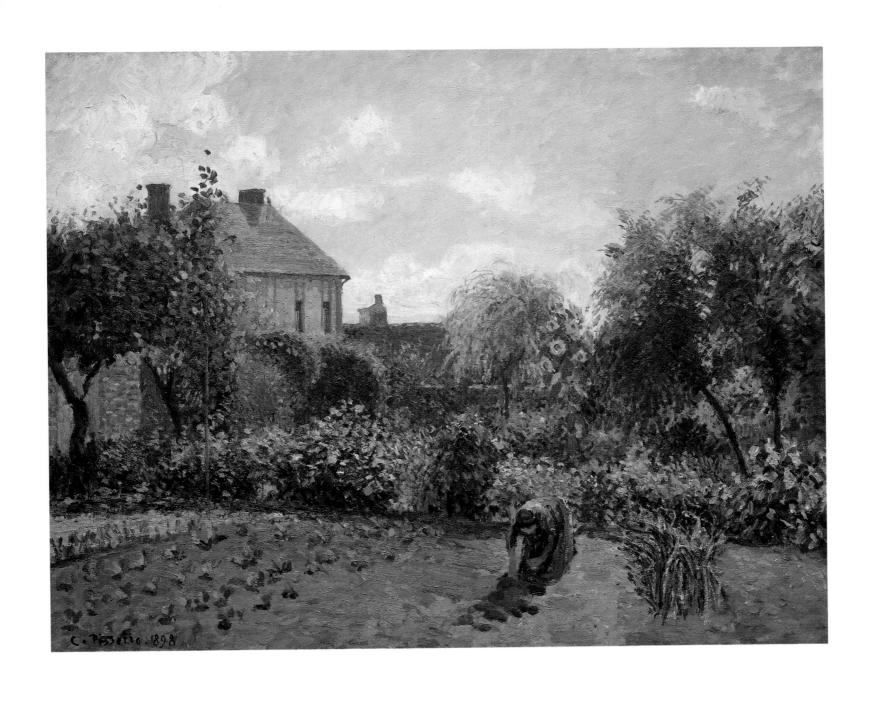

The Artist's Garden at Eragny

1898. Oil on canvas. 73.6 × 92.3 cm. (29 × 36⅜ in.)
Ailsa Mellon Bruce Collection, National Gallery of Art, Washington

ALFRED SISLEY
1839–1899

ALFRED SISLEY was born in Paris into the family of a well-to-do English businessman. Between 1857 and 1861, he lived in England, where his father wished him to study commerce. Instead, he entered the Atelier Gleyre in Paris and there met Monet, Renoir, and Bazille. He often worked with his new friends in the suburbs of Paris during the summer. Sisley first sent his paintings to the Salon in 1866 and subsequently exhibited there in 1868 and 1870. After the Franco-Prussian War, his father's business collapsed, and the artist lived in poverty for many years. Until 1880, he lived and worked in the countryside and small provincial towns near Versailles and Louveciennes, especially Villeneuve-la-Garenne, Bougival, and Port-Marly. The flood of 1876 at Port-Marly became the subject of a large series of his landscapes. From 1880 onwards, he painted almost exclusively landscapes depicting the banks of the Seine and the Loing at Saint-Mammès and Sablon and the picturesque and peaceful life in Veneux and Moret-sur-Loing, the town where he lived from 1889 until his death.

Sisley did not live to see his talent recognized. He had contributed to the Impressionist exhibitions of 1874, 1876, 1877, and 1882, and he exhibited at the Durand-Ruel galleries in Paris and New York. Every year, starting from 1892, his paintings were on show at the Salon des Beaux-Arts; several of his works were displayed by Georges Petit at international exhibitions. However, he found neither fame nor relief from financial difficulty. The failure of his retrospective exhibition at Georges Petit's in 1897, to which he had been looking forward and for which he had selected his best pictures, was an especially hard blow to the artist. Backed by one of his patrons, François Depeau, a Rouen manufacturer, Sisley left for the south of England. From May to October 1897, he stayed at Penarth, a seaside resort near Cardiff, and painted views of rocky seashores. On his return to Moret-sur-Loing, Sisley decided to apply for French citizenship. But by that time he had already become incurably ill. He died on January 29, 1899.

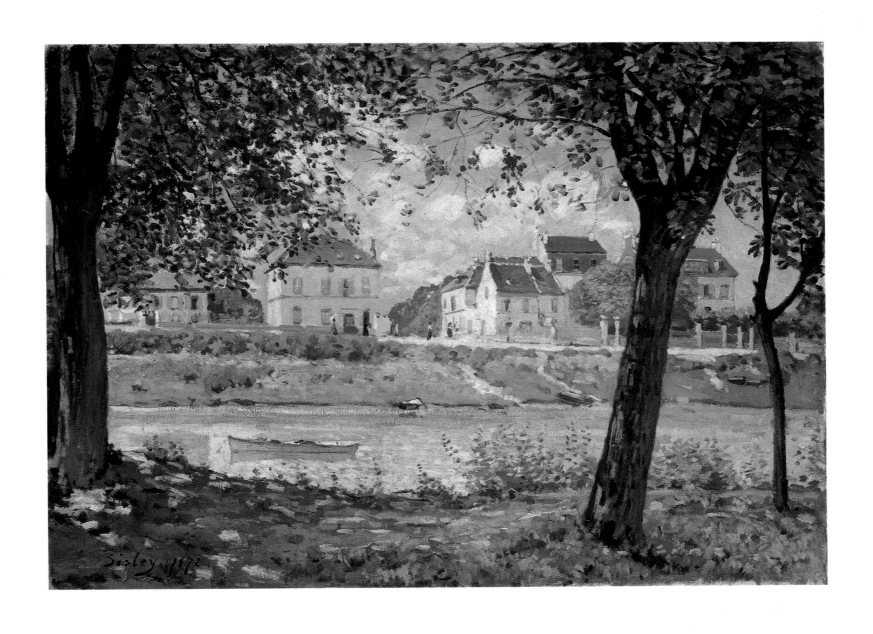

Village on the Seine, Villeneuve-la-Garenne

1872. Oil on canvas. 59 × 80.5 cm. (23¼ × 31¾ in.)
The Hermitage, Leningrad

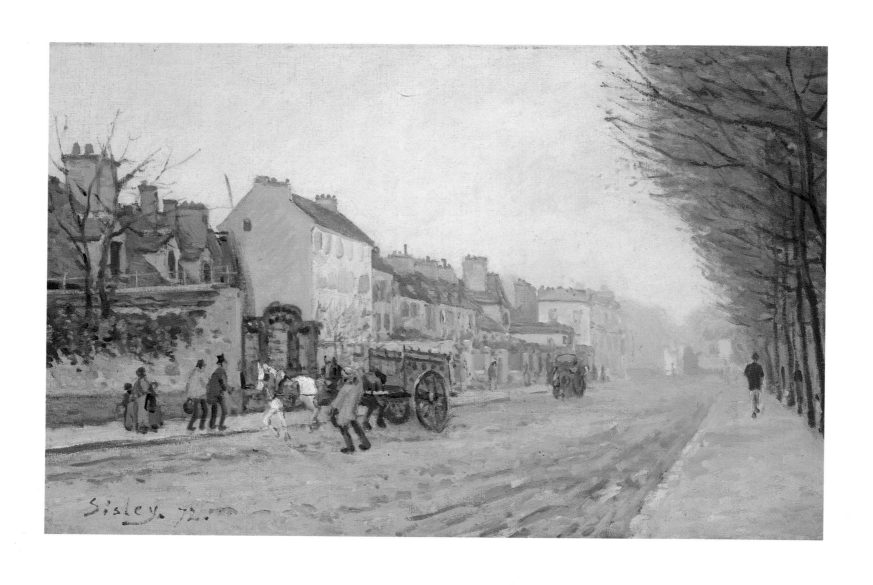

Boulevard Heloise, Argenteuil

1872. Oil on canvas. 39.5 × 59.6 cm. (15½ × 23½ in.)
Ailsa Mellon Bruce Collection, National Gallery of Art, Washington

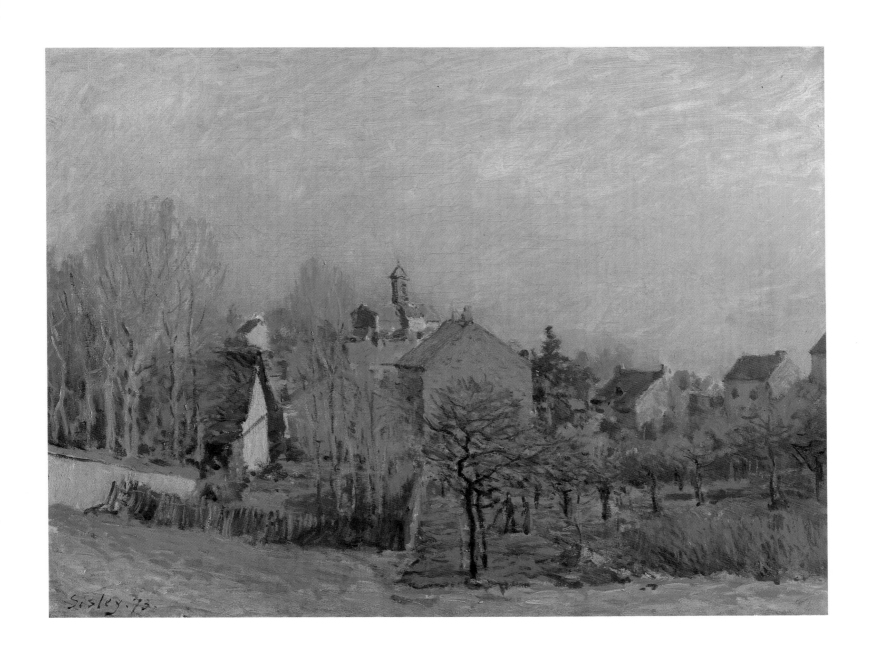

Frosty Morning in Louveciennes

1873. Oil on canvas. 46 × 61 cm. (18⅛ × 24 in.)
The Pushkin Museum, Moscow

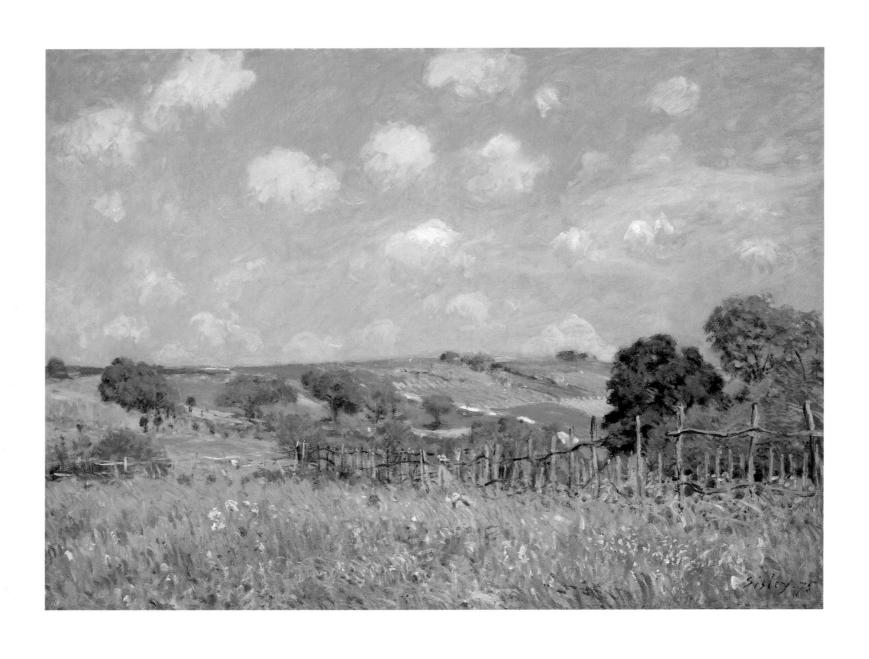

Meadow

1875. Oil on canvas. 54.9 × 73 cm. (21⅝ × 28¾ in.)
Ailsa Mellon Bruce Collection, National Gallery of Art, Washington

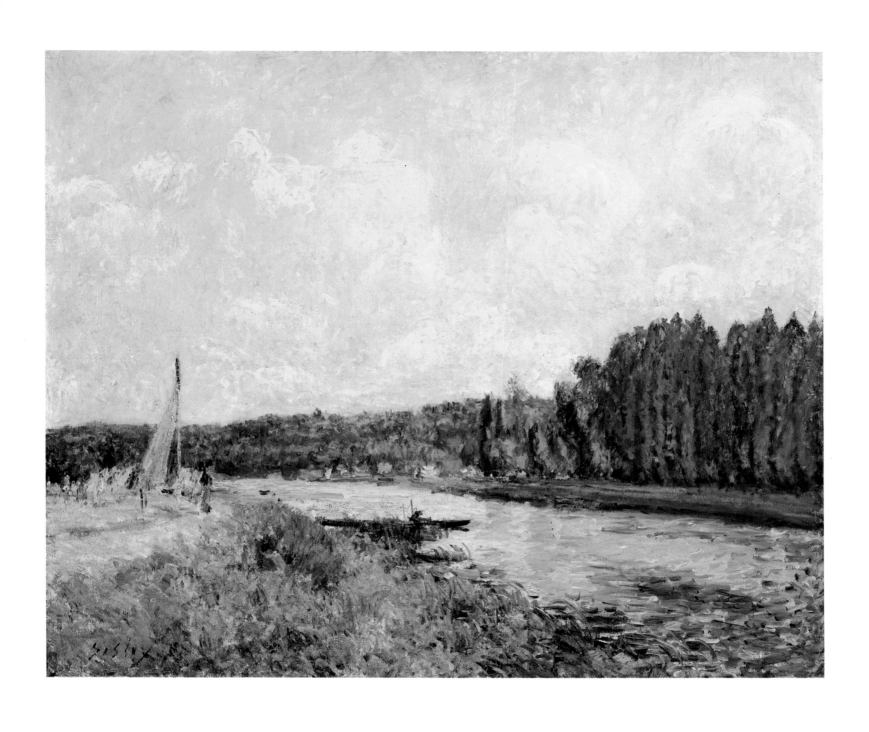

The Banks of the Oise

1877/78. Oil on canvas. 54.3 × 64.7 cm. (21⅜ × 25½ in.)
Chester Dale Collection, National Gallery of Art, Washington

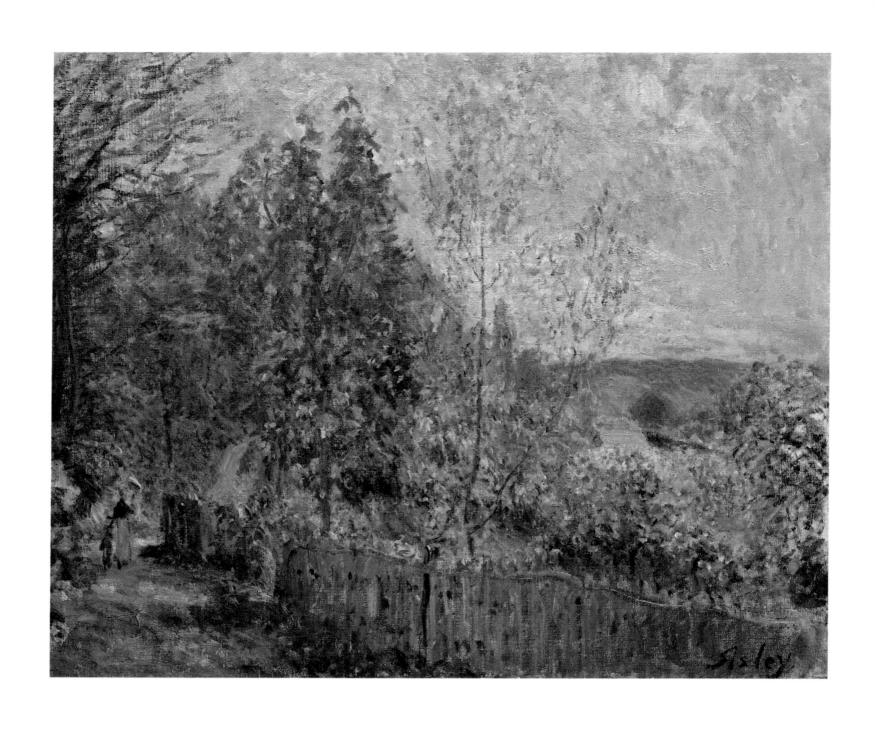

The Road in the Woods

1879. Oil on canvas. 46.3 × 55.8 cm. (18¼ × 22 in.)
Chester Dale Collection, National Gallery of Art, Washington

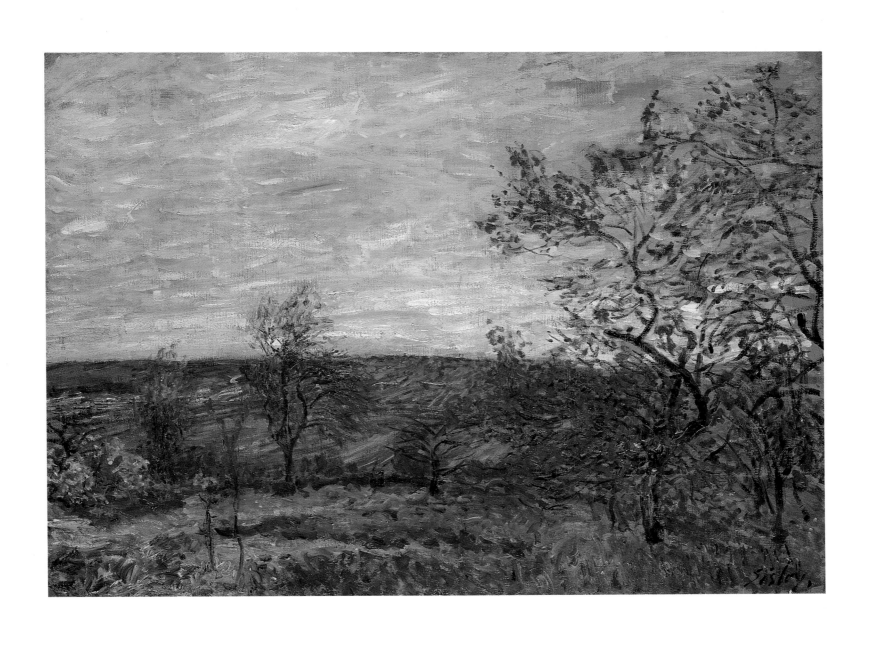

Windy Day at Veneux

c. 1882. Oil on canvas. 60 × 81 cm. (23⅝ × 31⅞ in.)
The Hermitage, Leningrad

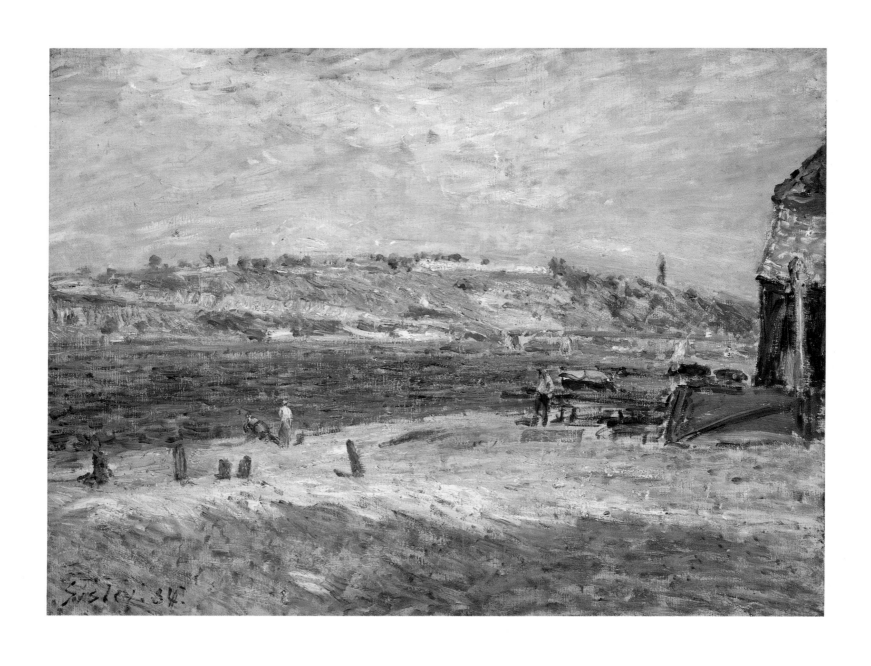

River Banks at Saint-Mammès

1884. Oil on canvas. 50 × 65 cm. (19⅝ × 25⅝ in.)
The Hermitage, Leningrad

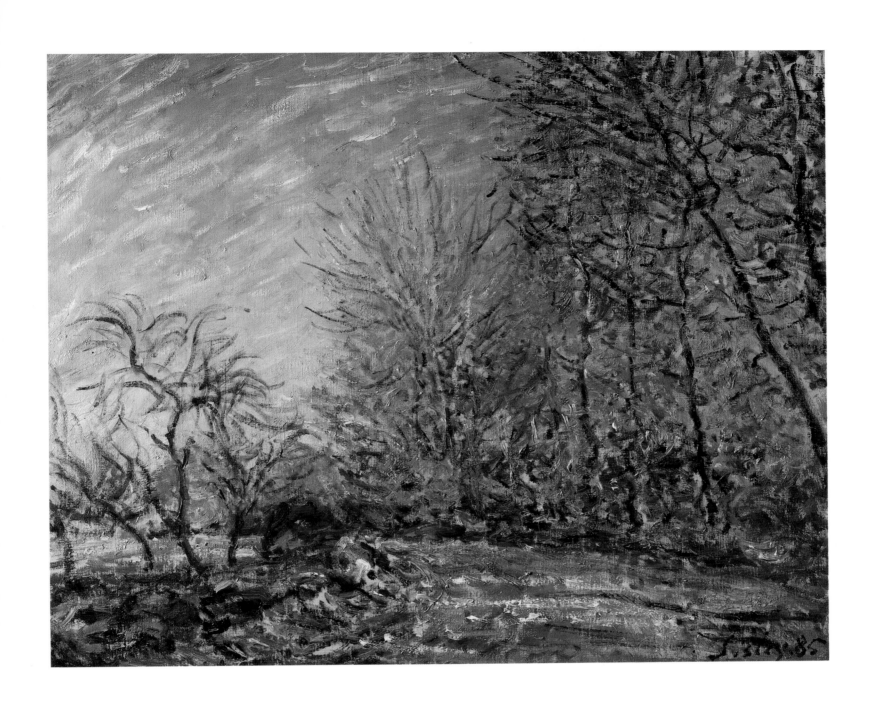

The Skirts of the Fontainebleau Forest

1885. Oil on canvas. 60 × 73 cm. (23⅝ × 28¾ in.)
The Pushkin Museum, Moscow

PIERRE-AUGUSTE RENOIR
1841–1919

PIERRE-AUGUSTE RENOIR was born in Limoges and brought up in Paris, where his father, a tailor with a large family, had settled in 1845. From the age of thirteen, he worked as an apprentice, painting flowers on porcelain plates and, after a mechanical method of coloring ceramics had been introduced, decorating fans and screens. Having saved some money, Renoir enrolled in 1862 at the Atelier Gleyre and there made friends with Monet, Sisley, and Bazille; some time later he met Pissarro and Cézanne. He first exhibited at the Salon in 1864; after that the jury rejected his works, except in 1867, when they accepted *Lise with a Parasol*.

During the early period of his artistic career, Renoir came under the influence of Delacroix and Manet. His Impressionist individuality was most strongly manifested in the *plein-air* studies of La Grenouillère at Bougival (1869).

It was in the 1870s that Renoir's Impressionism reached its peak. He worked at Argenteuil with Monet, and in Paris. He participated in the Impressionist exhibitions of 1874, 1876, 1877, and 1882 and was a founding member of the review *L'Impressionniste* (1877), where he published his treatise on the principles of contemporary decorative art.

Renoir attained renown earlier than his friends. In 1879–80, he sent several portraits to the official Salon, among them *Portrait of the Actress Jeanne Samary.*

In the 1880s, the artist found himself at a critical point, and he abandoned Impressionism for what is often called the *style aigre*. He began a search for solid form and stable composition, a search which led him to the masters of the Renaissance. At that time, he joined up with Cézanne and worked with him in Aix, Montbriant, and L'Estaque (1883, 1888, 1889). In 1885, they visited La Roche-Guyon. By the late 1880s, Renoir had come a long way from the dry outlines of his *style aigre*, replacing it with a free and rich pictorial style.

In December 1898, the first attacks of arthritis compelled Renoir to move to the south of France. In 1903, he finally settled in Cagnes-sur-Mer, where he bought an estate named "Les Collettes," leaving it only in summer to go to Paris and other places. In his last years, Renoir took up sculpture and produced some pieces of impressive simplicity. From 1912 until his death, although partly crippled with arthritis, he continued painting, strapping a brush to his wrist.

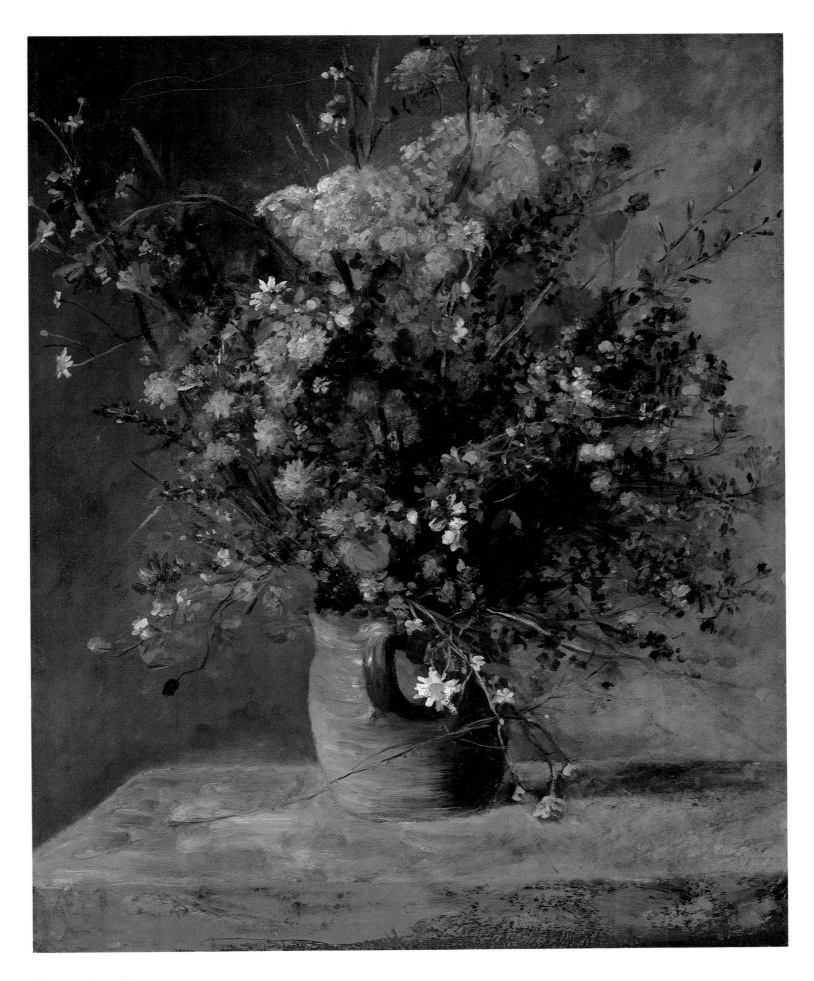

Flowers in a Vase

c. 1866. Oil on canvas. 81.3 × 65.1 cm. (32 × 25⅝ in.)
Collection of Mr. and Mrs. Paul Mellon, National Gallery of Art, Washington

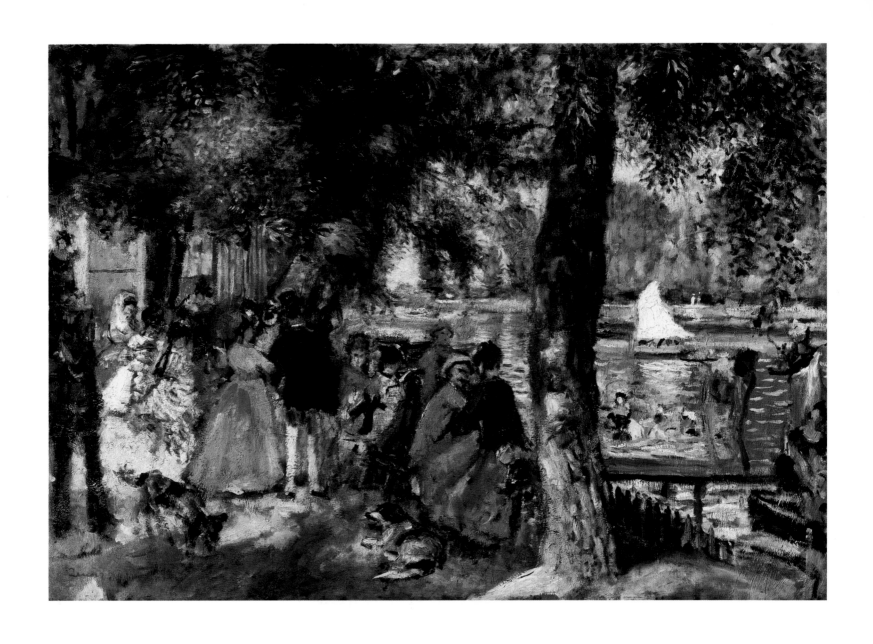

Bathing on the Seine, La Grenouillère

c. 1869. Oil on canvas. 59 × 80 cm. (23¼ × 31½ in.)
The Pushkin Museum, Moscow

OPPOSITE:

Diana

1867. Oil on canvas. 199.5 × 129.5 cm. (77 × 51¼ in.)
Chester Dale Collection, National Gallery of Art, Washington

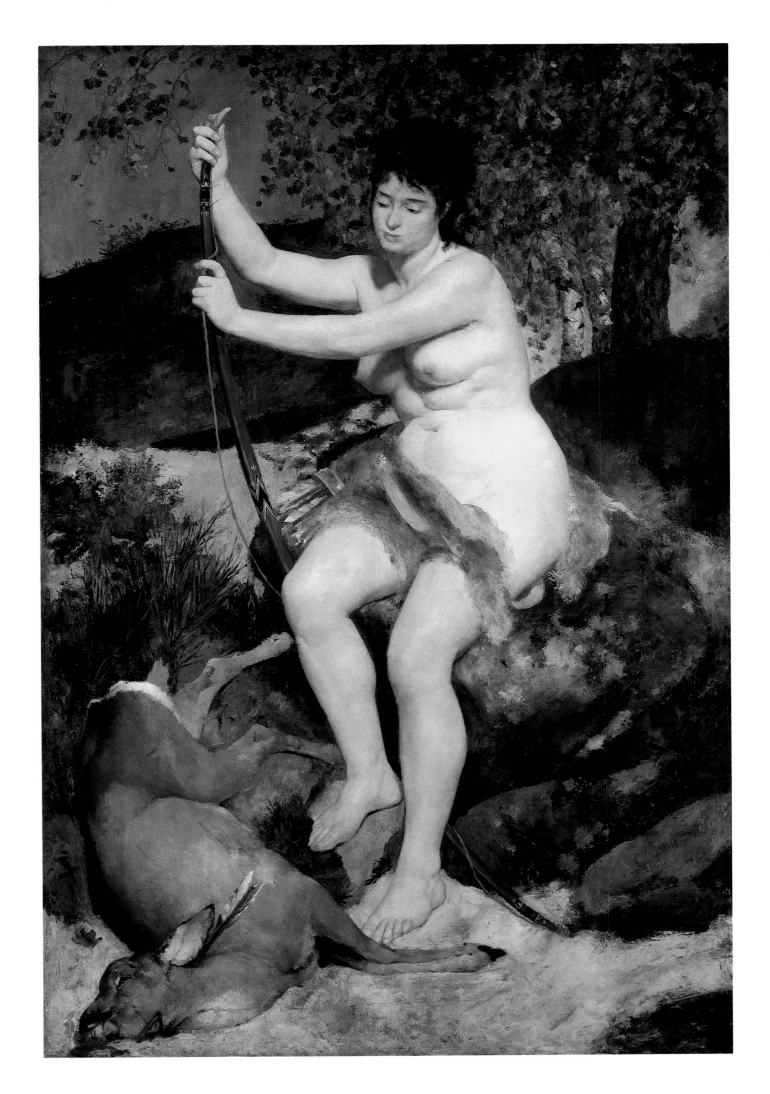

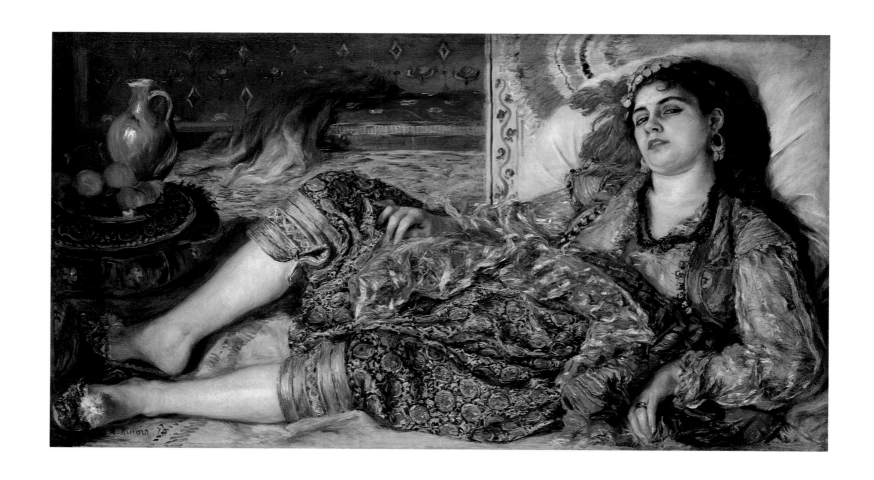

Odalisque

1870. Oil on canvas. 69.2 × 122.6 cm. (27¼ × 48¼ in.)
Chester Dale Collection, National Gallery of Art, Washington

Head of a Dog

1870. Oil on canvas. 21.9 × 20 cm. (8⅝ × 7⅞ in.)
Ailsa Mellon Bruce Collection, National Gallery of Art, Washington

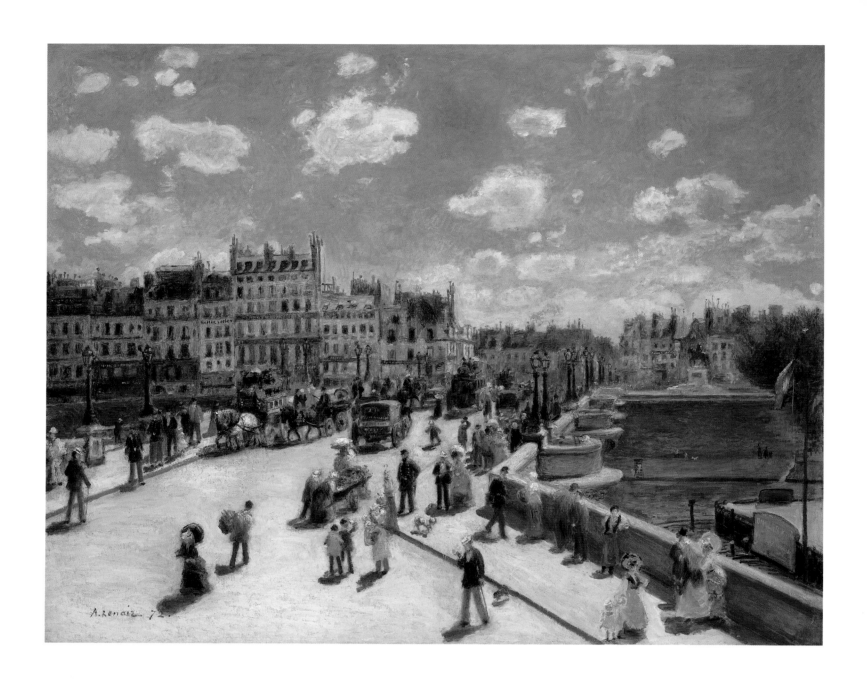

Pont Neuf, Paris

1872. Oil on canvas. 75.3 × 93.7 cm. (29⅝ × 36⅞ in.)
Ailsa Mellon Bruce Collection, National Gallery of Art, Washington

OPPOSITE:

The Dancer

1874. Oil on canvas. 142.5 × 94.5 cm. (56⅛ × 37⅛ in.)
Widener Collection, National Gallery of Art, Washington

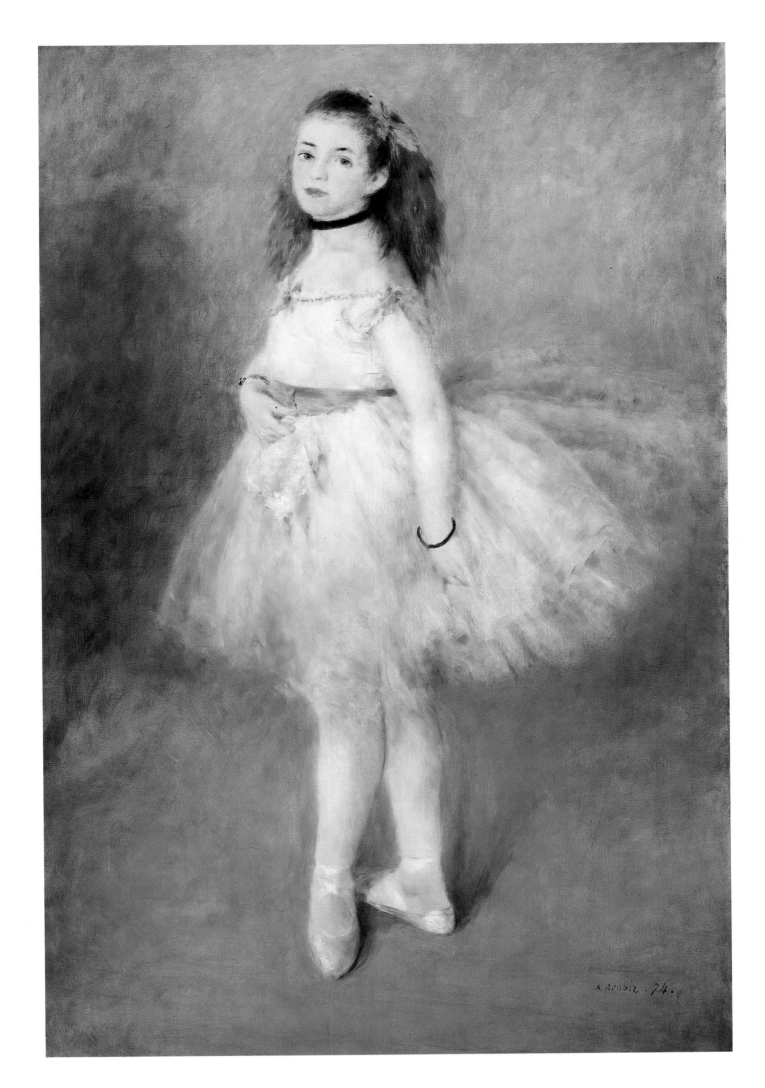

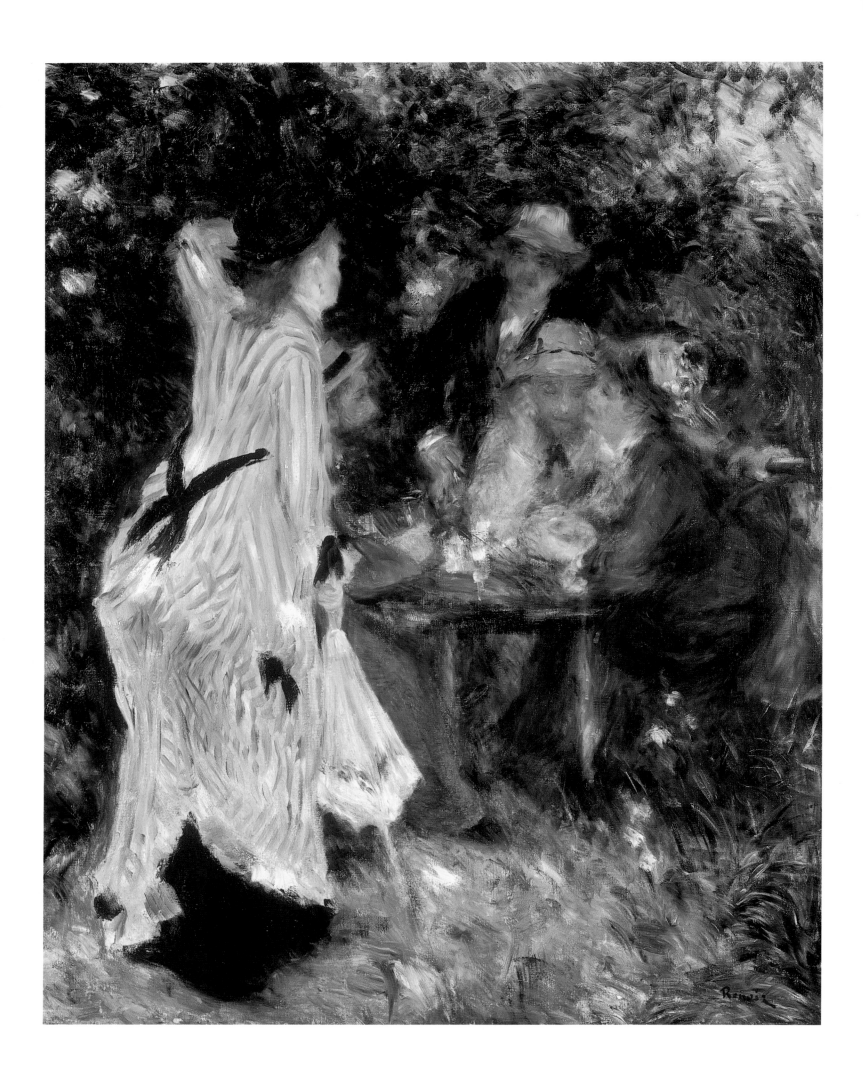

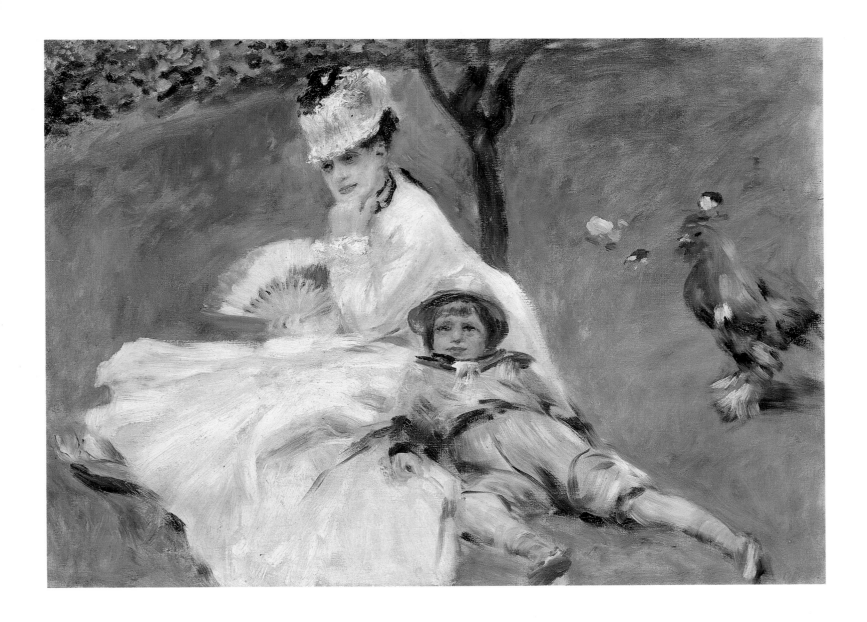

Madame Monet and Her Son

1874. Oil on canvas. 50.4 × 68 cm. (19⅞ × 26¾ in.)
Ailsa Mellon Bruce Collection, National Gallery of Art, Washington

OPPOSITE:

In the Garden: Under the Trees of the Moulin de la Galette

c. 1875–76. Oil on canvas. 81 × 65 cm. (31⅞ × 25⅝ in.)
The Pushkin Museum, Moscow

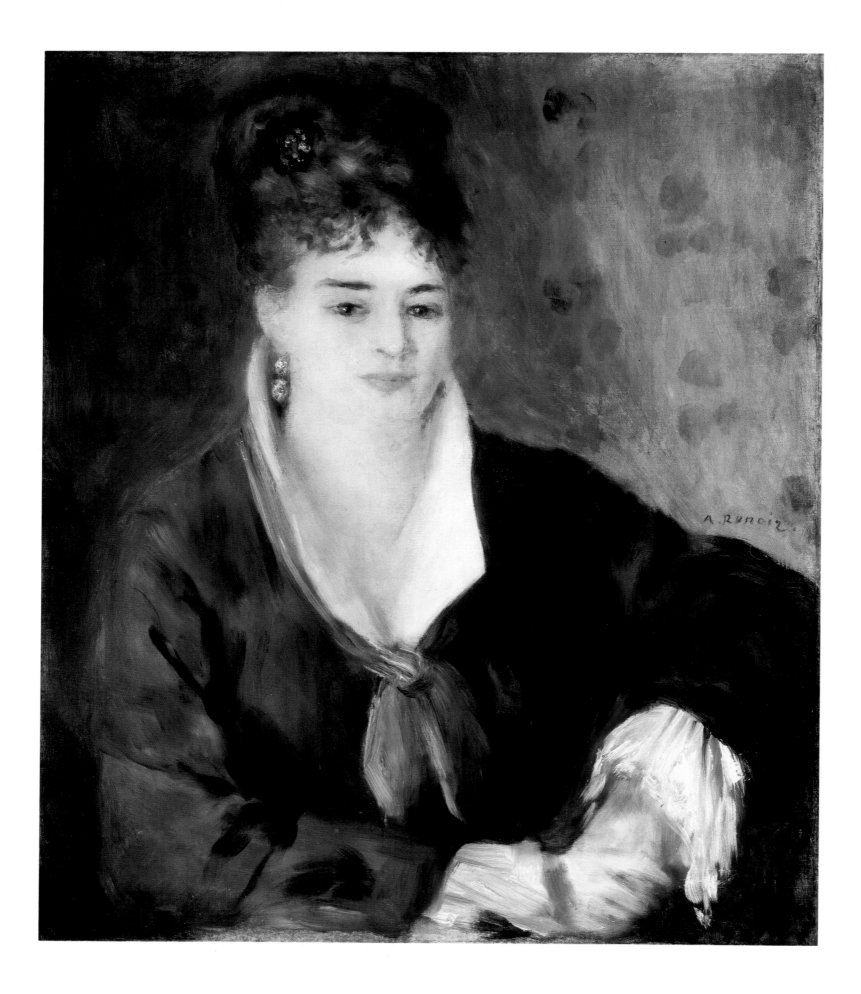

Lady in Black

c. 1876. Oil on canvas. 63 × 53 cm. (24¾ × 20¾ in.)
The Hermitage, Leningrad

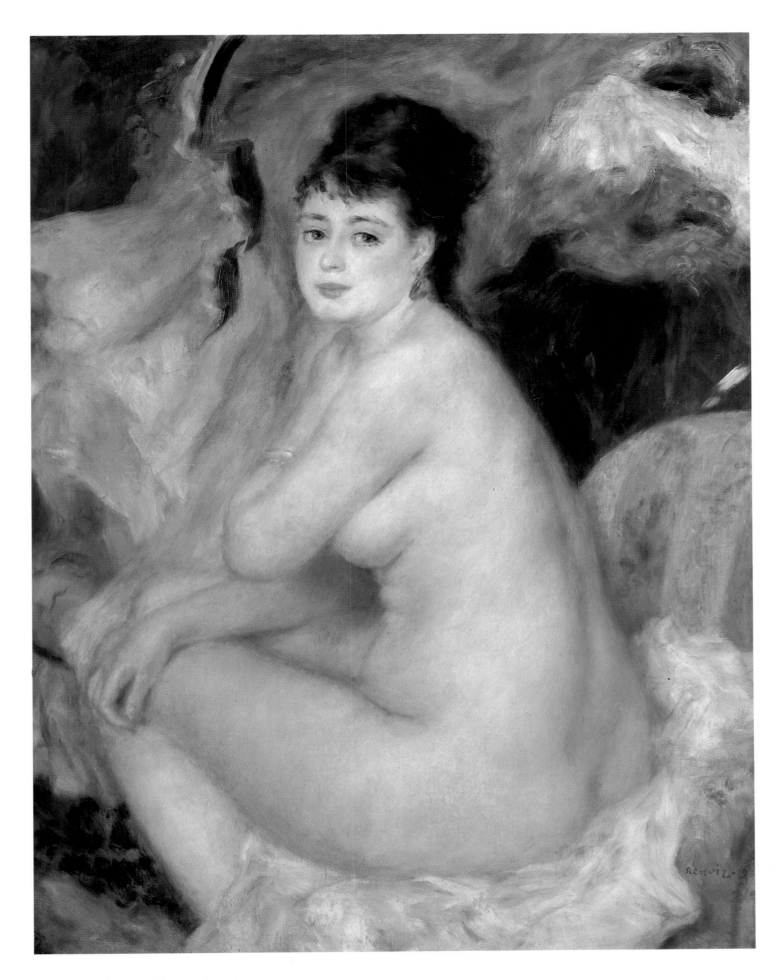

Nude (Nude Seated on a Sofa)

1876. Oil on canvas. 92 × 73 cm. (36¼ × 28¾ in.)
The Pushkin Museum, Moscow

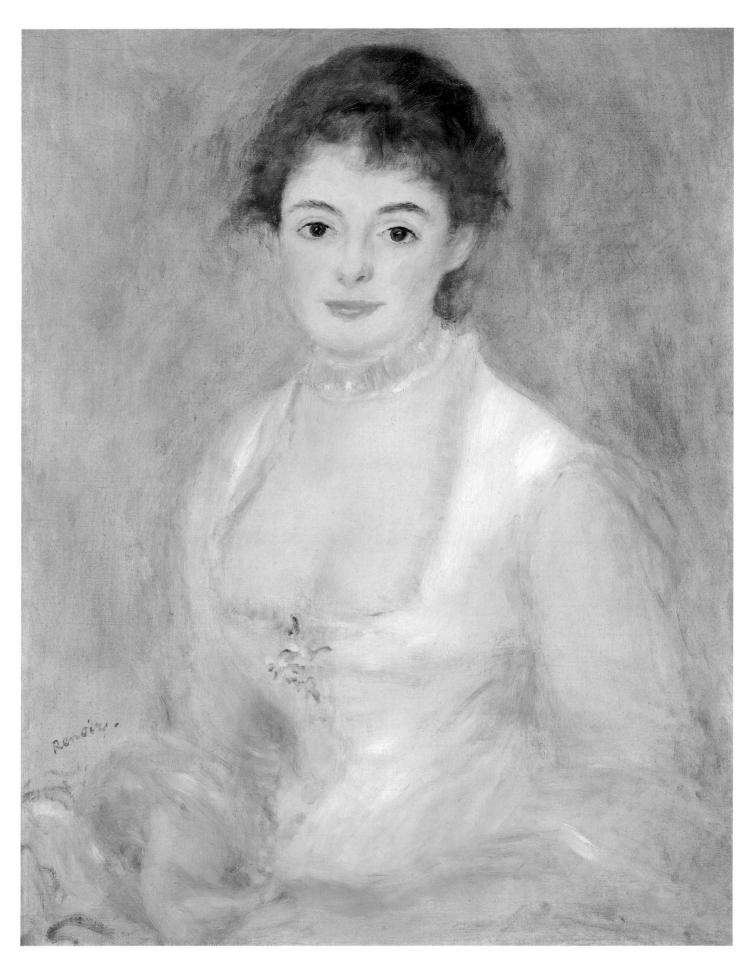

Madame Henriot

c. 1876. Oil on canvas. 65.9 × 49.8 cm. (26 × 19⅝ in.)
Gift of the Adele R. Levy Fund, National Gallery of Art, Washington

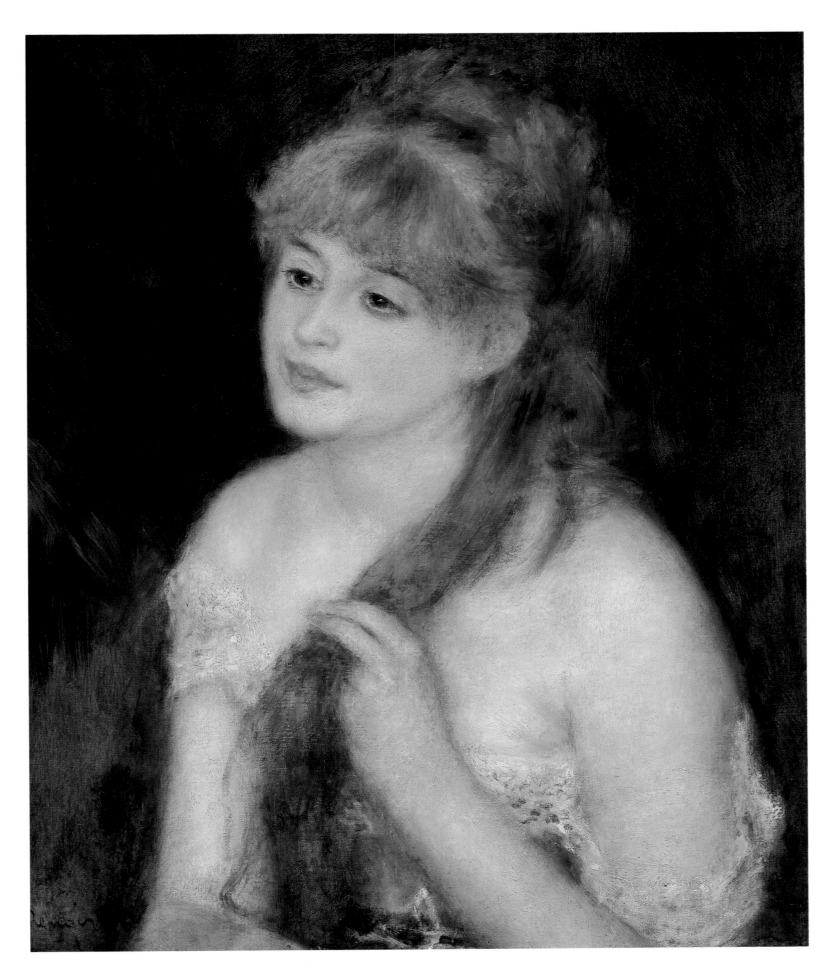

Young Woman Braiding Her Hair

1876. Oil on canvas. 55.6 × 46.4 cm. (21⅞ × 18¼ in.)
Ailsa Mellon Bruce Collection, National Gallery of Art, Washington

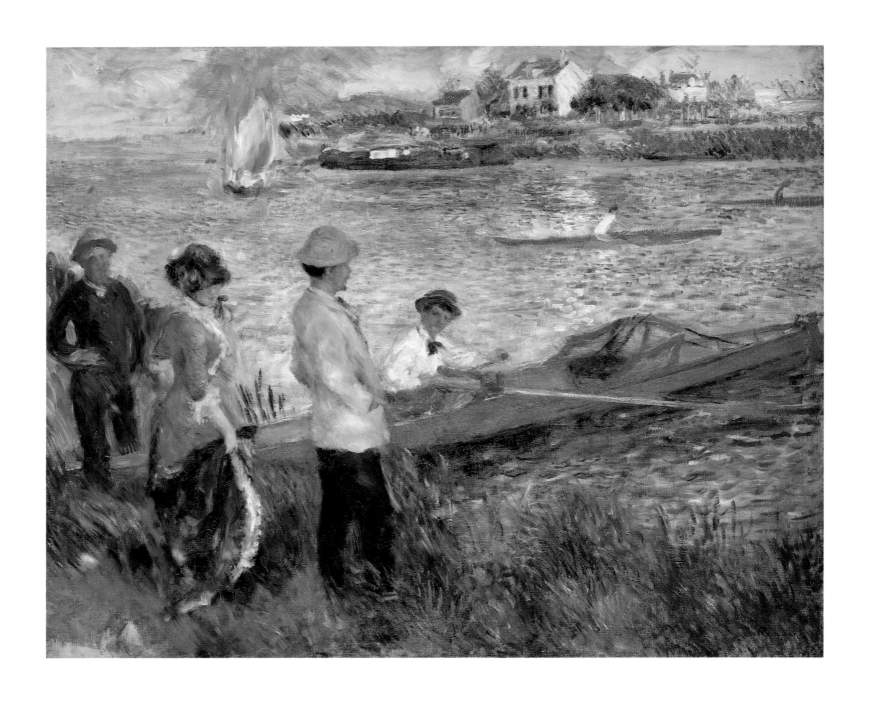

Oarsmen at Chatou

1879. Oil on canvas. 81.3 × 100.3 cm. (32 × 39½ in.)
Gift of Sam A. Lewisohn, National Gallery of Art, Washington

OPPOSITE:

A Girl with a Watering Can

1876. Oil on canvas. 100.3 × 73.2 cm. (39½ × 28¾ in.)
Chester Dale Collection, National Gallery of Art, Washington

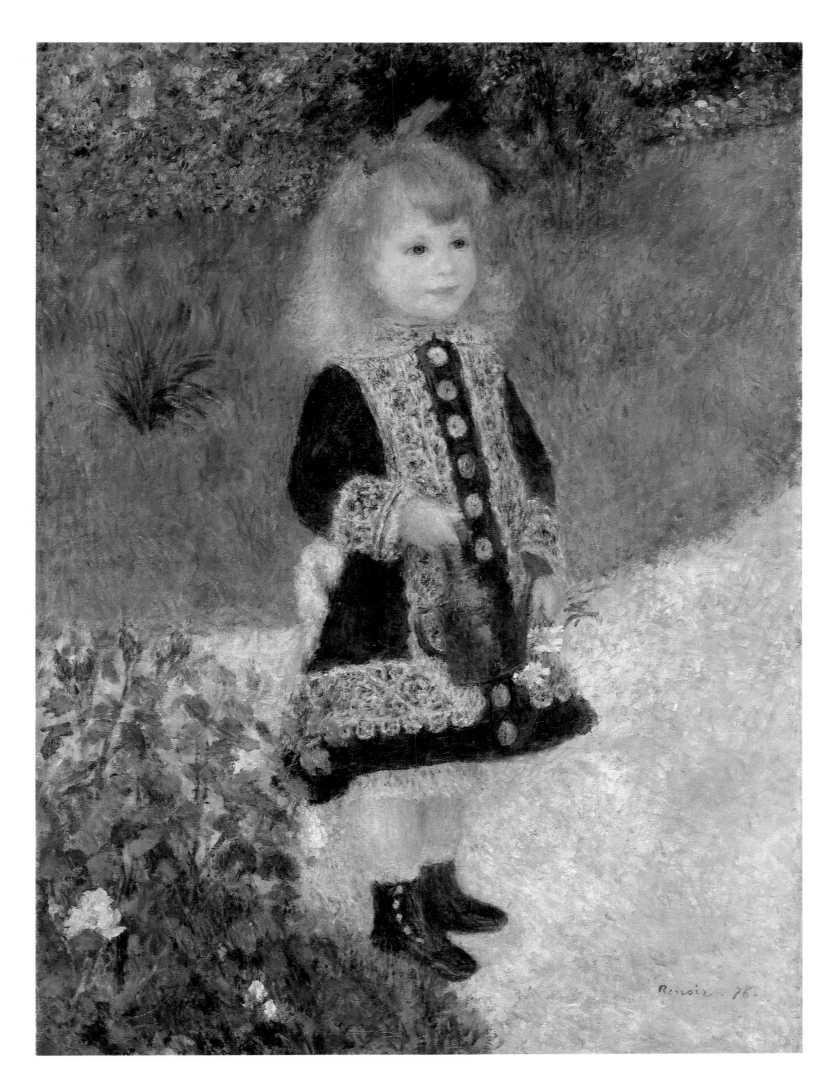

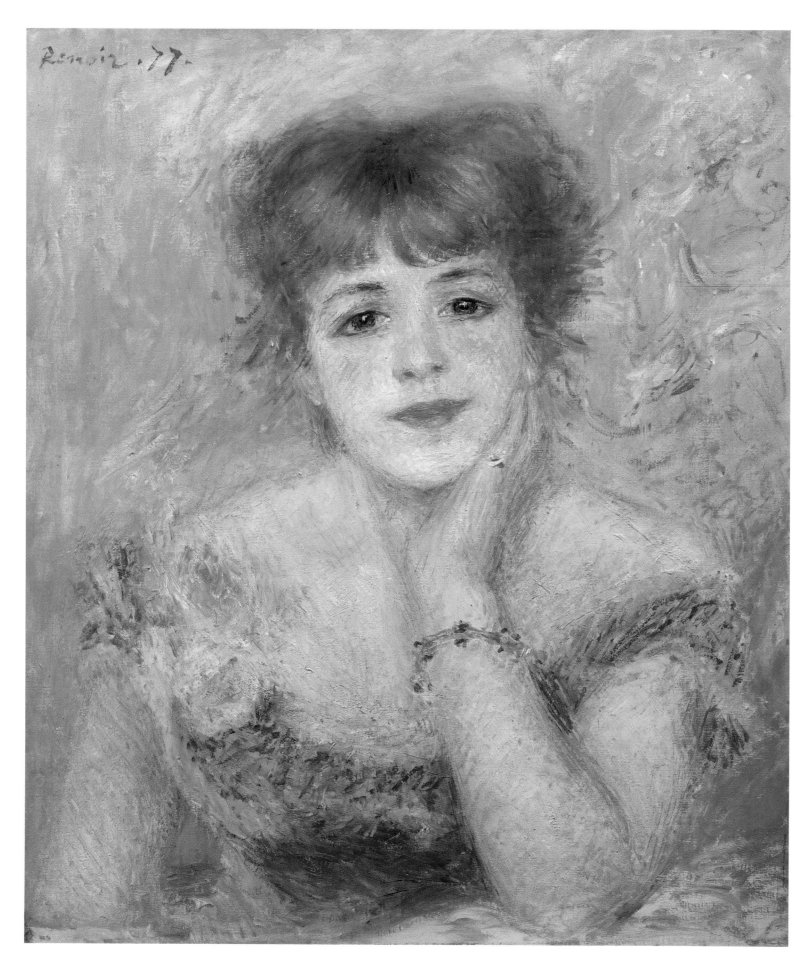

Portrait of the Actress Jeanne Samary. Study

1877. Oil on canvas. 56 × 47 cm. (21¼ × 18½ in.)
The Pushkin Museum, Moscow

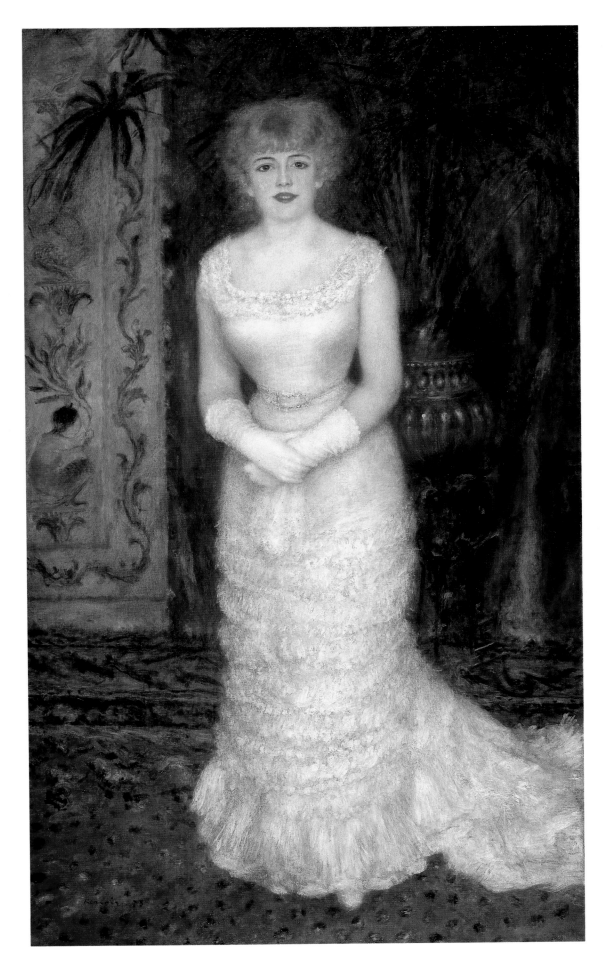

Portrait of the Actress Jeanne Samary

1878. Oil on canvas. 173 × 103 cm. (68 × 40½ in.)
The Hermitage, Leningrad

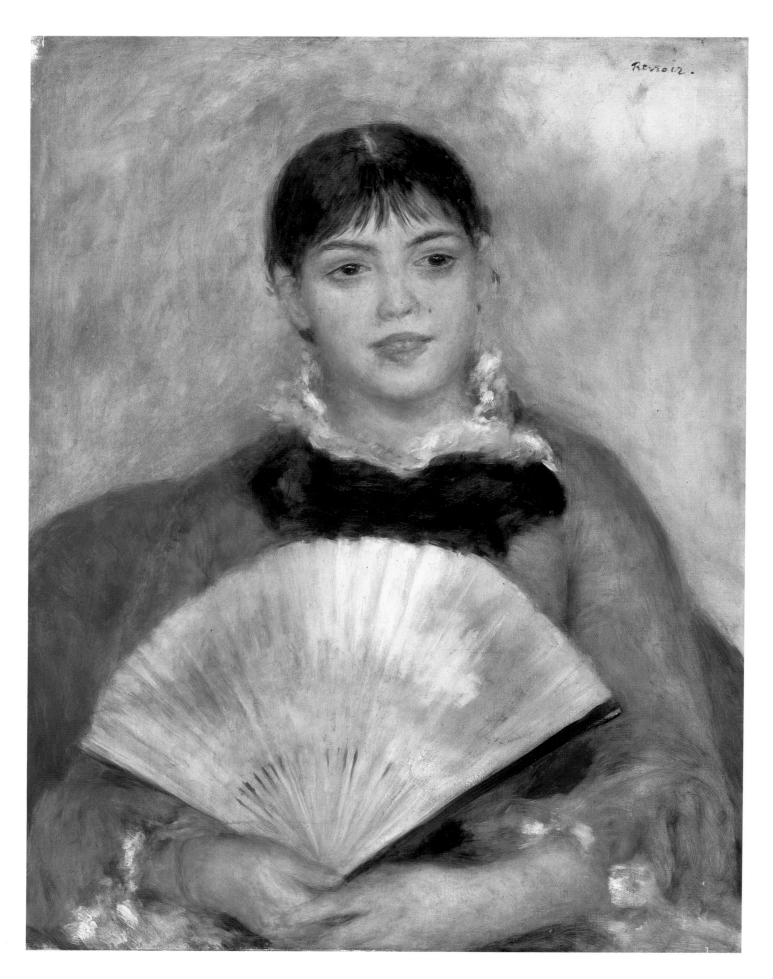

Girl with a Fan

c. 1881. Oil on canvas. 65 × 50 cm. (25⅝ × 19⅝ in.)
The Hermitage, Leningrad

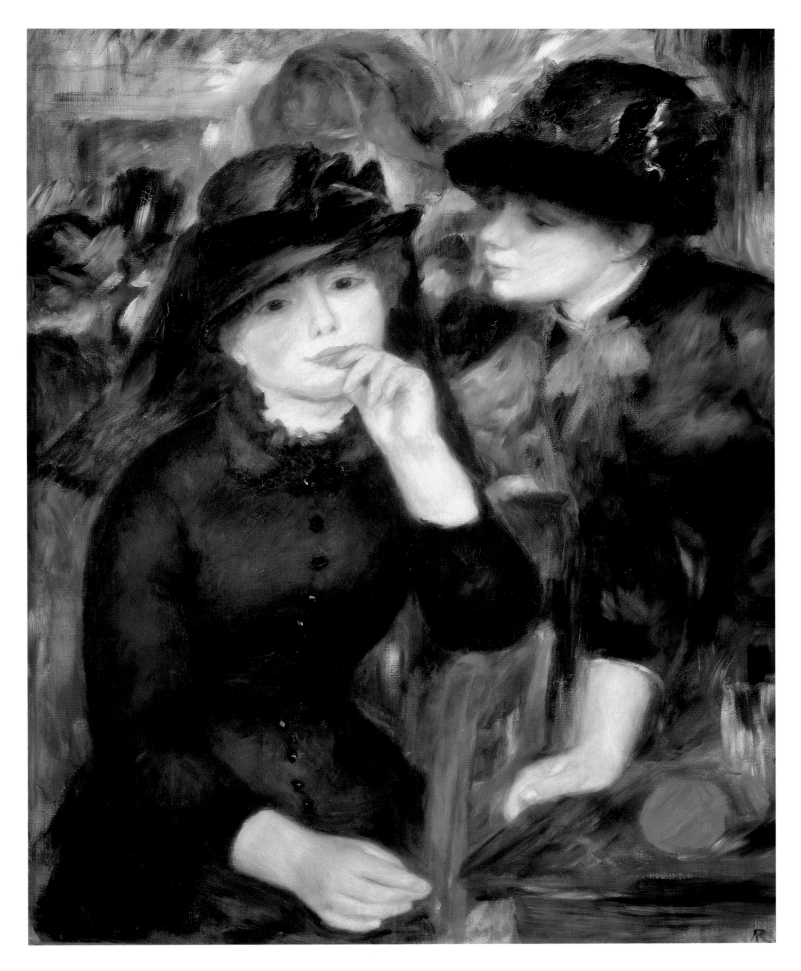

Girls in Black

c. 1880–82. Oil on canvas. 81.3 × 65.2 cm. (32 × 25⅝ in.)
The Pushkin Museum

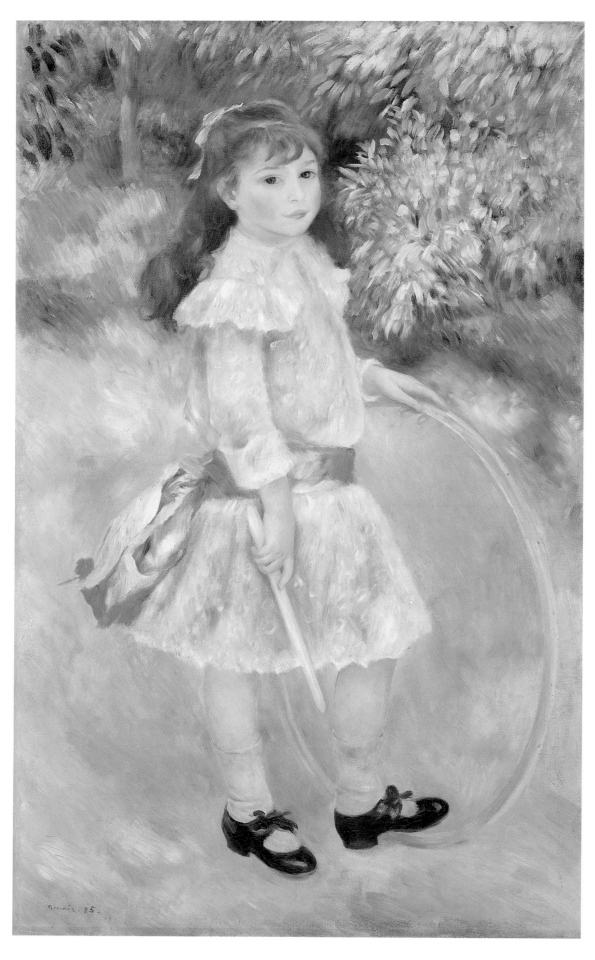

Girl with a Hoop

1885. Oil on canvas. 125.7 × 76.6 cm. (49½ × 30⅛ in.)
Chester Dale Collection, National Gallery of Art, Washington

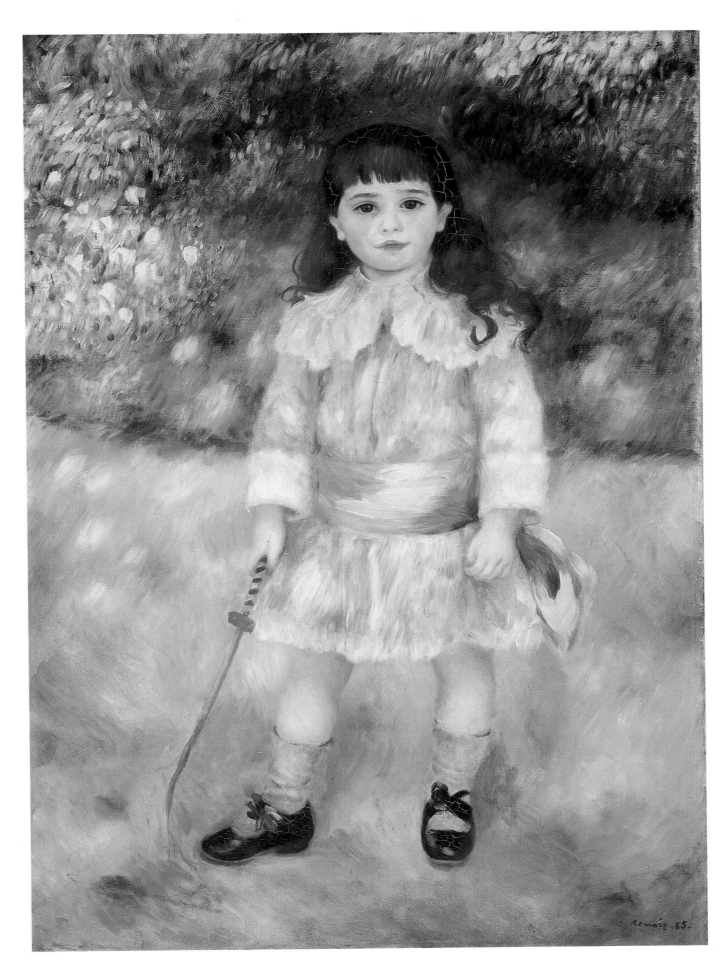

Child with a Whip

1885. Oil on canvas. 107 × 75 cm. (42⅛ × 29½ in.)
The Hermitage, Leningrad

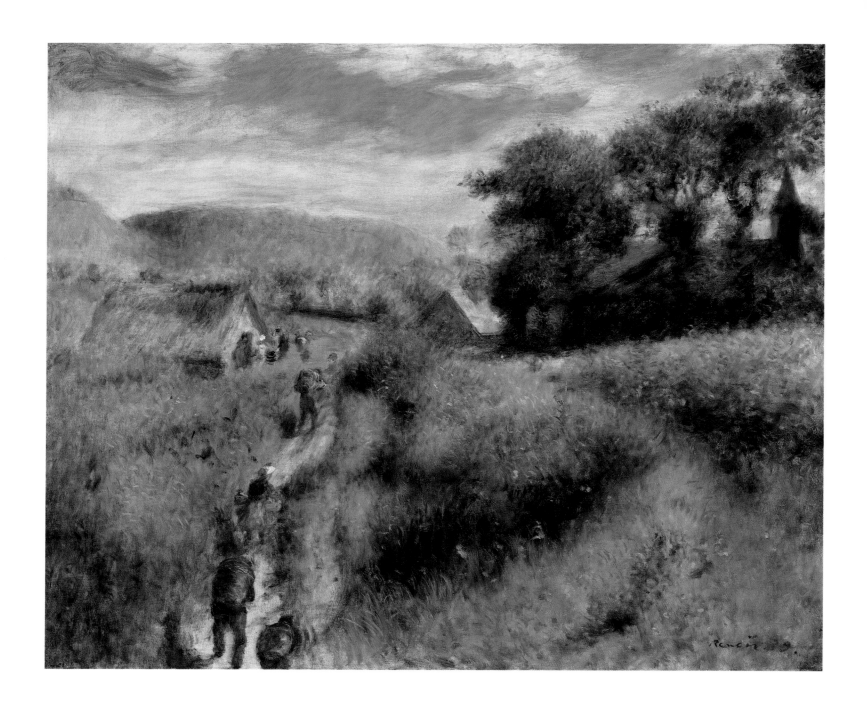

The Vintagers

1879. Oil on canvas. 54.2 × 65.4 cm. (21¼ × 25¾ in.)
Gift of Margaret Seligman Lewisohn in memory of her husband,
Sam A. Lewisohn, National Gallery of Art, Washington

OPPOSITE:

Girl with a Basket of Fish

c. 1889. Oil on canvas. 130.7 × 41.8 cm. (51½ × 16½ in.)
Gift of William Robertson Coe, National Gallery of Art, Washington

Girl with a Basket of Oranges

c. 1889. Oil on canvas. 130.7 × 42 cm. (51½ × 16½ in.)
Gift of William Robertson Coe, National Gallery of Art, Washington

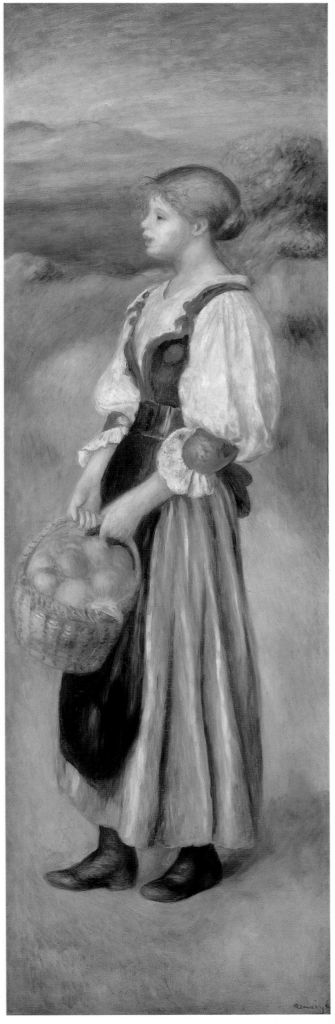

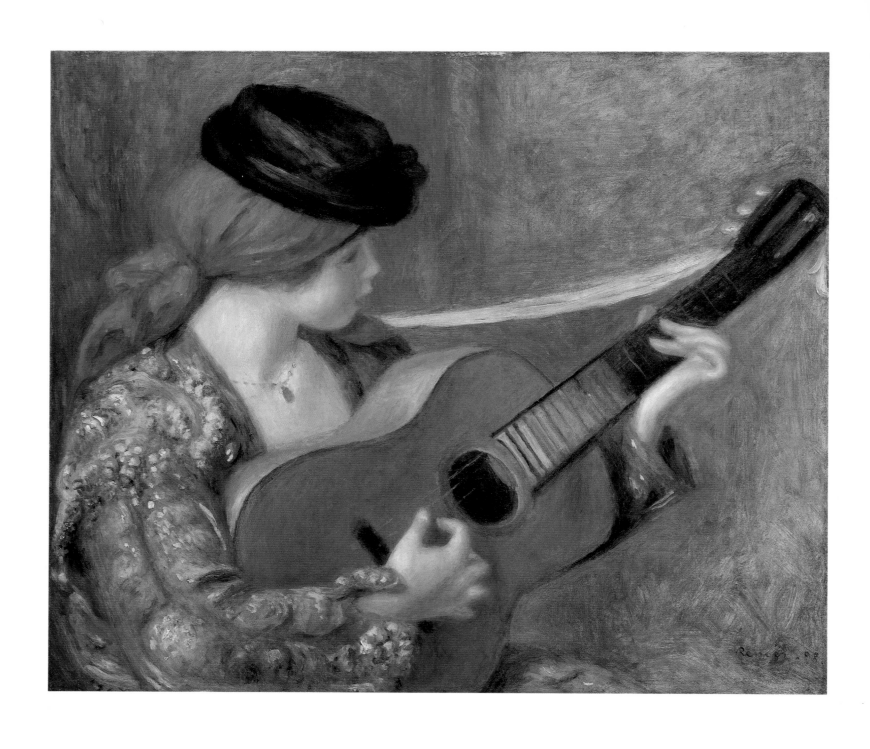

Young Spanish Woman with a Guitar

1898. Oil on canvas. 55.6 × 65.2 cm. (21⅞ × 25⅝ in.)
Ailsa Mellon Bruce Collection, National Gallery of Art, Washington

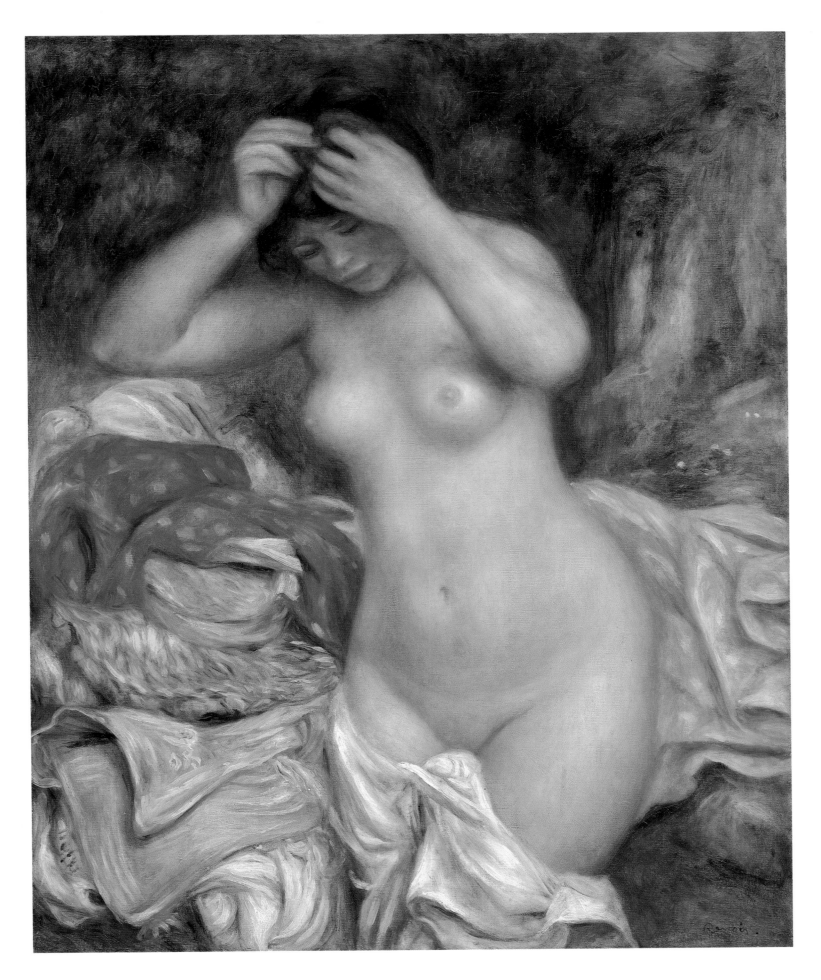

Bather Arranging Her Hair

1893. Oil on canvas. 92.2 × 73.9 cm. (36⅜ × 29⅛ in.)
Chester Dale Collection, National Gallery of Art, Washington

Peaches on a Plate

1902/05. Oil on canvas. 22.2 × 35.6 cm. (8¾ × 14 in.)
Ailsa Mellon Bruce Collection, National Gallery of Art, Washington

Maison de la Poste, Cagnes

1906/07. Oil on canvas. 13.3 × 22.5 cm. (5¼ × 8⅞ in.)
Ailsa Mellon Bruce Collection, National Gallery of Art, Washington

EDGAR DEGAS

1834–1917

EDGAR DEGAS received a sound academic training at the Ecole des Beaux-Arts under Louis Lamothe, a pupil of Ingres. As a young man, while copying the old masters in the Louvre, he met Fantin-Latour and Manet. Degas also did a lot of copying during his long sojourns in Naples between 1855 and 1859. The range of the young artist's interests was, however, certainly not limited to this; he was fascinated by Japanese prints and closely followed discoveries in the new art of photography.

At the very beginning of his artistic career, he painted portraits—the most significant of which is *Portrait of the Bellelli Family* (1860)—and several history pictures, including *Spartan Girls and Boys Exercising* (1860), *Jephthah's Daughter* (1861), and the *Misfortunes of the City of Orléans,* the last of which he sent to the 1865 Salon under the title *Scènes de guerre au moyen-âge.*

In the mid-1860s, Degas joined up with the future Impressionists, participated in their famous soirées at the Café Guerbois, and gave himself un-reservedly to purely contemporary themes. He displayed his *Steeplechase Scene* at the Salon of 1866 and his first ballet scene, *Mademoiselle Fiocre in "La Source,"* at the Salon of 1868. From then on, the artist turned more and more often for his subject matter to the daily lives of dancers, opera musicians, and jockeys, developing a novel kind of composition based on angles of view unusual at that time.

From the 1870s onwards, Degas painted in pastels more than in any other medium. In the 1880s, he produced large pastel cycles of *Milliners, Laundresses,* and *Nudes at Their Toilette.* During this period, he took part in all the Impressionist exhibitions except the one of 1882. However, the art of Degas is closer to Post-Impressionism than to Impressionism.

Besides painting and drawing, sculpture was one of Degas' constant interests, especially towards the end of his life, when his progressively failing eyesight compelled him to give up pastel.

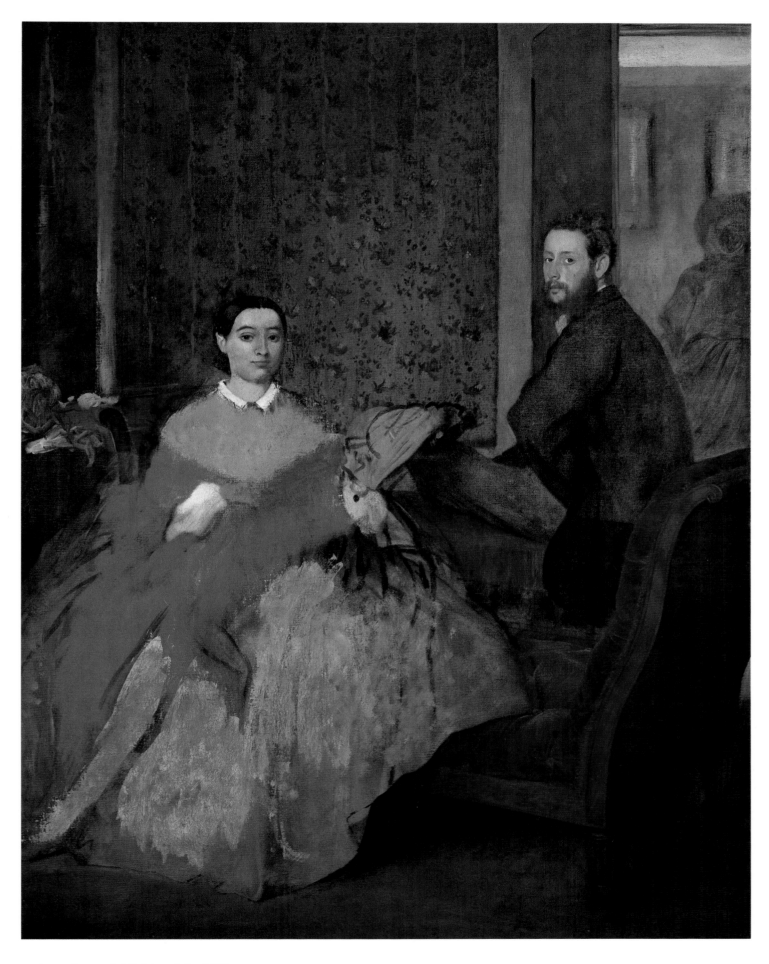

Edmondo and Thérèse Morbilli

c. 1865. Oil on canvas. 117.1 × 89.9 cm. (46⅛ × 35⅜ in.)
Chester Dale Collection, National Gallery of Art, Washington

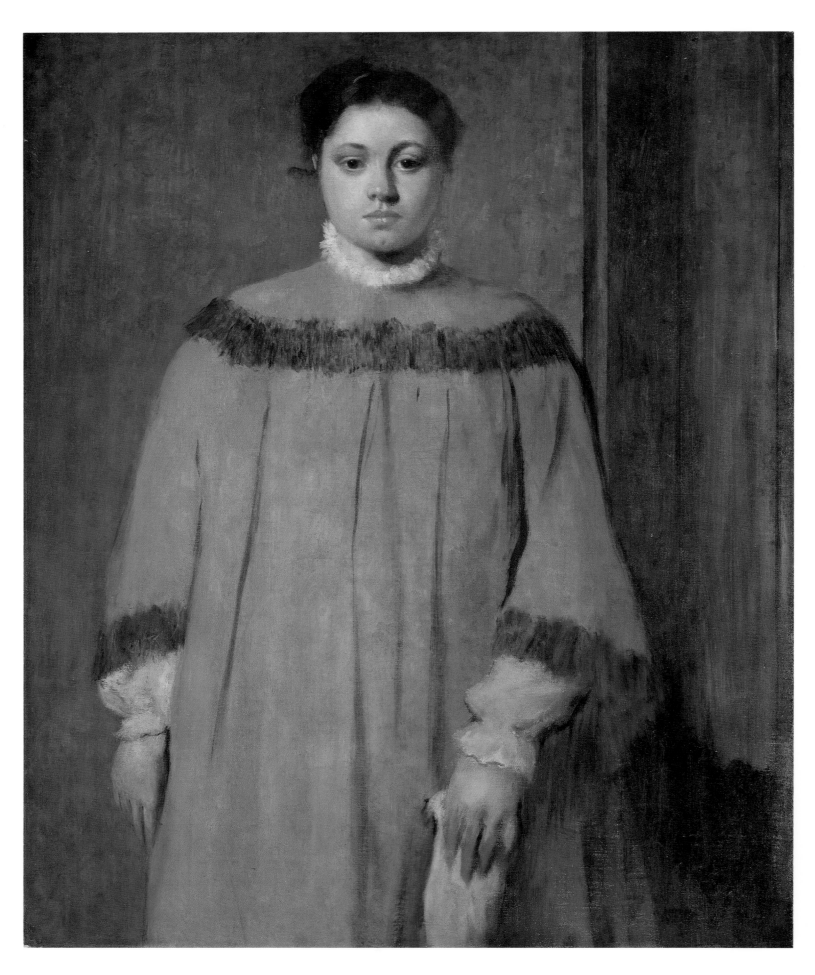

Girl in Red

c. 1866. Oil on canvas. 98.9 × 80.8 cm. (38⅞ × 31⅞ in.)
Chester Dale Collection, National Gallery of Art, Washington

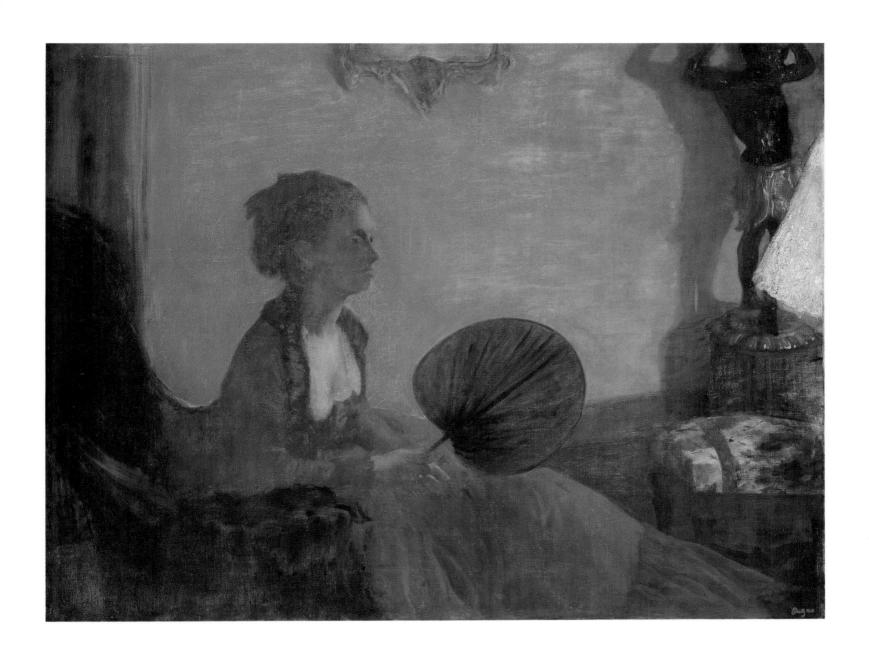

Madame Camus

1869/70. Oil on canvas. 72.7 × 92.1 cm. (28⅝ × 36¼ in.)
Chester Dale Collection, National Gallery of Art, Washington

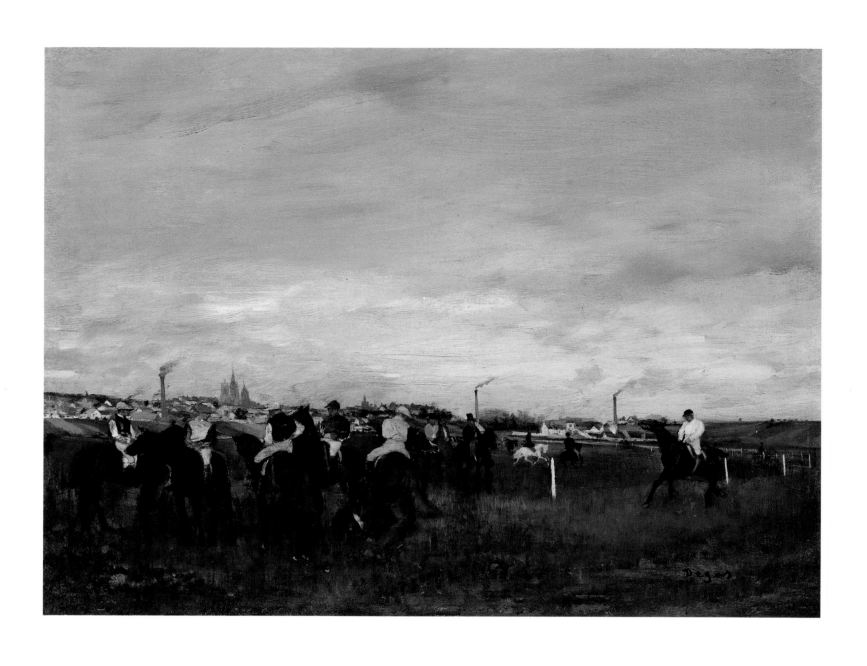

The Races

Before 1873. Oil on canvas. 26.5 × 35 cm. (10½ × 13¾ in.)
Widener Collection, National Gallery of Art, Washington

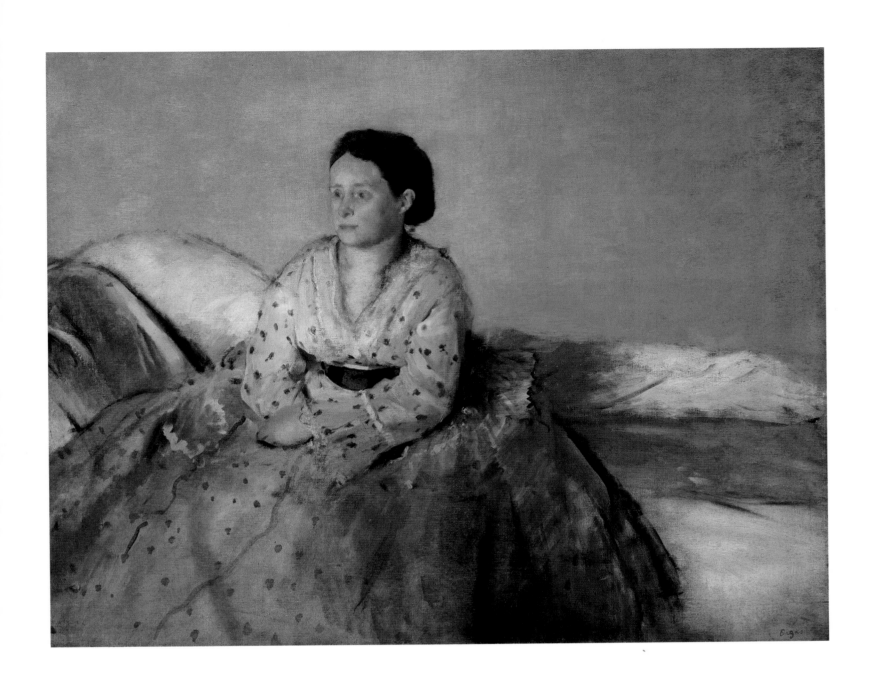

Madame René de Gas

1872/73. Oil on canvas. 72.9 × 92 cm. (28¾ × 36¼ in.)
Chester Dale Collection, National Gallery of Art, Washington

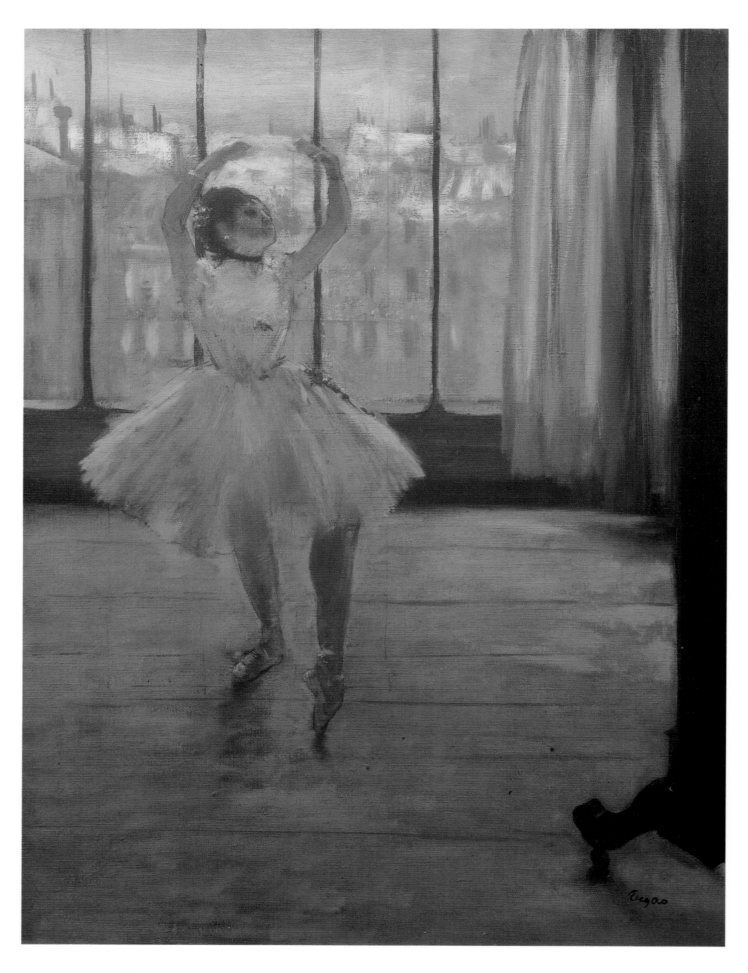

Dancer Posing for a Photographer, or *Dancer Before the Window*

c. 1874–77. Oil on canvas. 65 × 50 cm. (25⅝ × 19⅝ in.)
The Pushkin Museum, Moscow

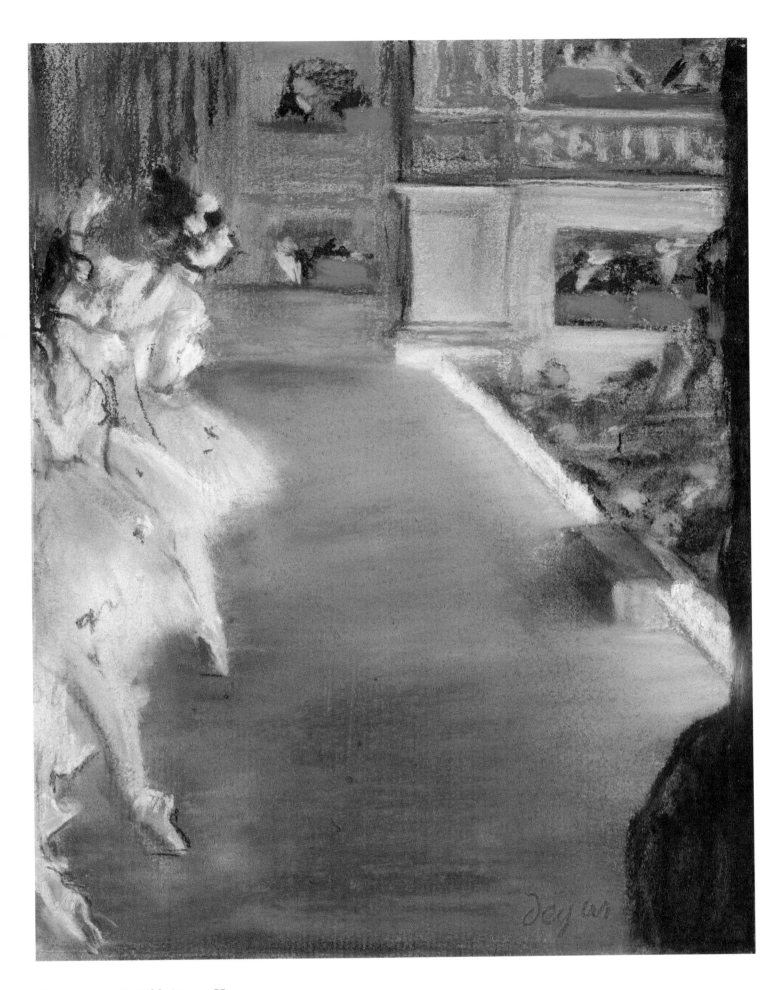

Dancers at the Old Opera House

c. 1877. Pastel. 21.8 × 17.1 cm. (8⅝ × 6¾ in.)
Ailsa Mellon Bruce Collection, National Gallery of Art, Washington

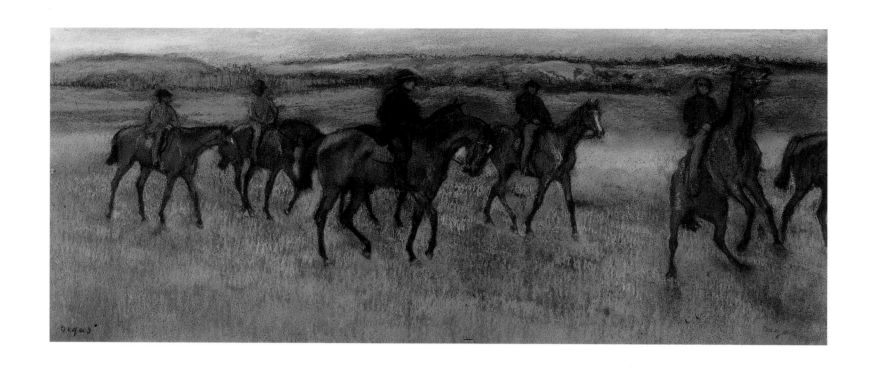

Exercising Racehorses

c. 1880. Pastel. 36 × 86 cm. (14⅛ × 33¾ in.)
The Pushkin Museum, Moscow

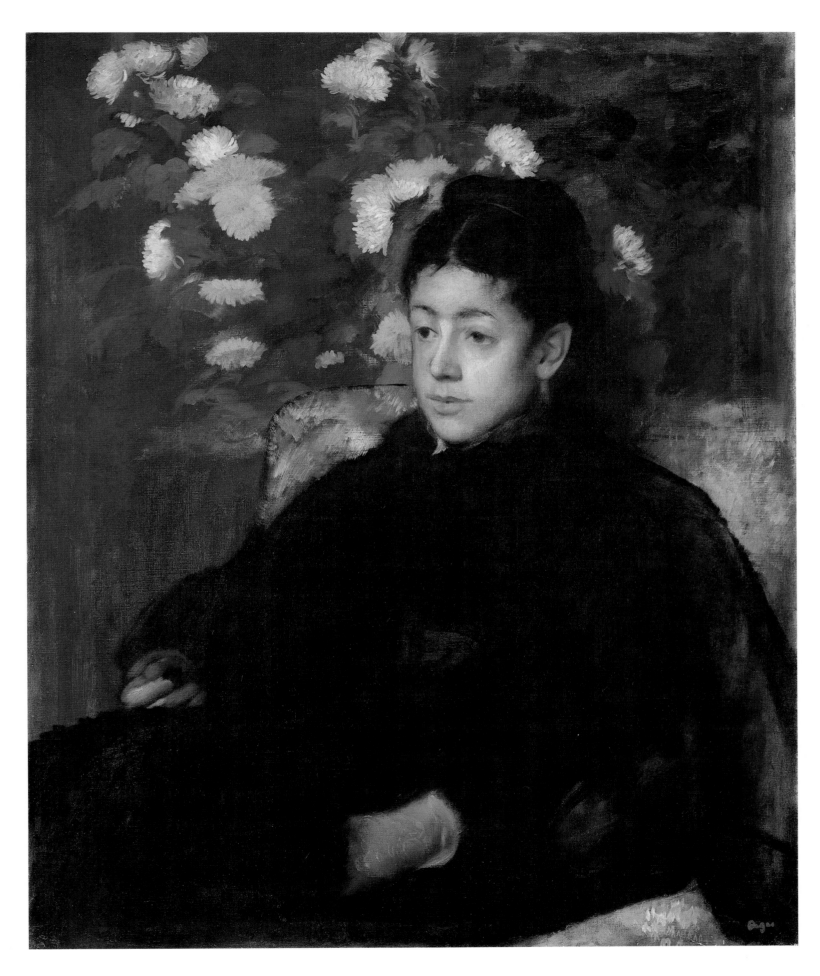

Mademoiselle Malo

c. 1877. Oil on canvas. 81.1 × 65.1 cm. (31⅞ × 25⅝ in.)
Chester Dale Collection, National Gallery of Art, Washington

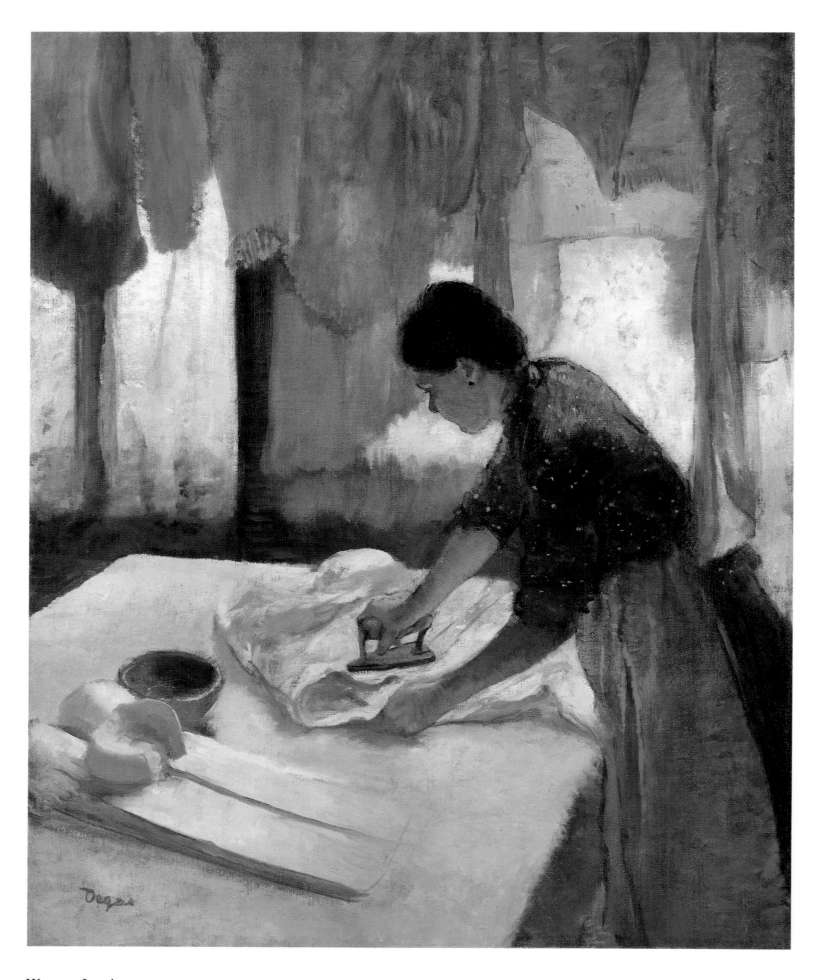

Woman Ironing

1882. Oil on canvas. 81.3 × 66 cm. (32 × 26 in.)
Collection of Mr. and Mrs. Paul Mellon, National Gallery of Art, Washington

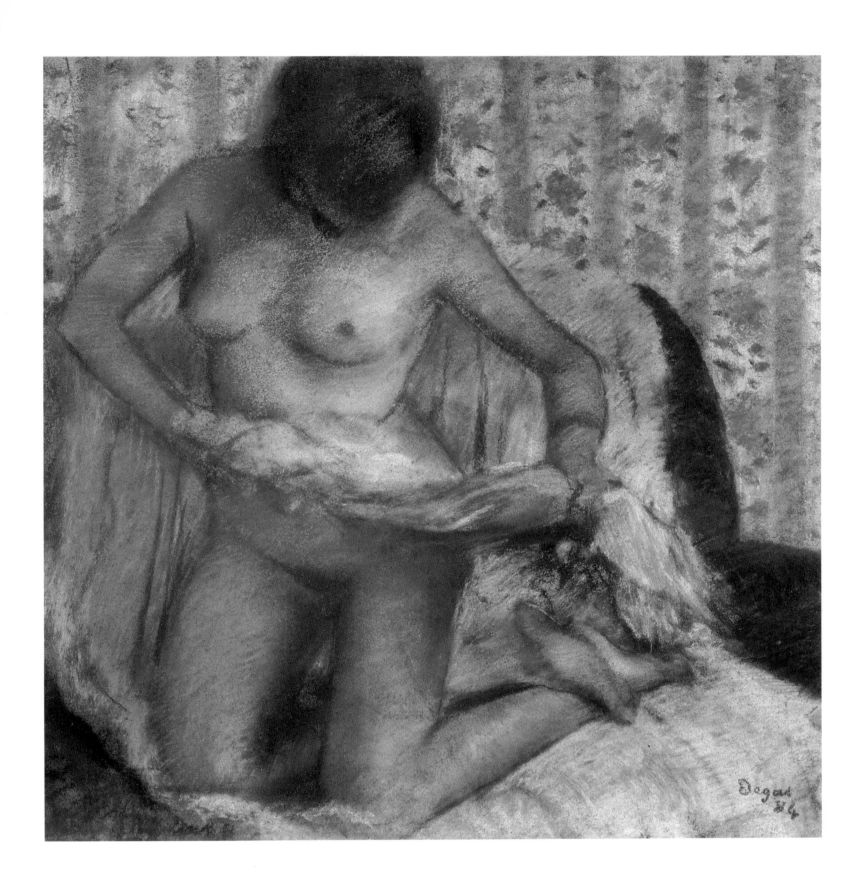

After the Bath (Woman Drying Herself)

1884. Pastel on paper mounted on cardboard. 50 × 50 cm. (19⅝ × 19⅝ in.)
The Hermitage, Leningrad

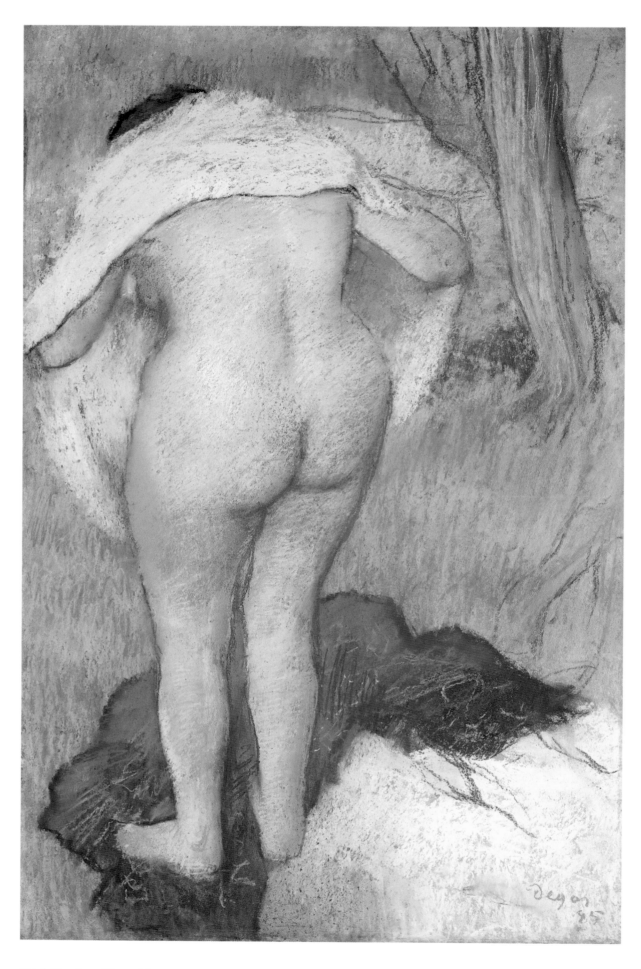

Girl Drying Herself

1885. Pastel. 80.1 × 51.2 cm. (31½ × 20⅛ in.) Gift of the W. Averell Harriman Foundation in memory of Marie N. Harriman, National Gallery of Art, Washington

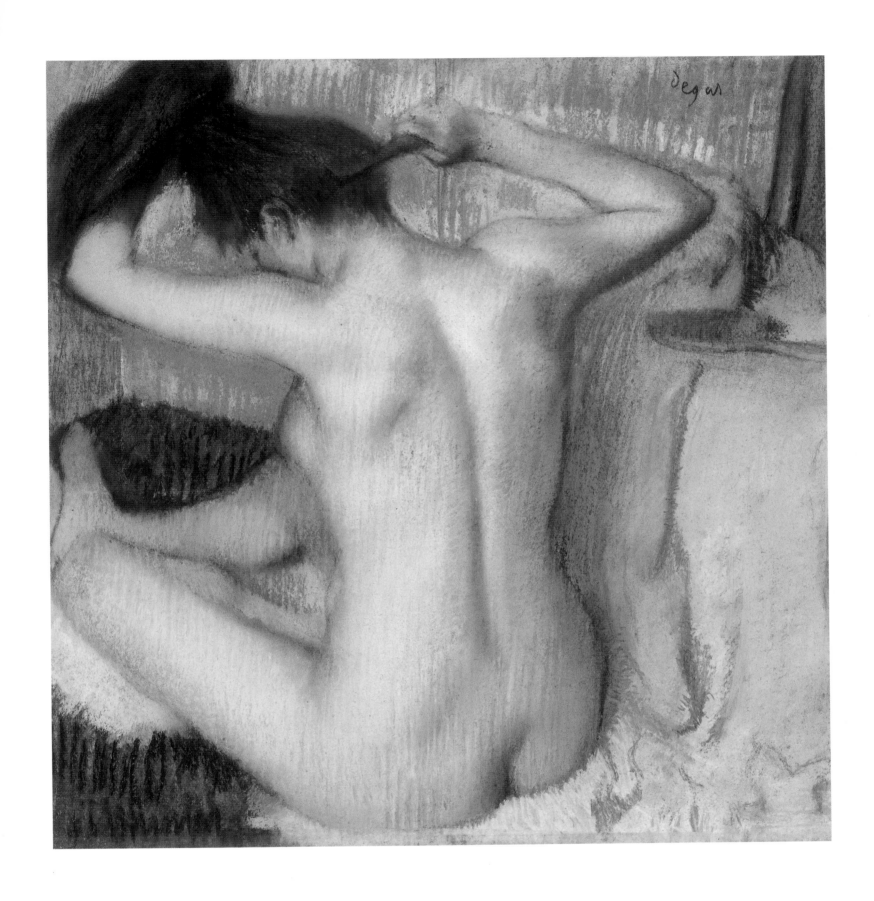

Woman Combing Her Hair

c. 1885. Pastel. 53 × 52 cm. (20¾ × 20½ in.)
The Hermitage, Leningrad

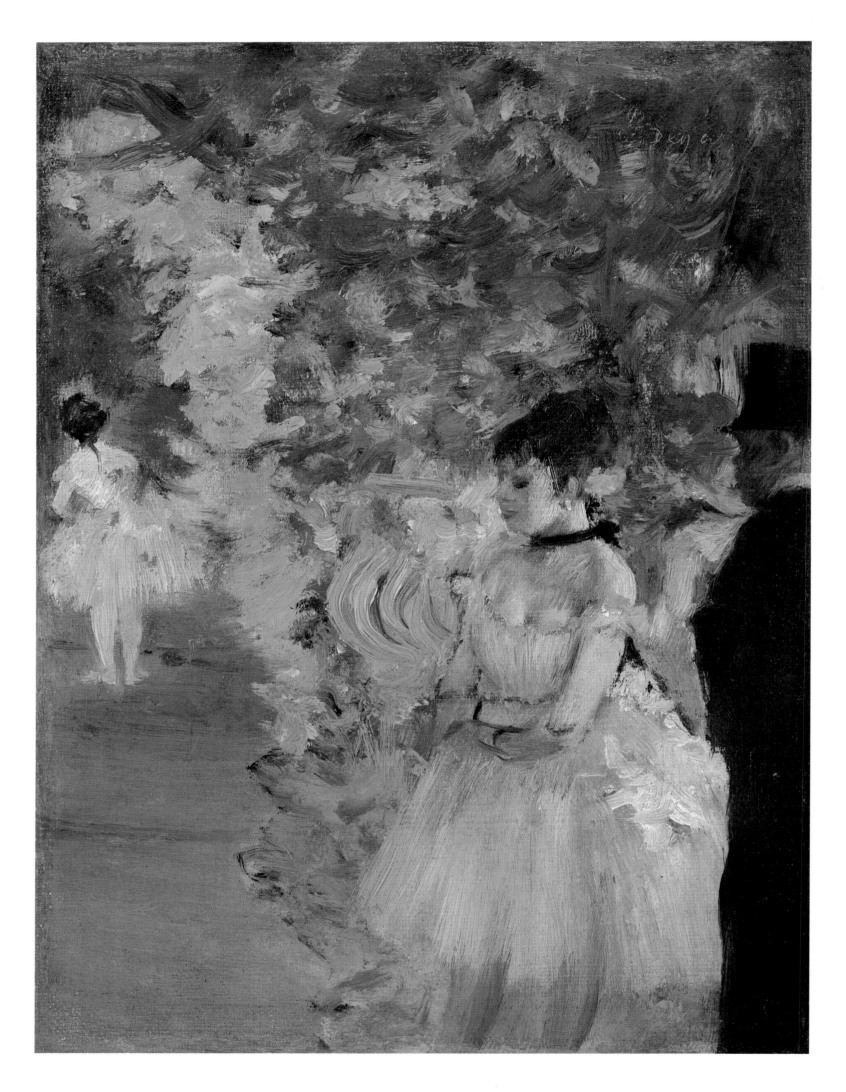

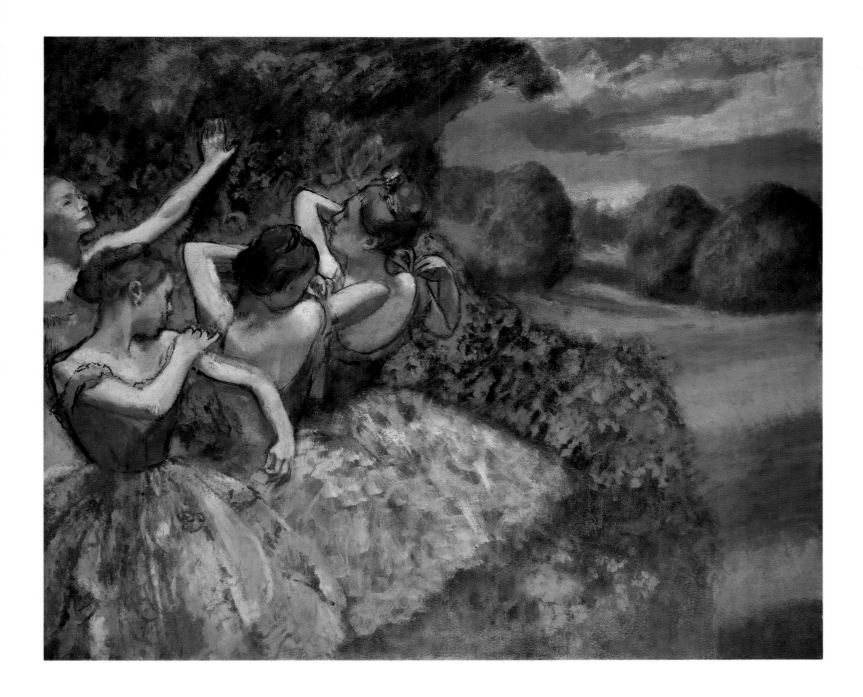

Four Dancers

c. 1899. Oil on canvas. 151.1 × 180.2 cm. (59½ × 71 in.)
Chester Dale Collection, National Gallery of Art, Washington

OPPOSITE:

Dancers Backstage

c. 1890. Oil on canvas. 24.2 × 18.8 cm. (9½ × 7⅜ in.)
Ailsa Mellon Bruce Collection, National Gallery of Art, Washington

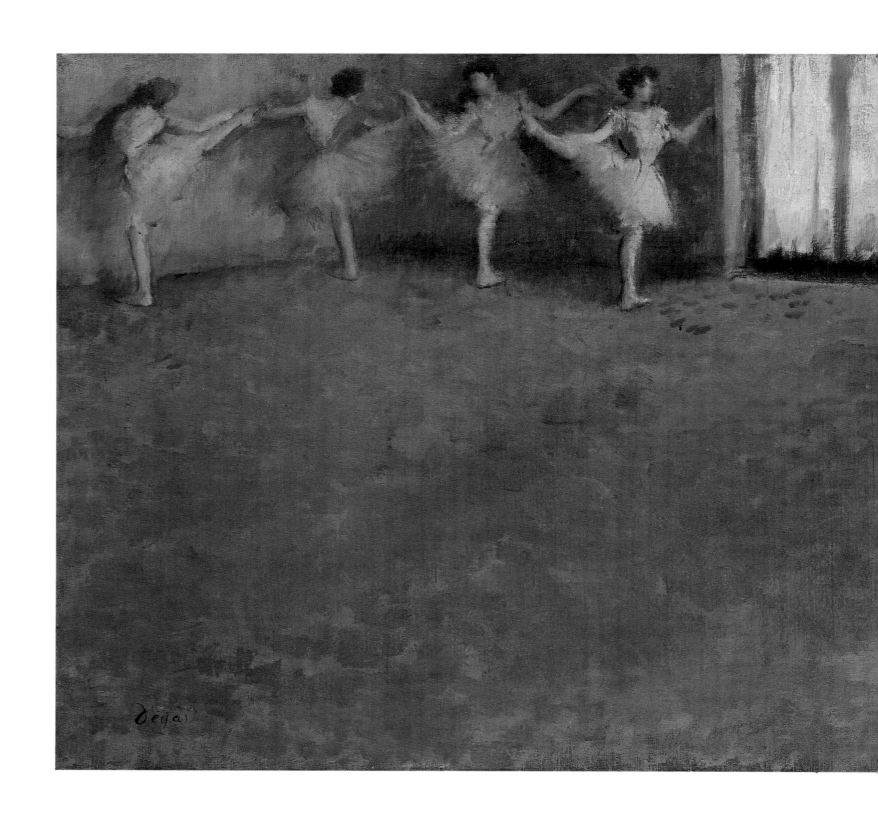

Before the Ballet

1888. Oil on canvas. 40 × 89 cm. (15¾ × 35 in.)
Widener Collection, National Gallery of Art, Washington

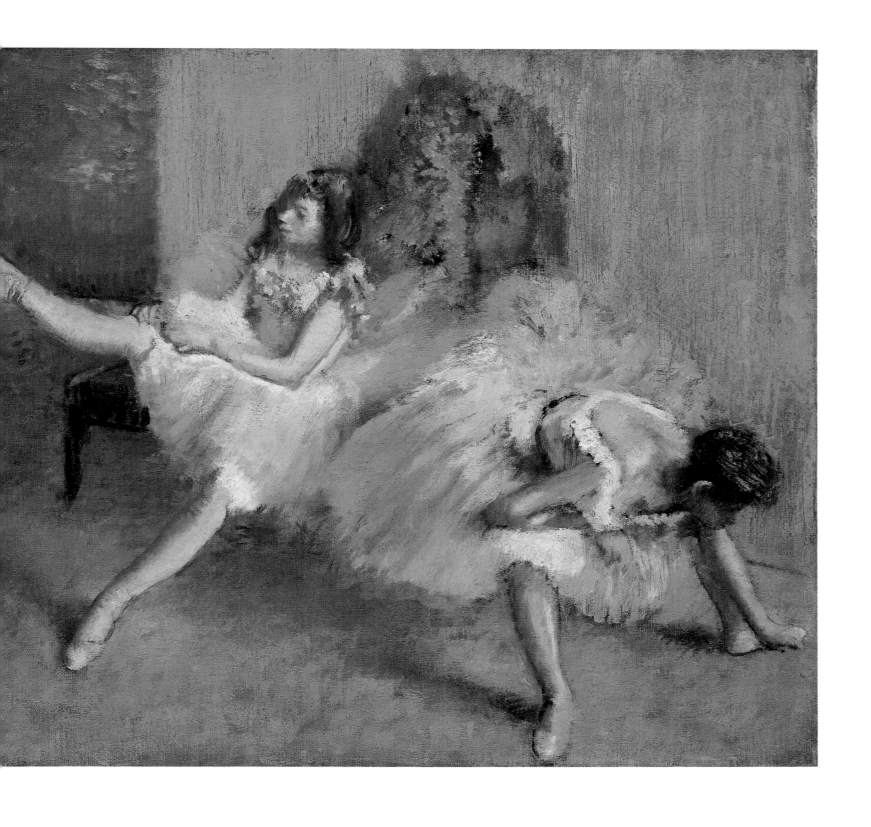

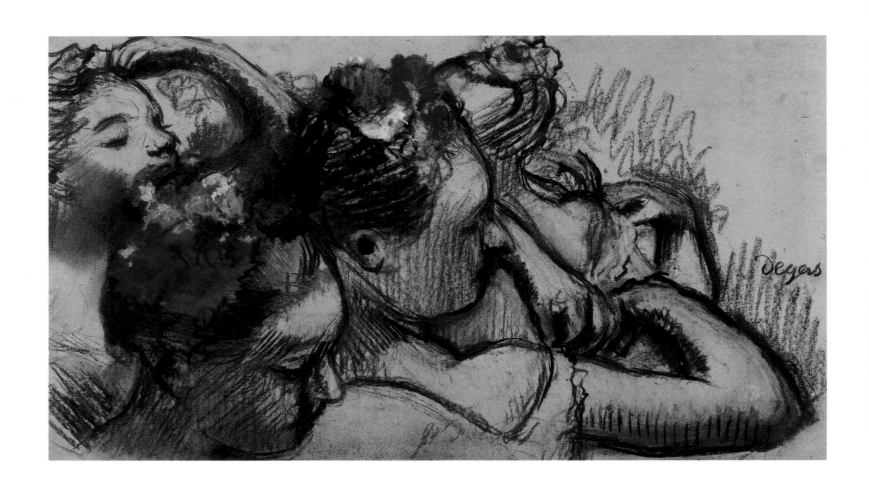

Heads of Dancers

c. 1895–1900. Pastel and charcoal on grayish-buff paper mounted on cardboard.
31 × 55 cm. (12¼ × 21⅝ in.) The Hermitage, Leningrad

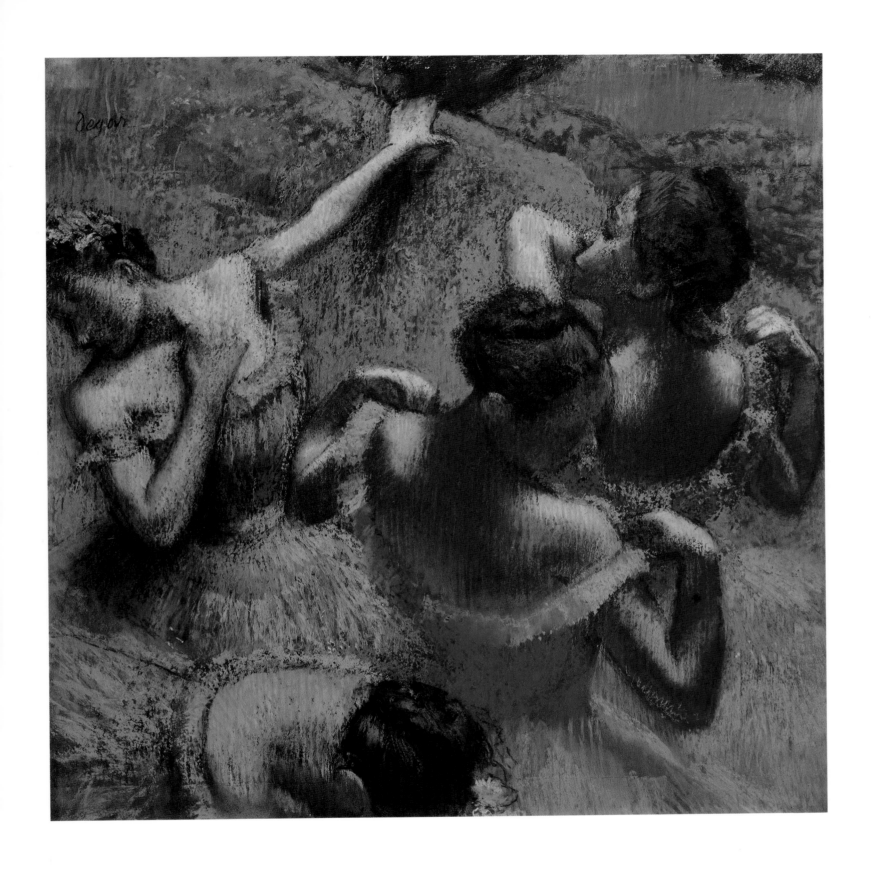

Blue Dancers

c. 1897. Pastel. 65 × 65 cm. (25⅝ × 25⅝ in.)
The Pushkin Museum, Moscow

PAUL CEZANNE
1839–1906

PAUL CÉZANNE was born into a family of Italian origin in Cesana Forinese, at the French border, on the slopes of Mongineiro. His father had established a felt hat business in Aix-en-Provence and later became a banker. In 1859, he bought a country house on the outskirts of Aix, the Jas de Bouffan, which was to be frequently represented in Cézanne's paintings.

Between 1852 and 1859, Paul Cézanne studied at the Collège Bourbon, and it was there that he formed a friendship with Emile Zola. In 1856, he began to attend the evening drawing courses of Joseph-Marc Gibert at the Aix Museum. By April 1861, his father had finally yielded to Cézanne's desire to make a career in art and allowed him to go to Paris. There Cézanne frequented the Académie Suisse, visited the Louvre, met Pissarro and Guillaumin, and, later on, Monet, Sisley, Bazille, and Renoir. In September of the same year, he was refused admission to the Ecole des Beaux-Arts and went back to Aix, to the great delight of his father, who offered him a position in the bank. But in November 1862, Cézanne gave it up and went back to Paris.

During this so-called Dark or Romantic period (1862–70), Cézanne often met with Edouard Manet and the future Impressionists and tried to be accepted at the Salon. The Franco-Prussian War drove him to L'Estaque near Marseilles. Cézanne's Impressionist period (1873–79) is connected with his staying at Pontoise and Auvers-sur-Oise in 1872, 1873, 1874, 1877, and 1881. He worked with Pissarro and exhibited with the Impressionists in 1874 and 1877. The canvases produced at L'Estaque (1880–83) and at Gardanne (1885–88) are usually referred to as Cézanne's Constructive period.

In 1887, after a long break, he participated in the Exhibition of the Société des XX at Brussels. Towards the beginning of Cézanne's Synthetic period (1890–1906), the younger generation of artists started to take an interest in him. His first one-man show was held in the Vollard Gallery in 1895. During these years the artist seldom visited Paris—the longest sojourns there took place in 1895, 1899, and 1904—and produced many versions of canvases depicting Mount Sainte-Victoire, smokers, card-players, bathers, still lifes, and other portraits. By 1901, Cézanne had become recognized. He met with the Nabis—Denis, Bonnard, and Vuillard. In 1901, Denis painted *Hommage à Cézanne*. The future Fauvist Charles Camoin sought his advice, and in 1904 he was visited by Emile Bernard, an artist of the Pont-Aven school, with whom Cézanne corresponded extensively, stating his views on art.

In the Salon d'Automne of 1904, an entire room was reserved for Cézanne's paintings, and a year after his death, in 1907, a retrospective exhibition of his works was held there.

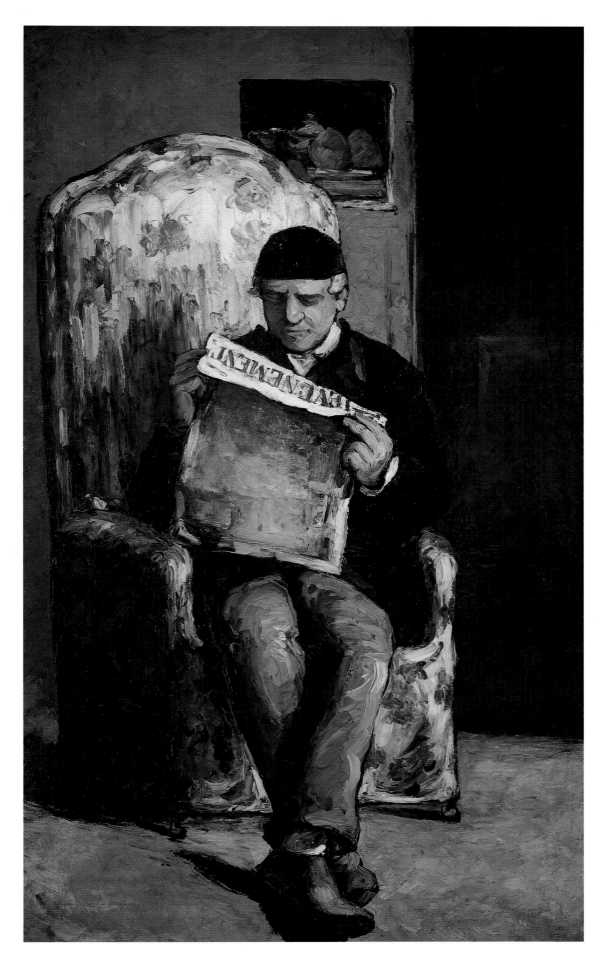

The Artist's Father

1866. Oil on canvas. 198.5 × 119.3 cm. (78⅛ × 47 in.)
Collection of Mr. and Mrs. Paul Mellon, National Gallery of Art, Washington

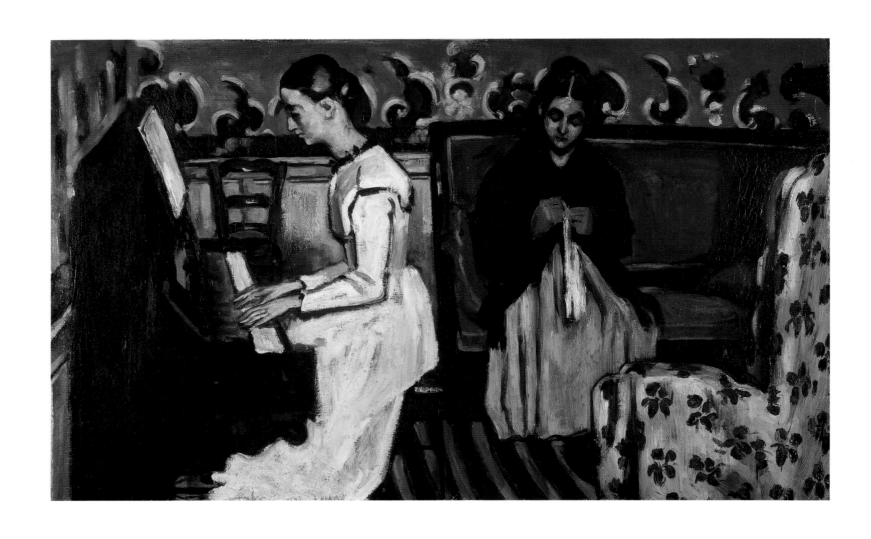

Girl at the Piano (Overture to Tannhäuser)

c. 1867–68. Oil on canvas. 57 × 92 cm. (22 × 36¼ in.)
The Hermitage, Leningrad

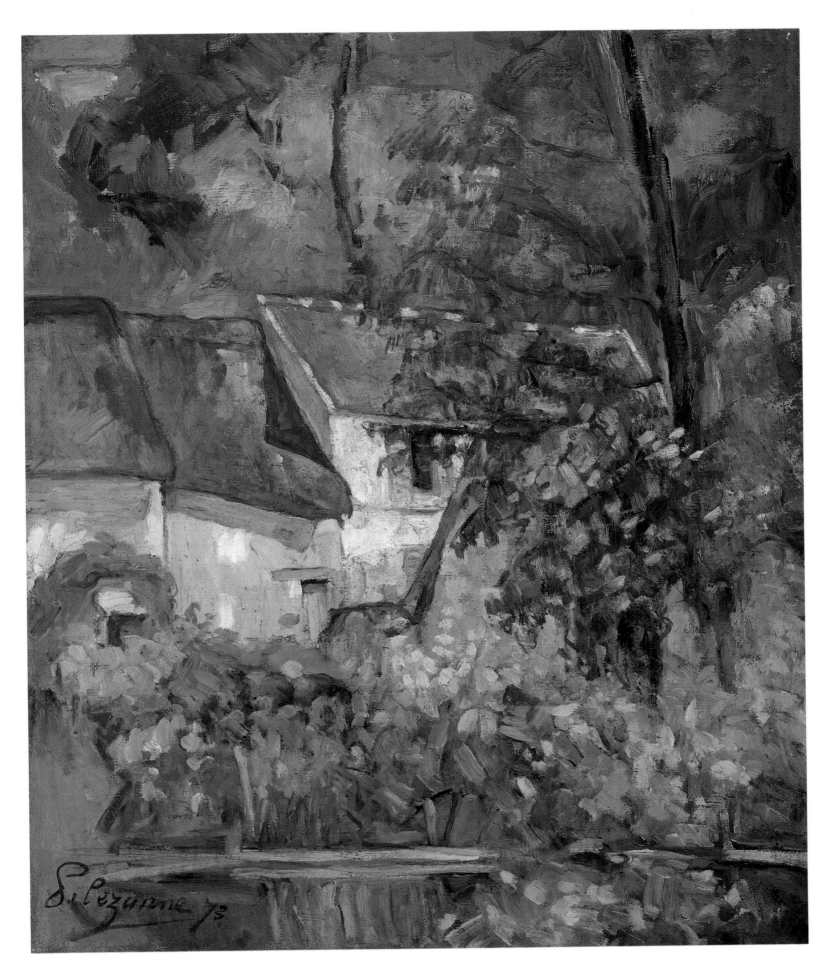

House of Père Lacroix

1873. Oil on canvas. 61.3 × 50.6 cm. (24⅛ × 20 in.)
Chester Dale Collection, National Gallery of Art, Washington

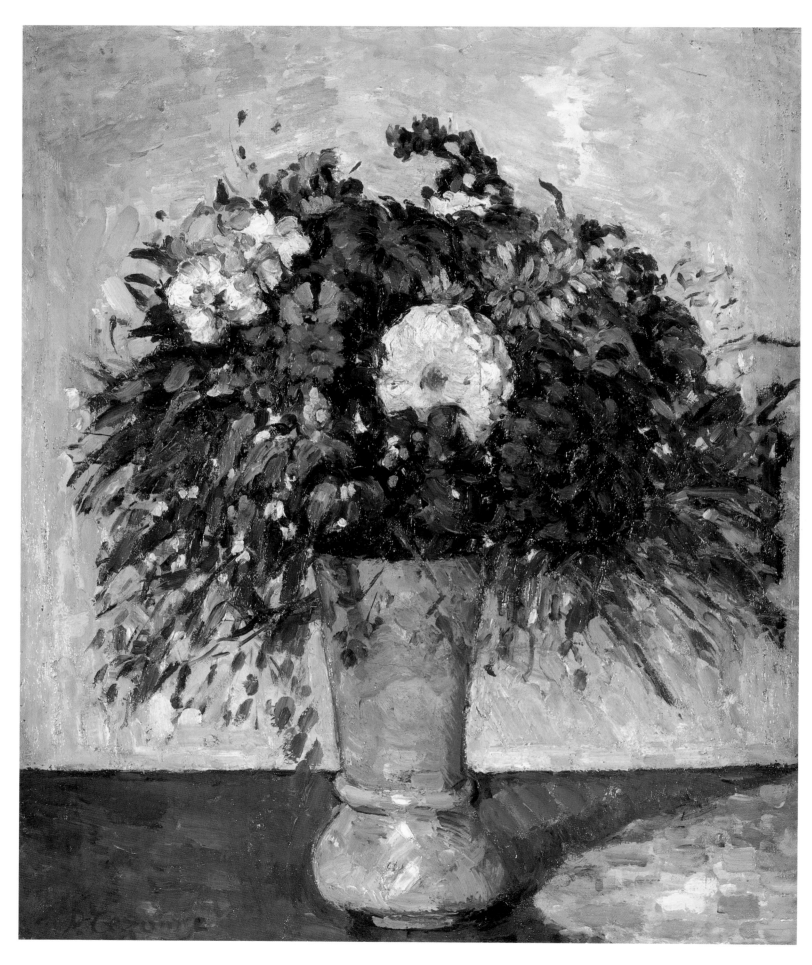

Flowers in a Blue Vase

c. 1873–75. Oil on canvas. 56 × 46 cm. (21¼ × 18⅛ in.)
The Hermitage, Leningrad

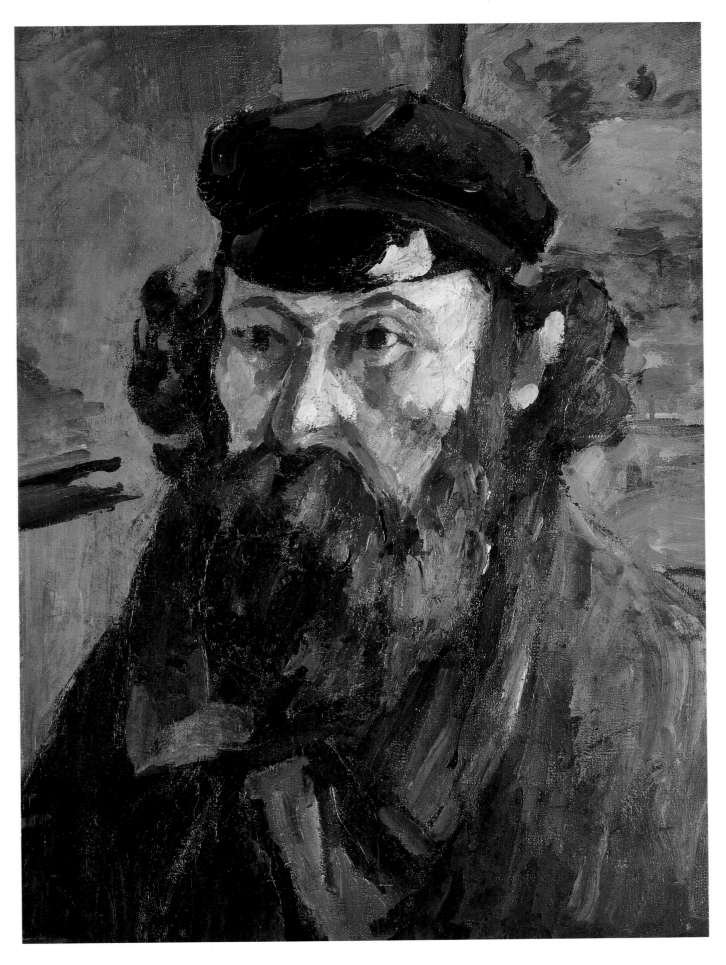

Self-Portrait with a Cap

c. 1873–75. Oil on canvas. 53 × 38 cm. (20¾ × 15 in.)
The Hermitage, Leningrad

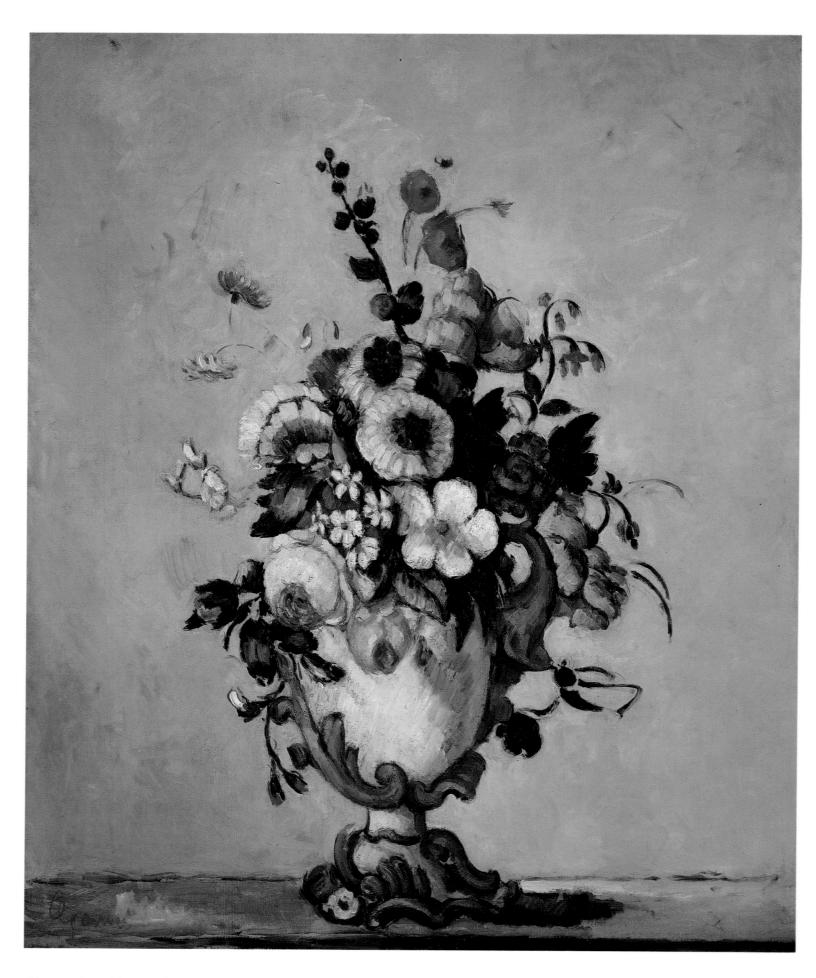

Flowers in a Rococo Vase

c. 1876. Oil on canvas. 73 × 59.8 cm. (28¾ × 23½ in.)
Chester Dale Collection, National Gallery of Art, Washington

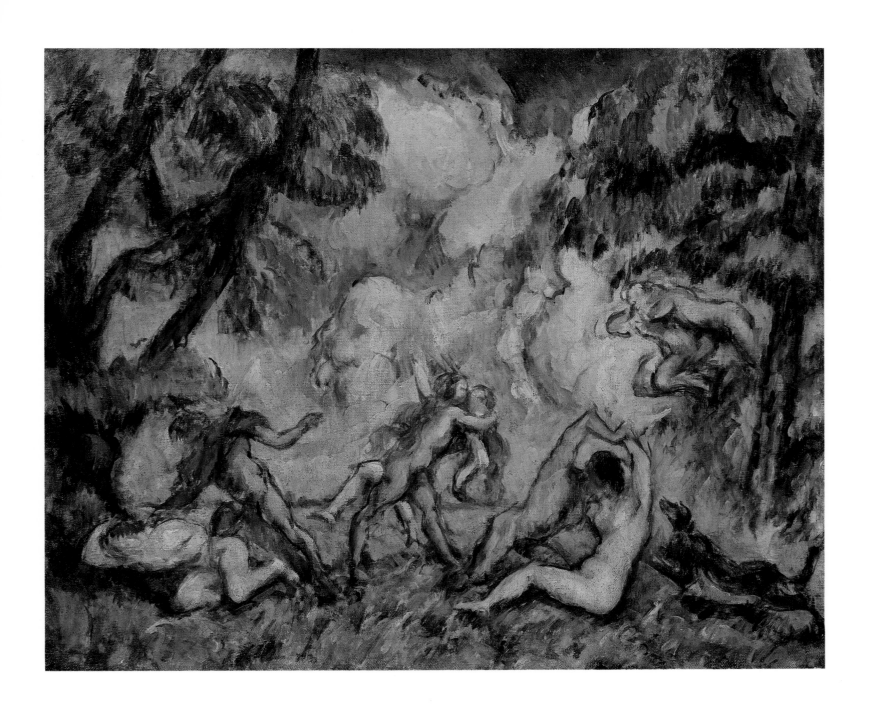

The Battle of Love

c. 1880. Oil on canvas. 37.8 × 46.2 cm. (14⅞ × 18¼ in.)
Gift of the W. Averell Harriman Foundation in memory of Marie N. Harriman,
National Gallery of Art, Washington

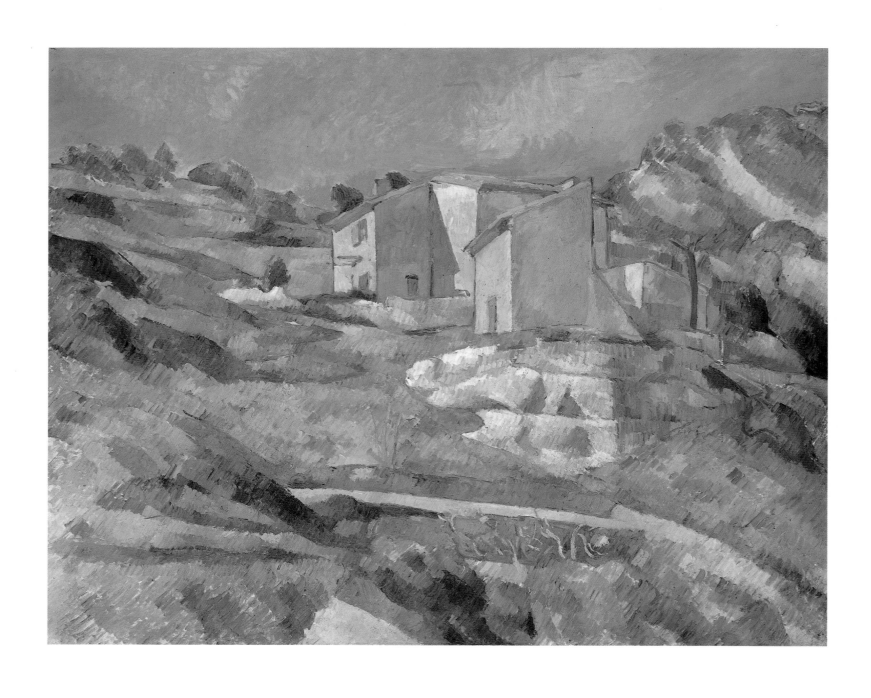

Houses in Provence

c. 1880. Oil on canvas. 65 × 81.3 cm. (25⅝ × 32 in.)
Collection of Mr. and Mrs. Paul Mellon, National Gallery of Art, Washington

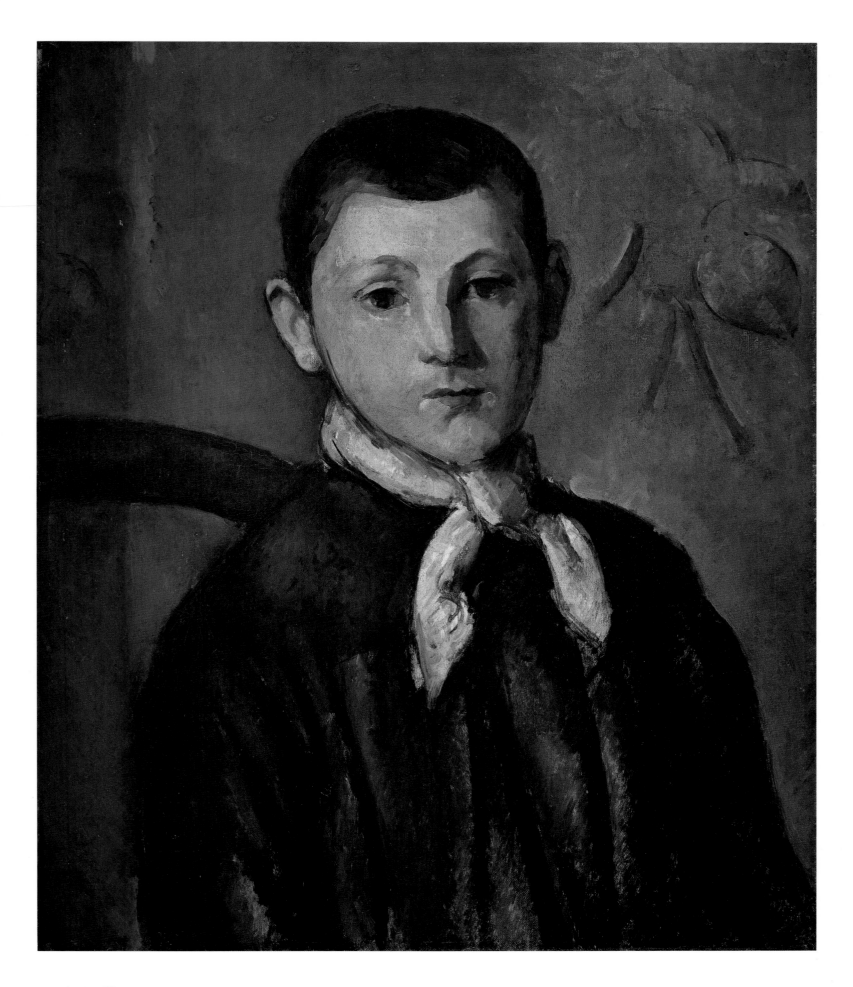

Louis Guillaume

c. 1882. Oil on canvas. 55.9 × 46.7 cm. (22 × 18⅜ in.)
Chester Dale Collection, National Gallery of Art, Washington

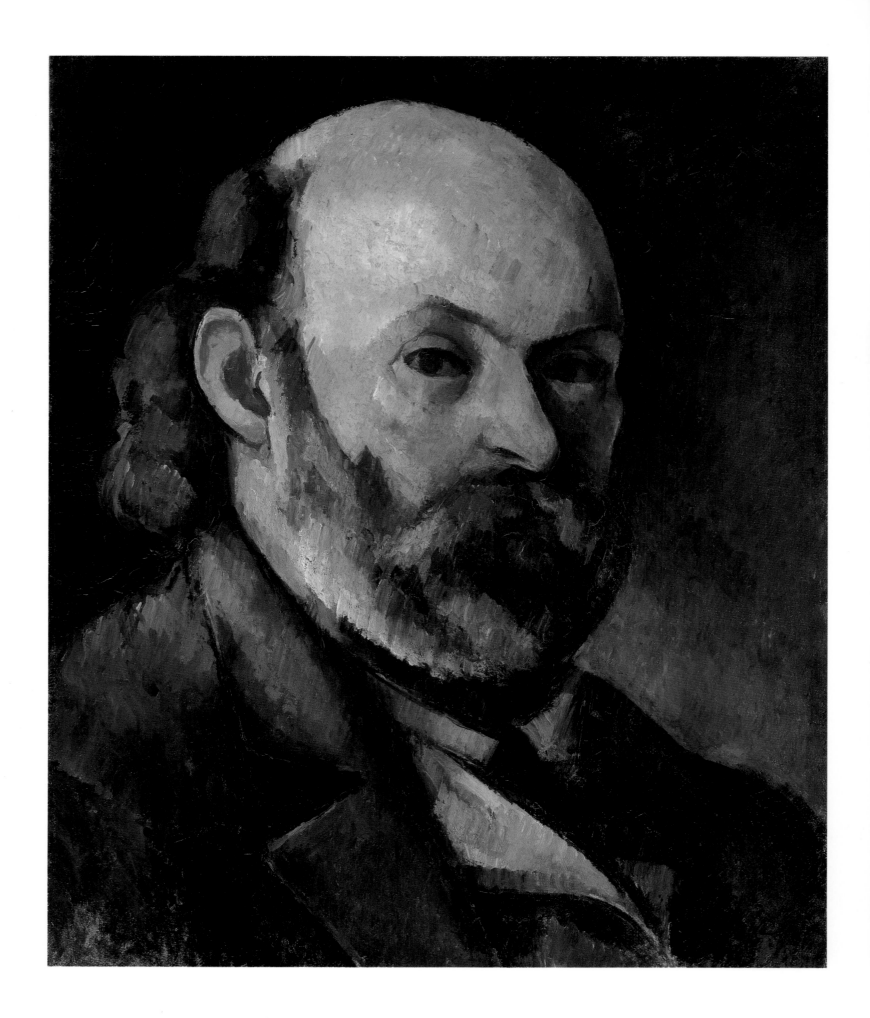

Self-Portrait

c. 1882–85. Oil on canvas. 45 × 37 cm. (17¾ × 14½ in.)
The Pushkin Museum, Moscow

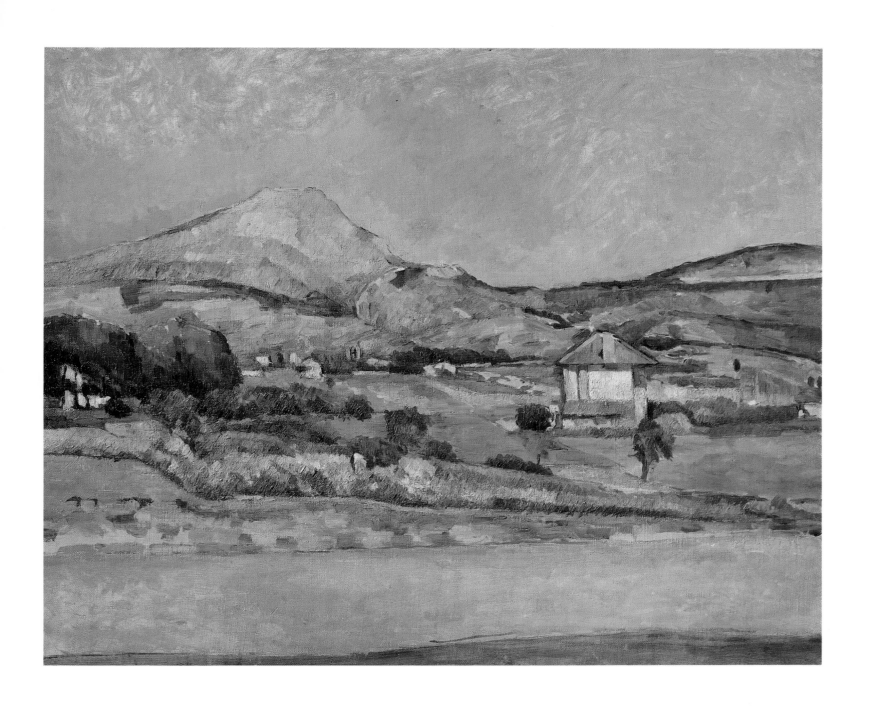

Plain by Mont Sainte-Victoire

c. 1882–85. Oil on canvas. 58 × 72 cm. (22¾ × 28⅜ in.)
The Pushkin Museum, Moscow

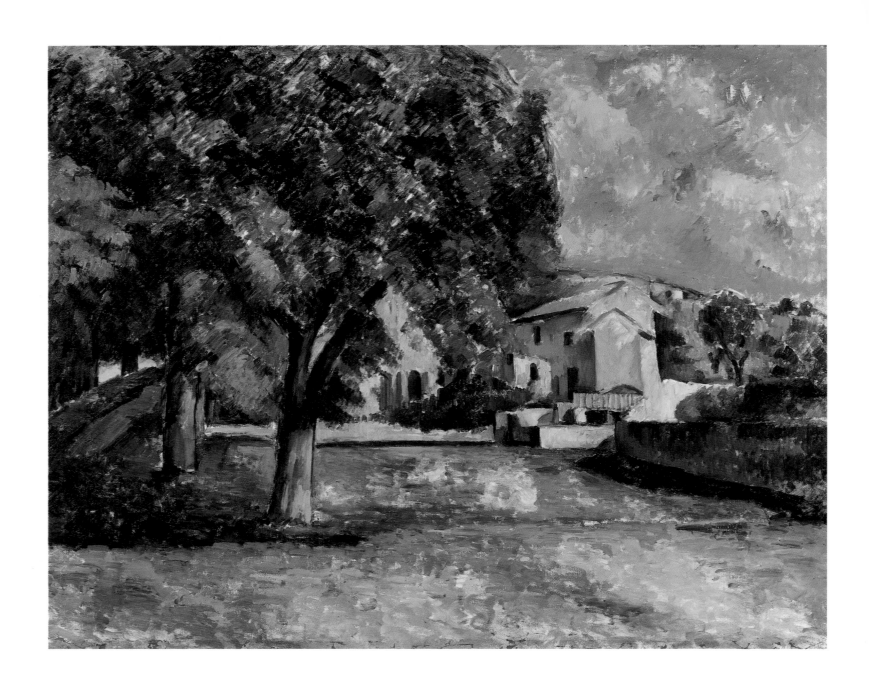

Trees in a Park (Le Jas de Bouffan)

c. 1885. Oil on canvas. 72 × 91 cm. (28⅜ × 36 in.)
The Pushkin Museum, Moscow

OPPOSITE:

The Aqueduct

c. 1885–87. Oil on canvas. 91 × 72 cm. (36 × 28⅜ in.)
The Pushkin Museum, Moscow

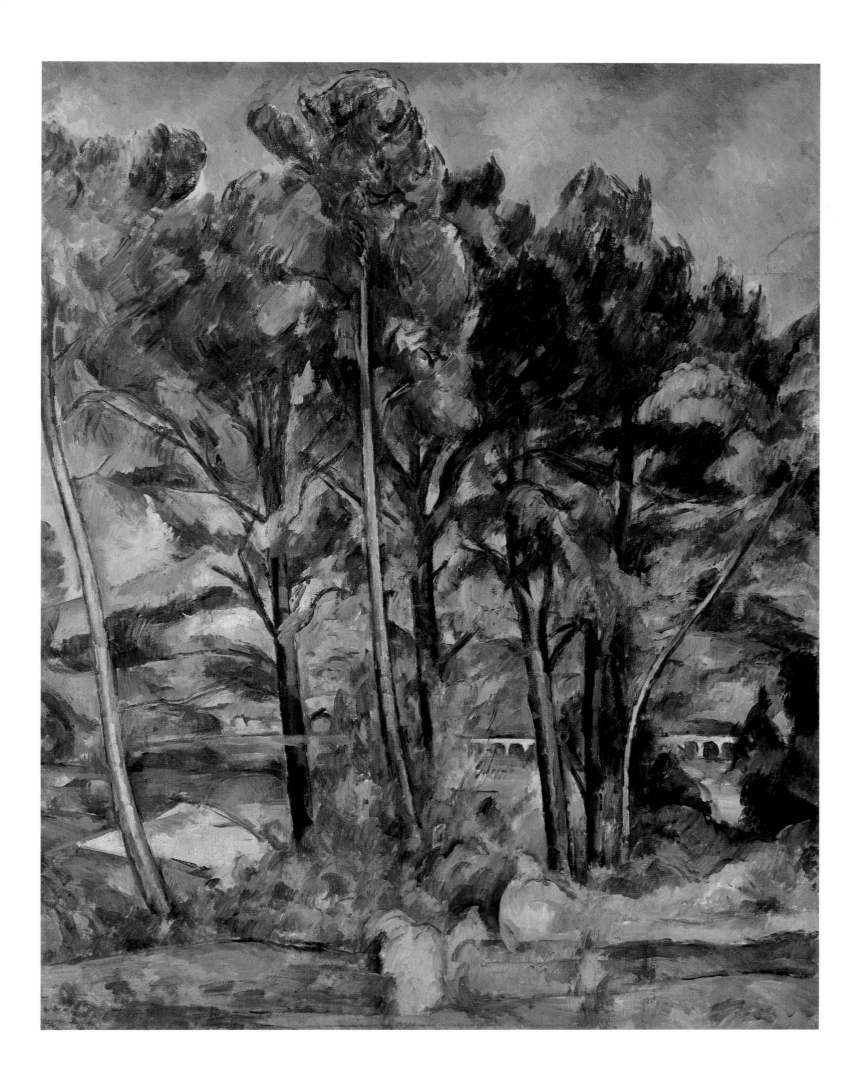

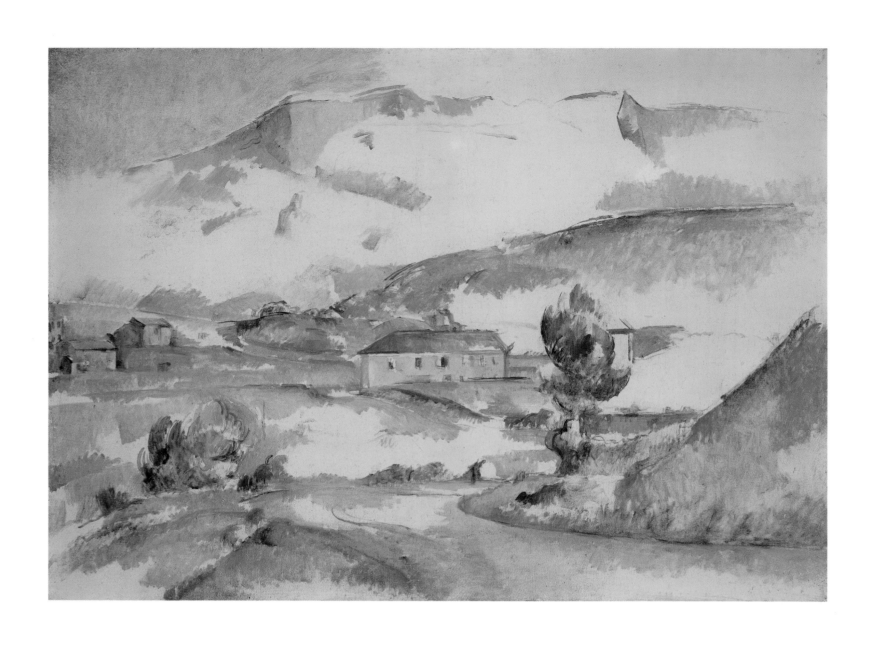

Mont Sainte-Victoire

c. 1887. Oil on canvas. 67.2 × 91.3 cm. (26½ × 36 in.)
Gift of the W. Averell Harriman Foundation in memory of Marie N. Harriman,
National Gallery of Art, Washington

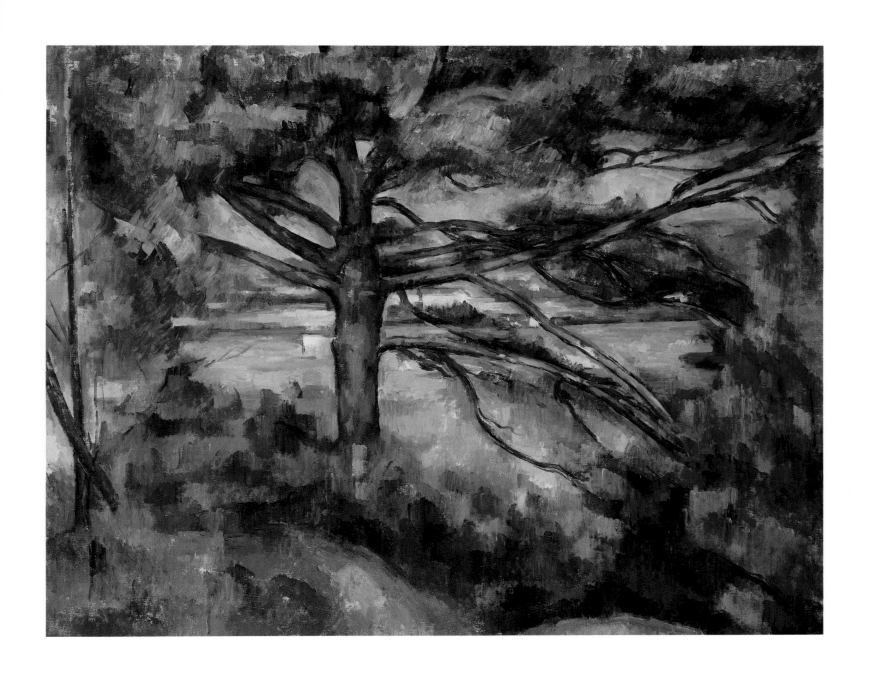

Great Pine near Aix

c. 1885–87. Oil on canvas. 72 × 91 cm. (28⅜ × 36 in.)
The Hermitage, Leningrad

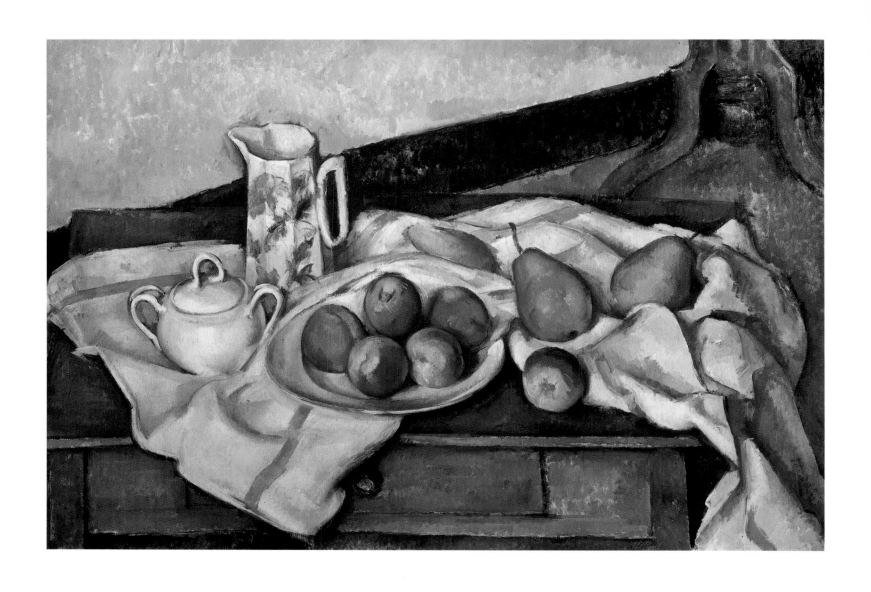

Still Life with Peaches and Pears

c. 1888–90. Oil on canvas. 61 × 90 cm. (24 × 35½ in.)
The Pushkin Museum, Moscow

OPPOSITE:

Pierrot and Harlequin

c. 1888. Oil on canvas. 102 × 81 cm. (40 × 31⅞ in.)
The Pushkin Museum, Moscow

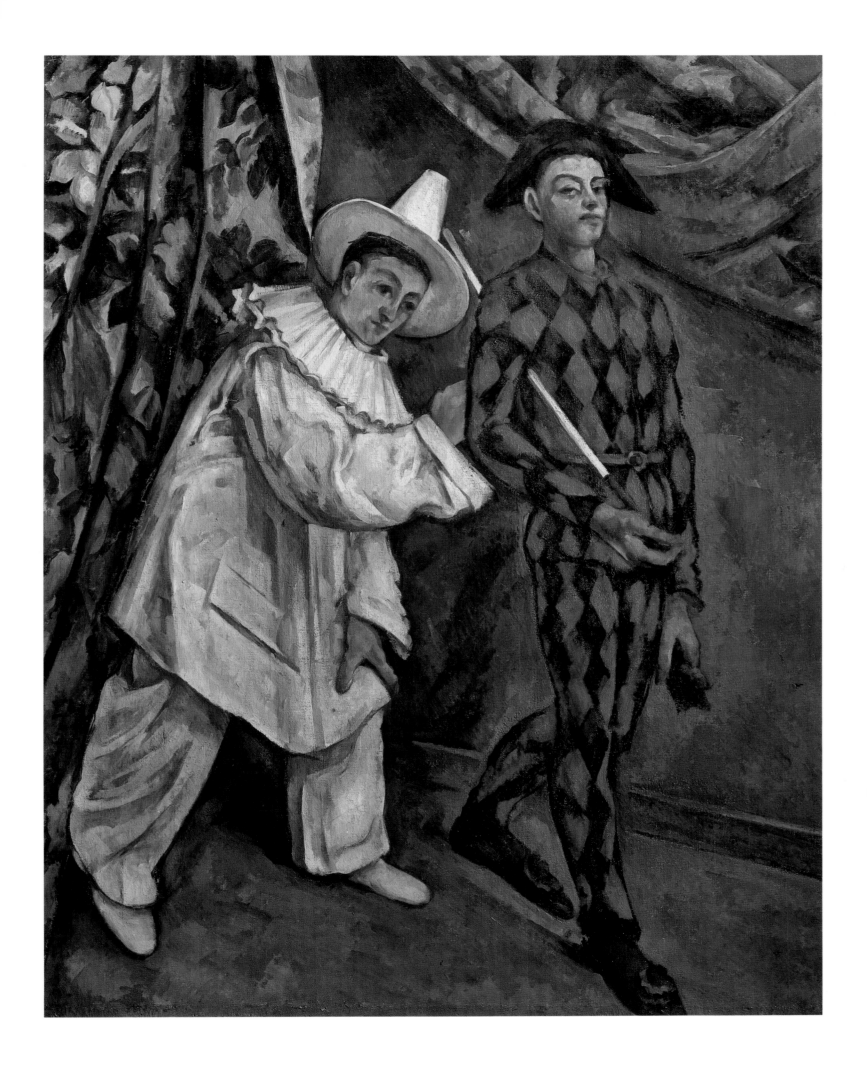

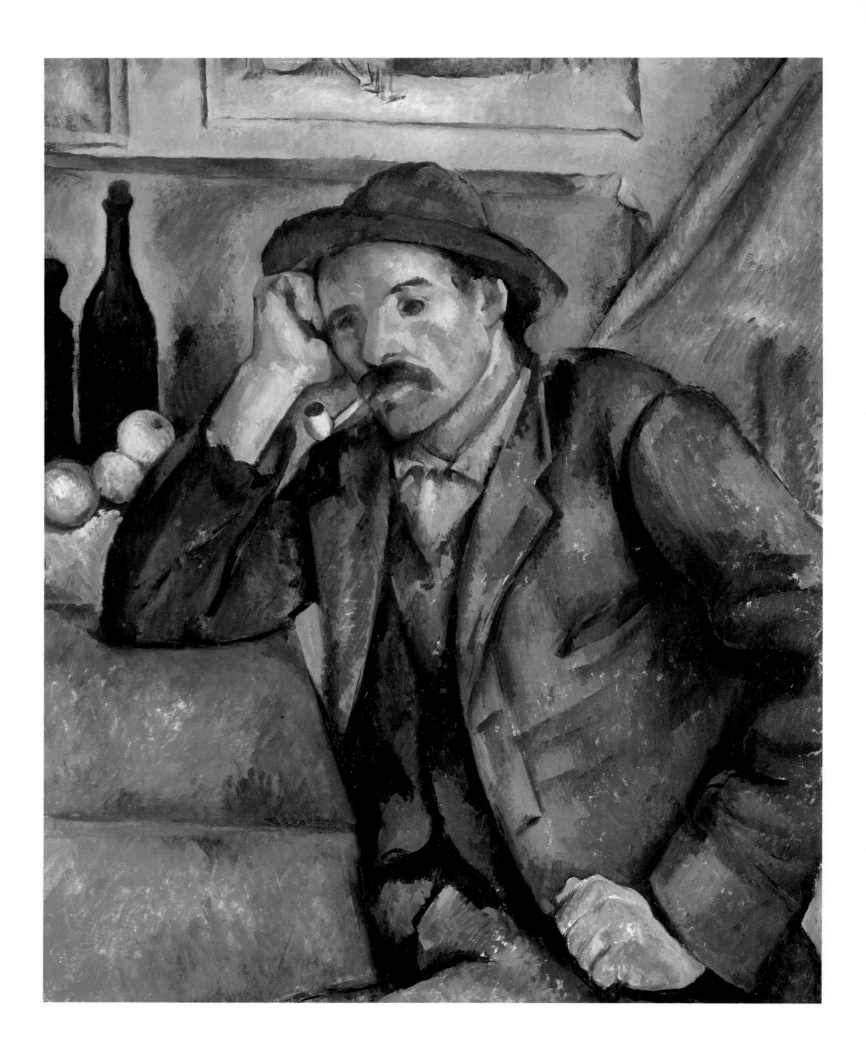

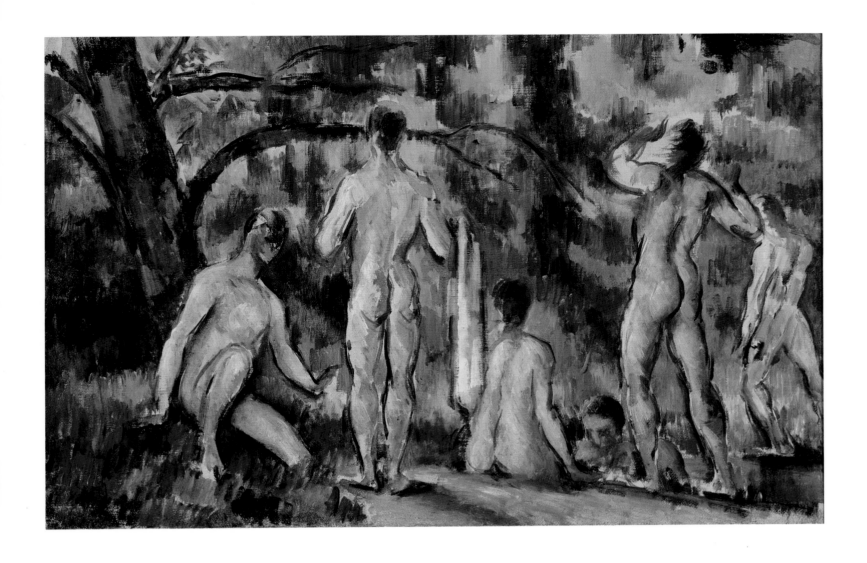

Bathers. Study

c. 1889–90. Oil on canvas. 26 × 40 cm. (10¼ × 15¾ in.)
The Pushkin Museum, Moscow

OPPOSITE:

The Smoker

1890s. Oil on canvas. 91 × 72 cm. (36 × 28⅜ in.)
The Hermitage, Leningrad

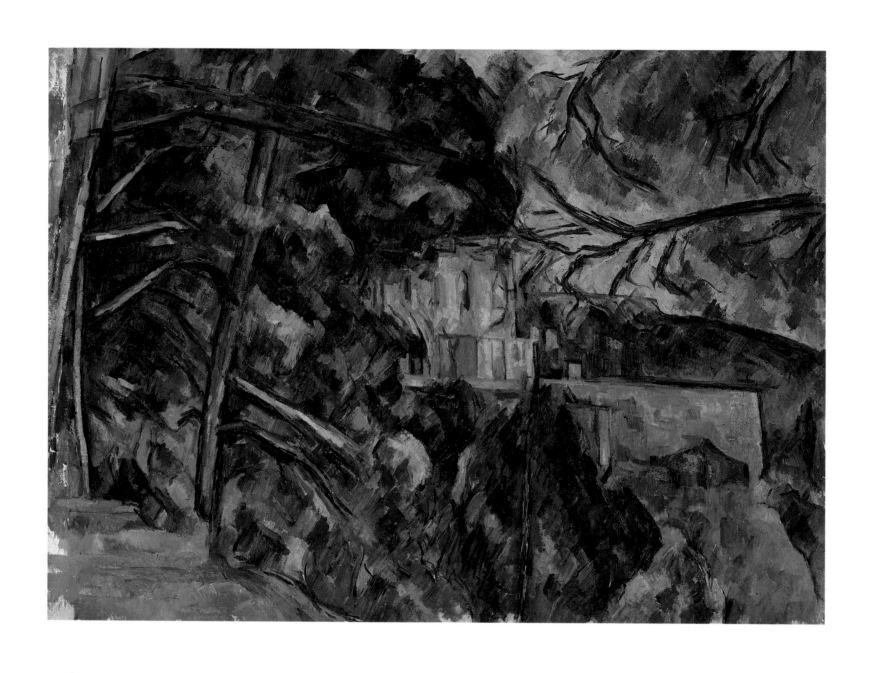

Le Château Noir

1900/04. Oil on canvas. 73.7 × 96.6 cm. (29 × 38 in.)
Gift of Eugene and Agnes Meyer, National Gallery of Art, Washington

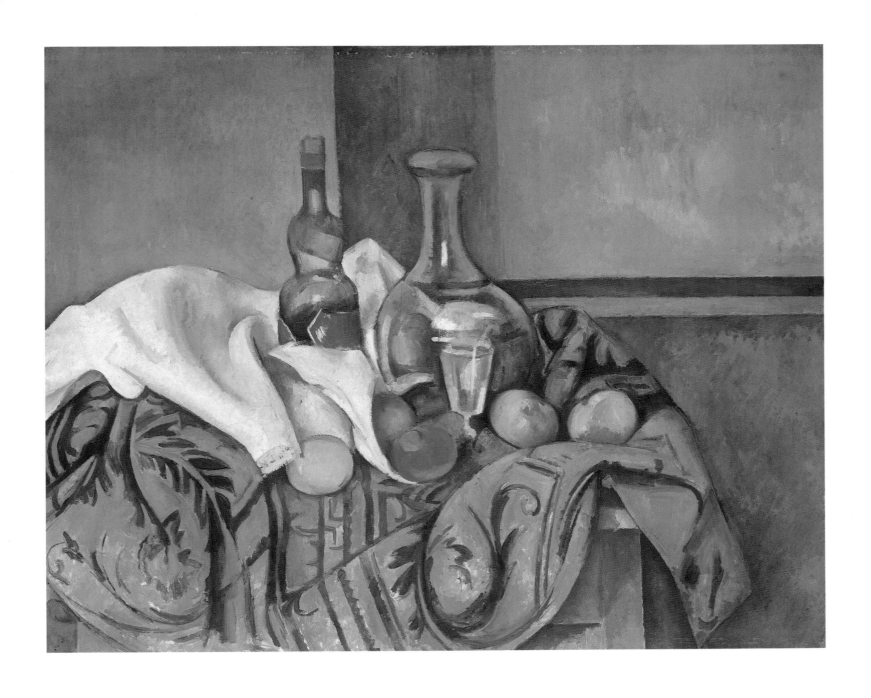

Still Life with Peppermint Bottle

c. 1894. Oil on canvas. 65.9 × 82.1 cm. (26 × 32⅜ in.)
Chester Dale Collection, National Gallery of Art, Washington

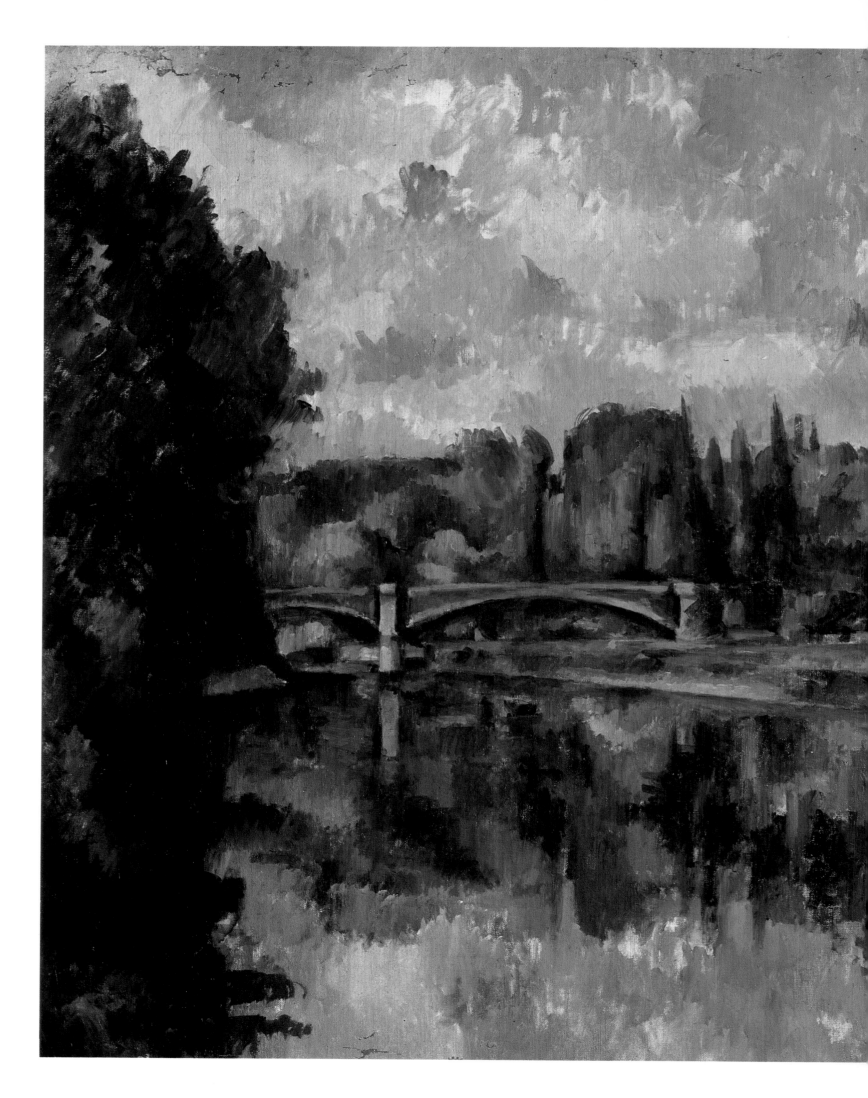

The Banks of the Marne

c. 1893–95. Oil on canvas. 71 × 90 cm. (28 × 35½ in.)
The Pushkin Museum, Moscow

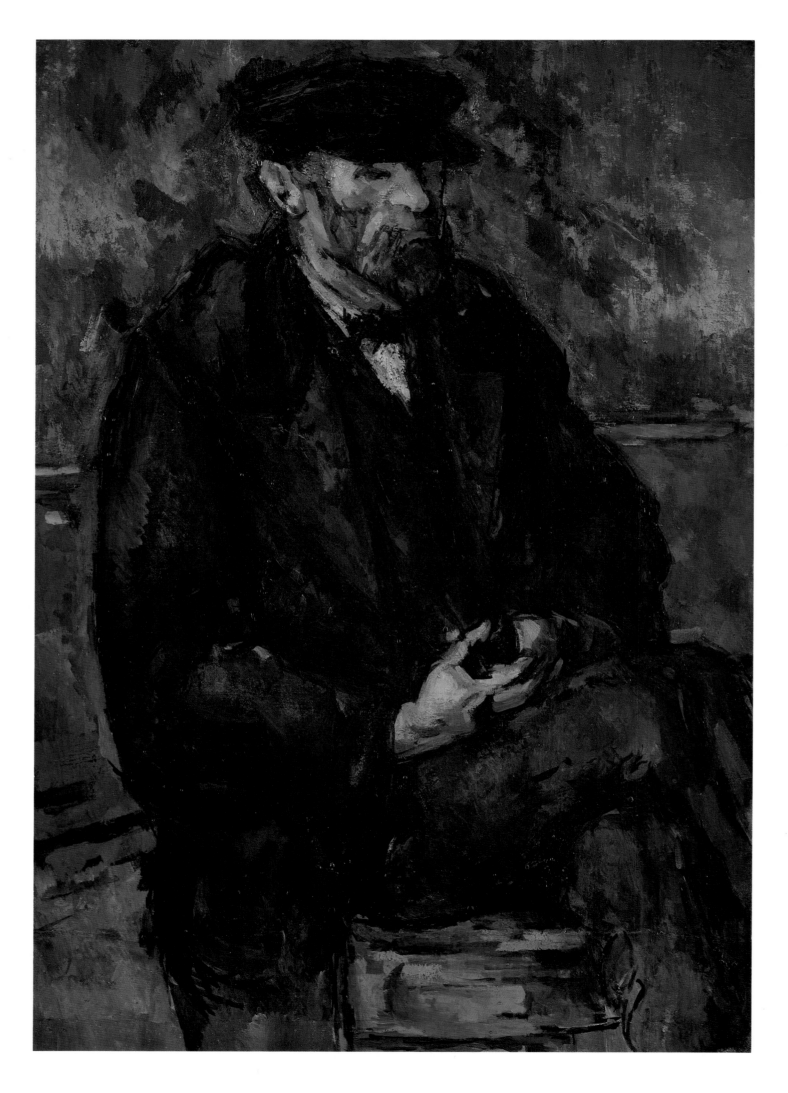

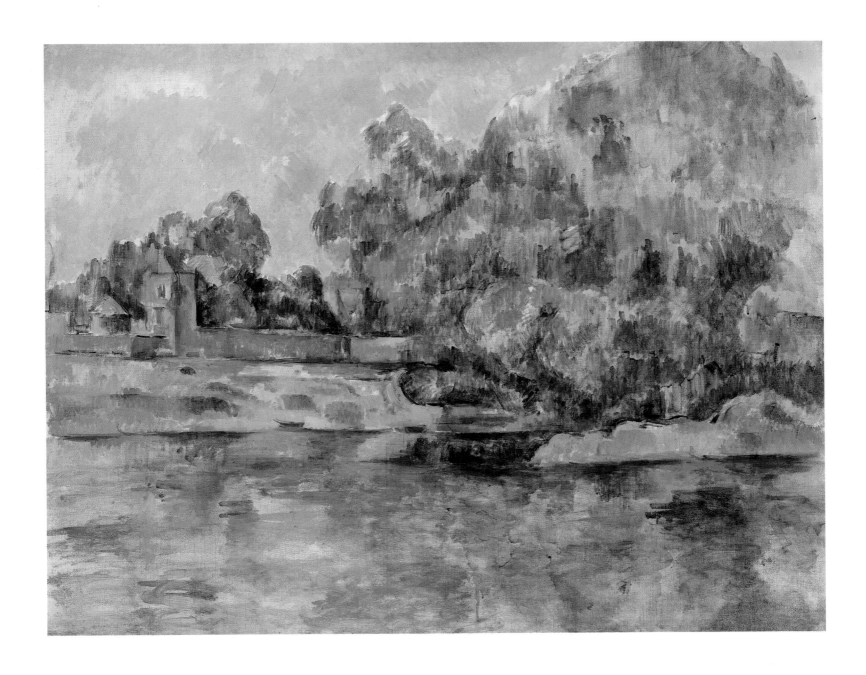

Riverbank

c. 1895. Oil on canvas. 73 × 92.3 cm. (28¾ × 36⅜ in.)
Ailsa Mellon Bruce Collection, National Gallery of Art, Washington

OPPOSITE:

The Sailor

c. 1905. Oil on canvas. 107.4 × 74.5 cm. (42½ × 29⅜ in.)
Gift of Eugene and Agnes Meyer, National Gallery of Art, Washington

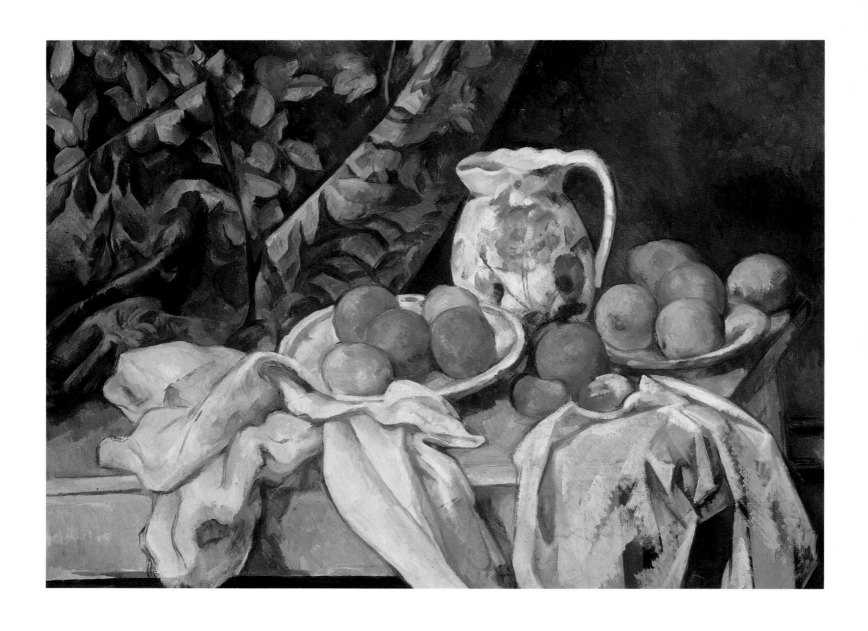

Still Life with Curtain

c. 1898–99. Oil on canvas. 54.7 × 74 cm. (21½ × 29 in.)
The Hermitage, Leningrad

OPPOSITE:

Lady in Blue

c. 1899. Oil on canvas. 88.5 × 72 cm. (34¾ × 28⅜ in.)
The Hermitage, Leningrad

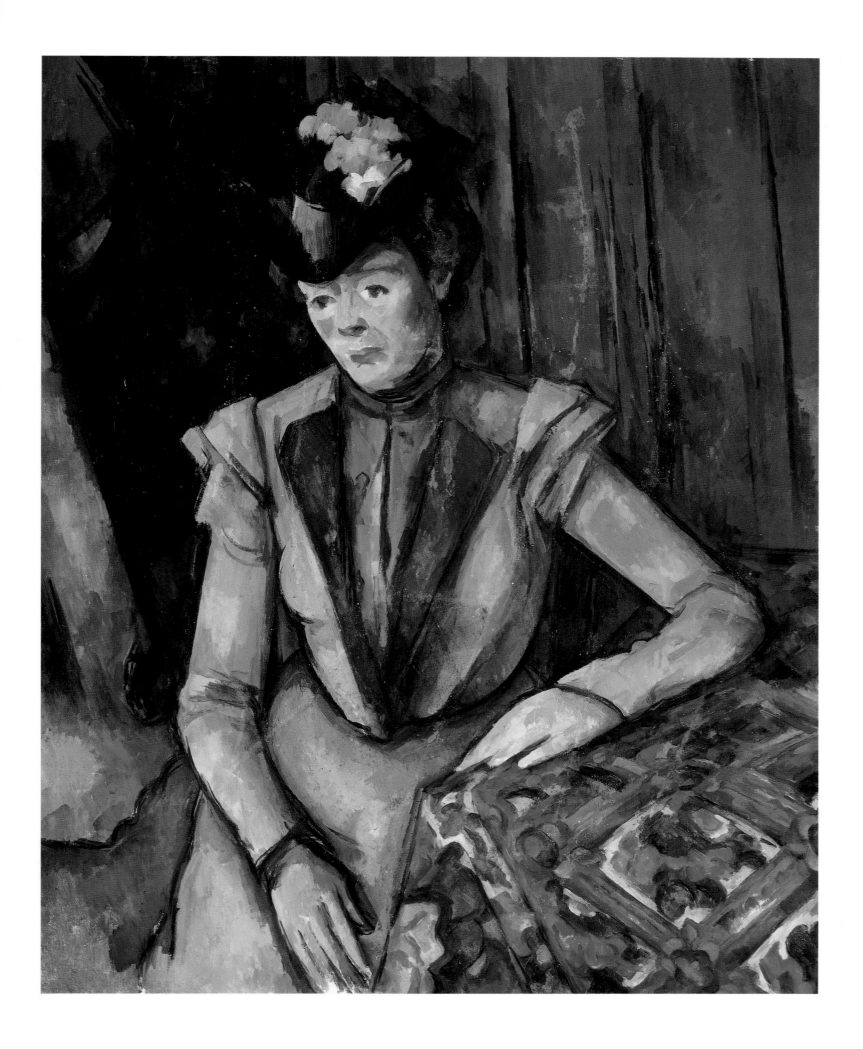

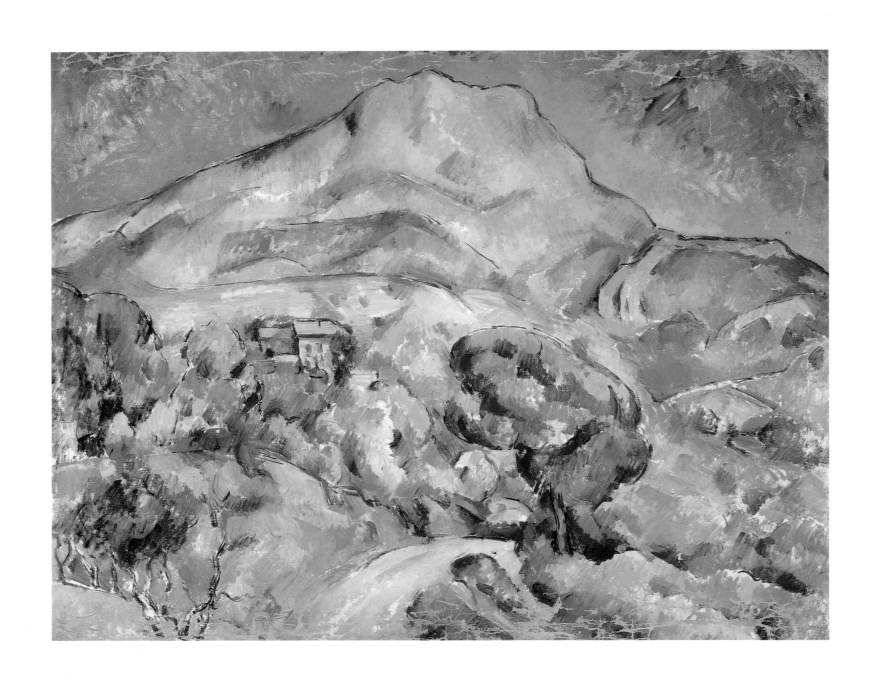

Mont Sainte-Victoire

c. 1900. Oil on canvas. 78 × 99 cm. (30¾ × 39 in.)
The Hermitage, Leningrad

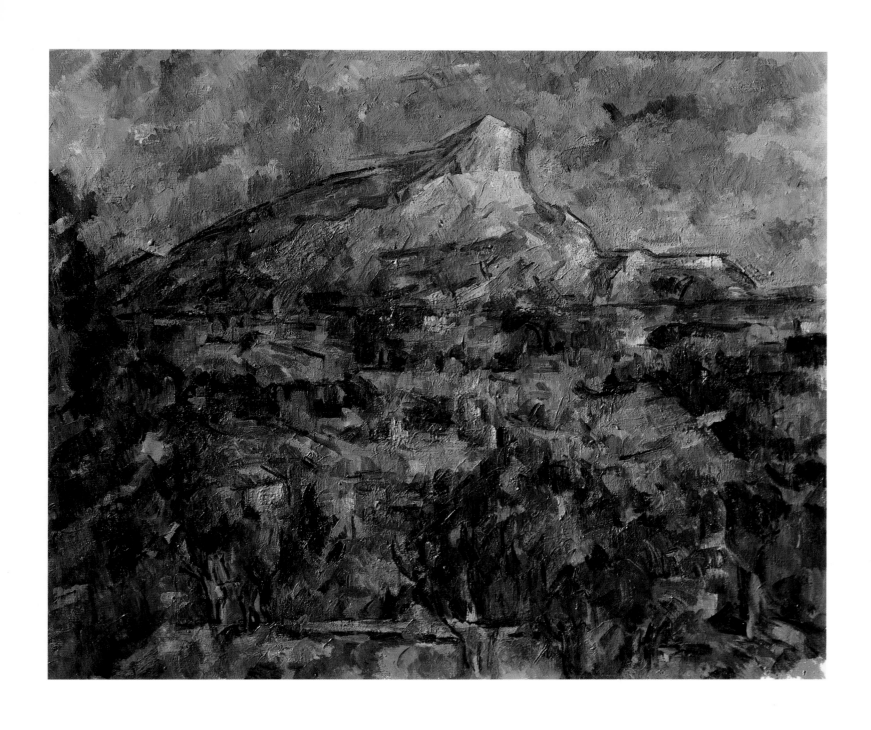

Landscape at Aix (Mont Sainte-Victoire)

c. 1905. Oil on canvas. 60 × 73 cm. (23½ × 28¾ in.)
The Pushkin Museum, Moscow

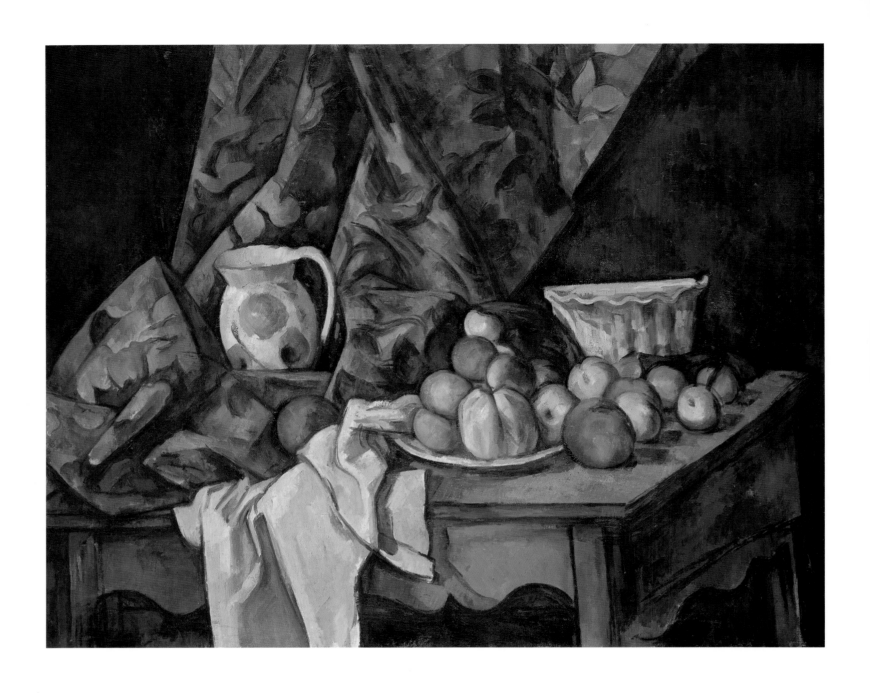

Still Life with Apples and Peaches

c. 1905. Oil on canvas. 81.2 × 100.6 cm. (32 × 39⅝ in.)
Gift of Eugene and Agnes Meyer, National Gallery of Art, Washington

OPPOSITE:

Blue Landscape

c. 1904–6. Oil on canvas. 102 × 83 cm. (40 × 32½ in.)
The Hermitage, Leningrad

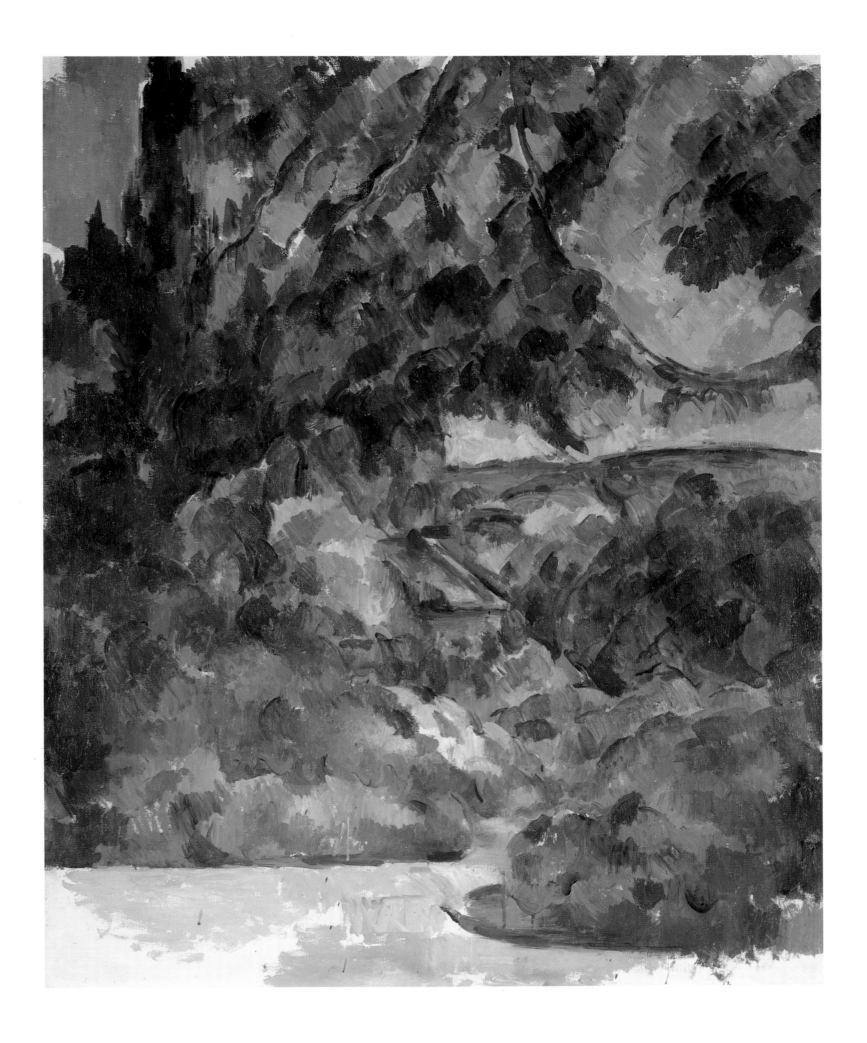

PAUL SIGNAC
1863–1935

PAUL SIGNAC was born in Paris. He began to paint in 1882, initially influenced by Claude Monet. In 1883, the young artist attended the free studio of S. Bing and in 1884 was among those who founded the Société des Artistes Indépendants, which organized annual art exhibitions without jury or prizes. Around 1885, he came into close contact with a group of younger artists, including Seurat, Maximilien Luce, Henri-Edmond Cross, and Theo van Rysselberghe, who set forth the aesthetic and technical tenets of Neo-Impressionism, or Divisionism. The first canvases painted by Signac in a new manner belong to this time. Soon Pissarro joined the Divisionists, and during the formative years of Fauvism, Matisse's and Derain's attention was also drawn to the technique of the divided brush stroke.

Signac's artistic output consists mainly of seascapes and town views. He travelled widely across the country, from Le Havre to Marseilles, painting views of Paris, La Rochelle, Avignon, Collioure, Saint-Tropez, and Antibes. He painted harbor scenes in Venice and Constantinople. His passion for travelling accounts to a certain extent for the specific type of his many watercolors, which combine a free, spontaneous portrayal of nature with a rapid, yet elaborate, execution. Besides paintings, travel sketches, and drawings, Signac produced a large decorative canvas, *Au temps d'Harmonie,* for the Maison du Peuple in Brussels.

Signac has left us several important works on the theory of art, among them *From Eugène Delacroix to Neo-Impressionism,* published in 1899; a monograph devoted to Jongkind (1927); several introductions to the catalogues of art exhibitions; and many other hitherto unpublished writings.

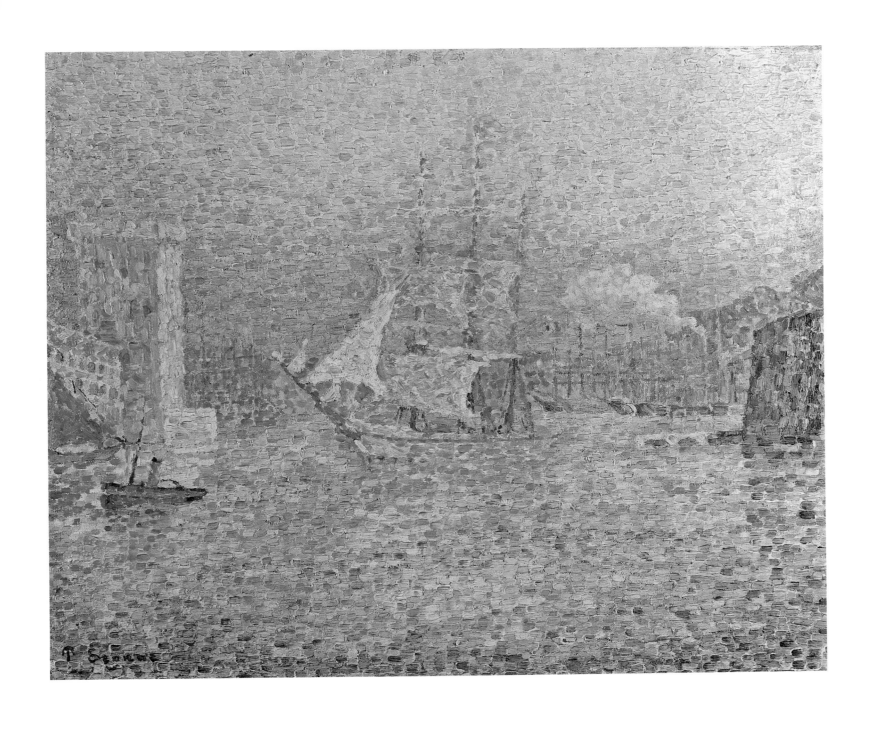

Harbor at Marseilles

c. 1906. Oil on canvas. 46 × 55 cm. (18⅛ × 21⅝ in.)
The Hermitage, Leningrad

HENRI-EDMOND CROSS
1856–1910

HENRI-EDMOND DELACROIX, known by his pseudonym of Cross, spent his childhood and youth in Lille. At the age of ten, he took drawing and painting lessons from E. A. Carolus-Duran and then studied briefly under Colas at the Ecole des Beaux-Arts. In 1878, he settled in Paris and there made friends with François Bonvin, whose work influenced him for some time. In 1881, Delacroix first exhibited at the Salon under the pseudonym of Cross, which he had chosen in order not to be confused with the little-known artist Henri-Eugène Delacroix who was exhibiting in the same period.

In May 1884, Cross took part in the first exhibition of the Salon des Artistes Indépendants; in 1891, he was elected vice-president of the Société des Artistes Indépendants. By then he had become one of the leading exponents of Neo-Impressionism. His style changed sharply. He renounced the principles of chiaroscuro and painted with rectangular, divided strokes, creating canvases full of color.

Cross often visited Italy, and in 1908 he spent July and August in Tuscany and Umbria, visiting Florence, Pisa, Assisi, and other Italian towns. Here he painted many studies of nature which he used for his 1909 and 1910 landscapes.

Rheumatism compelled the artist to spend his summers in the south of France; for the last years of his life, he settled at Saint-Clair.

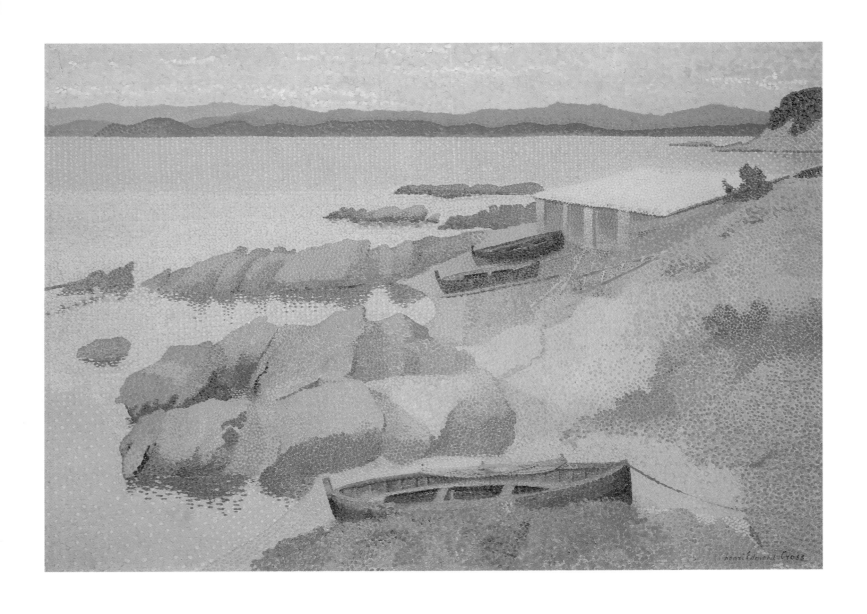

Coast near Antibes

1891–92. Oil on canvas. 65.1 × 92.3 cm. (25⅝ × 36⅜ in.)
John Hay Whitney Collection, National Gallery of Art, Washington

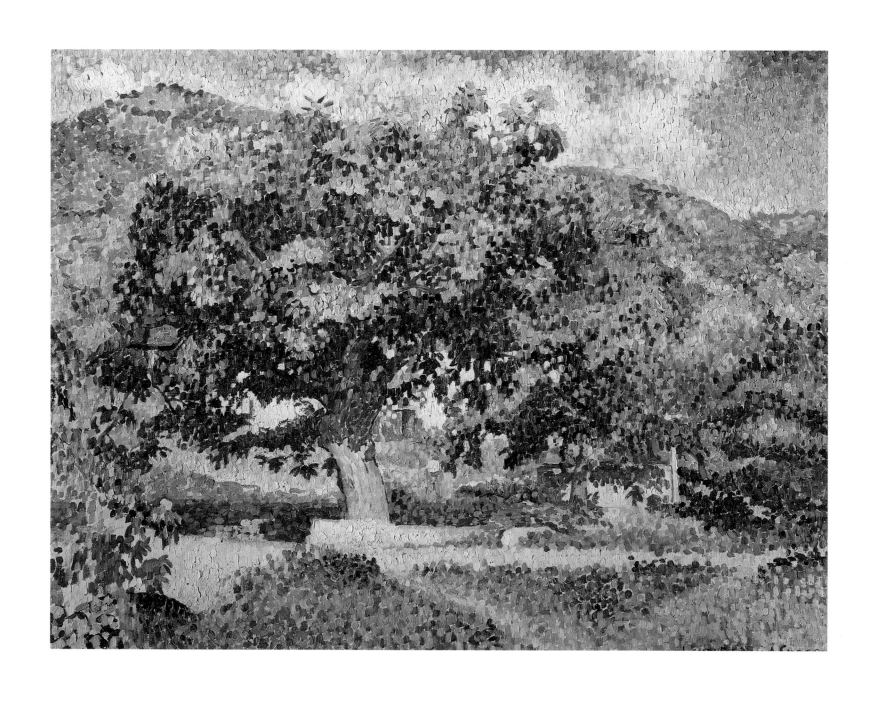

Around My House

1906–7. Oil on canvas. 61 × 79 cm. (24 × 31 in.)
The Pushkin Museum, Moscow

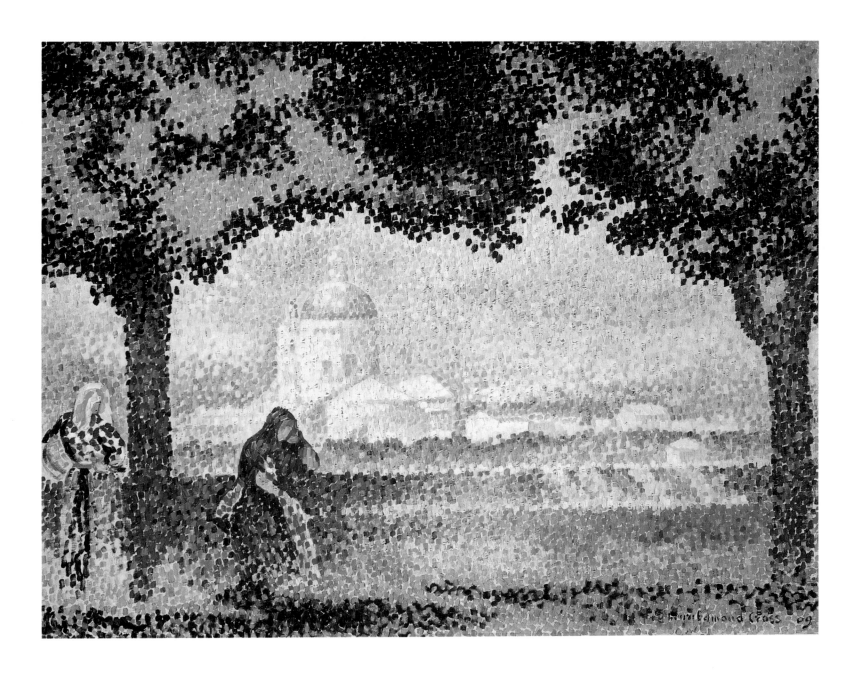

View of Santa Maria degli Angeli near Assisi

1909. Oil on canvas. 74 × 92 cm. (29 × 36¼ in.)
The Hermitage, Leningrad

GEORGES SEURAT
1859–1891

GEORGES SEURAT was born and died in Paris. His early artistic training at a municipal school was followed by two years at the Ecole des Beaux-Arts, where he studied with Henri Lehmann, a former pupil of Ingres. A Classicist at heart, Seurat was inspired by Impressionism and by the scientific color theories of Blanc, Chevreul, Helmholtz, and Rood, which he applied to painting in a highly individual and personal manner.

In his short lifetime, Seurat developed theories and practices of painting that represented not so much a codification of Impressionism as a singular elaboration of its discoveries about light and color. His "Pointillist" method of applying paint in tiny uniform dots of pure color nonetheless had a powerful impact on a widening circle of artists, from contemporary disciples Paul Signac and Henri Cross, to the more indirectly affected Camille Pissarro and Vincent van Gogh, to the Fauves of the following geneation. Seurat's attention to the abstract foundations of expression was perhaps even more important for the masters of early twentieth-century painting.

Methodical in every aspect of his work, Seurat developed a new technique of drawing in 1882 and 1883 that depended entirely on shading to elicit form, space, and light—a graphic emphasis equivalent to the atmospheric color of the Impressionists. His subsequent paintings of port scenes, of bathers and strollers, of women and the circus are Impressionist in theme, but the first-hand immediacy of Impressionism is replaced by optically analytical combinations of color, predetermined arrangements of line, and gradations of tone that convey various moods. The principles involved were articulated by Seurat only a few months before his death.

With Signac, Redon, and Dubois-Pillet, Seurat was instrumental in establishing the Société des Artistes Indépendants, which organized the Salon des Indépendants as an alternative to the official Salon. Seurat exhibited his monumental masterpiece, *A Sunday Afternoon on the Island of La Grande Jatte*, at the eighth and final Impressionist exhibition in 1886 and at the second Salon des Indépendants.

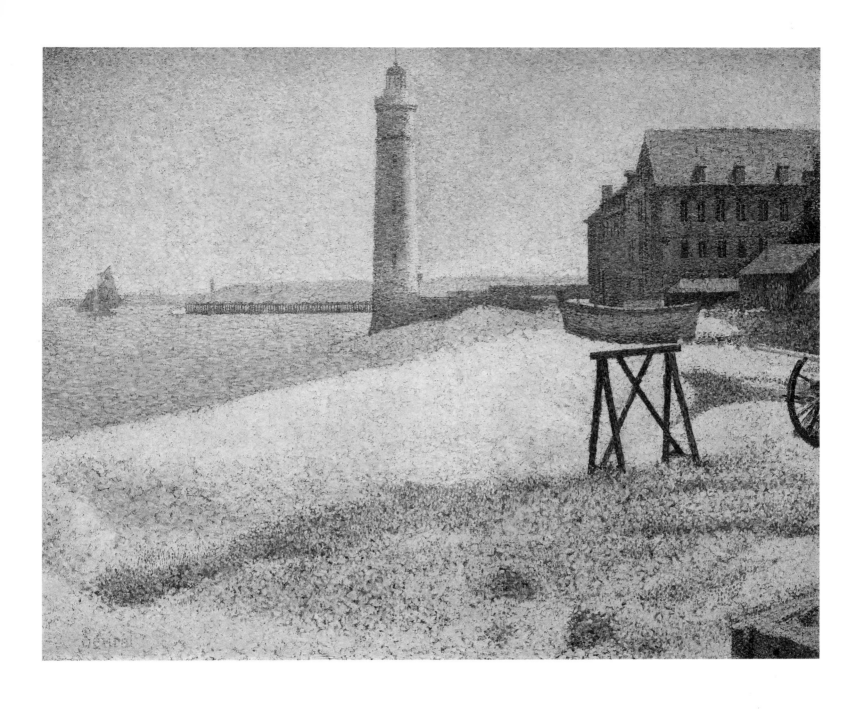

The Lighthouse at Honfleur

1886. Oil on canvas. 66.7 × 81.9 cm. (26¼ × 32¼ in.)
Collection of Mr. and Mrs. Paul Mellon, National Gallery of Art, Washington

Vincent

VINCENT VAN GOGH
1853–1890

VINCENT VAN GOGH, the son of a Dutch pastor, went to work in 1869 as a salesman in an art gallery in The Hague. He then worked in a bookshop in Holland, taught in two English schools, and became a missionary in the coal-mining district of Borinage in Belgium. In his spare time, he executed drawings chiefly on the lives of local workmen and peasants. It was not until 1880 that he decided to dedicate himself to painting. He painted his first pictures in 1881 while staying at Etten with his parents. His teacher in The Hague was Antoine Mauve.

In February 1886, Van Gogh arrived in Paris and immediately plunged into the atmosphere of the city's intense artistic life. He enrolled at the Ecole des Beaux-Arts and frequented Cormon's studio, where he made friends with Toulouse-Lautrec. Later, he met Gauguin and became enthralled by his powerful talent. He was also at-tracted by the light colors of the Impressionists and took an interest in Japanese prints. However, he quickly absorbed all these influences and during the ensuing years his unique art reached its height. In 1888, while living at Arles, Van Gogh painted *The Red Vineyard at Arles, Farmhouse in Provence, Arles,* and *Roulin's Baby.*

In October 1888, Gauguin joined him at Arles. Their cooperation was short-lived, however, lasting a mere two months, and ended in a total break and Gauguin's sudden departure on December 24.

Suffering from intermittent attacks of mental disorder, Van Gogh asked to be interned at the asylum in Saint-Rémy. In May 1890, he went to live with his friend, Doctor Gachet, at Auvers-sur-Oise. There he resumed painting and produced many views of the environs of Auvers. On July 27, 1890, under the strain of mental crisis, he shot himself in the chest with a pistol and died two days later.

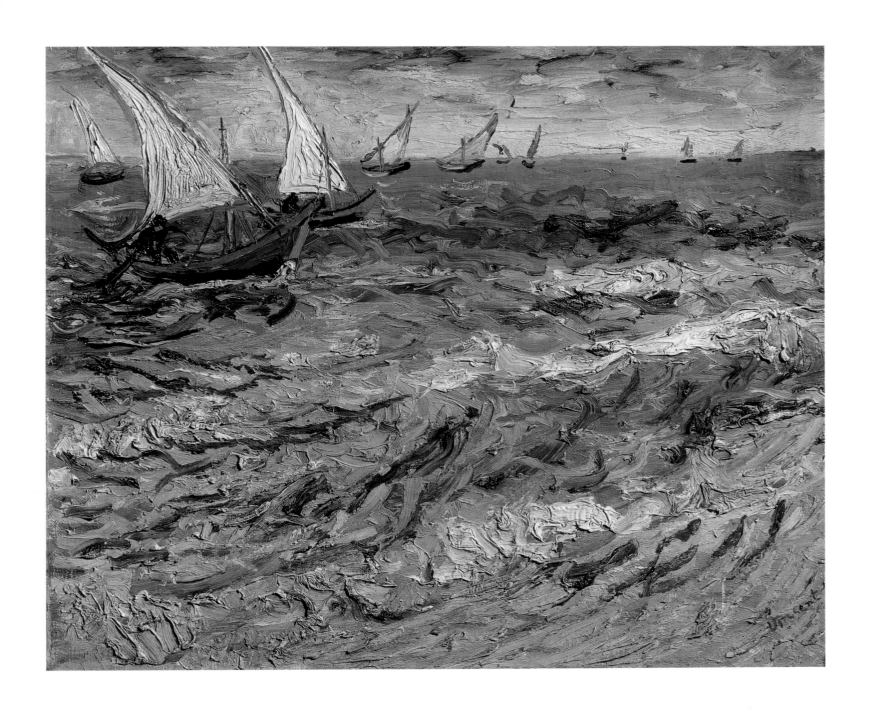

Seascape at Saintes-Maries

c. 1888. Oil on canvas. 44 × 53 cm. (17⅜ × 20¾ in.)
The Pushkin Museum, Moscow

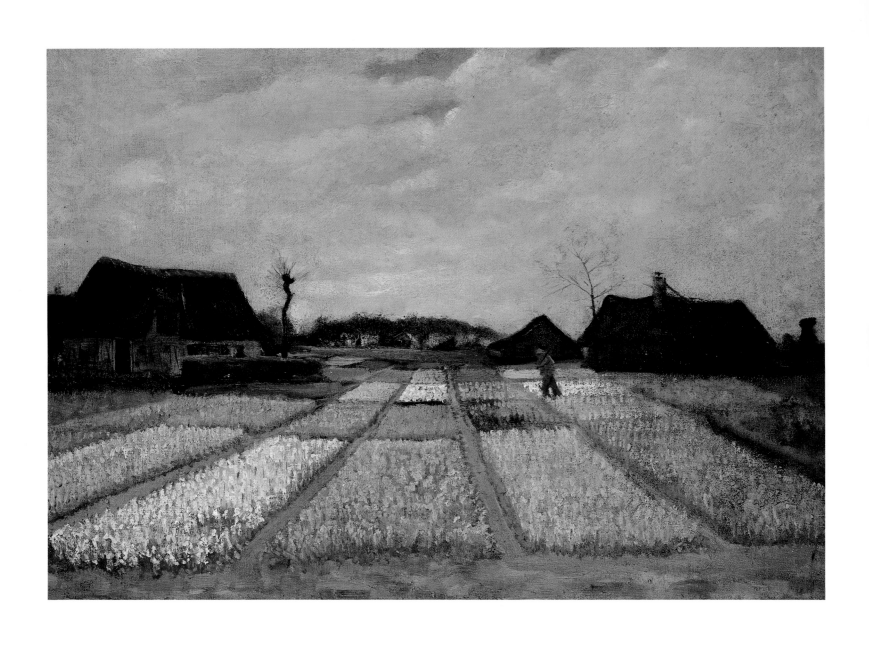

Flower Beds in Holland

c. 1883. Oil on canvas on wood. 48.9 × 66 cm. (19¼ × 26 in.)
Collection of Mr. and Mrs. Paul Mellon, National Gallery of Art, Washington

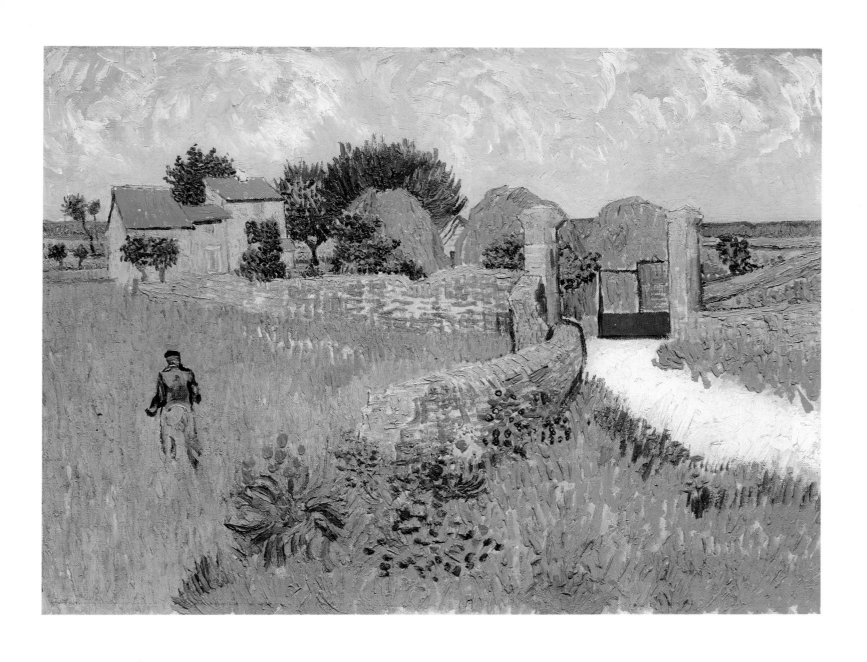

Farmhouse in Provence, Arles

1888. Oil on canvas. 46.1 × 60.9 cm. (18⅛ × 24 in.)
Ailsa Mellon Bruce Collection, National Gallery of Art, Washington

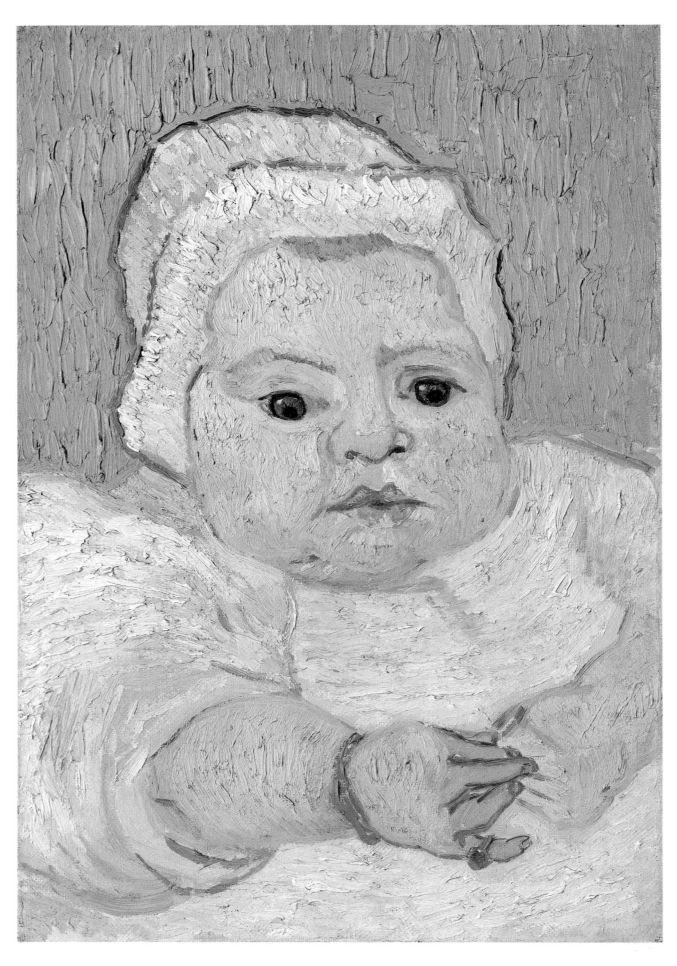

Roulin's Baby

1888. Oil on canvas. 35 × 23.9 cm. (13¾ × 9⅜ in.)
Chester Dale Collection, National Gallery of Art, Washington

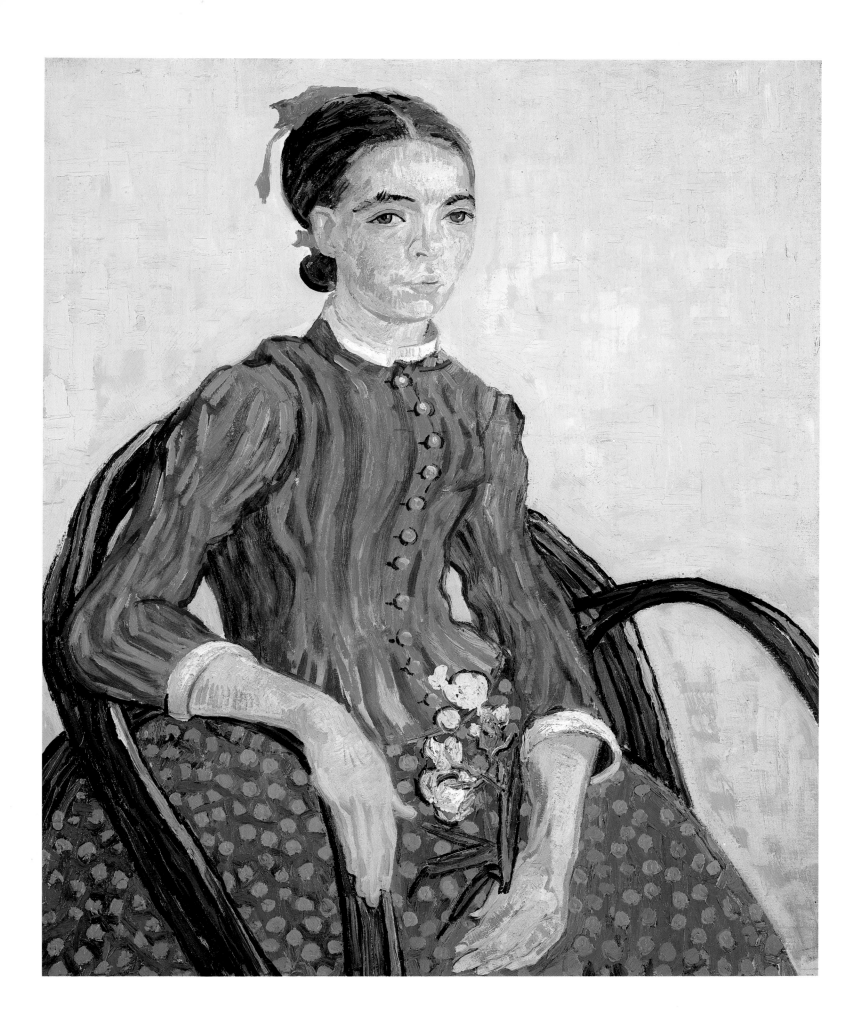

La Mousmé

1888. Oil on canvas. 73.3 × 60.3 cm. (28⅞ × 23¾ in.)
Chester Dale Collection, National Gallery of Art, Washington

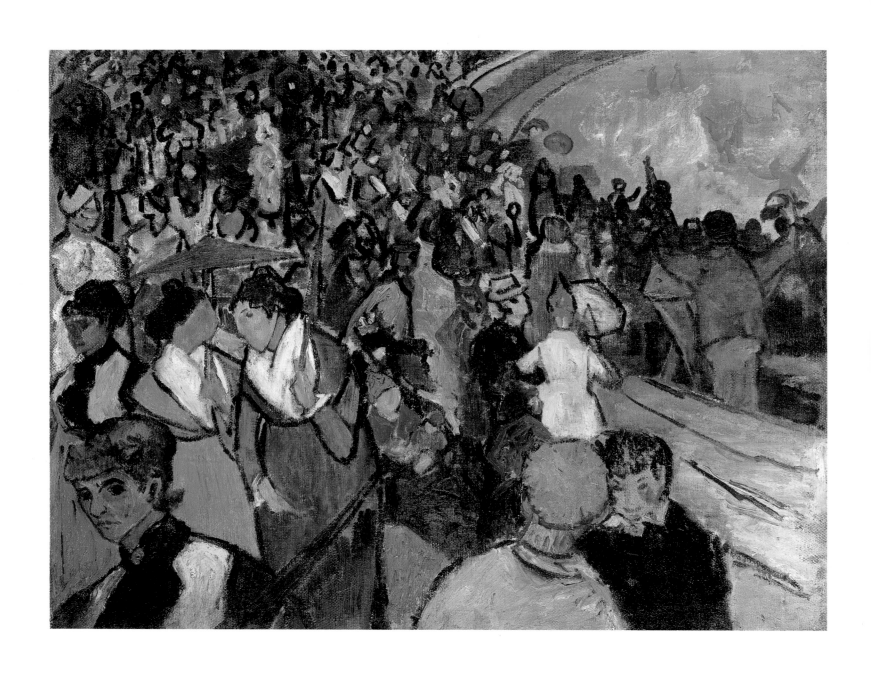

The Arena at Arles

c. 1888. Oil on canvas. 72 × 92 cm. (28⅜ × 36¼ in.)
The Hermitage, Leningrad

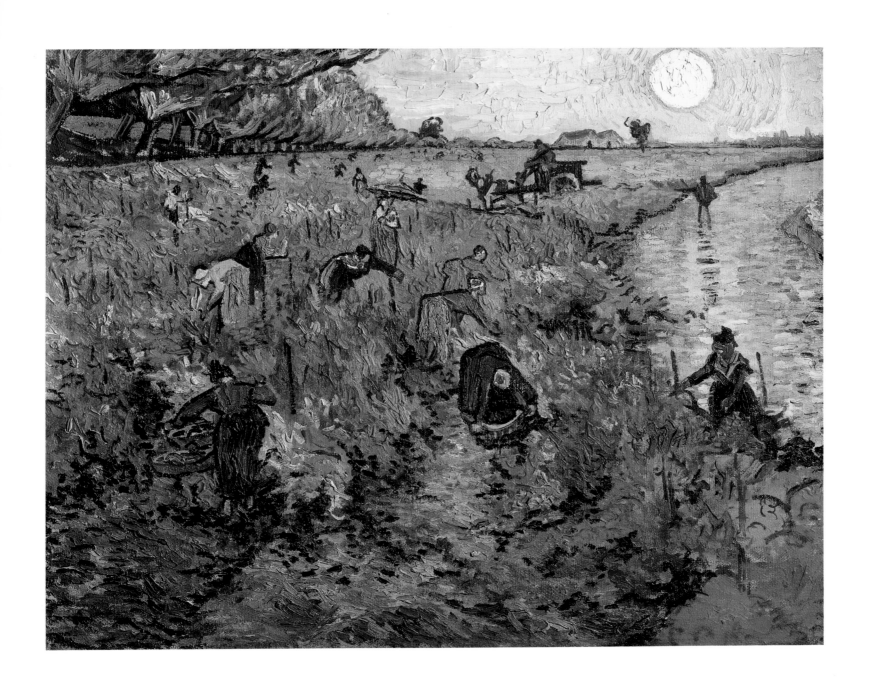

The Red Vineyard at Arles

c. 1888. Oil on canvas. 73 × 91 cm. (28¾ × 36 in.)
The Pushkin Museum, Moscow

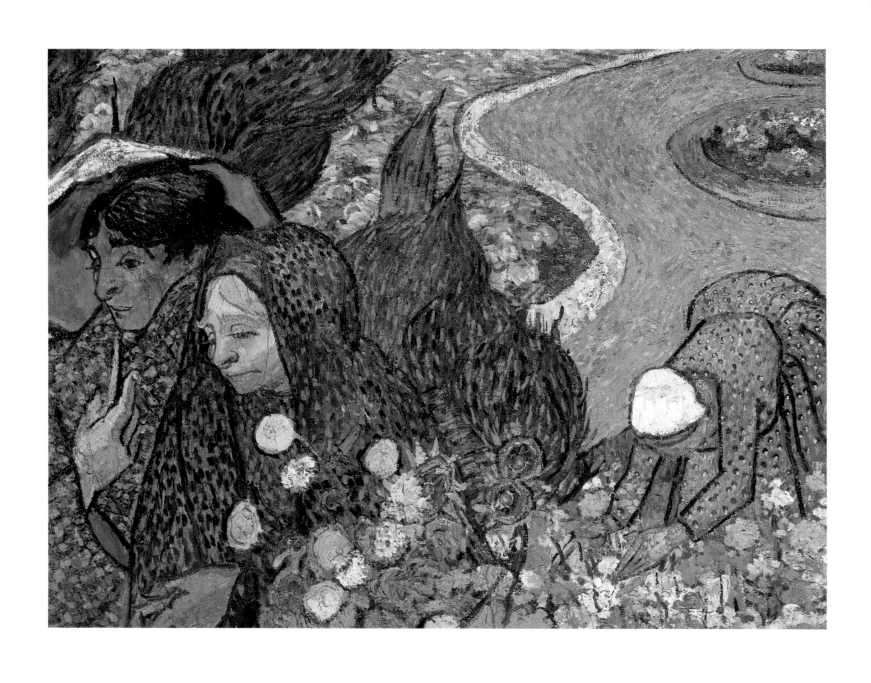

Ladies of Arles (Reminiscence of the Garden at Etten)

c. 1888. Oil on canvas. 73.5 × 92.5 cm. (29 × 36½ in.)
The Hermitage, Leningrad

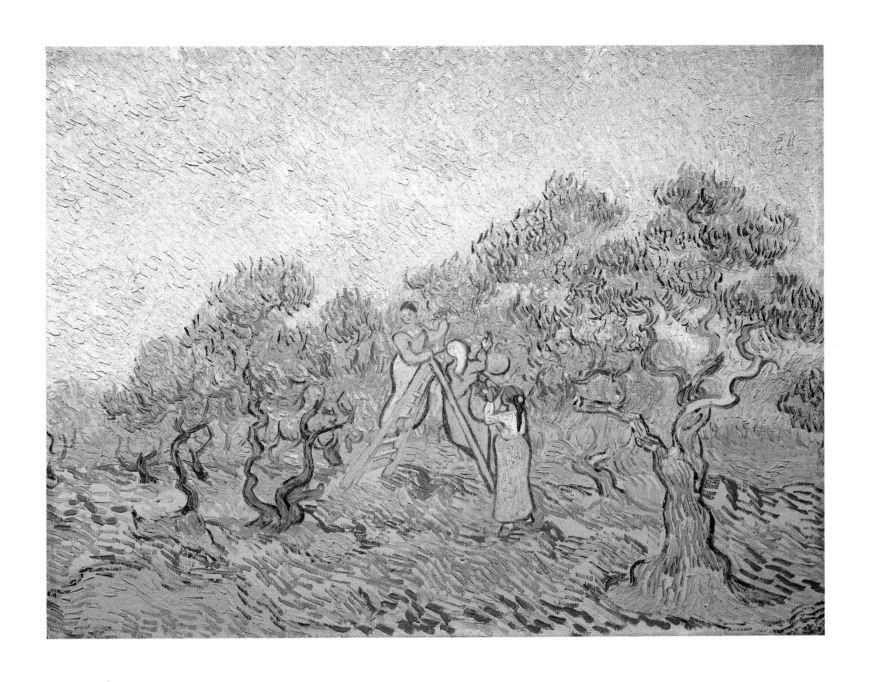

The Olive Orchard

1889. Oil on canvas. 73 × 92 cm. (28¾ × 36¼ in.)
Chester Dale Collection, National Gallery of Art, Washington

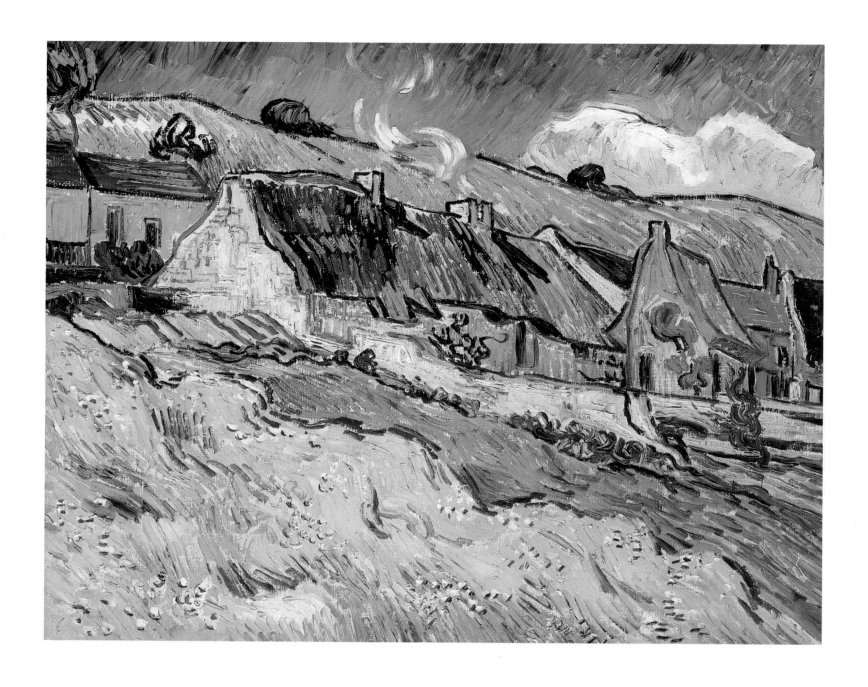

Cottages

c. 1890. Oil on canvas. 60 × 73 cm. (23½ × 28¾ in.)
The Hermitage, Leningrad

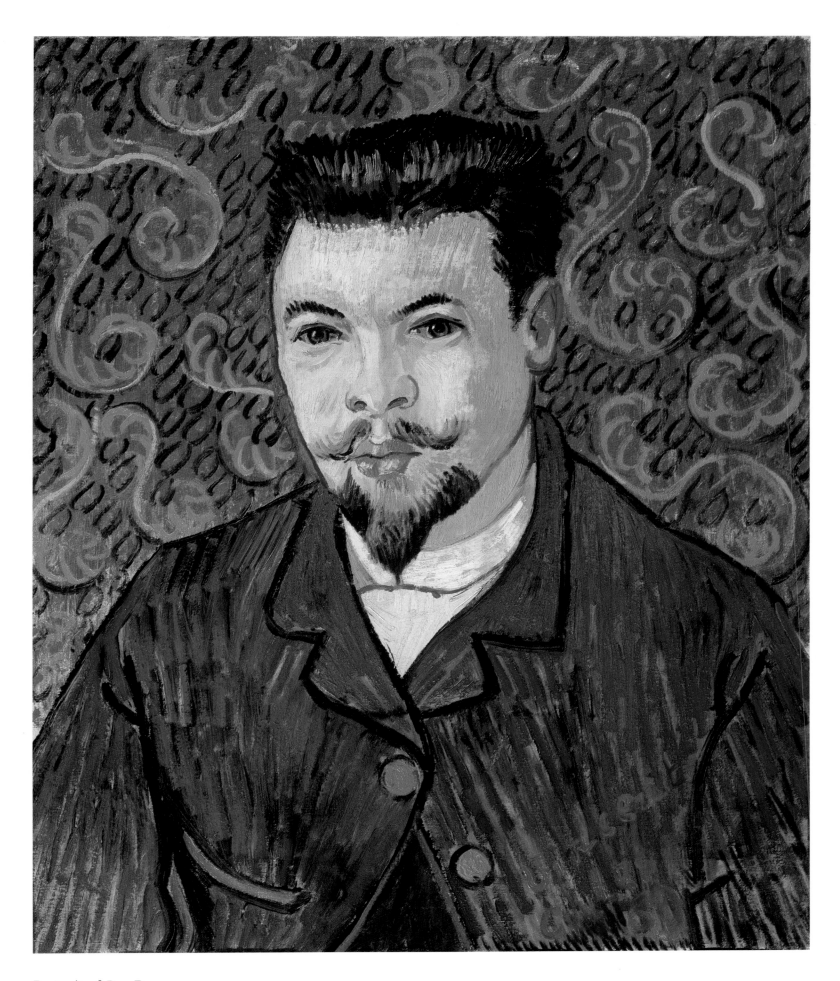

Portrait of Dr. Rey

1889. Oil on canvas. 64 × 53 cm. (25¼ × 20¾ in.)
The Pushkin Museum, Moscow

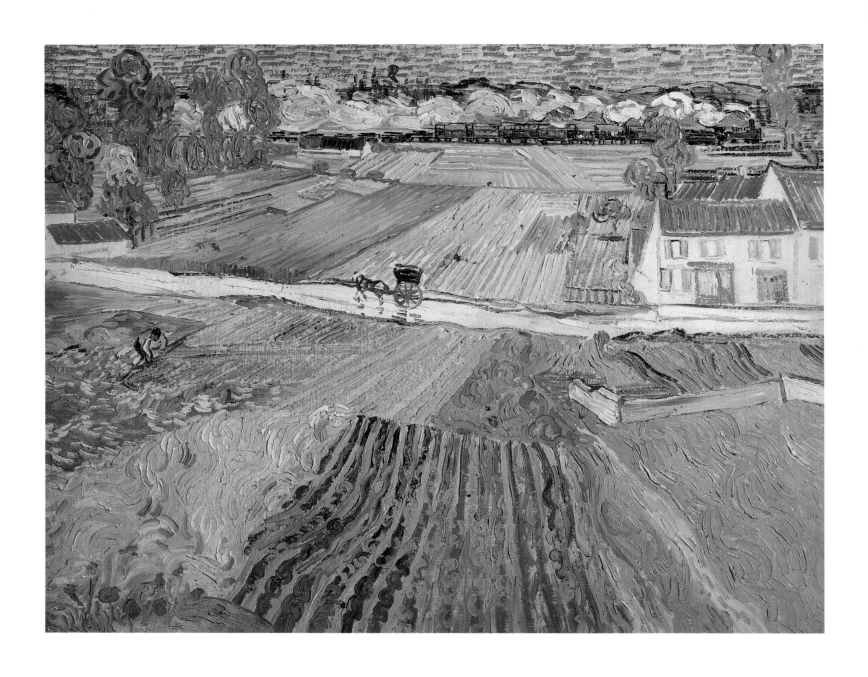

Landscape at Auvers after the Rain

c. 1890. Oil on canvas. 72 × 90 cm. (28⅜ × 35½ in.)
The Pushkin Museum, Moscow

OPPOSITE:

The Convict Prison

c. 1890. Oil on canvas. 80 × 64 cm. (31½ × 25¼ in.)
The Pushkin Museum, Moscow

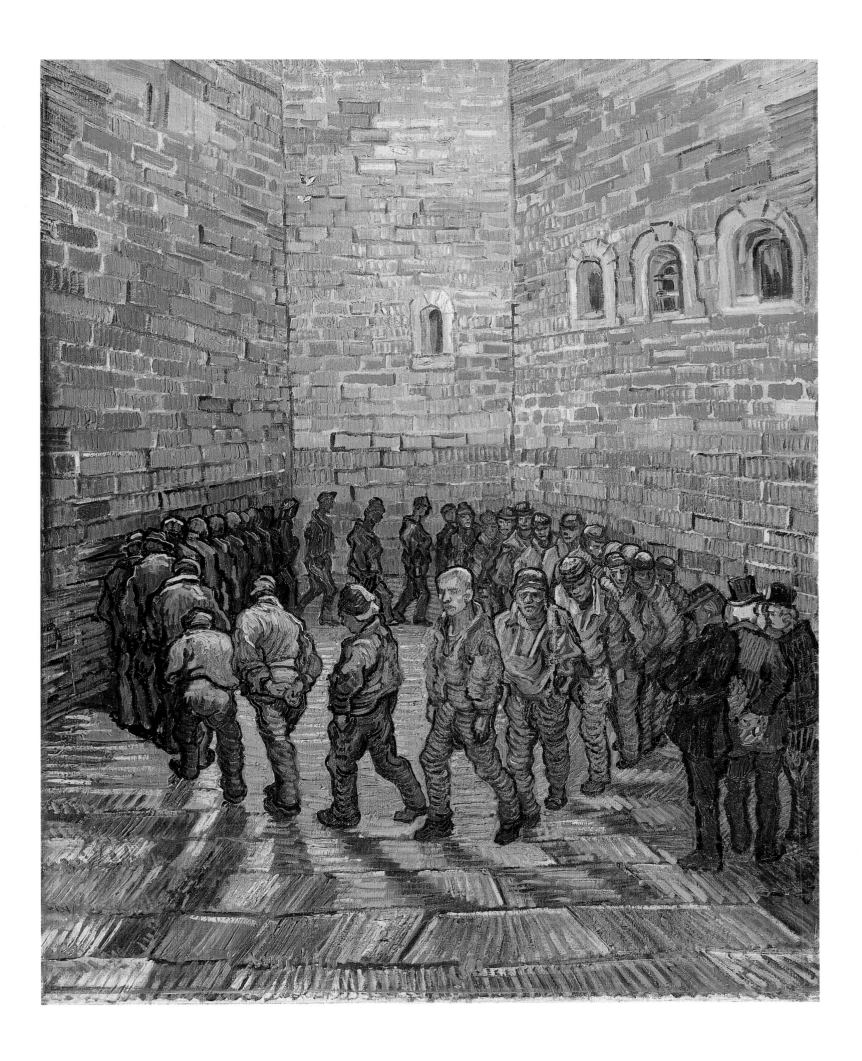

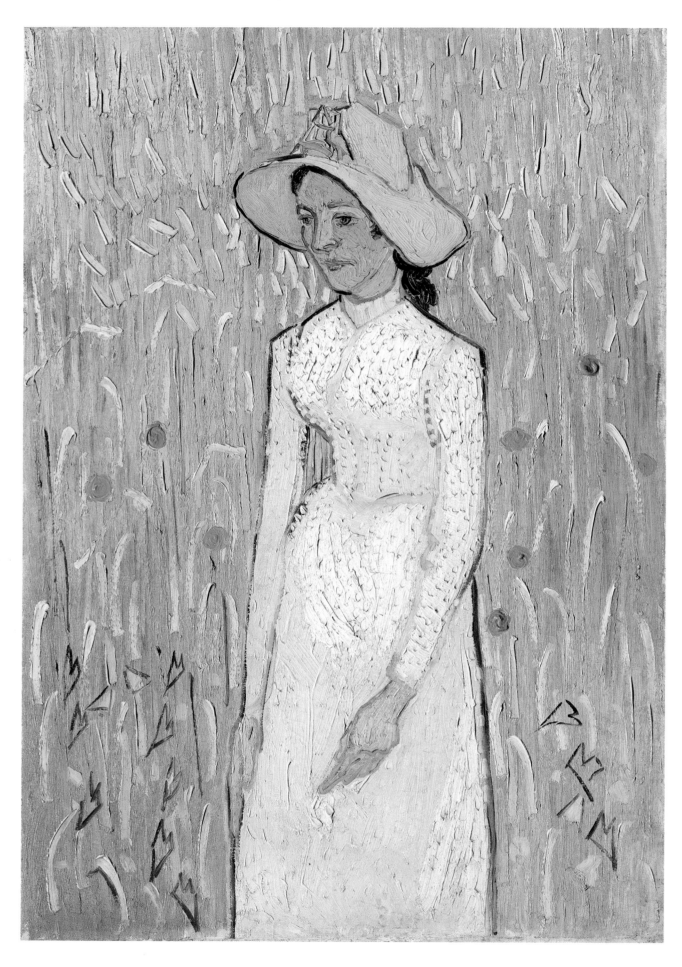

Girl in White

1890. Oil on canvas. 66.3 × 45.3 cm. (26⅛ × 17⅞ in.)
Chester Dale Collection, National Gallery of Art, Washington

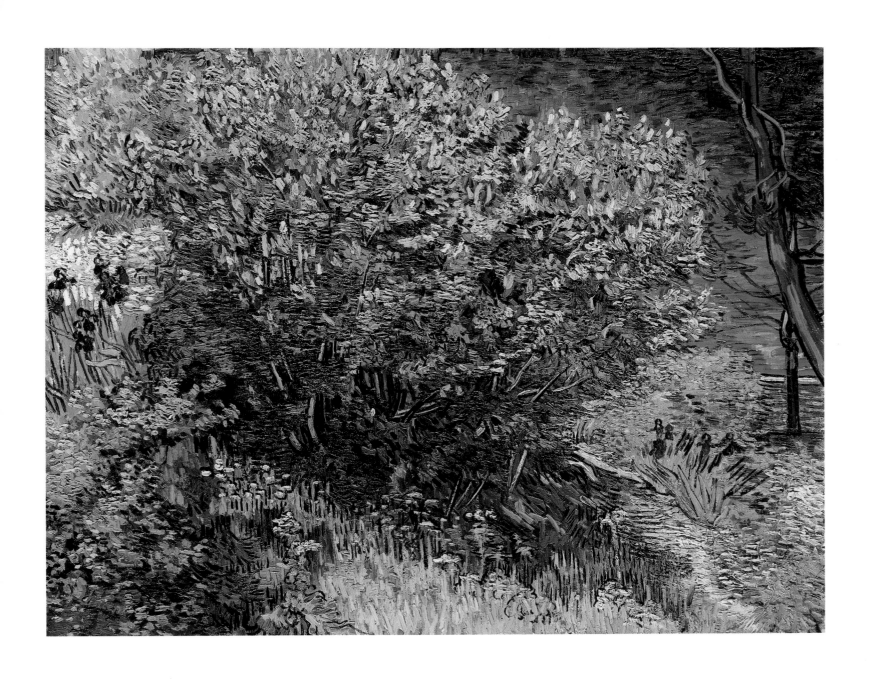

Lilac Bush

c. 1890. Oil on canvas. 72 × 92 cm. (28⅜ × 36¼ in.)
The Hermitage, Leningrad

PAUL GAUGUIN
1848–1903

PAUL GAUGUIN was the son of a Paris journalist. His father died in 1849, and his family was forced by circumstances to emigrate to Peru, where they had some wealthy relatives and where Gauguin spent his childhood. Between 1864 and 1868, he served aboard several merchant ships, then gave up the sea and went to work for a Paris Exchange broker. He drew and painted landscapes in his leisure time and first exhibited in the 1876 Salon. A decisive influence on the evolution of his artistic talent was exercised by Camille Pissarro, whom he met in 1877. Pissarro did much to help him acquire professional skill and persuaded him to exhibit with the Impressionists. From 1883 onwards, Gauguin devoted himself entirely to painting; he abandoned his business career, became separated from his family, and often changed places of residence, suffering from constant lack of money. He spent the summer of 1885 at Pont-Aven, and a year later he embarked for Martinique.

In November and December 1888, Gauguin stayed with Van Gogh in Arles, but after a painful quarrel this association broke up.

While living in Brittany, at Pont-Aven, and Le Pouldu, Gauguin formulated the aesthetic principles of what he called "Synthetism," a style characterized by a symbolic representation of nature and the use of massive, simplified forms and large, bright planes of color. Between 1885 and 1890, eight painters grouped around him and formed the Pont-Aven school. Their first public show was held in 1889 at the Café Volpini in Paris, where Gauguin's works were in the limelight. In April 1891, he undertook his first trip to Tahiti and stayed there for two years, the first Tahitian period (1891–93). He gained nothing by returning to France in April 1893. Rejected by official critics and being in straitened circumstances, Gauguin decided to leave Europe. He set out for Tahiti, arrived there in July 1895, and settled in the north of the island. He stayed there until 1901 and then moved to Atuana in the Marquesas; this was his second Oceanian period (1895–1903). During his last years, besides painting, Gauguin tried his hand at sculpture, drawing, and xylography and wrote prose pieces, among them *Noa-Noa, Racontars d'un rapin,* and *Avant et Après.*

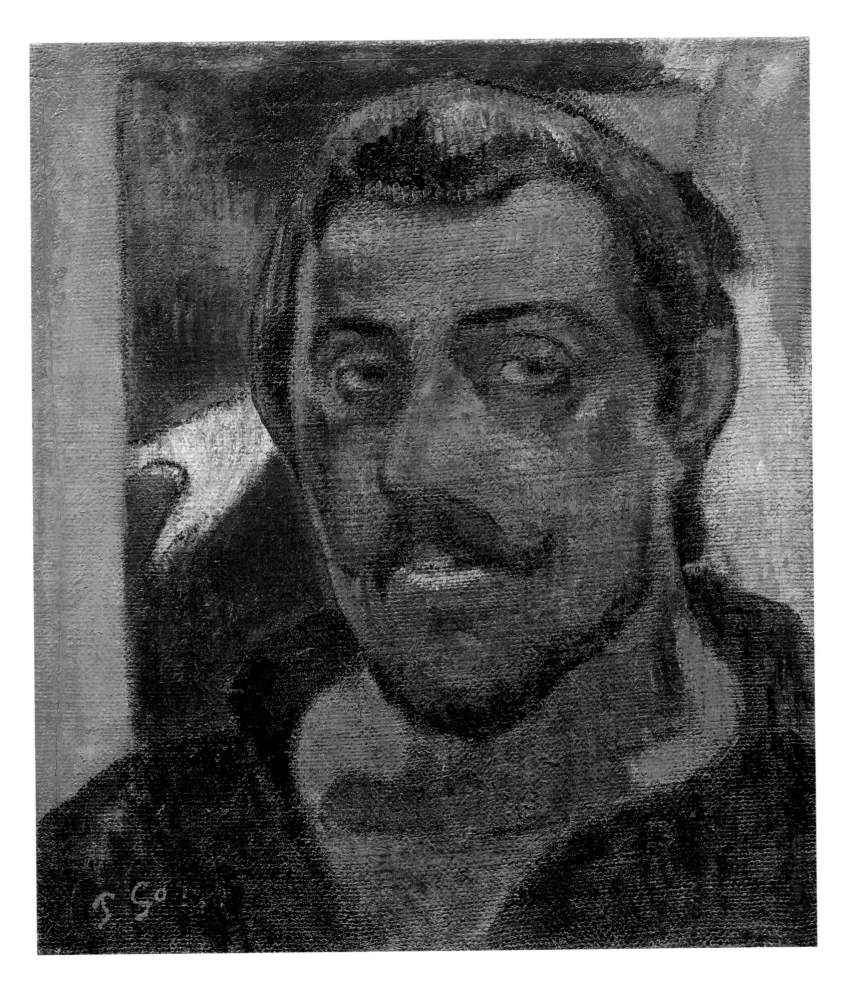

Self-Portrait

c. 1888. Oil on canvas. 46 × 38 cm. (18⅛ × 15 in.)
The Pushkin Museum, Moscow

Brittany Landscape

1888. Oil on canvas. 71.1 × 89.5 cm. (28 × 35¼ in.)
Chester Dale Collection, National Gallery of Art, Washington

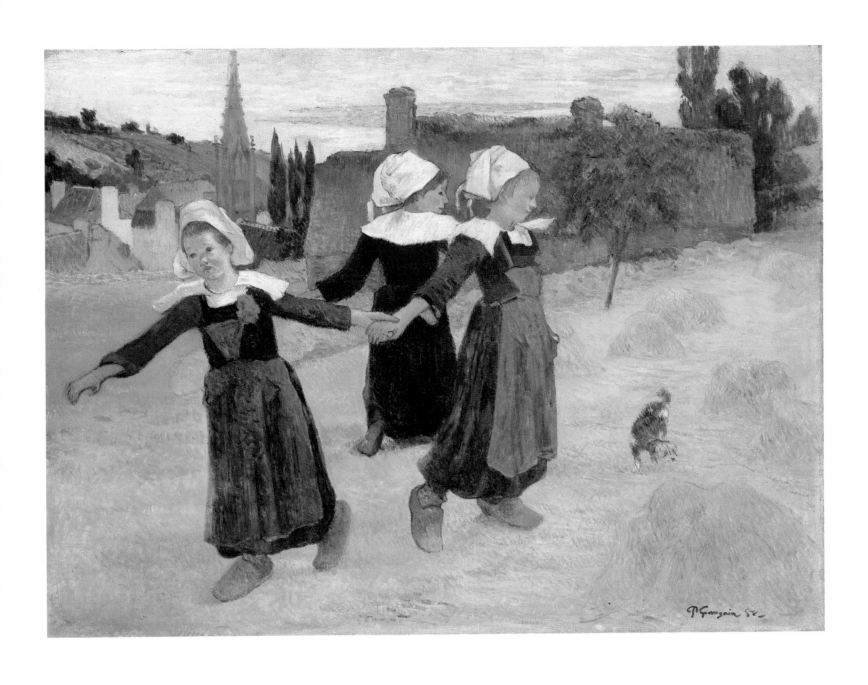

Breton Girls Dancing, Pont Aven

1888. Oil on canvas. 73 × 92.7 cm. (28¾ × 36½ in.)
Collection of Mr. and Mrs. Paul Mellon, National Gallery of Art, Washington

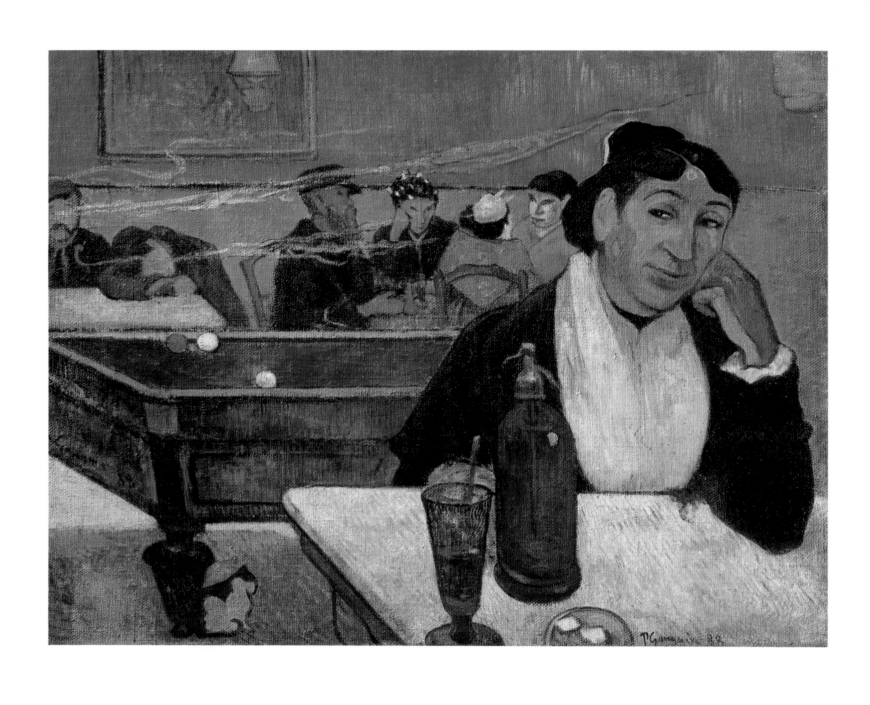

Café at Arles

1888. Oil on canvas. 72 × 92 cm. (28⅜ × 36¼ in.)
The Pushkin Museum, Moscow

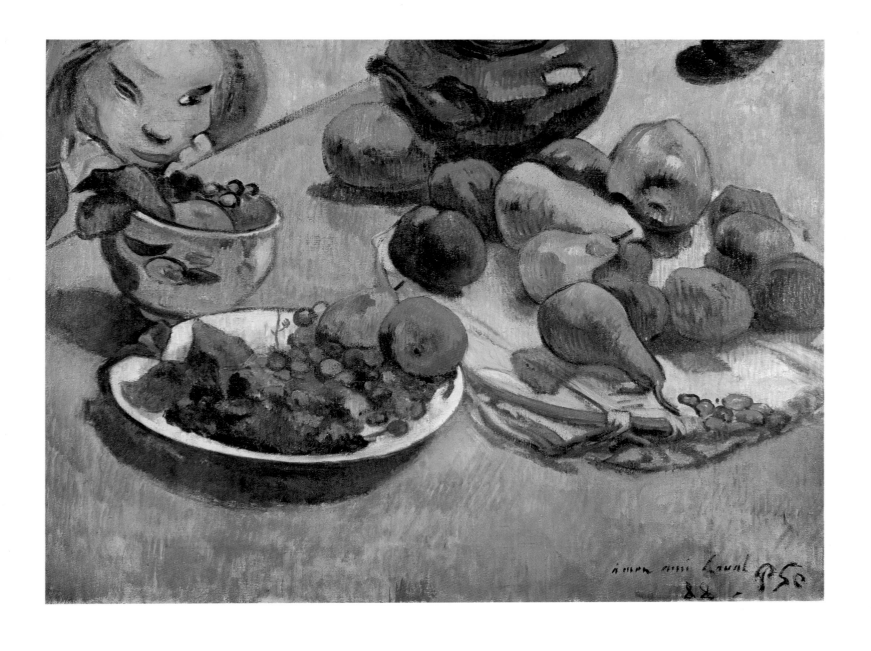

Fruit

1888. Oil on canvas. 43 × 58 cm. (17 × 22¾ in.)
The Pushkin Museum, Moscow

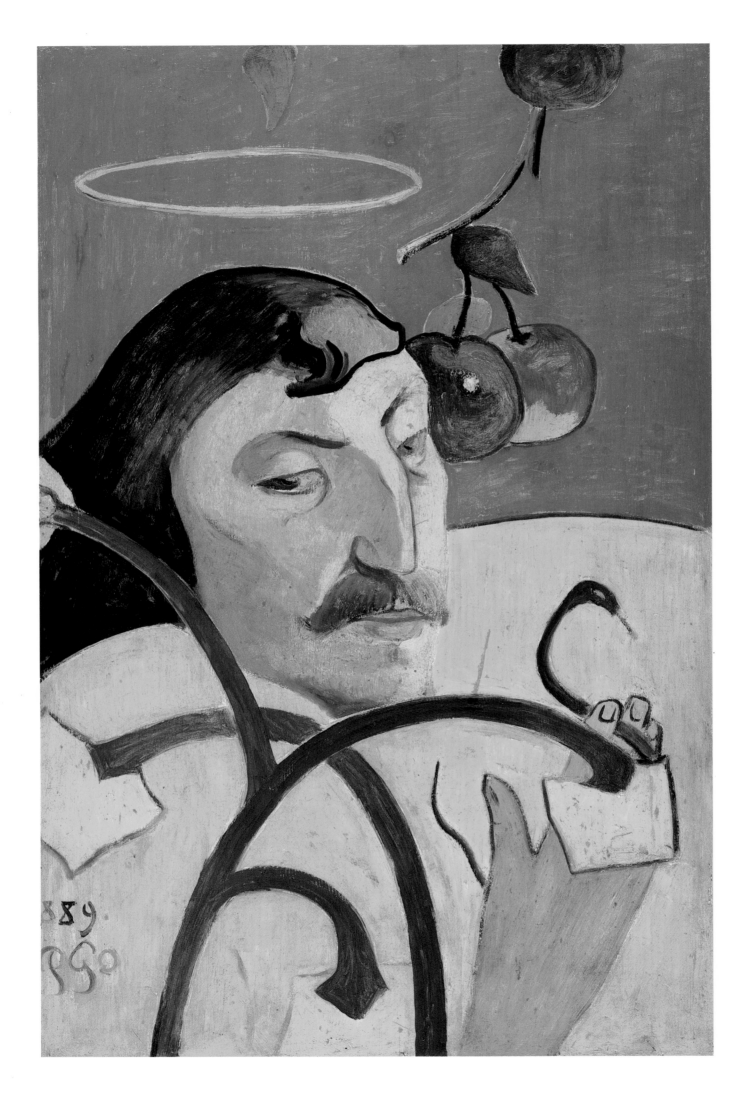

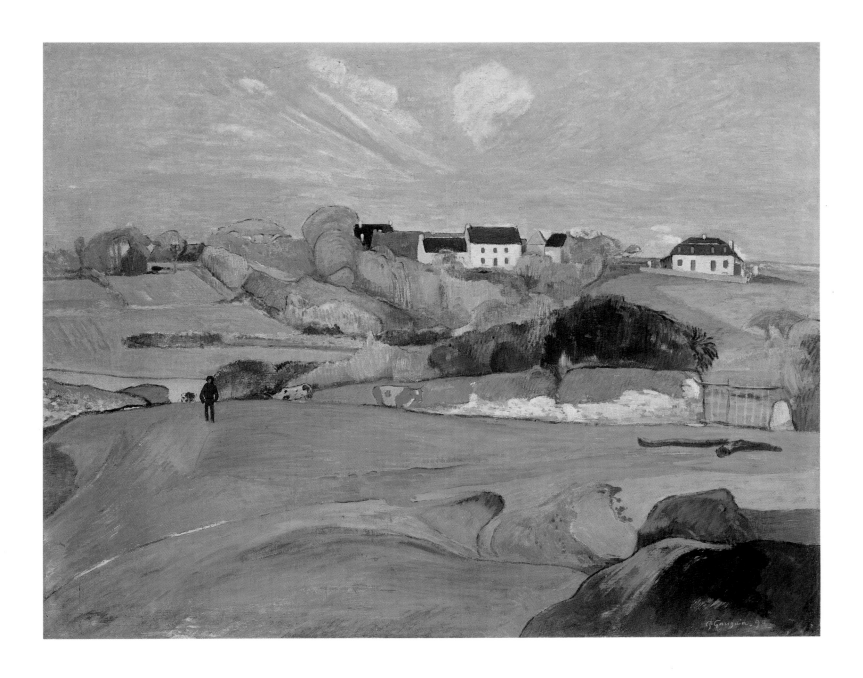

Landscape at Le Pouldu

1890. Oil on canvas. 73.3 × 92.4 cm. (28⅞ × 36⅜ in.)
Collection of Mr. and Mrs. Paul Mellon, National Gallery of Art, Washington

OPPOSITE:

Self-Portrait

1889. Oil on wood. 79.2 × 51.3 cm. (31¼ × 20¼ in.)
Chester Dale Collection, National Gallery of Art, Washington

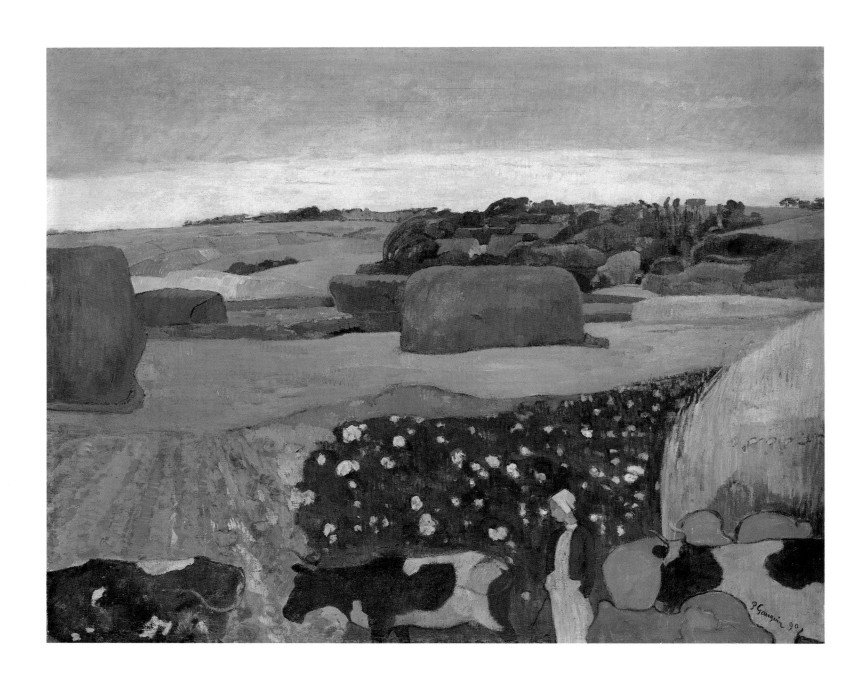

Haystacks in Brittany

1890. Oil on canvas. 74.3 × 93.6 cm. (29¼ × 36⅞ in.)
Gift of the W. Averell Harriman Foundation in memory of Marie N. Harriman,
National Gallery of Art, Washington

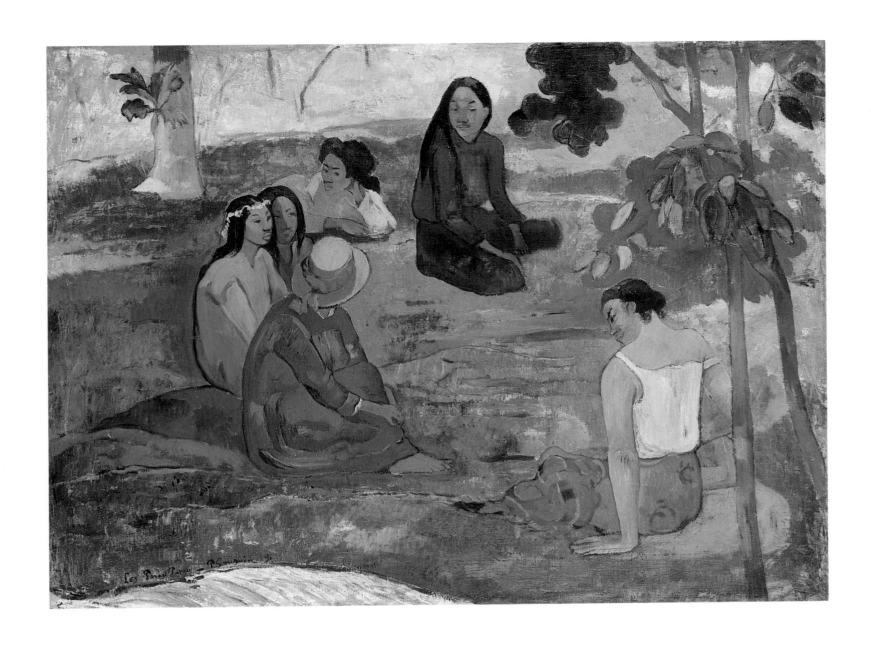

Les Parau Parau (Conversation)

1891. Oil on canvas (relined). 71 × 92.5 cm. (28 × 36½ in.)
The Hermitage, Leningrad

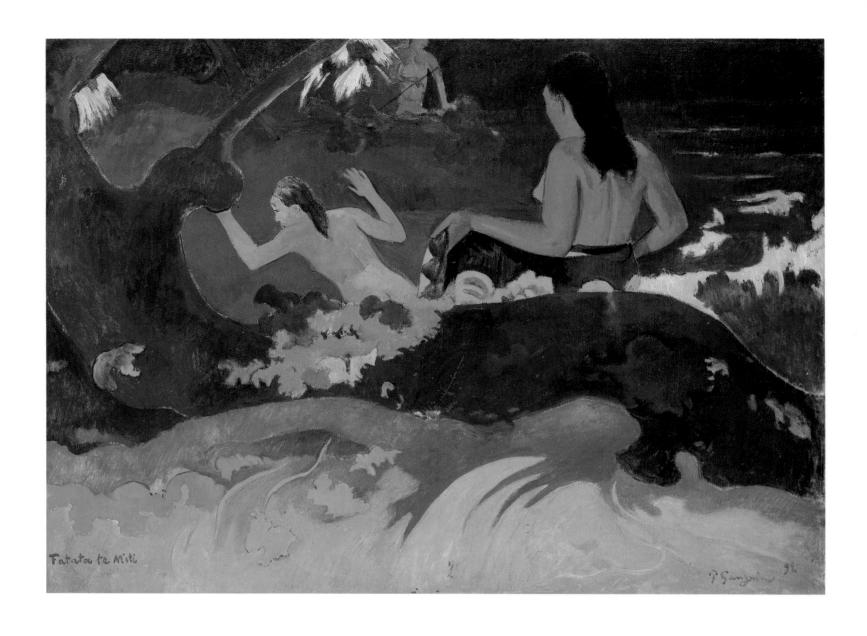

Fatata te Miti (By the Sea)

1892. Oil on canvas. 67.9 × 91.5 cm. (26¾ × 36 in.)
Chester Dale Collection, National Gallery of Art, Washington

OPPOSITE:

Vaïraumati têi oa (Her Name Is Vaïraumati)

1892. Oil on canvas. 91 × 68 cm. (36 × 26¾ in.)
The Pushkin Museum, Moscow

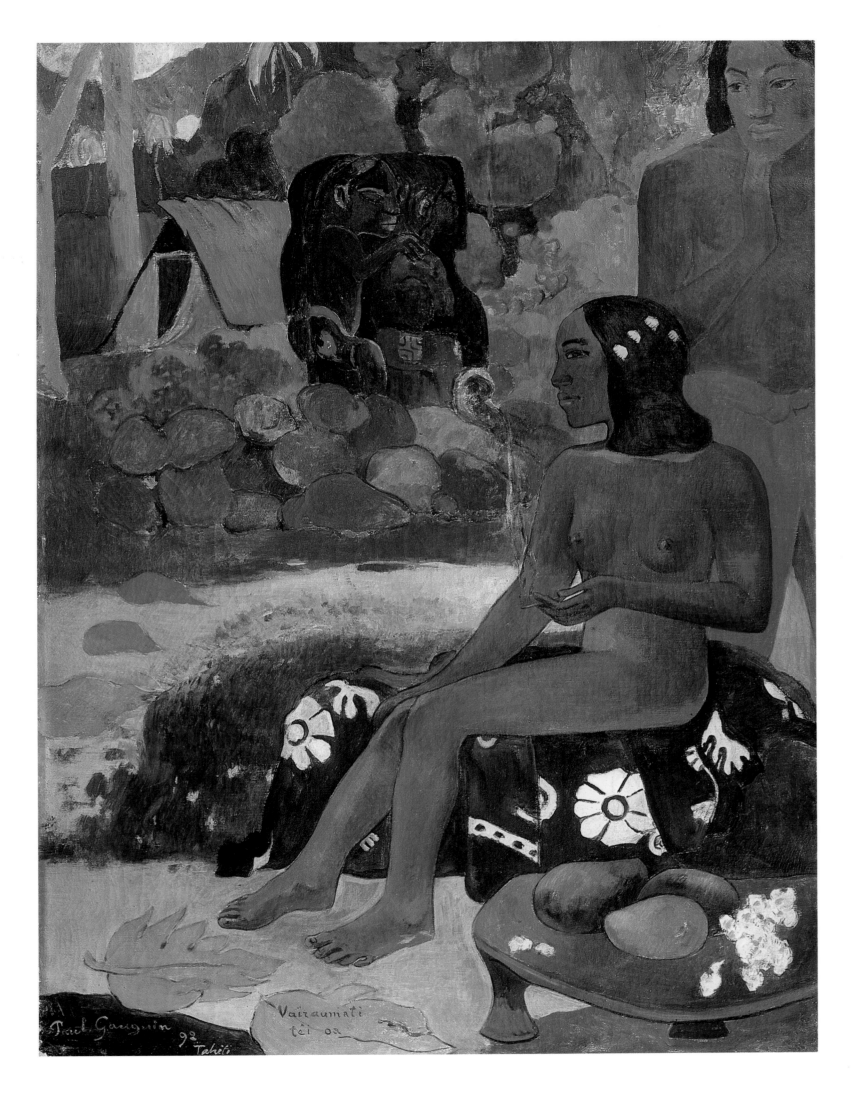

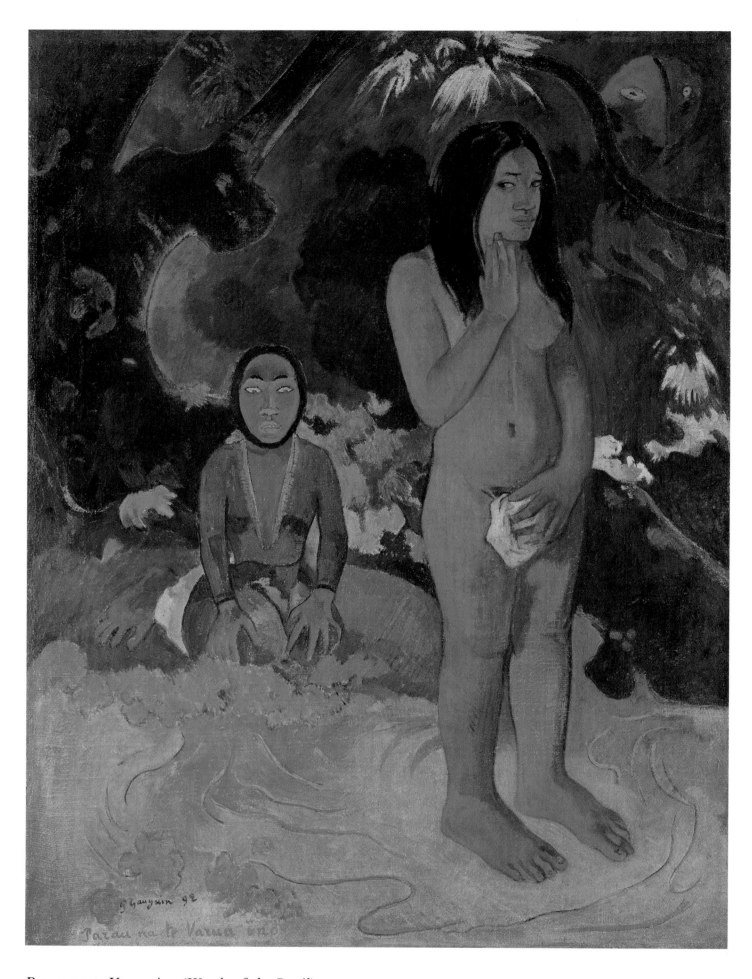

Parau na te Varua ino (Words of the Devil)

1892. Oil on canvas. 91.7 × 68.5 cm. (36⅛ × 27 in.) Gift of the W. Averell Harriman Foundation
in memory of Marie N. Harriman, National Gallery of Art, Washington

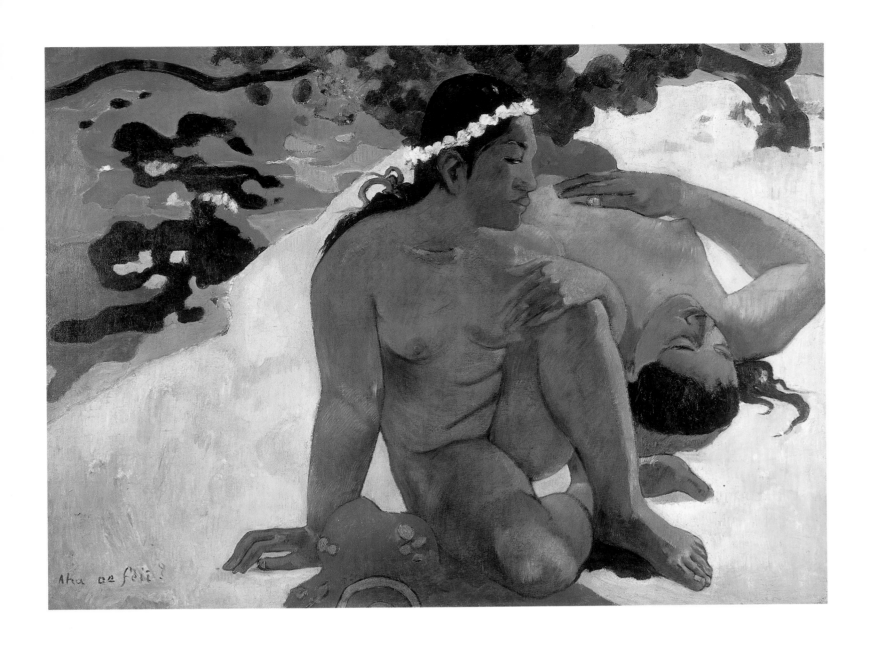

Aha oe feii? (Are You Jealous?)

1892. Oil on canvas. 66 × 89 cm. (26 × 35 in.)
The Pushkin Museum, Moscow

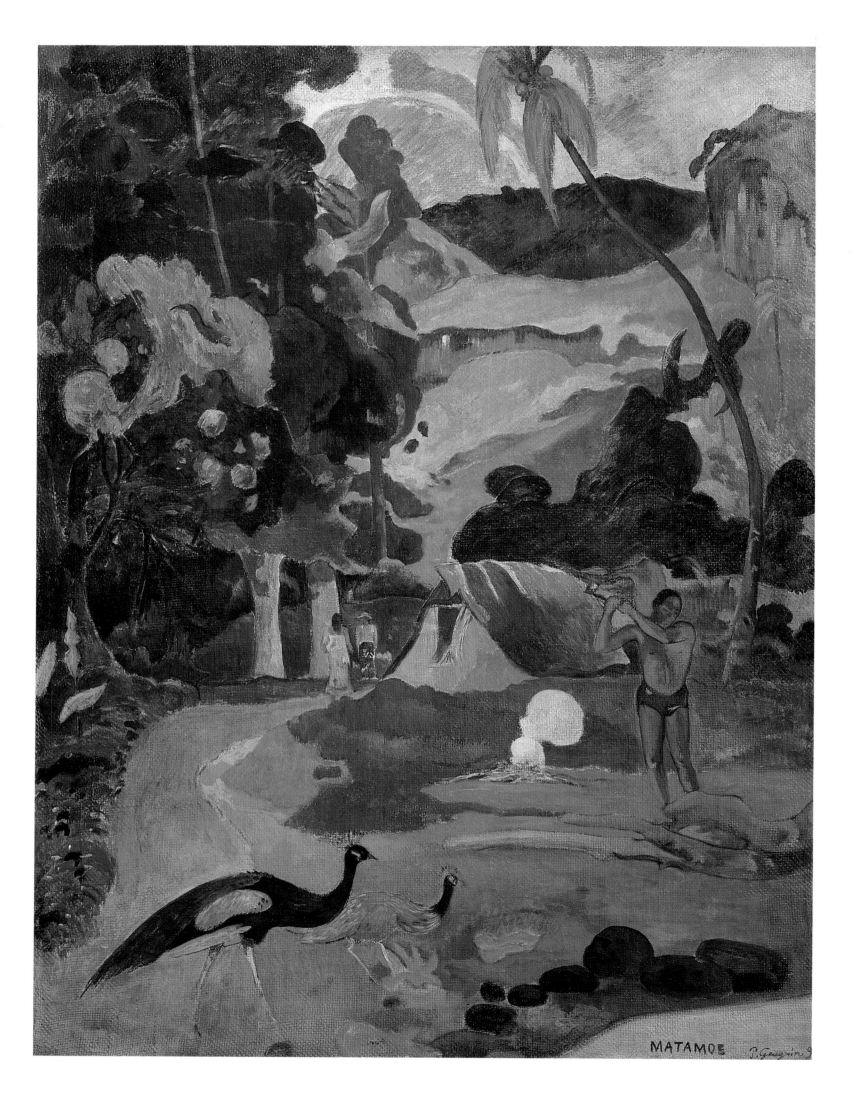

MATAMOE

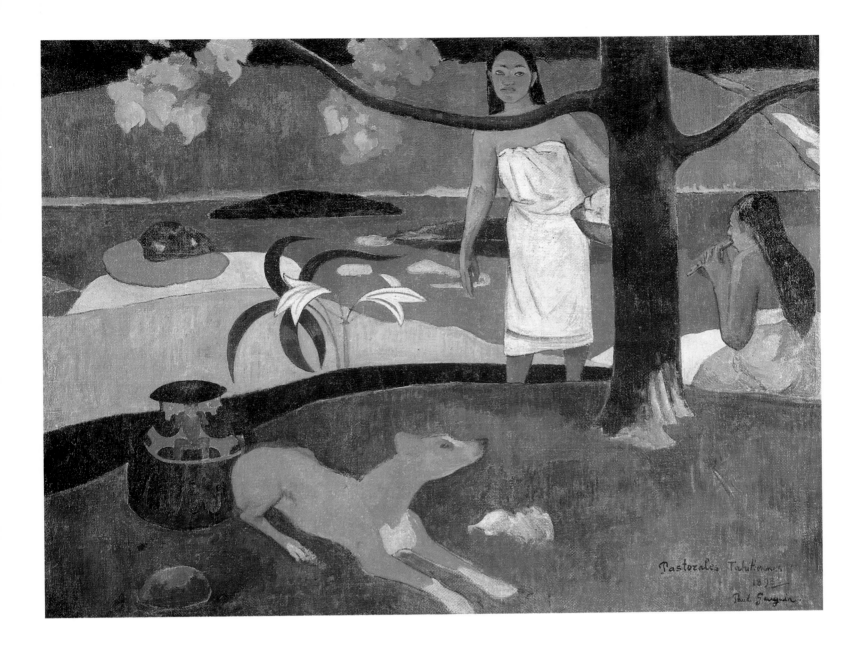

Pastorales Tahitiennes

1893. Oil on canvas. 86 × 113 cm. (33¾ × 44½ in.)
The Hermitage, Leningrad

OPPOSITE:

Matamoe (Landscape with Peacocks)

1892. Oil on canvas. 115 × 86 cm. (45¼ × 33¾ in.)
The Pushkin Museum, Moscow

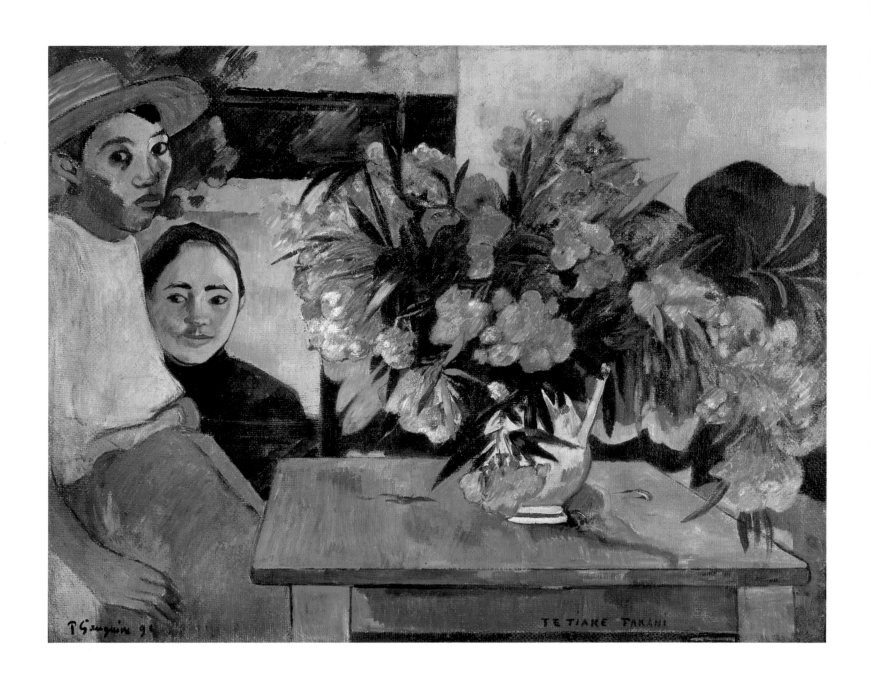

Te Tiare Farani (The Flowers of France)

1891. Oil on canvas. 72 × 92 cm. (28⅜ × 36¼ in.)
The Pushkin Museum, Moscow

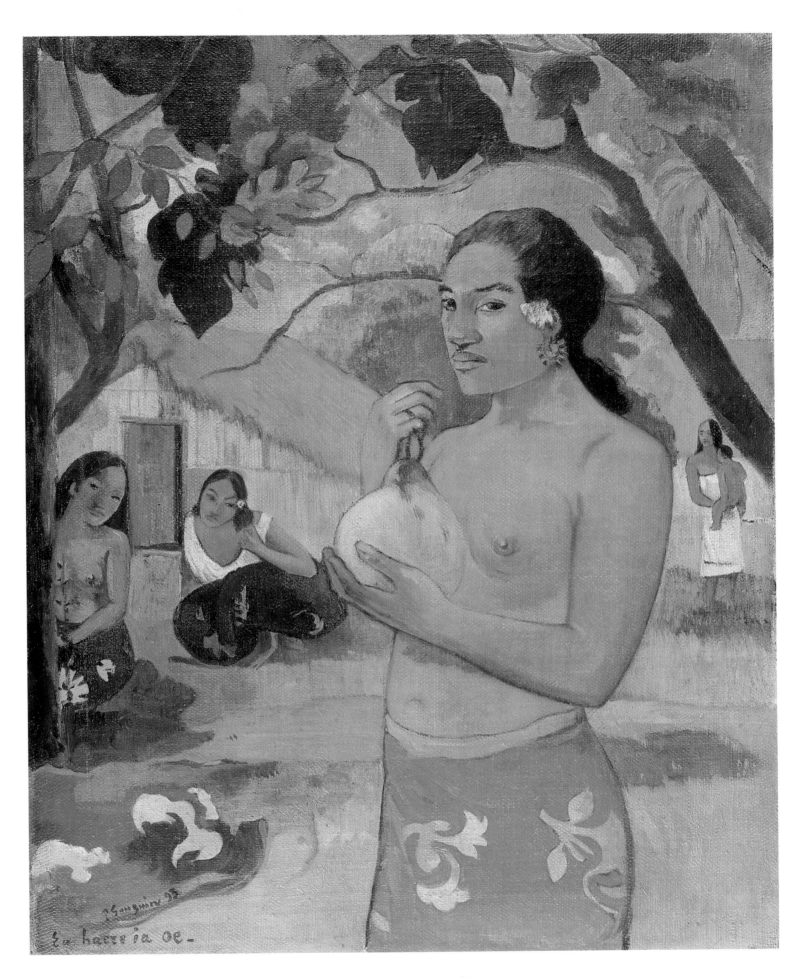

Eu haere ia oe (Woman Holding a Fruit: Where Are You Going?)

1893. Oil on canvas (relined). 92 × 73 cm. (36¼ × 28¾ in.)
The Hermitage, Leningrad

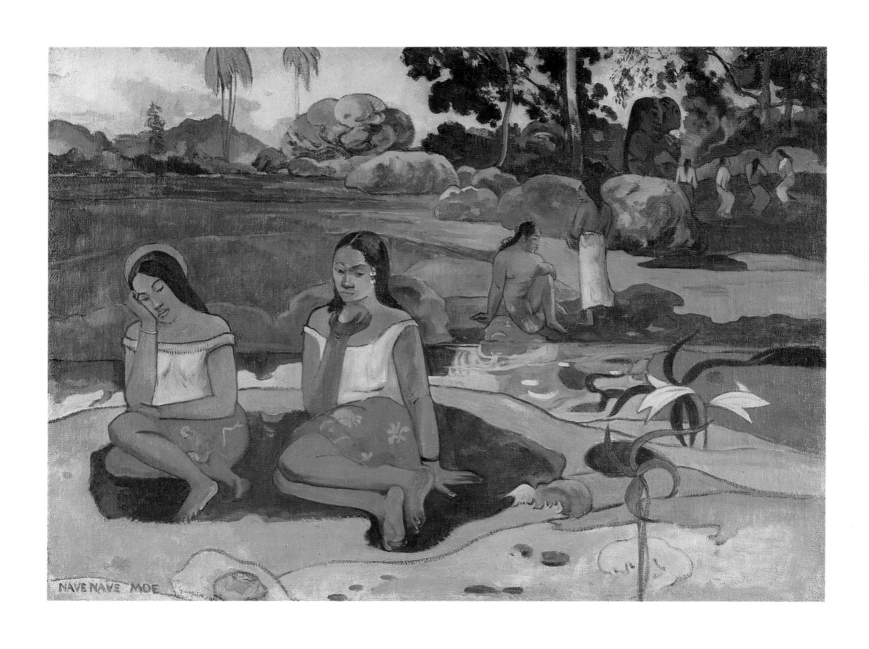

Nave nave moe (Sweet Dreams)

1894. Oil on canvas (relined). 73 × 98 cm. (28¾ × 38½ in.)
The Hermitage, Leningrad

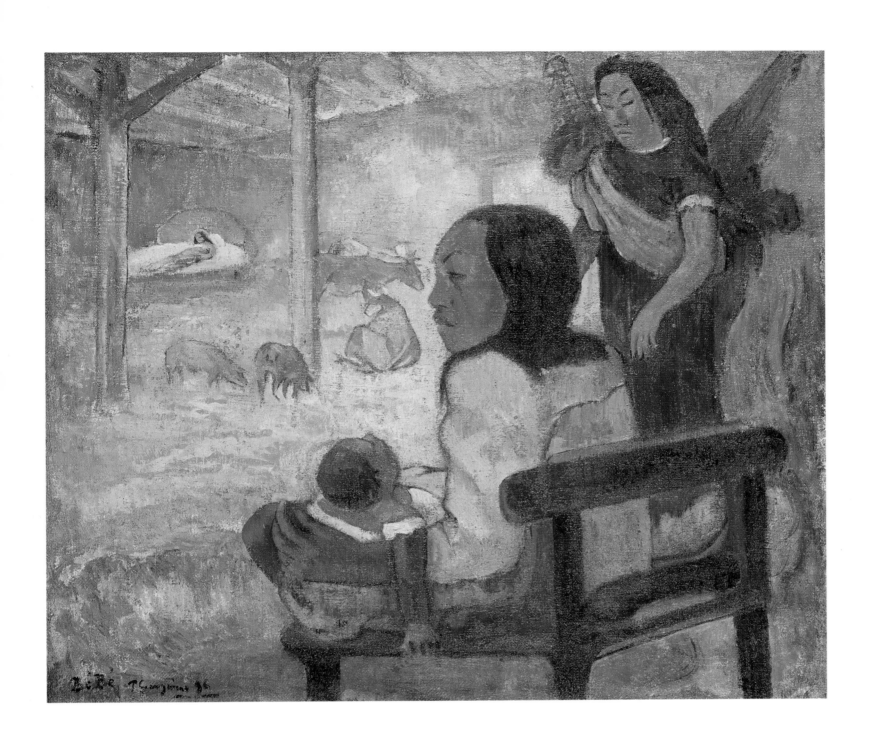

Bé Bé (The Nativity)

1896. Oil on canvas. 66 × 75 cm. (26 × 29½ in.)
The Hermitage, Leningrad

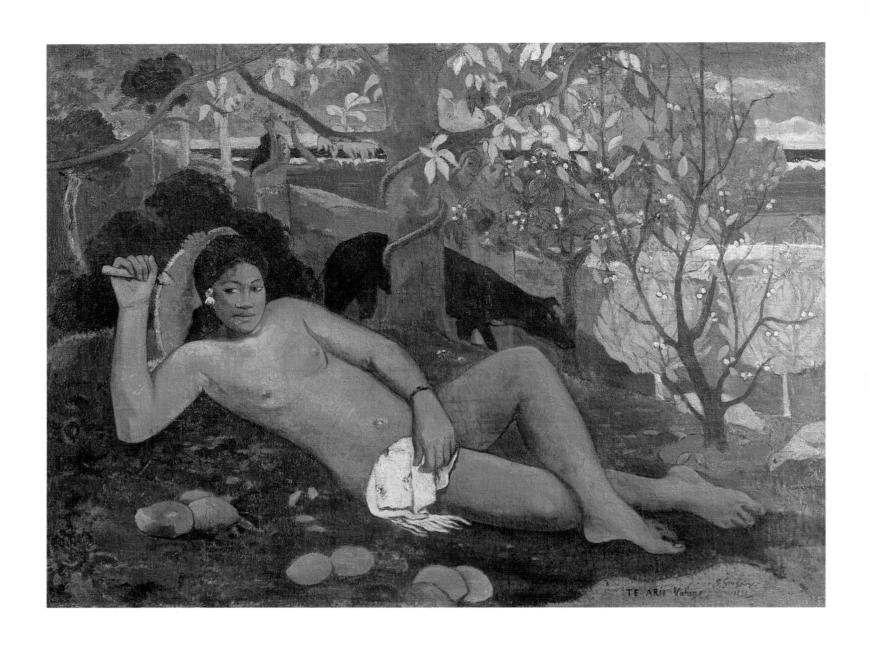

Te Arii Vahine (The King's Wife)

1896. Oil on canvas. 97 × 130 cm. (39 × 51¼ in.)
The Pushkin Museum, Moscow

OPPOSITE:

Te avae no Maria (The Month of Mary)

1899. Oil on canvas. 97 × 72 cm. (39 × 28⅜ in.)
The Hermitage, Leningrad

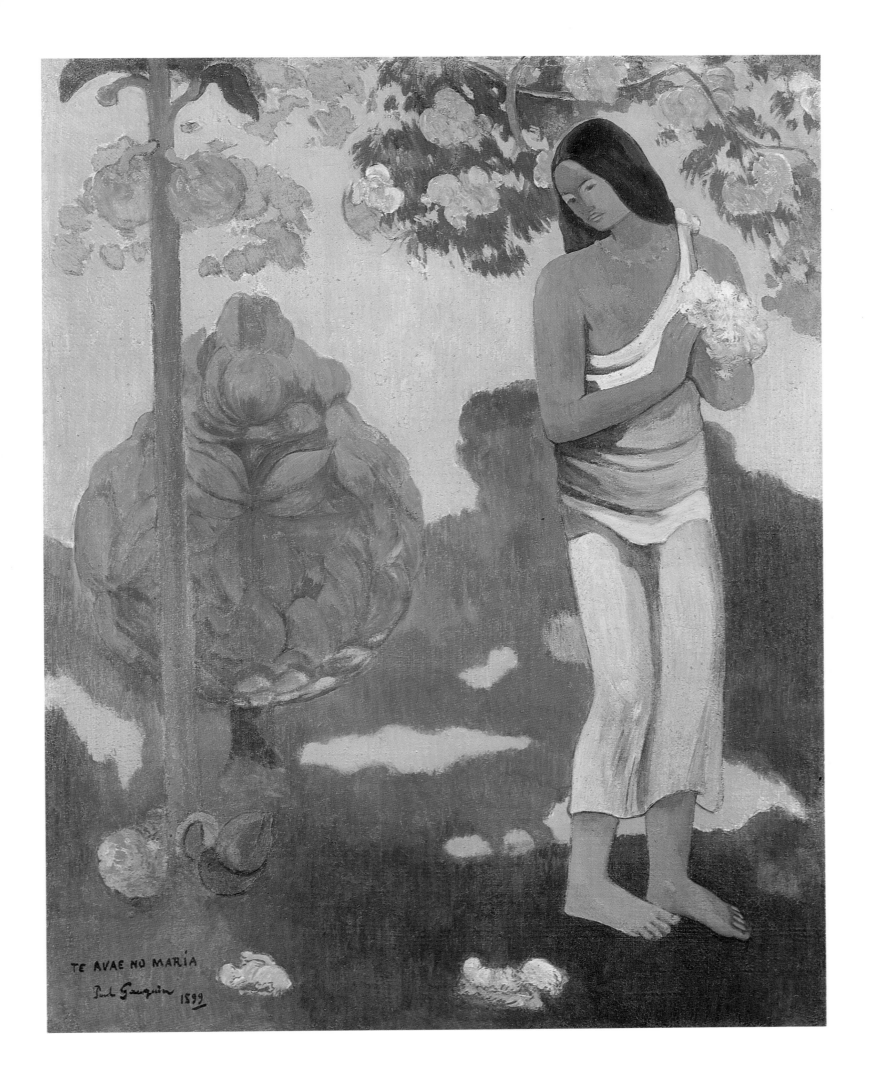

TE AVAE NO MARÍA

Paul Gauguin 1899

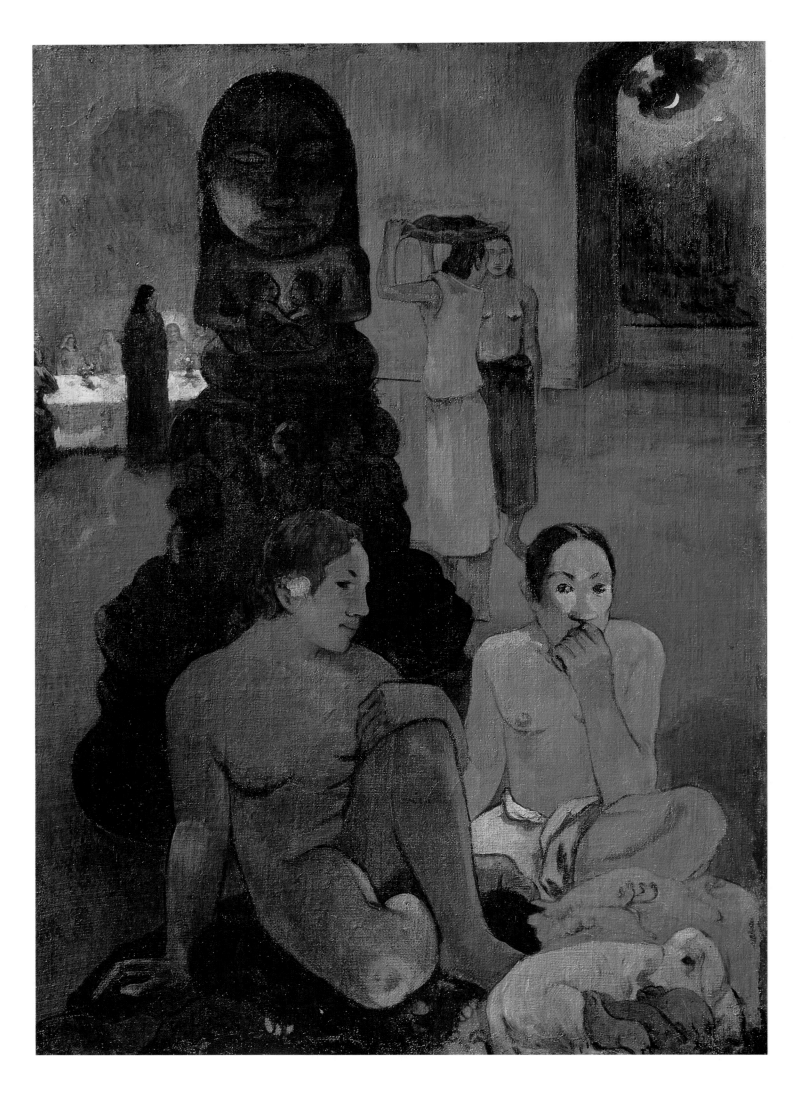

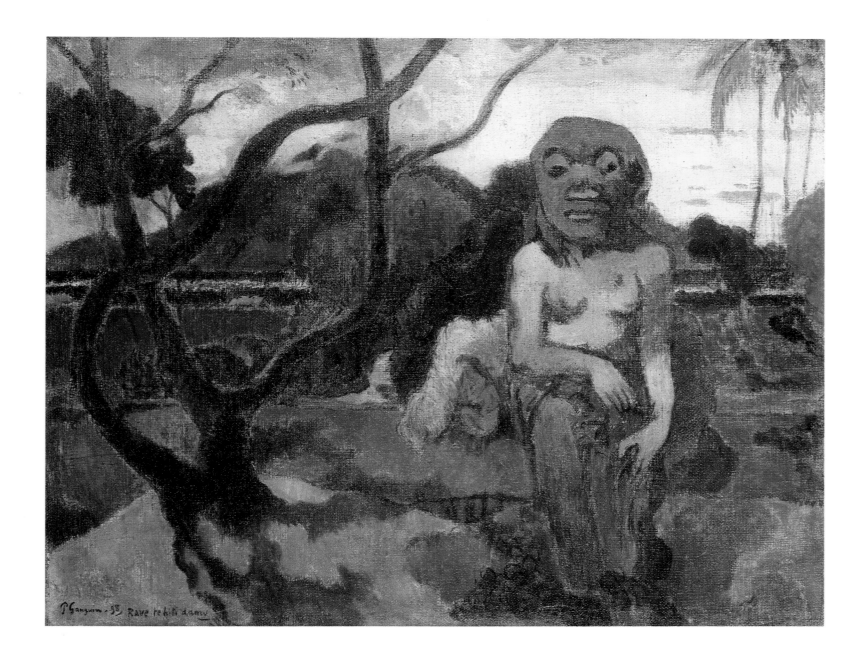

Rave te hiti aamu (The Idol)

1898. Oil on canvas. 73 × 91 cm. (28¾ × 36 in.)
The Hermitage, Leningrad

OPPOSITE:

The Great Buddha

1899. Oil on canvas. 134 × 95 cm. (52¾ × 37½ in.)
The Pushkin Museum, Moscow

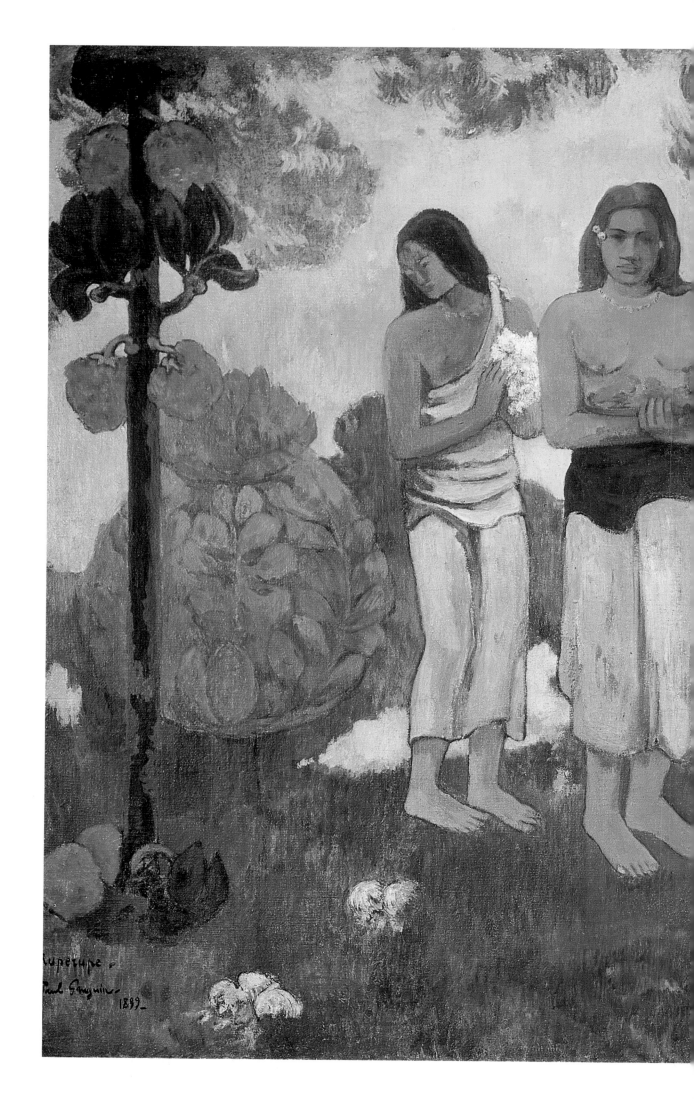

Ruperupe
(Gathering Fruit)

1899. Oil on canvas.
128 × 190 cm.
(50⅜ × 74¾ in.)
The Pushkin Museum,
Moscow

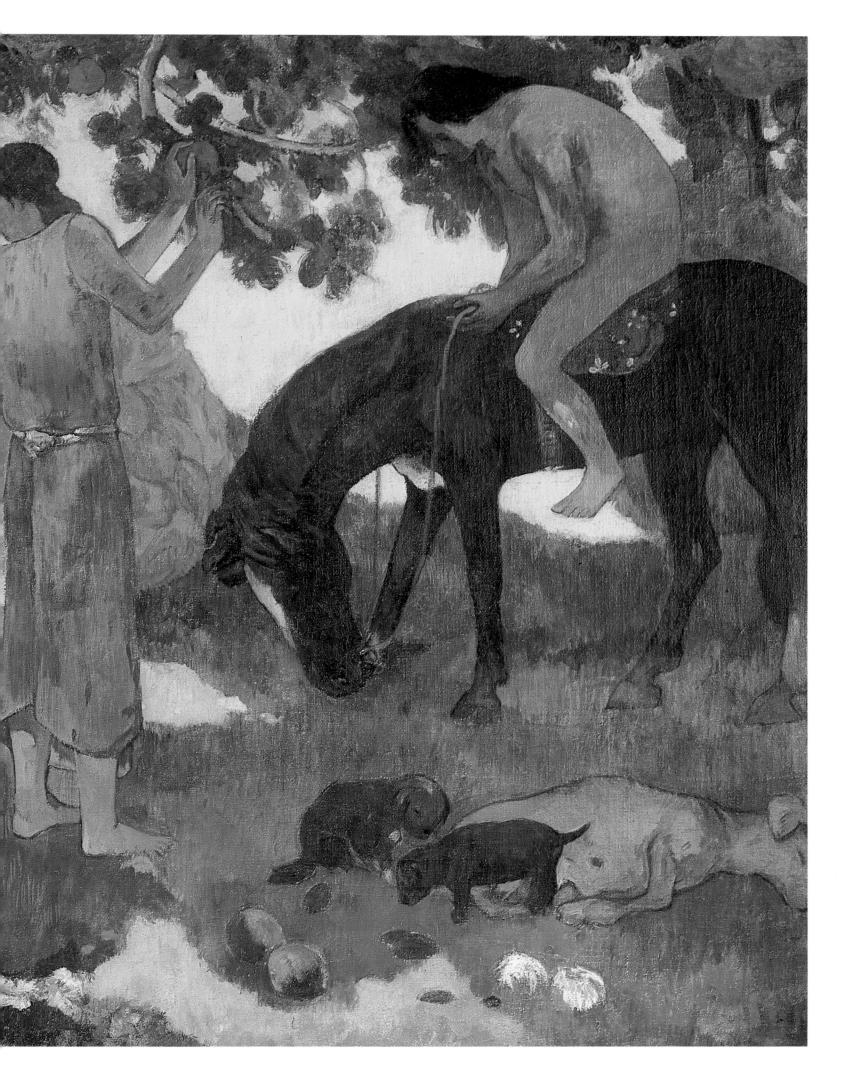

Sunflowers

1901. Oil on canvas. 72 × 91 cm. (28⅜ × 36 in.)
The Hermitage, Leningrad

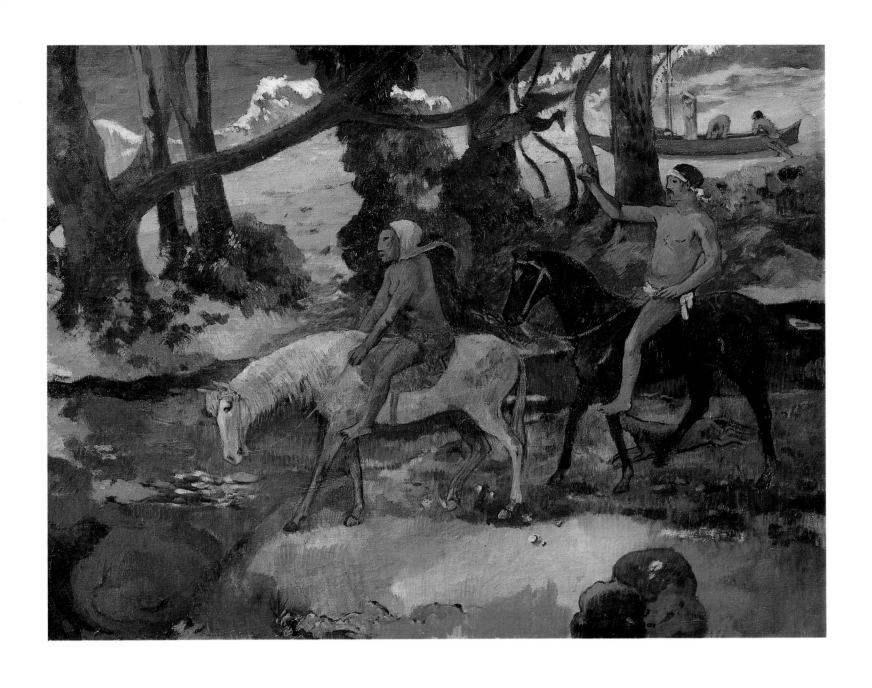

The Ford (The Flight)

1901. Oil on canvas. 76 × 95 cm. (30 × 37½ in.)
The Pushkin Museum, Moscow

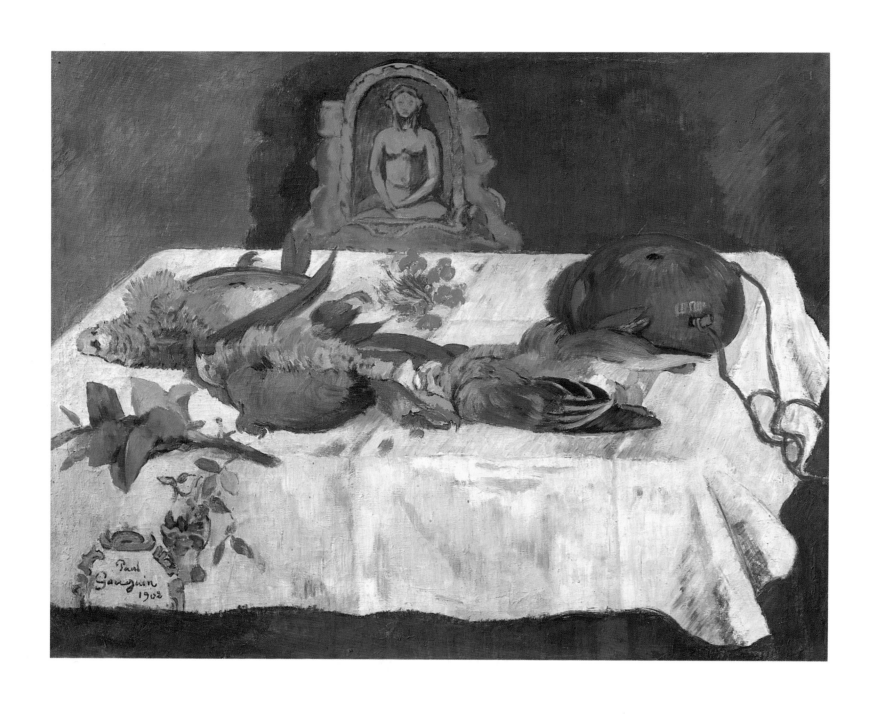

Still Life with Parrots

1902. Oil on canvas. 62 × 76 cm. (24½ × 30 in.)
The Pushkin Museum, Moscow

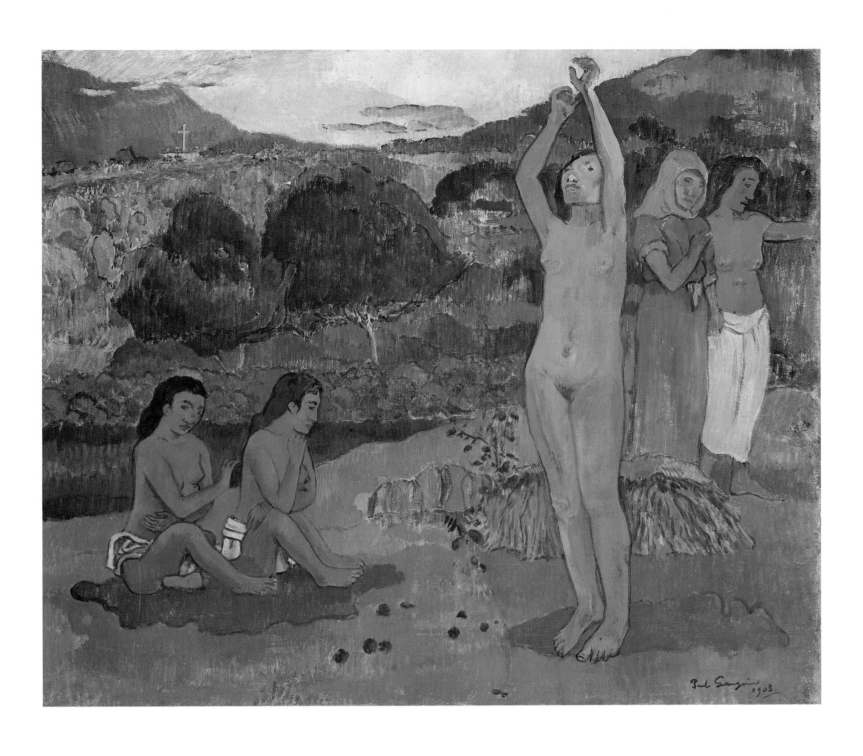

The Invocation

1903. Oil on canvas. 65.5 × 75.6 cm. (25¾ × 29¾ in.)
Gift from the Collection of John and Louise Booth in memory of their daughter,
Winkie, National Gallery of Art, Washington

HENRI ROUSSEAU
1844–1910

HENRI ROUSSEAU, often called Le Douanier (customs officer), came of a tinsmith's family of the town of Laval. He studied at the Lycée in his native town. In order to get away from home, he joined the army, serving as a regimental bandsman from 1864 to 1868. After leaving the army, he married and settled in the Plaisance quarter of Paris, inhabited mostly by artisans. In 1870, he entered the customs service: hence his nickname. According to Rousseau, he received valuable artistic advice from Gérôme and Clément. In 1884, he retired from the customs service and began painting steadily. In 1886, at the age of forty-two, he first exhibited at the Salon des Indépendants. His work of this period, however, remained unnoticed. Signac was the first to pay attention to Rousseau's naive style, which seemed to stem from primitive folk art.

Picasso, Apollinaire, and Delaunay admired his talent and in 1908 organized a banquet in his honor at Picasso's studio in the Bateau-Lavoir. A close friend of the poet Alfred Jarry, author of the play *Ubu roi,* Rousseau also composed music and wrote poetry and plays.

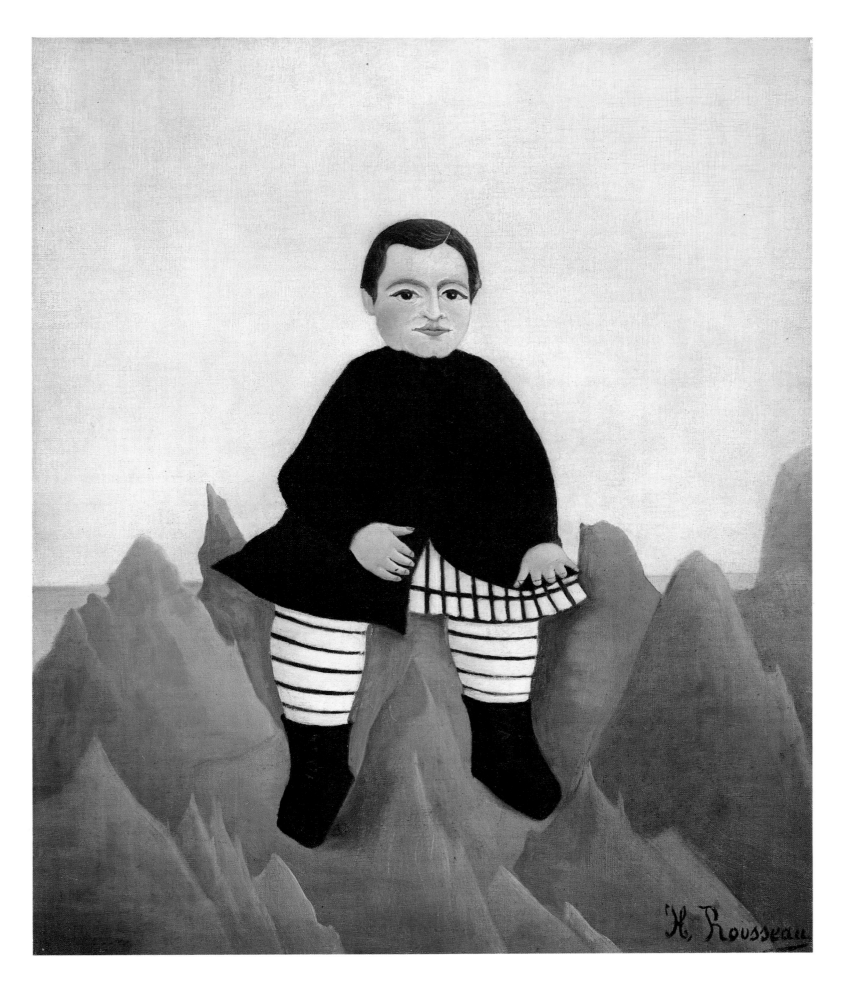

Boy on the Rocks

1895–97. Oil on canvas. 55.4 × 45.7 cm. (21¾ × 18 in.)
Chester Dale Collection, National Gallery of Art, Washington

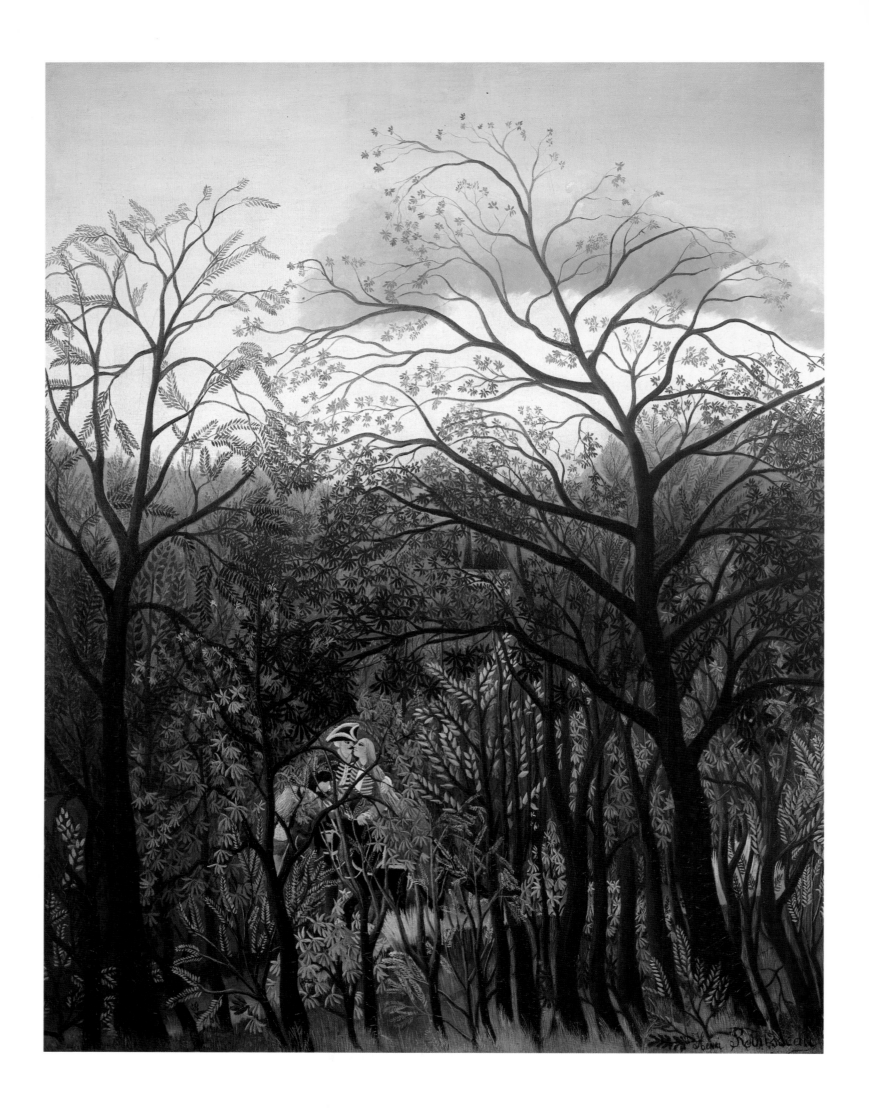

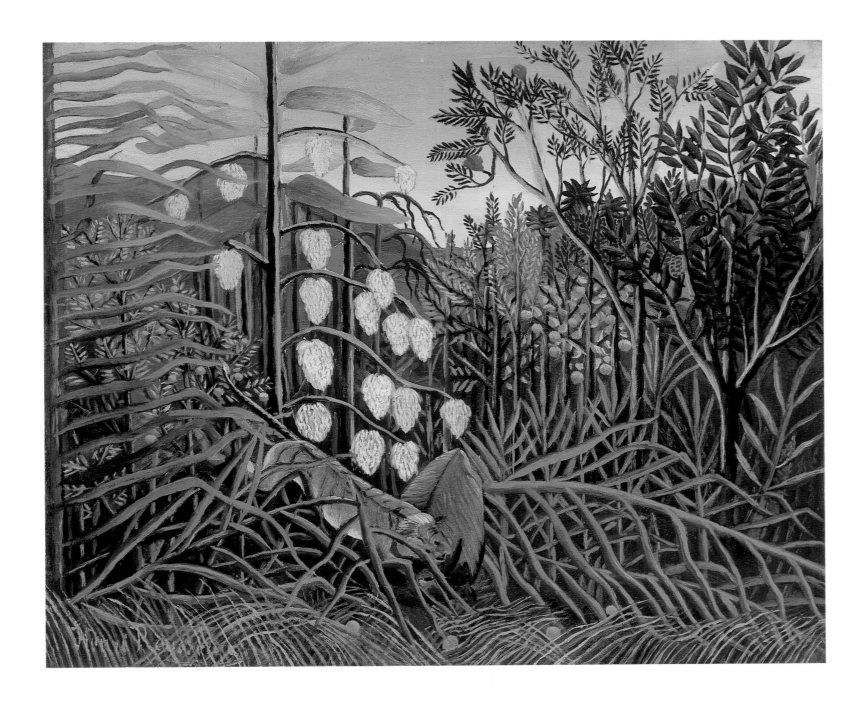

In a Tropical Forest: Struggle Between Tiger and Bull

c. 1908–9. Oil on canvas. 46 × 55 cm. (18⅛ × 21⅝ in.)
The Hermitage, Leningrad

OPPOSITE:

Rendezvous in the Forest

1889. Oil on canvas. 92 × 73 cm. (36¼ × 28¾ in.)
Gift of the W. Averell Harriman Foundation in memory of Marie N. Harriman,
National Gallery of Art, Washington

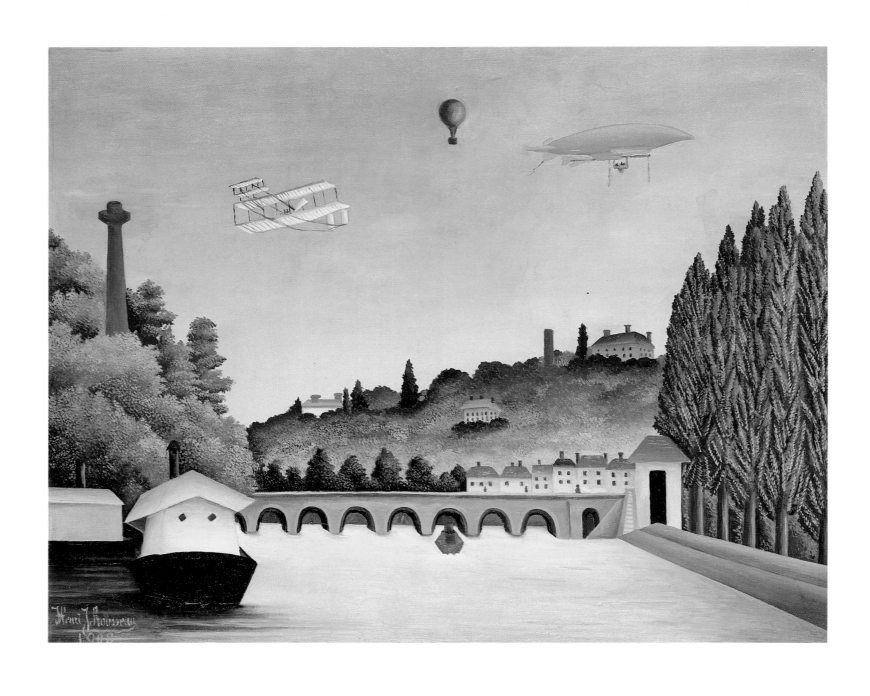

View of the Sèvres Bridge and the Hills of Clamart, Saint-Cloud, and Bellevue

1908. Oil on canvas. 80 × 102 cm. (31½ × 40 in.)
The Pushkin Museum, Moscow

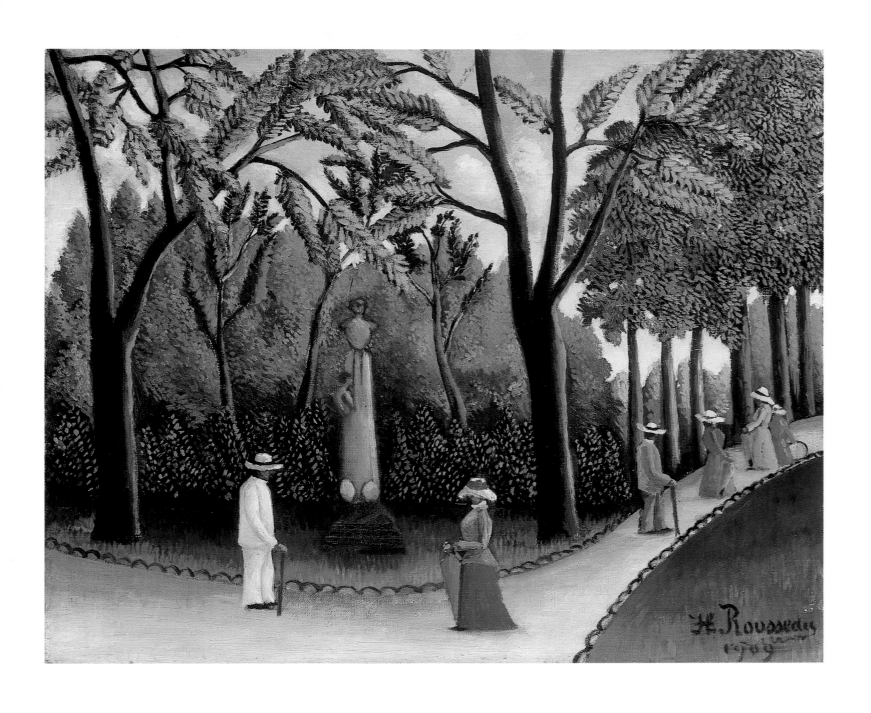

The Chopin Memorial in the Luxembourg Gardens

1909. Oil on canvas. 38 × 47 cm. (15 × 18½ in.)
The Hermitage, Leningrad

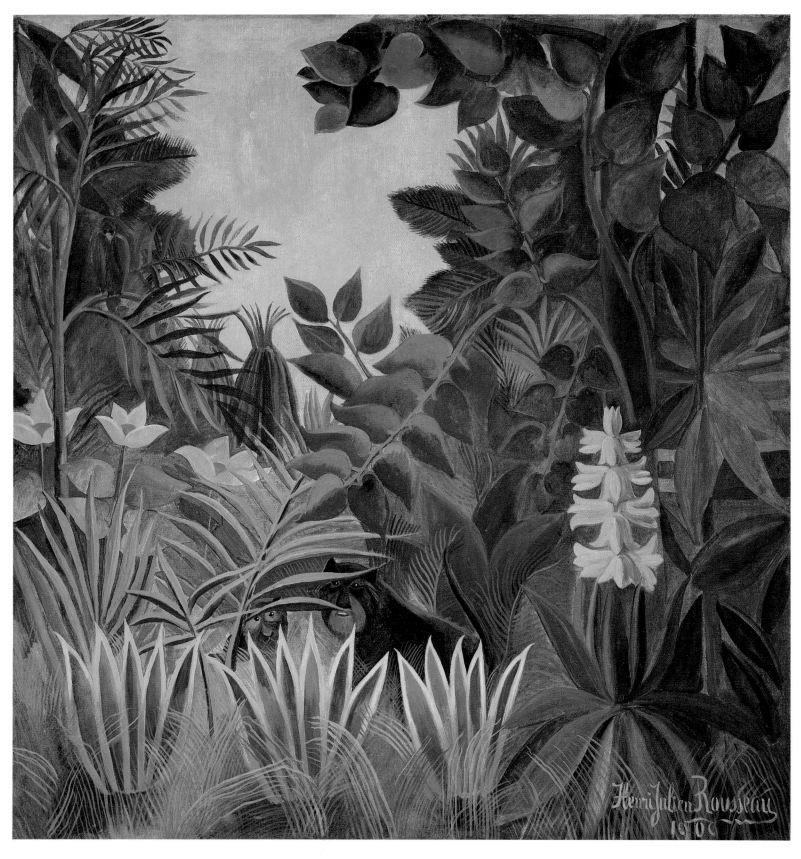

The Equatorial Jungle

1909. Oil on canvas. 140.6 × 129.5 cm. (55¼ × 51 in.) Chester Dale Collection, National Gallery of Art, Washington

OPPOSITE:

The Poet and His Muse: Portrait of Apollinaire and Marie Laurencin

1909. Oil on canvas. 131 × 97 cm. (51½ × 38 in.) The Pushkin Museum, Moscow

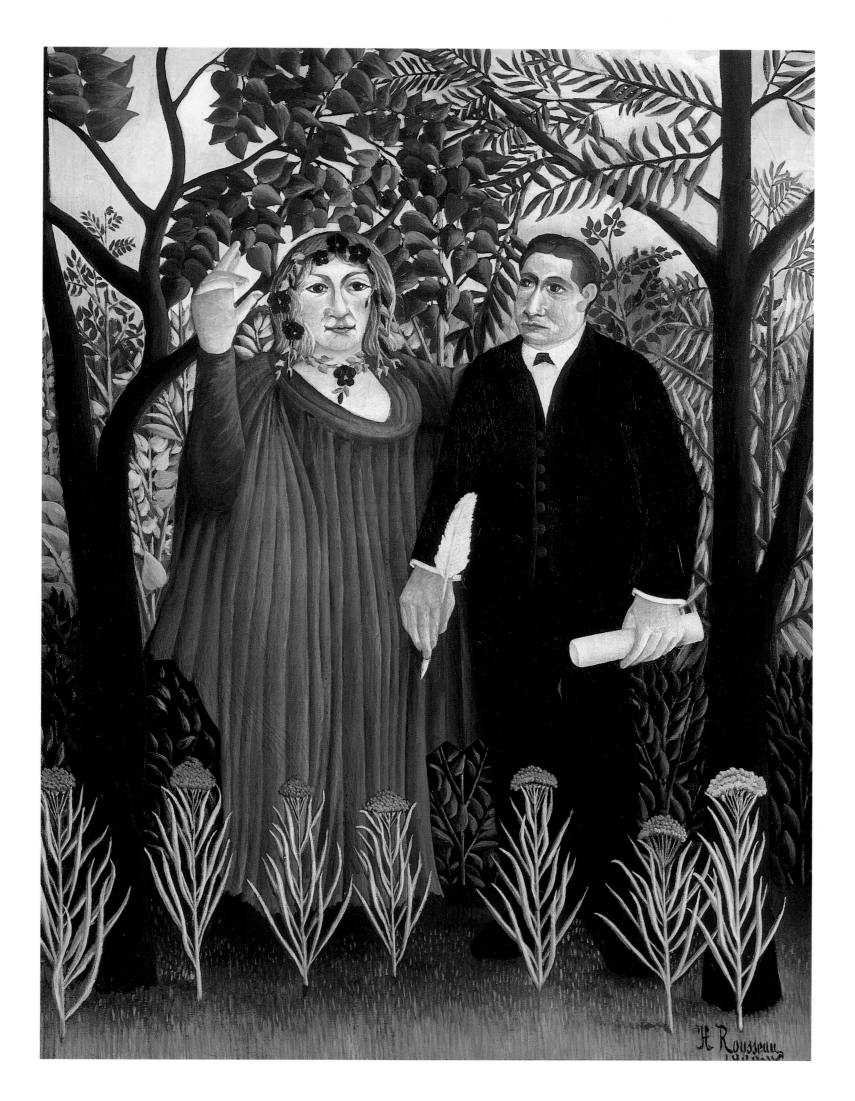

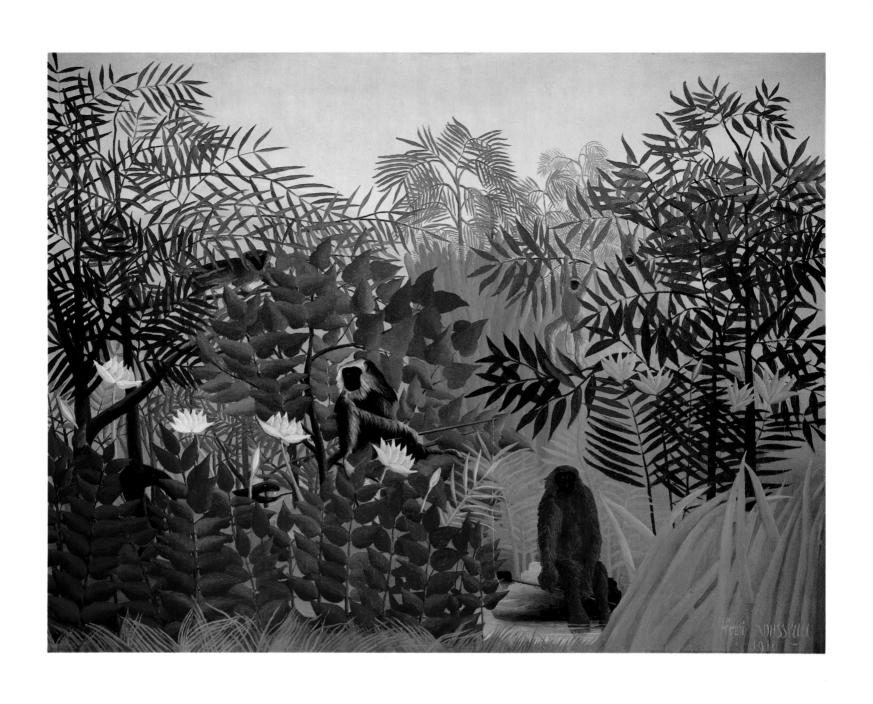

Tropical Forest with Monkeys

1910. Oil on canvas. 129.5 × 162.6 cm. (51 × 64 in.)
John Hay Whitney Collection, National Gallery of Art, Washington

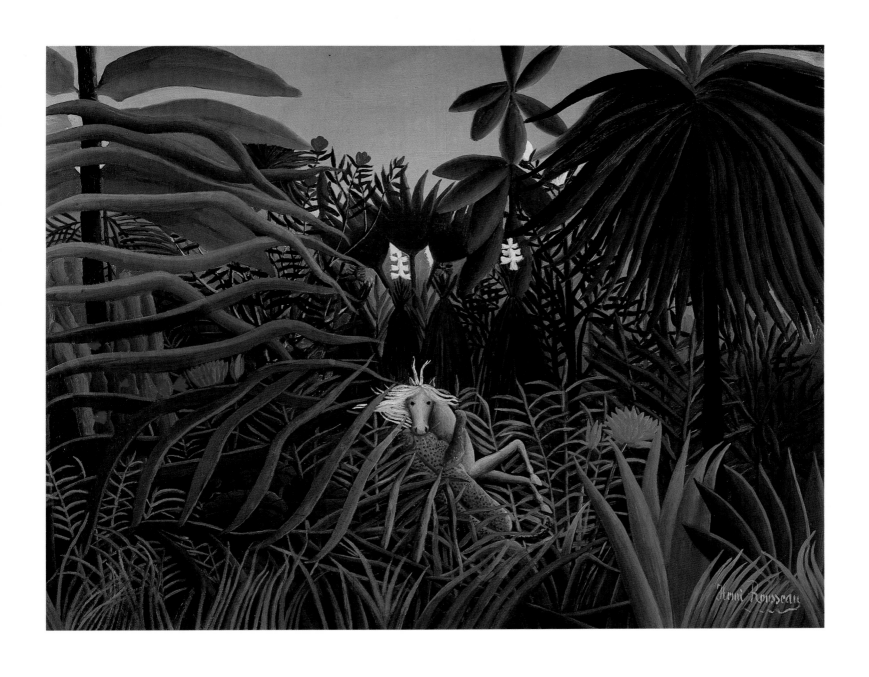

Jaguar Attacking a Horse

1910. Oil on canvas. 90 × 116 cm. (35½ × 45½ in.)
The Pushkin Museum, Moscow

HENRI DE TOULOUSE-LAUTREC
1864–1901

HENRI DE TOULOUSE-LAUTREC, the great portrayer of Paris's demimonde, was aristocratic by birth, a descendant of the Counts of Toulouse and the Viscounts of Lautrec. From an early age, he was a prolific and observant draftsman of people and animals. Accidental falls in 1878 and 1879 broke both his legs, preventing their further growth and leaving him deformed. In 1878, he studied painting with Princeteau in his native Albi, and in 1881, he went to Paris, where he entered the studio of Bonnat and then of Cormon, under the aegis of the Ecole Nationale des Beaux-Arts.

By 1885, Lautrec was living in Montmartre and beginning to frequent the circuses, cafés, cabarets, and ballrooms that would provide the subjects for most of his work. He evolved an ever more immediate and vibrant style to capture the rhythms, movements, gestures, and expressions of popular entertainers and their audience. He adopted the odd, camera-angle views of Degas, whom he greatly admired, but placed more emphasis on linear outline and human characterization. Lautrec was immersed in the world of the singers, dancers, actors, prostitutes, and ordinary neighborhood

people that he depicted with such acuity and sympathy.

In 1891, Lautrec designed his first poster, advertising the dancers La Goulue and Valentin le Désossé at the Moulin Rouge. There followed a succession of such works for various establishments, works that essentially transformed this genre, creating dramatic effects with sudden perspectives and simplified cutout shapes derived from Japanese woodcuts, and continuous, arabesque linear patterns in the organic style of Art Nouveau. Some of his paintings have the theatrical qualities of his posters, but Lautrec painted the environs of dressing rooms and brothels with a greater attention to intimate and unguarded gestures and attitudes, the other side of performance.

After several years of intensive activity, Lautrec practically stopped working in 1898, when his health began to deteriorate. Still, he managed to produce a series of circus drawings in colored pencils, illustrations for Jules Renard's *Histoires naturelles*, and several powerful, thickly painted canvases before his death.

The Artist's Dog Flèche

c. 1881. Oil on wood. 23.4 × 14.1 cm. (9¼ × 5½ in.)
Ailsa Mellon Bruce Collection, National Gallery of Art, Washington

Carmen Gaudin

1885. Oil on wood. 23.8 × 14.9 cm. (9⅜ × 5⅞ in.)
Ailsa Mellon Bruce Collection, National Gallery of Art, Washington

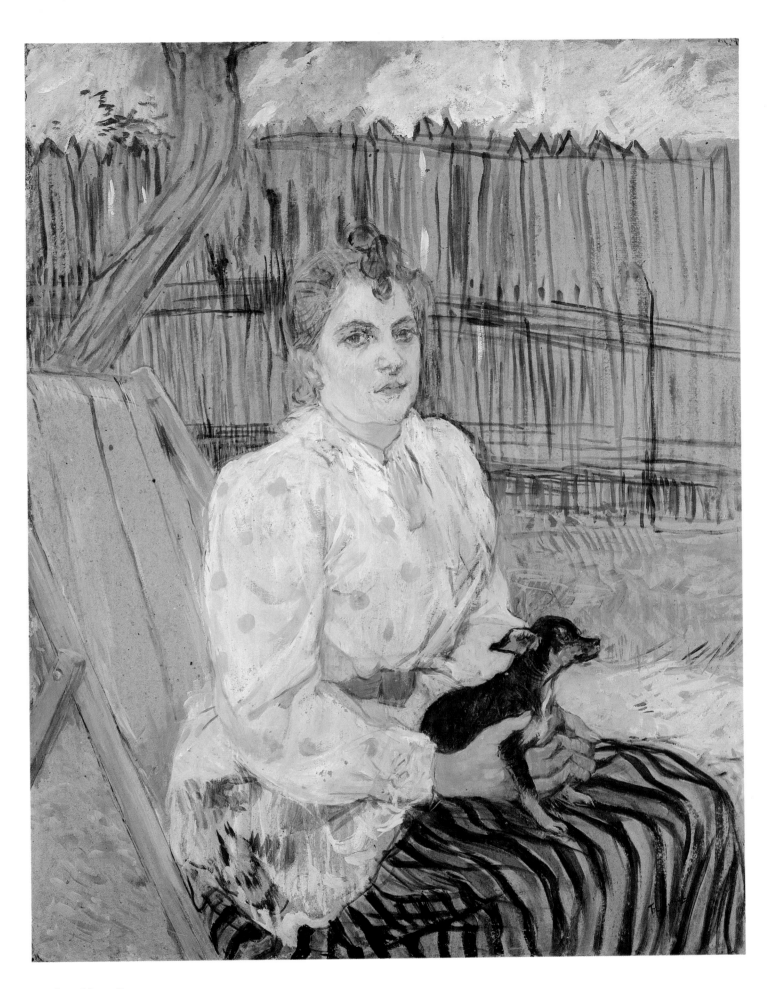

Lady with a Dog

1891. Oil on cardboard. 75 × 57.2 cm. (29½ × 22½ in.) Gift of the W. Averell Harriman
Foundation in memory of Marie N. Harriman, National Gallery of Art, Washington

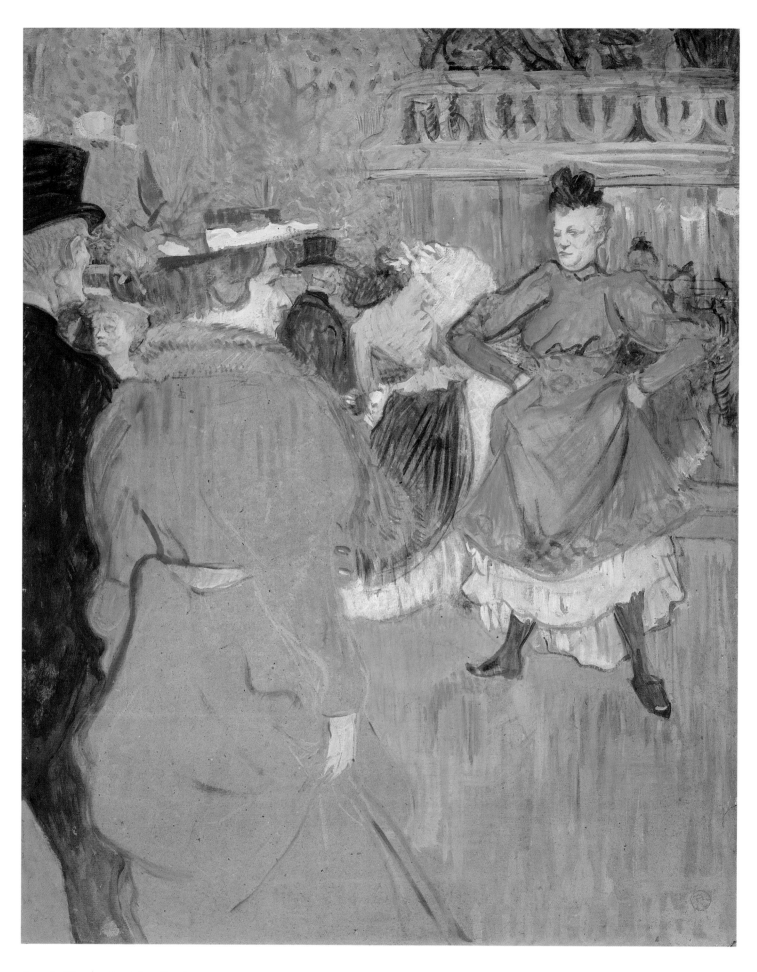

Quadrille at the Moulin Rouge

1892. Gouache on cardboard. 80.1 × 60.5 cm. (31½ × 23¾ in.)
Chester Dale Collection, National Gallery of Art, Washington

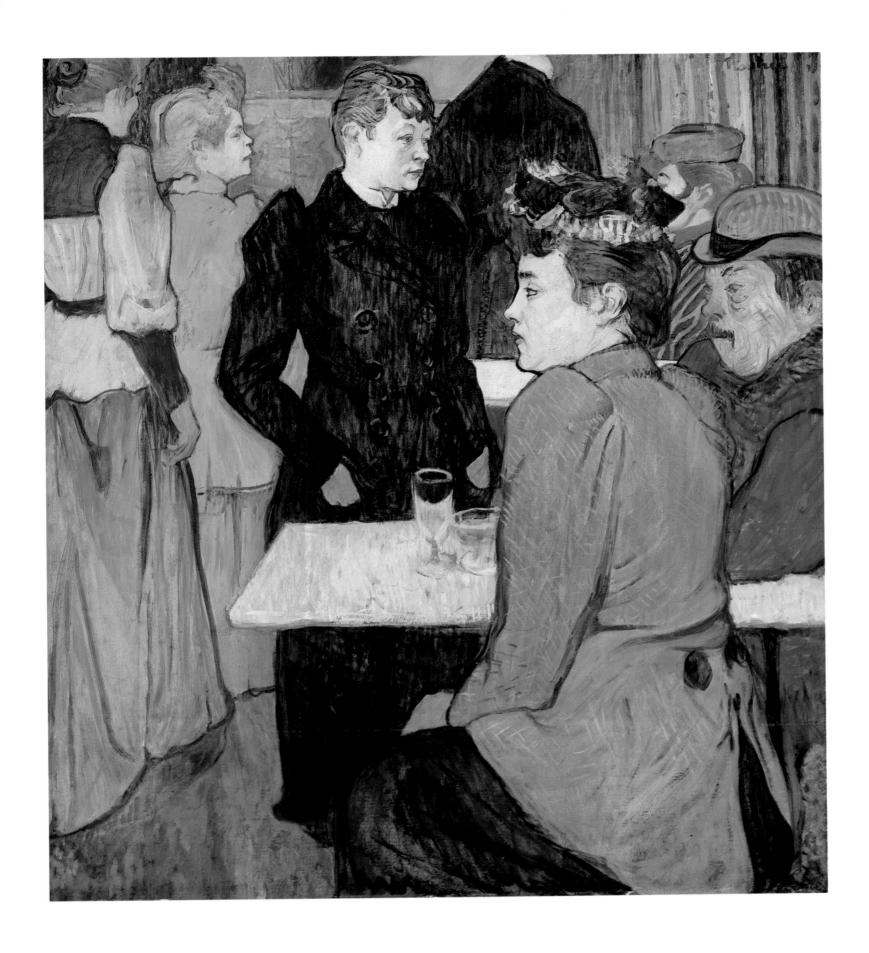

A Corner of the Moulin de la Galette

1892. Oil on cardboard mounted on wood. 100.3 × 89.1 cm. (39½ × 35⅛ in.)
Chester Dale Collection, National Gallery of Art, Washington

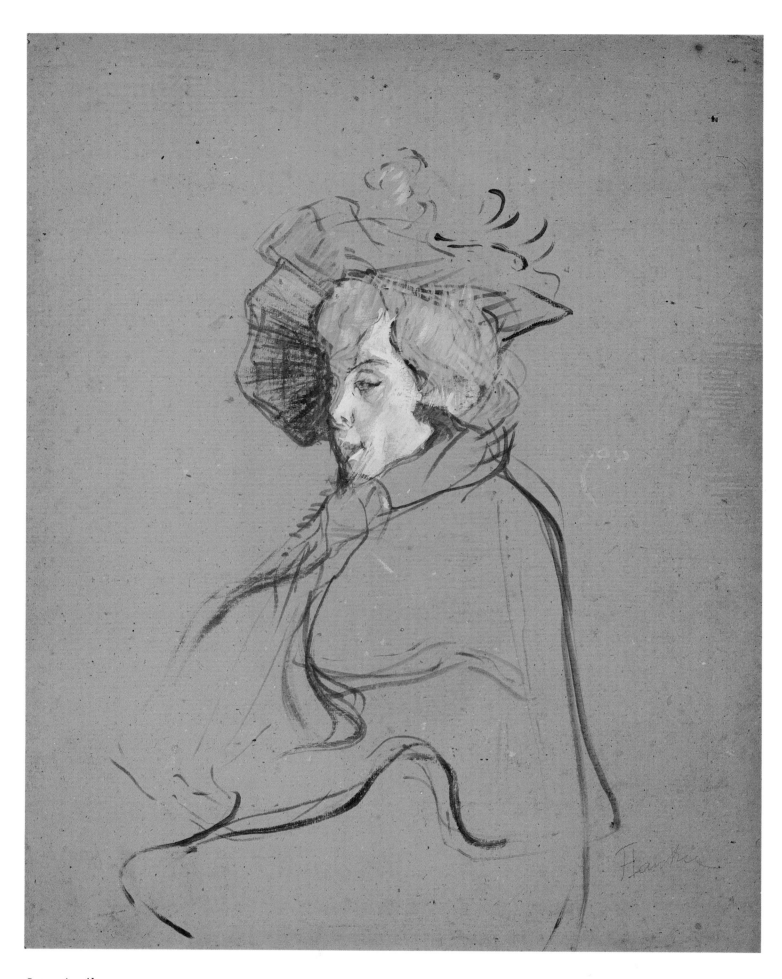

Jane Avril

1892. Oil on cardboard mounted on wood. 67.8 × 52.9 cm. (26¾ × 20⅞ in.)
Chester Dale Collection, National Gallery of Art, Washington

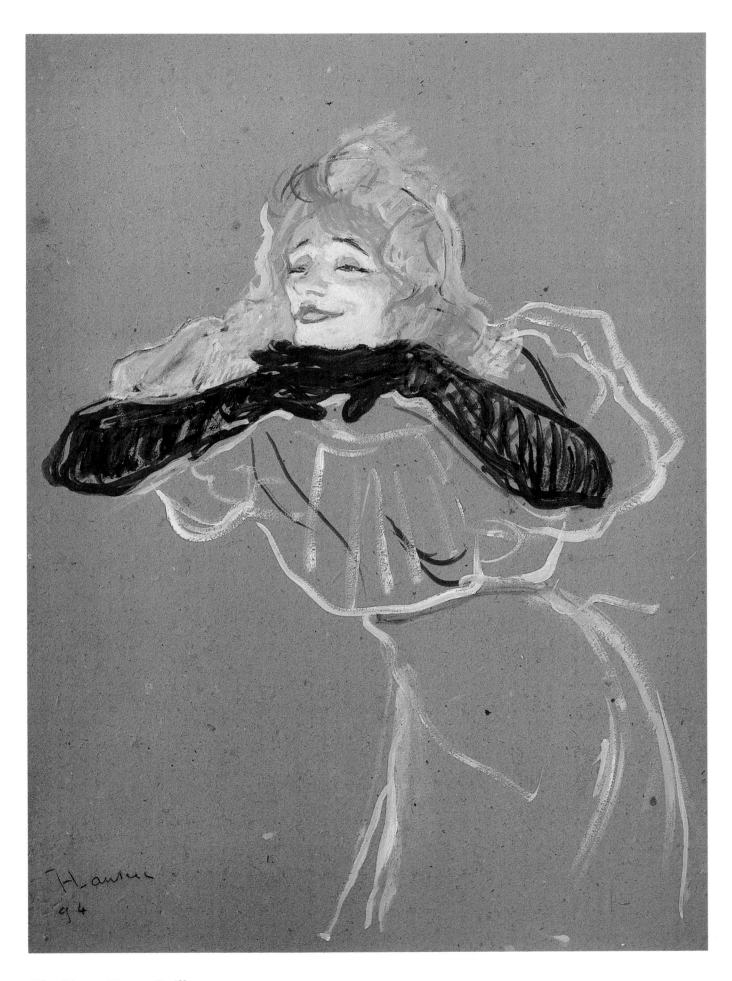

The Singer Yvette Guilbert

1894. Tempera on cardboard. 57 × 42 cm. (22 × 16½ in.)
The Pushkin Museum, Moscow

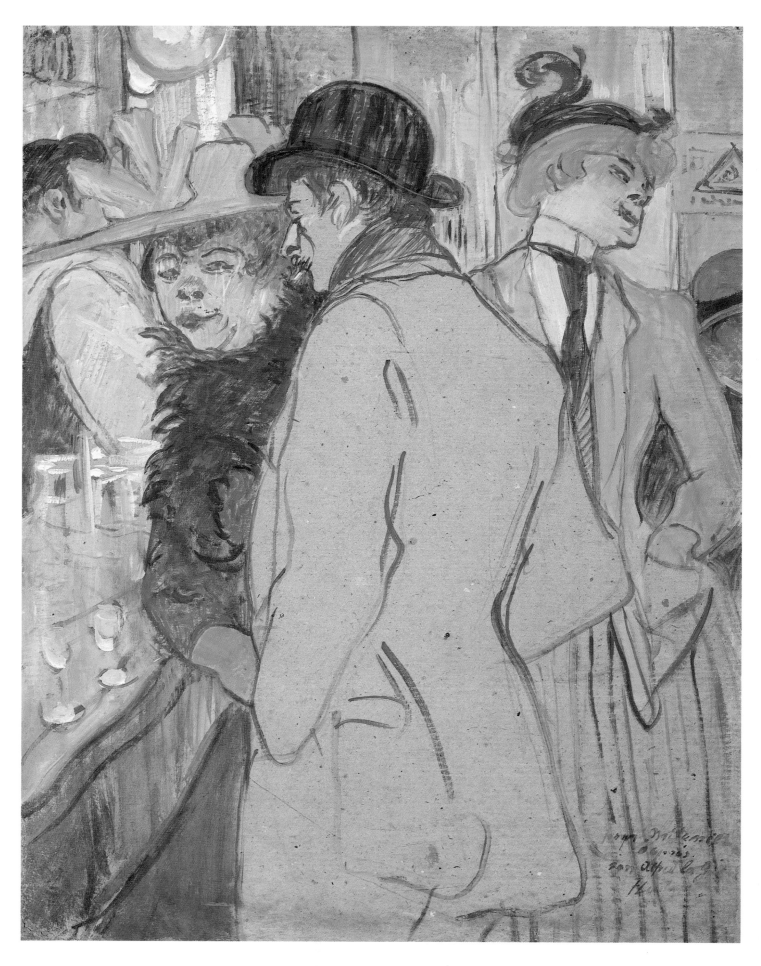

Alfred la Guigne

1894. Gouache on cardboard. 65.6 × 50.4 cm. (25¾ × 19¾ in.)
Chester Dale Collection, National Gallery of Art, Washington

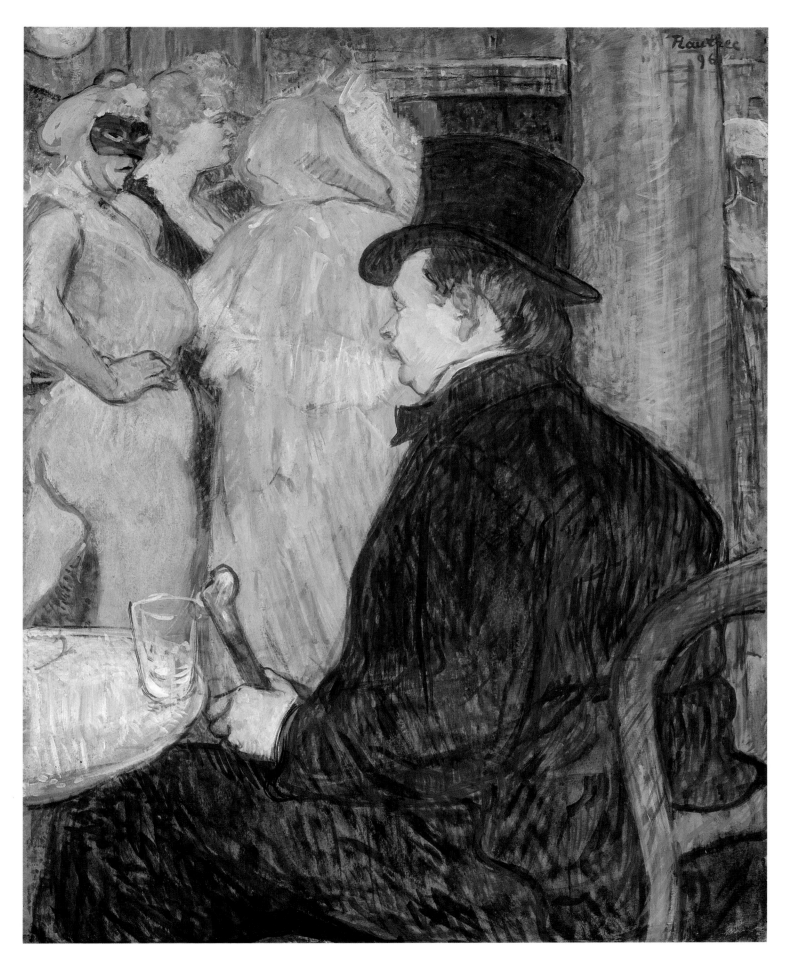

Maxime Dethomas

1896. Gouache on cardboard. 67.3 × 52 cm. (26½ × 20¾ in.)
Chester Dale Collection, National Gallery of Art, Washington

EDOUARD VUILLARD
1868–1940

EDOUARD VUILLARD, the son of a retired captain, spent his early youth at Cuiseaux (Saône-et-Loire); in 1878, his family moved to Paris. After his father's death in 1884, Vuillard received a scholarship to continue his education. In the Lycée Condorcet, Vuillard met K.-X. Roussel, Maurice Denis, and Lugné-Poë. On Roussel's advice, he gave up the idea of a military career and entered the Ecole des Beaux-Arts, where he met Bonnard.

In October 1888, Vuillard joined the Nabis and contributed to their exhibitions at the Gallery of Le Barc de Boutteville. He then shared a studio with Bonnard and Denis, and in 1893 designed settings and drew programs for the Théâtre de l'Oeuvre of Lugné-Poë. Vuillard first exhibited at the Salon des Indépendants of 1901 and at the Salon d'Automne in 1903.

In the 1890s, Vuillard met the brothers Alexandre and Thadée Natanson, the founders of the *Revue Blanche*, and in 1892 did on their advice his first decorations ("apartment frescoes") for the house of Mme. Desmarais. Subsequently, he fulfilled many other commissions of this kind: in 1894 for Alexandre Natanson, in 1898 for Claude Anet, in 1908 for Bernstein, and in 1913 for Bernheim and for the Théâtre des Champs-Elysées. The last commissions he received were in 1937 (Palais de Chaillot in Paris, with Bonnard) and 1939 (League of Nations in Geneva, with Denis, Roussel, and Chastel).

In his paintings and decorative pieces, Vuillard depicted mostly the interiors, street scenes, and gardens of Paris. Marked by a gentle humor, they are executed in the delicate range of soft, blurred colors characteristic of his art.

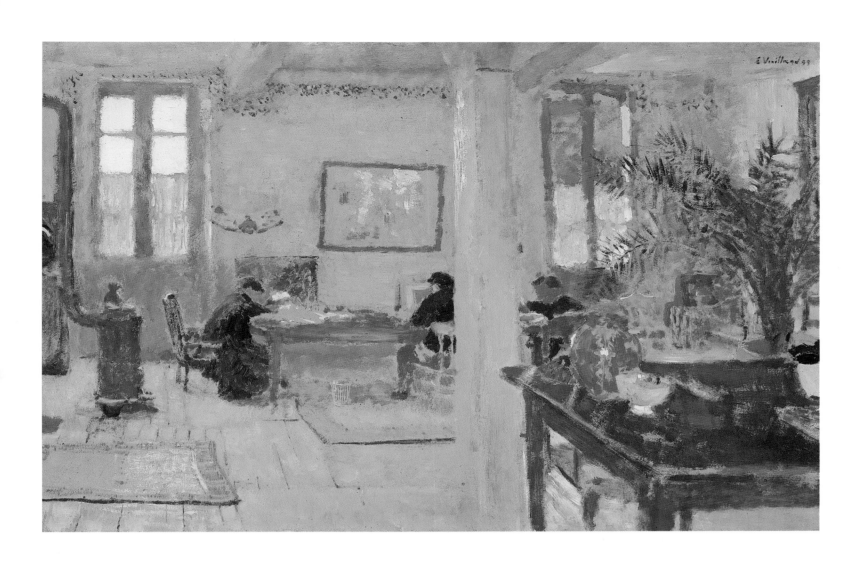

The Room

Late 1890s. Oil on cardboard pasted on a panel. 58 × 79 cm. (22¾ × 31 in.)
The Hermitage, Leningrad

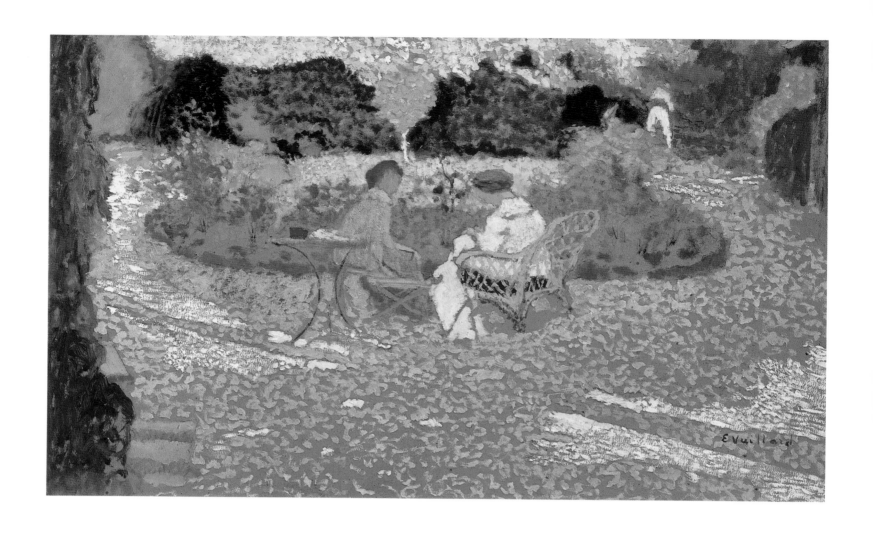

In the Garden

c. 1894–95. Tempera on cardboard. 51 × 83 cm. (20 × 32½ in.)
The Pushkin Museum, Moscow

OPPOSITE:

Child Wearing a Red Scarf

c. 1891. Oil on cardboard mounted on wood. 29.2 × 17.5 cm. (11½ × 6⅞ in.)
Ailsa Mellon Bruce Collection, National Gallery of Art, Washington

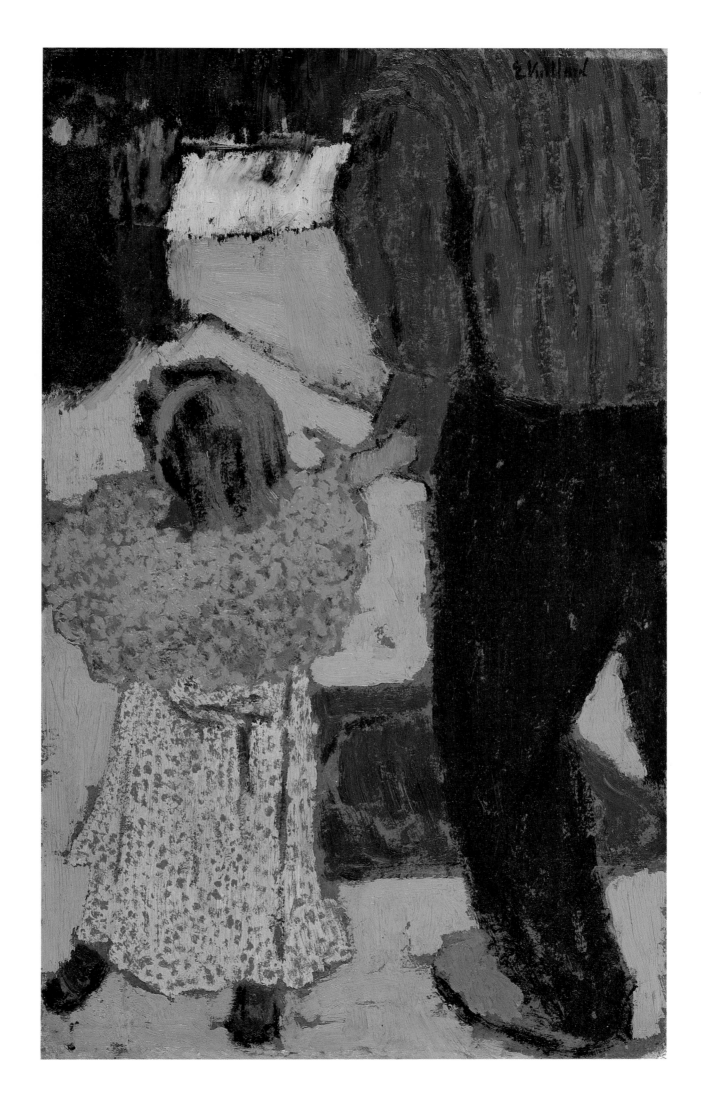

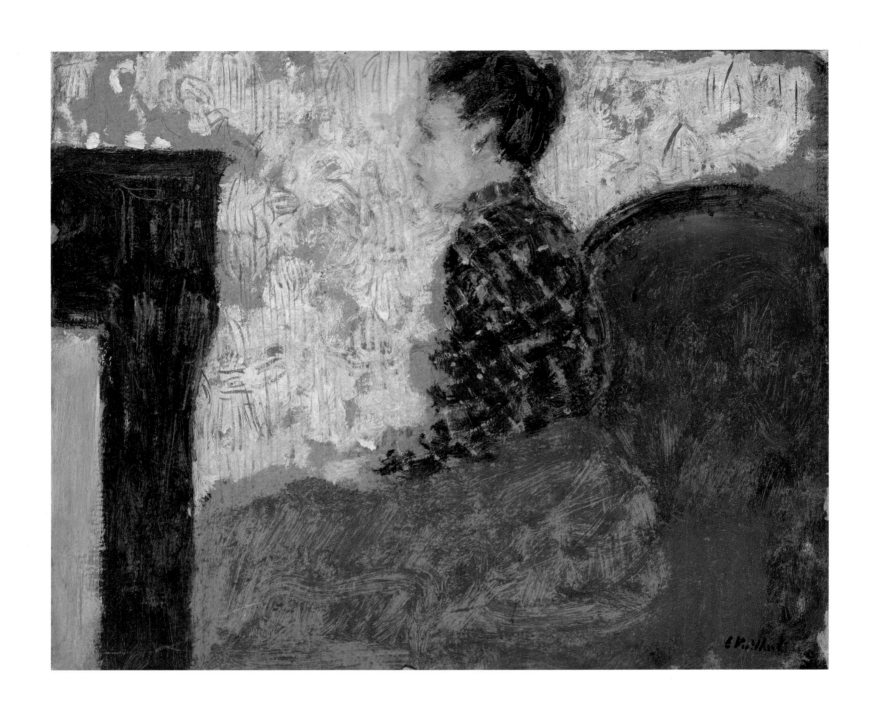

Woman Sitting by the Fireside

c. 1894. Oil on cardboard. 21.3 × 26.1 cm. (8⅜ × 10¼ in.)
Ailsa Mellon Bruce Collection, National Gallery of Art, Washington

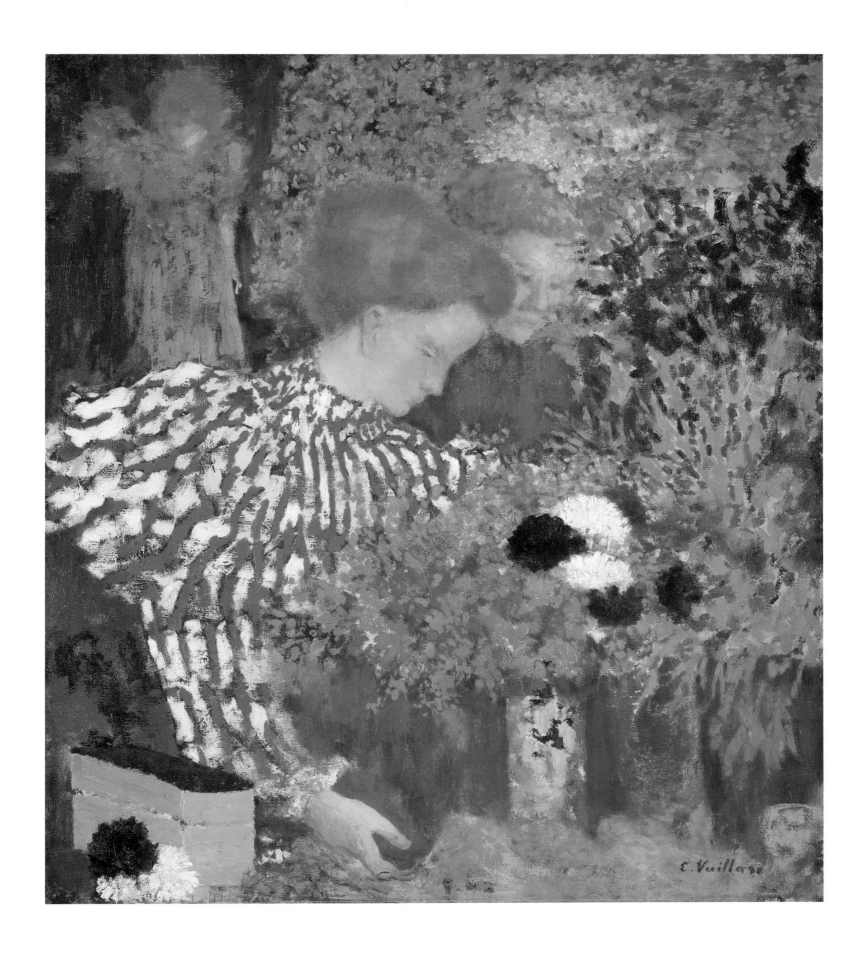

Woman in a Striped Dress

1895. Oil on canvas. 65.7 × 58.7 cm. (25⅞ × 23⅛ in.)
Collection of Mr. and Mrs. Paul Mellon, National Gallery of Art, Washington

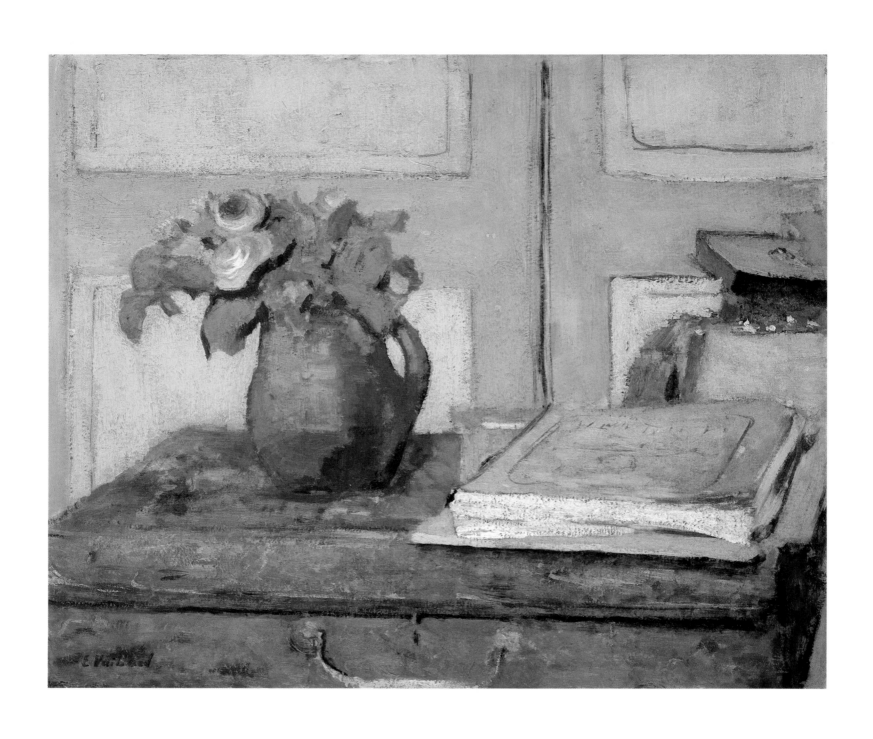

The Artist's Paint Box and Moss Roses

1898. Oil on cardboard. 36.1 × 42.9 cm. (14¼ × 16⅞ in.)
Ailsa Mellon Bruce Collection, National Gallery of Art, Washington

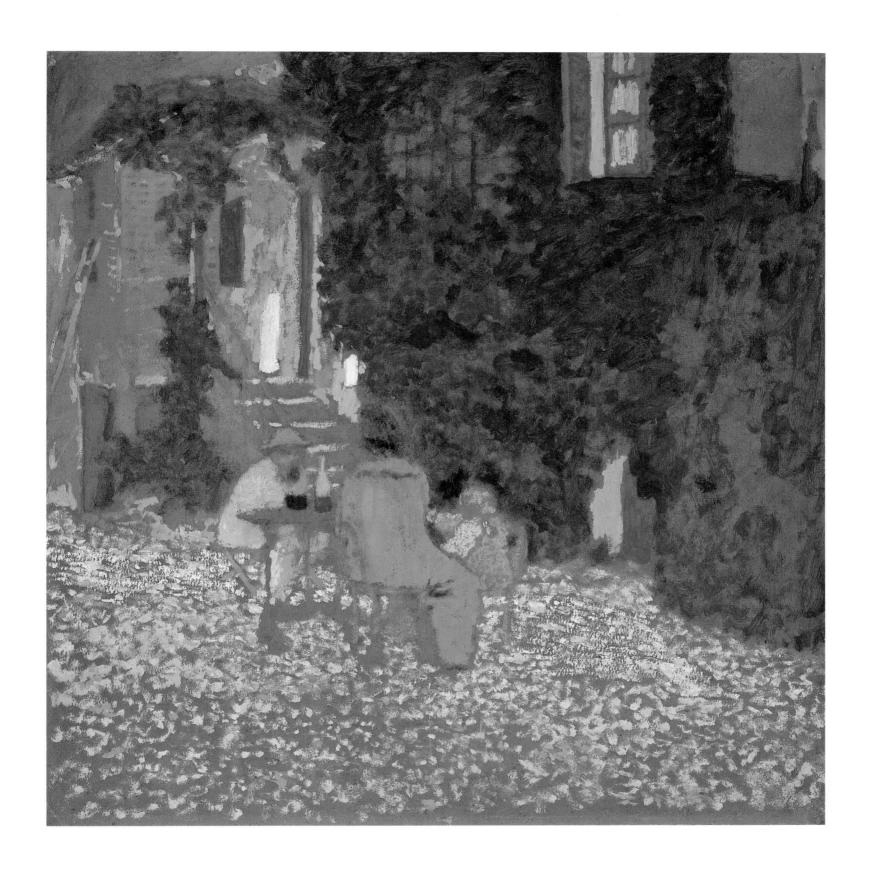

Repast in a Garden

1898. Gouache on cardboard. 54.3 × 53.1 cm. (21⅜ × 20⅞ in.)
Chester Dale Collection, National Gallery of Art, Washington

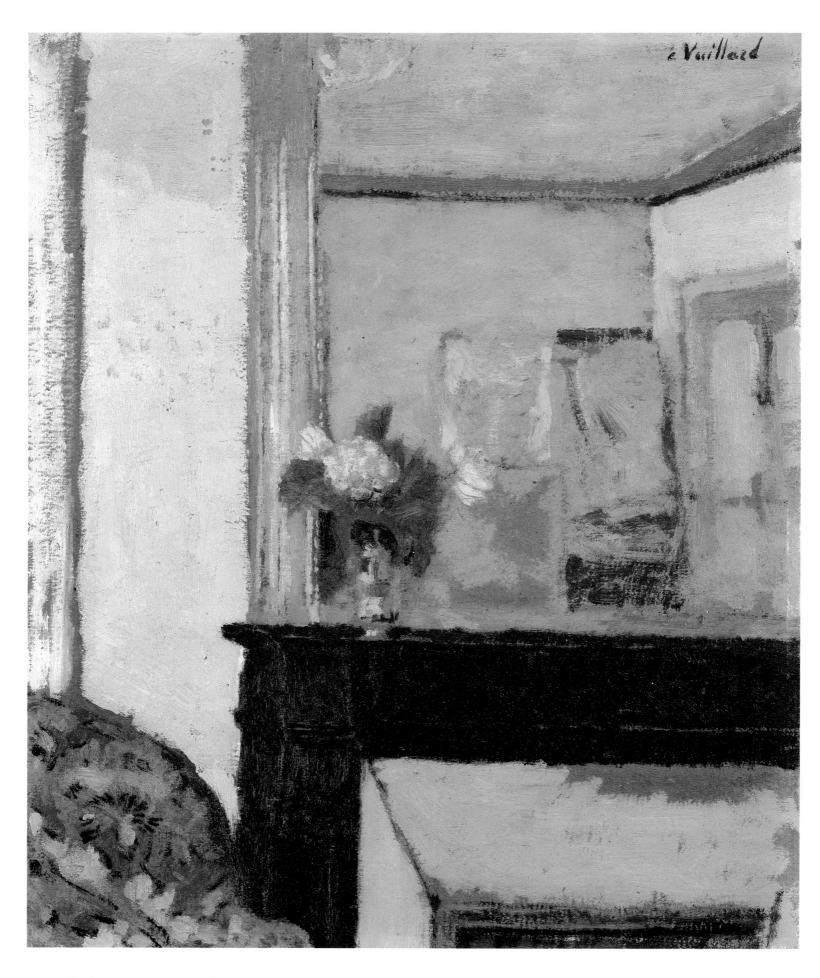

Vase of Flowers on a Mantelpiece

c. 1900. Oil on cardboard mounted on wood. 36.2 × 29.5 cm. (14½ × 11⅝ in.)
Ailsa Mellon Bruce Collection, National Gallery of Art, Washington

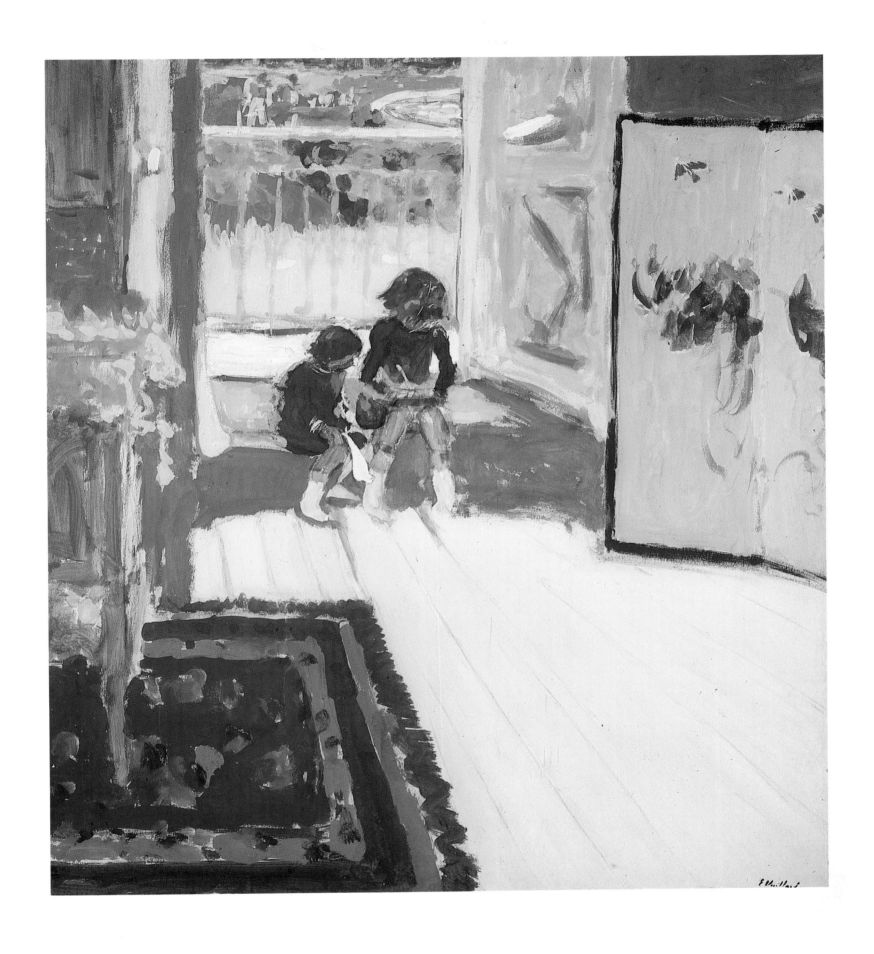

Children in a Room

c. 1909. Gouache. 84.5 × 77.7 cm. (33¼ × 30½ in.)
The Hermitage, Leningrad

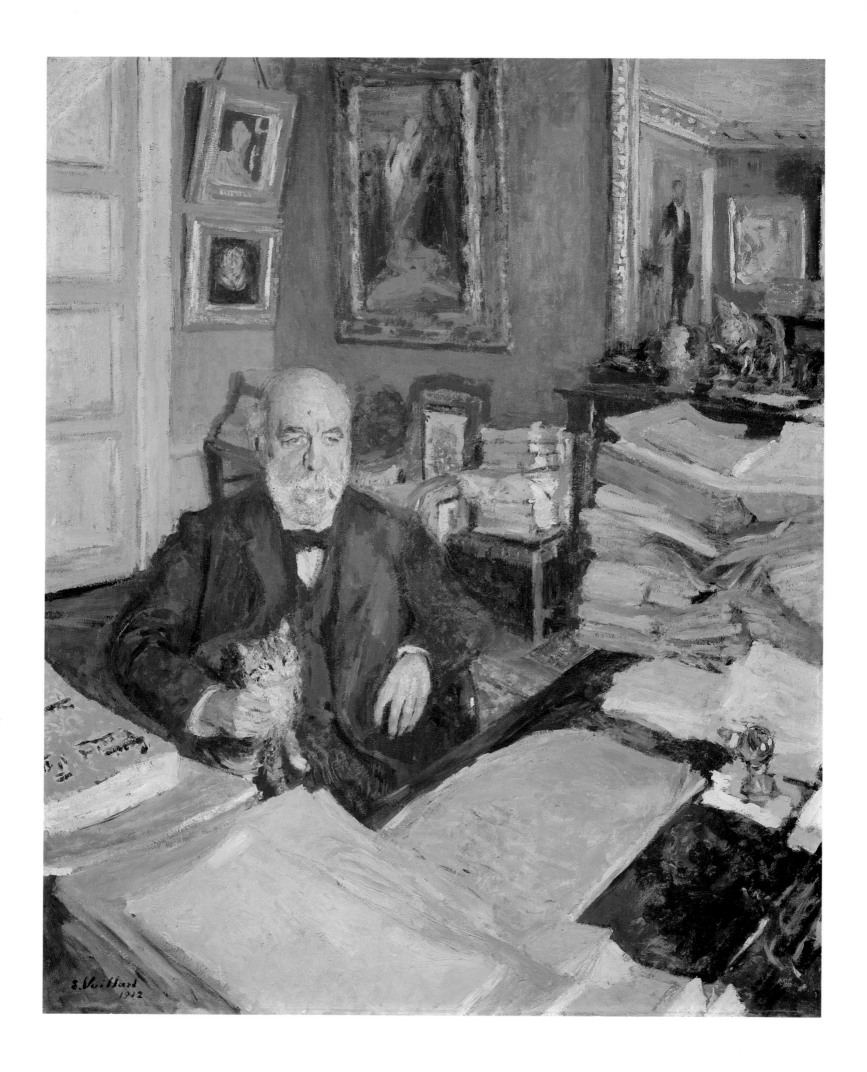

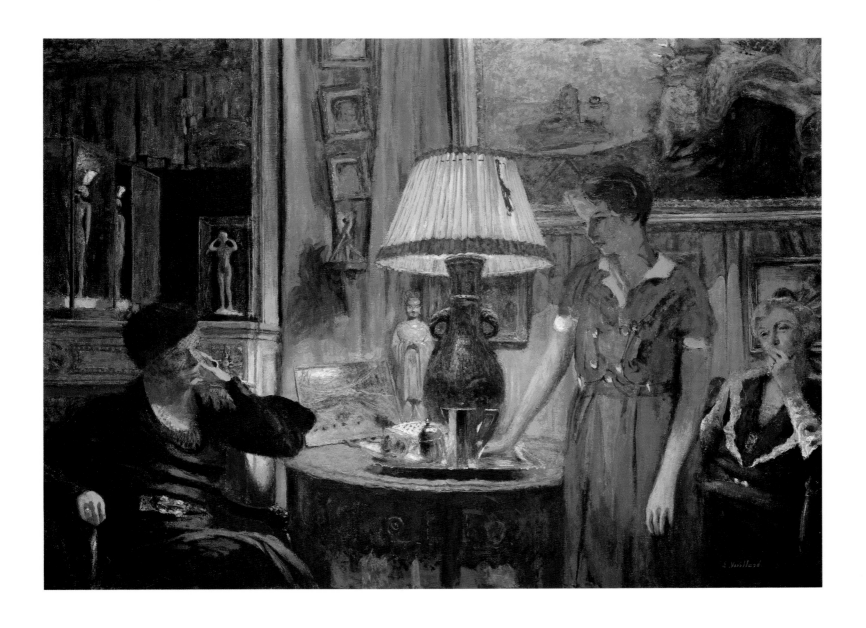

The Visit

1931. Mixed technique on canvas. 100.1 × 136.4 cm. (39⅜ × 53¾ in.)
Chester Dale Collection, National Gallery of Art, Washington

OPPOSITE:

Théodore Duret

1912. Oil on cardboard mounted on wood. 95.2 × 74.8 cm. (37½ × 29½ in.)
Chester Dale Collection, National Gallery of Art, Washington

PIERRE BONNARD
1867–1947

PIERRE BONNARD was born into the family of a well-to-do official of the War Ministry, who wanted his son to become a lawyer. Shunning law lessons, Bonnard attended the Académie Julian and in 1888 entered the Ecole des Beaux-Arts. However, he left a year later after competing unsuccessfully for the Prix de Rome.

In October 1888, Bonnard joined up with Vuillard, Roussel, Denis, Sérusier, Ranson, and, later, Vallotton, who called themselves the Nabis (a Hebrew term meaning "prophets"). The Nabis proclaimed that an artist should be versed in various spheres of art, the applied arts included. The group also collaborated with such eminent innovators of the theatre as André Antoine, Aurélien-Marie Lugné-Poë, and the poet Paul Fort.

At the start of his career, apart from paintings, Bonnard did posters, of which the first one, *France-Champagne*, appeared in 1889; he also worked on furniture designs and textile patterns, painted screens and stage settings, and made puppets for puppet shows. His friends nicknamed him "a highly Nipponized Nabi," because his individual style at that time developed under a strong influence of Japanese prints.

Bonnard made his first public appearance at the Salon des Indépendants in the spring of 1891 and subsequently participated in its many exhibitions. In the autumn of the same year he took part in the first exhibition of the Nabis in the Gallery of Le Barc de Boutteville. In 1896, Paul Durand-Ruel inaugurated Bonnard's one-man show, and in 1906 the Bernheim-Jeune firm signed an exclusive contract for the exhibition of his works. In the 1890s, Ambroise Vollard published several albums of colored prints by Bonnard and other artists and a large series of Bonnard's lithographs for *Daphnis et Chloé*.

By the late 1890s, Bonnard's artistic idiom began to assume new features. He gave up sharp delineation and glaring color contrasts for a softened spectrum based on a delicate interplay of tones. For the most part, he painted landscapes, interiors, and small street scenes which he saw with an artist's jovial and slightly mocking eye. The best known of his large decorative works are the reception-room panel commissioned by Missia Godebska in Paris (1910) and the triptych *The Mediterranean* done for the private residence of Ivan Morozov (1911).

In his old age, Bonnard returned to a youthful exuberance of light and color, producing compositions of exquisite taste. During the Second World War, he lived at Le Cannet in a small house called Le Bosquet, and continued living there as a recluse after his wife's death in 1942. In 1945, he paid his last visit to Paris.

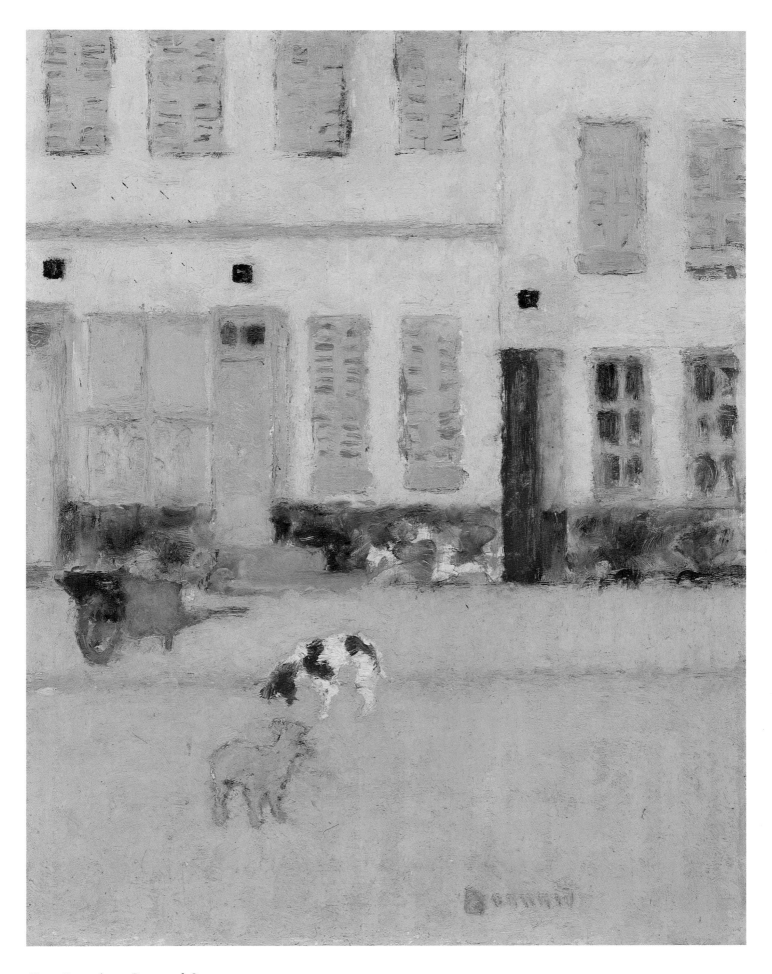

Two Dogs in a Deserted Street

c. 1894. Oil on wood. 35.1 × 27 cm. (13⅞ × 10⅝ in.)
Ailsa Mellon Bruce Collection, National Gallery of Art, Washington

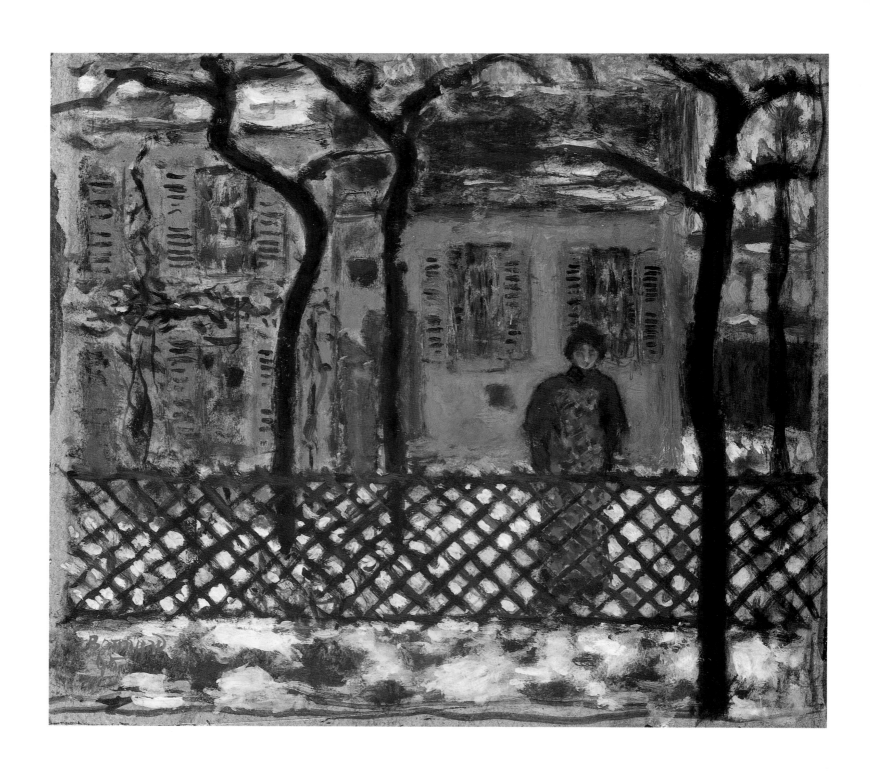

Woman Standing at a Railing

1895. Oil on cardboard. 31 × 35 cm. (12¼ × 13¾ in.)
The Hermitage, Leningrad

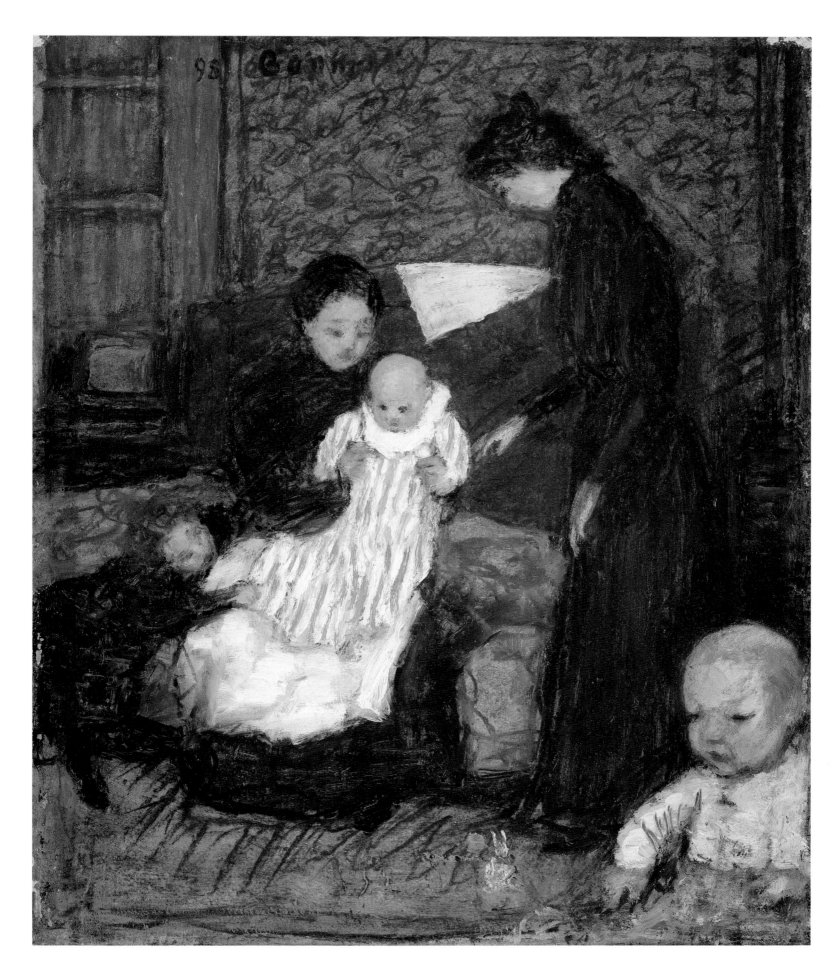

The Artist's Sister and Her Children

1898. Oil on cardboard mounted on wood. 30.5 × 25.4 cm. (12 × 10 in.)
Ailsa Mellon Bruce Collection, National Gallery of Art, Washington

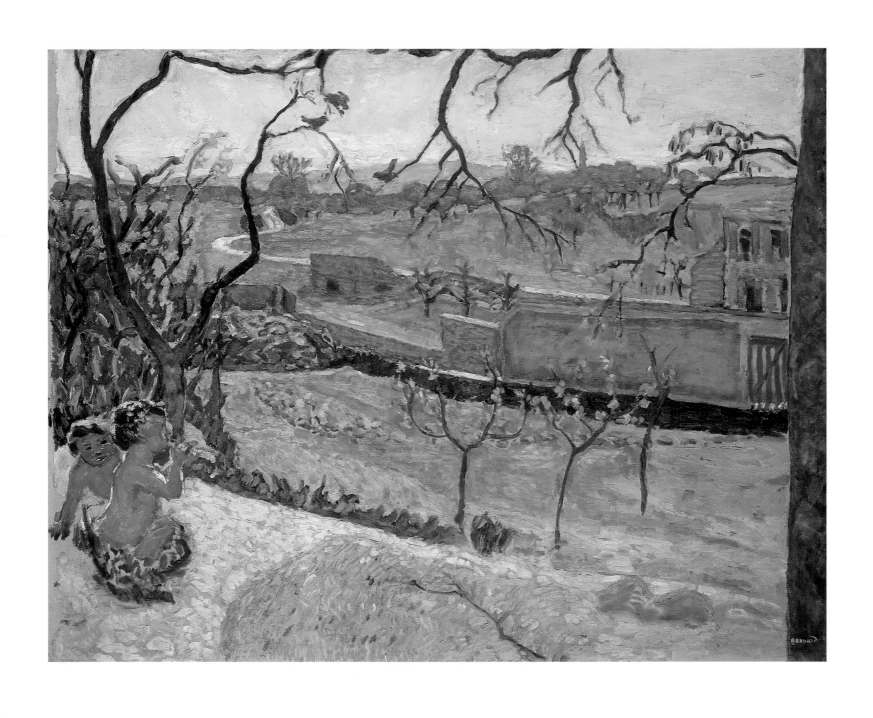

Early Spring: Little Fauns

c. 1909. Oil on canvas. 102.5 × 125 cm. (40⅜ × 49¼ in.)
The Hermitage, Leningrad

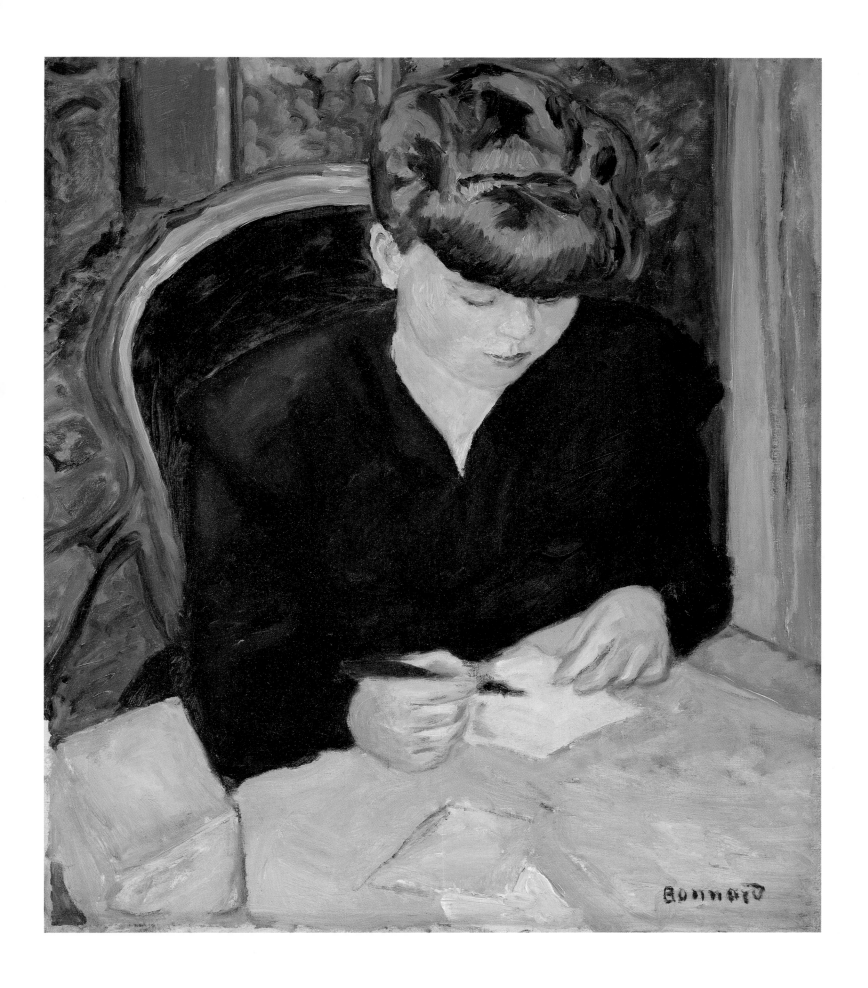

The Letter

c. 1906. Oil on canvas. 55 × 47.5 cm. (21⅝ × 18¾ in.)
Chester Dale Collection, National Gallery of Art, Washington

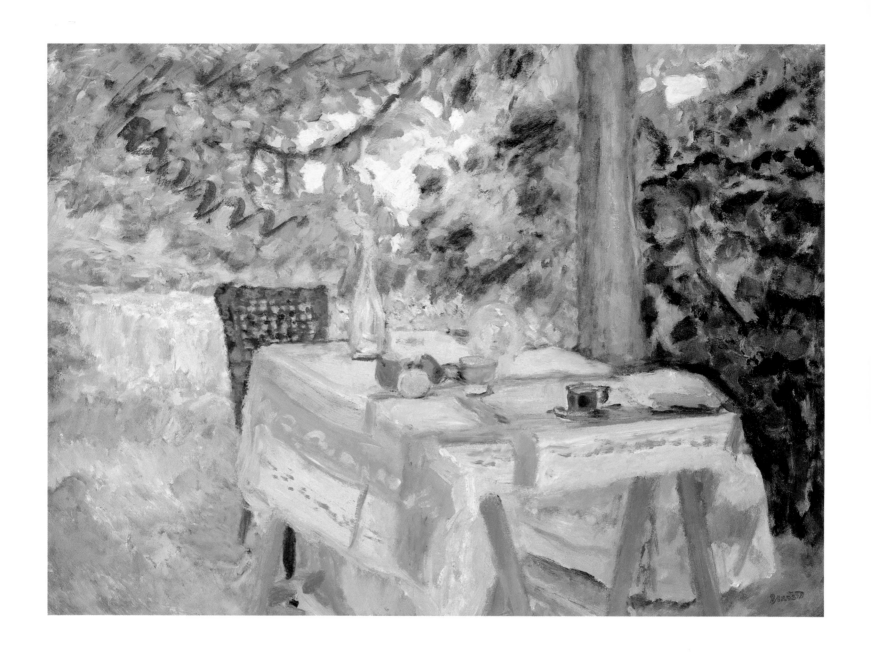

Table Set in a Garden

c. 1908. Oil on paper mounted on canvas. 49.5 × 64.7 cm. (19½ × 25½ in.)
Ailsa Mellon Bruce Collection, National Gallery of Art, Washington

OPPOSITE:

Mirror in the Dressing Room

c. 1908. Oil on canvas. 120 × 97 cm. (47¼ × 39 in.)
The Pushkin Museum, Moscow

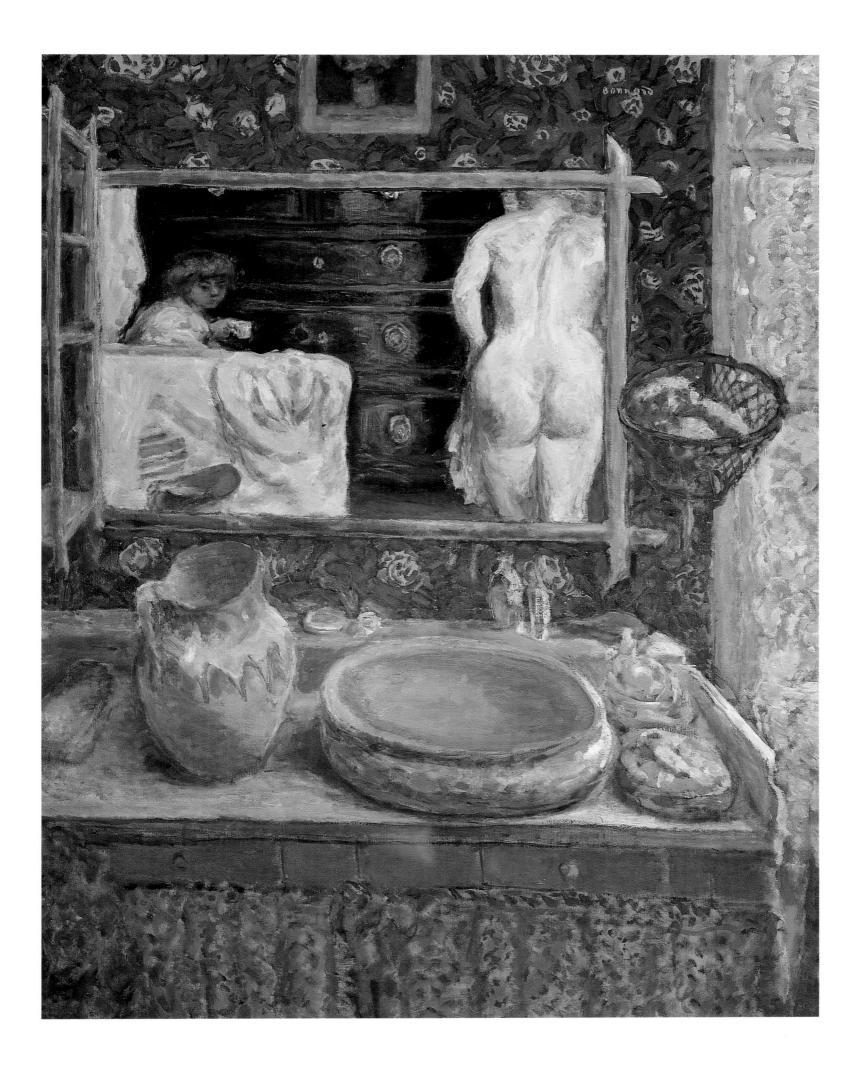

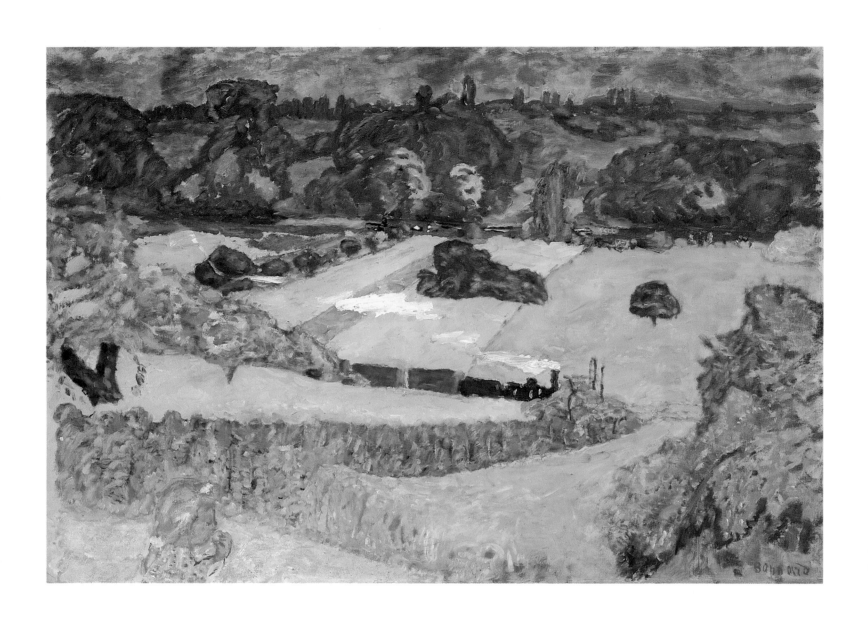

Landscape with a Goods Train

1909. Oil on canvas. 77 × 108 cm. (30⅜ × 42½ in.)
The Hermitage, Leningrad

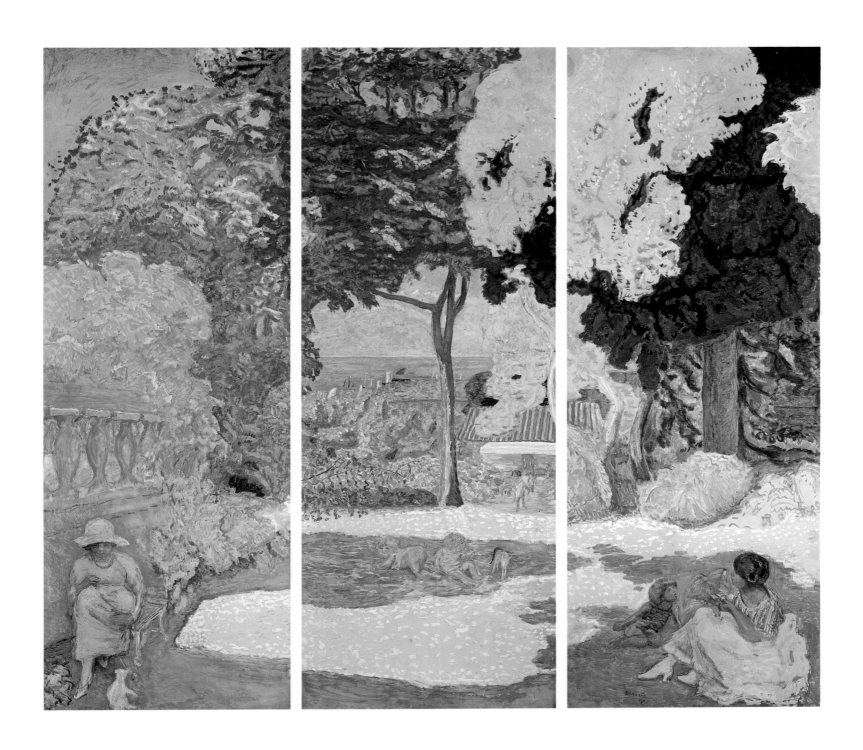

The Mediterranean. TRIPTYCH

1911–12. Oil on canvas. Left: 407 × 149 cm. (160¼ × 58⅝ in.); center: 407 × 152 cm. (160¼ × 59⅞ in.);
right: 407 × 149 cm. (160¼ × 58⅝ in.) The Hermitage, Leningrad

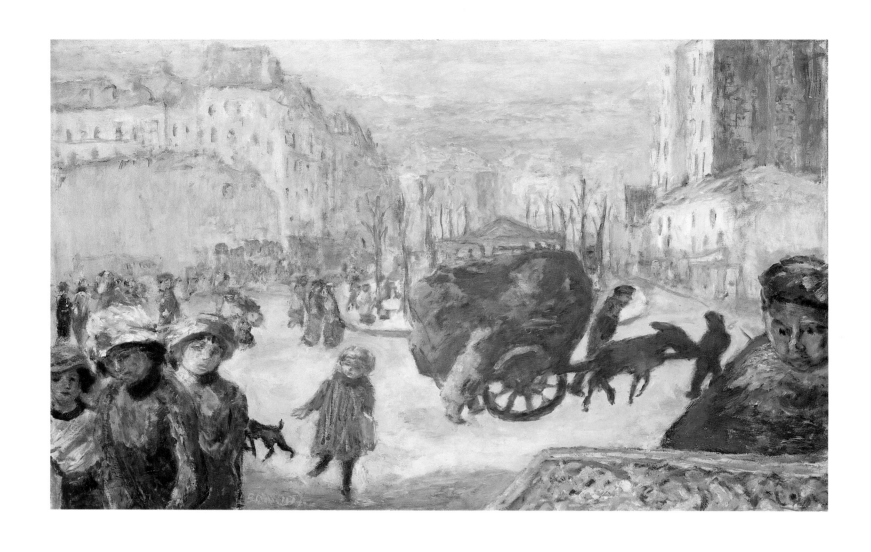

Morning in Paris

1911–12. Oil on canvas. 76.5 × 122 cm. (30⅛ × 48 in.)
The Hermitage, Leningrad

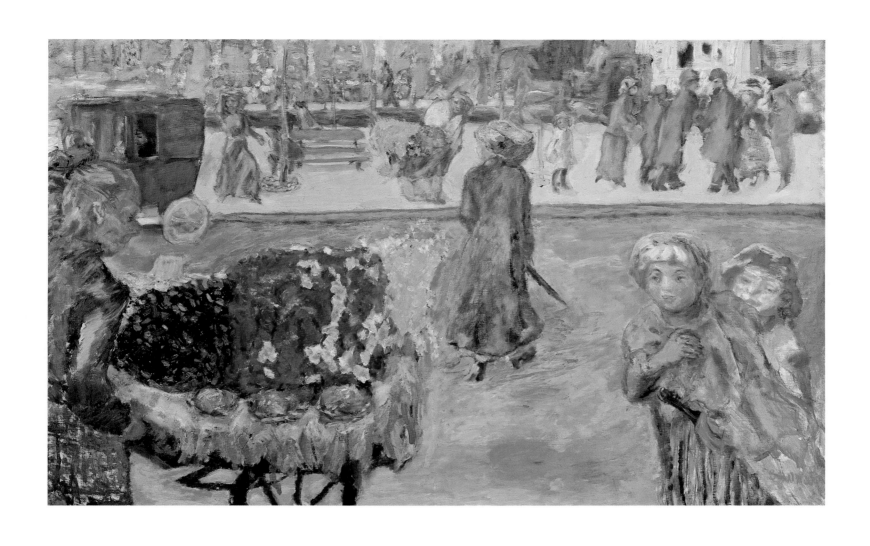

Evening in Paris

1911–12. Oil on canvas. 76 × 121 cm. (30 × 47⅝ in.)
The Hermitage, Leningrad

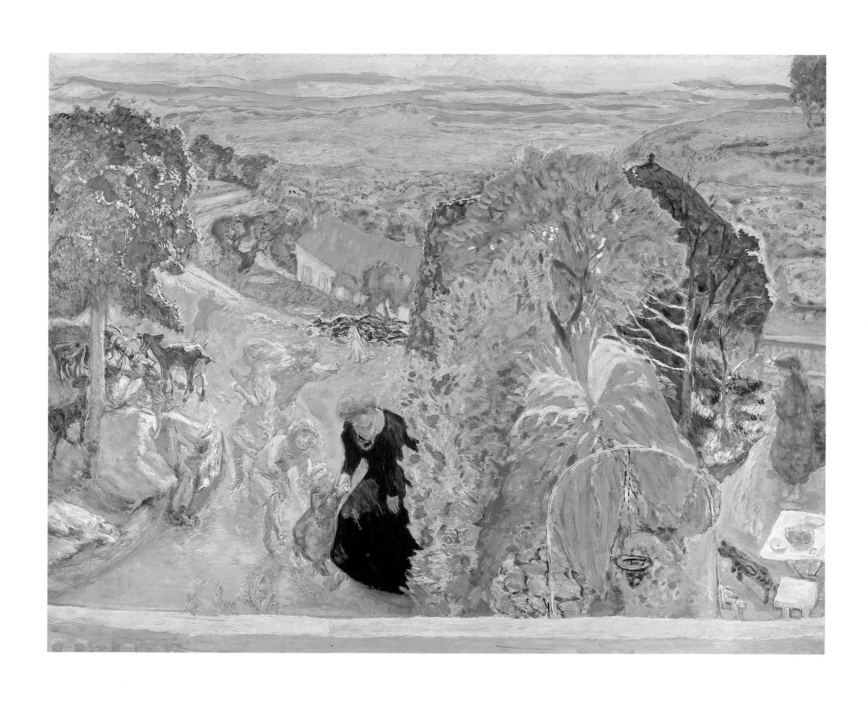

Summer: The Dance

c. 1912. Oil on canvas. 202 × 254 cm. (79½ × 100 in.)
The Pushkin Museum, Moscow

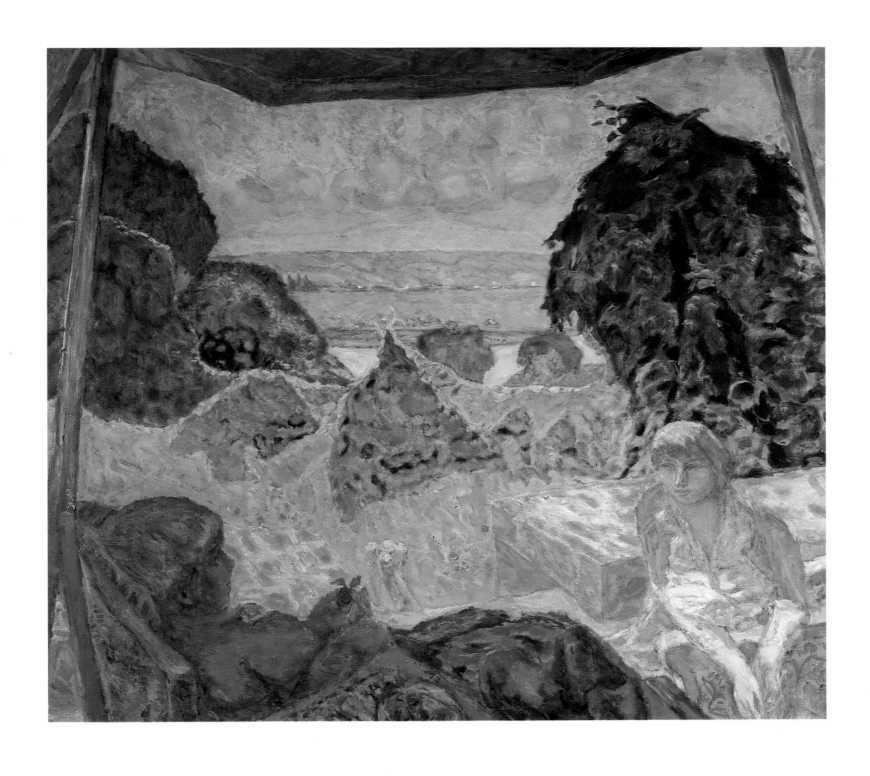

Summer in Normandy

c. 1912. Oil on canvas. 114 × 128 cm. (45 × 50⅜ in.)
The Pushkin Museum, Moscow

Bouquet of Flowers

1930. Oil on canvas. 70.3 × 47.4 cm. (27⅝ × 18⅝ in.)
Ailsa Mellon Bruce Collection, National Gallery of Art, Washington

Stairs in the Artist's Garden

1942/44. Oil on canvas. 63.3 × 73.1 cm. (24⅞ × 28¾ in.)
Ailsa Mellon Bruce Collection, National Gallery of Art, Washington

MAURICE DENIS
1870–1943

MAURICE DENIS received a classical education in the Lycée Condorcet, where he met Vuillard, Roussel, and Lugné-Poë. While studying in the Lycée, he took drawing lessons under Zani and copied paintings by the old masters. In 1888, he enrolled at the Académie Julian and then at the Ecole des Beaux-Arts, where he attended the classes of Lefevre and Doucet.

In the same year, Sérusier showed his friends at the Académie Julian the famous landscape that he had painted at the suggestion of Gauguin at Pont-Aven and that, for this reason, was considered a "talisman" of Gauguin's doctrine of Synthetism. This was a decisive revelation for Denis, who found himself attracted by the new ideas of Synthetism and by Gauguin's paintings, which he first saw at the exhibition of the Impressionist and Synthetist group at the Café Volpini in 1889. Denis joined the Nabis, and in 1890, in the review *Art et Critique,* he published his famous article in which he defined the artistic credo of the group. During this period, he became associated with the Symbolist writers, illustrating the books of André Gide and Paul Verlaine's *Sagesse,* and designing frontispieces for Maurice Maeterlinck's *Pelléas et Mélisande* and for the score of Claude Debussy's opera. Like the other Nabis, Denis experimented in various fields of art, designing carpets, painting cartoons for stained-glass and mosaic panels, and ornamenting ceramics. In the 1890s, he also did a number of mural decorations: he painted the ceiling in the house of the French composer Chausson (1894) and executed a cycle of panels on the theme of *The Legend of St. Hubert* (1897) in the house of the collector Cochin.

His early work as a painter bears the stamp of originality, though he was strongly influenced by the art of the Italian Renaissance, especially after his trips to Tuscany and Umbria in 1895 and 1897. Though his paintings and mural decorations of subsequent years can seem to many now as rather anemic and sugary, his fame continued to grow. He received numerous commissions: from 1899 to 1903, he decorated the Church Sainte-Croix at Vésinet; in 1908, he produced his *Eternal Spring* for Thomas; and in 1908–9, he was commissioned by Ivan Morozov to make a series of decorative panels, *The History of Psyche,* which he brought to Moscow in January 1909 to mount in Morozov's house. In 1913, Denis painted the ceilings at the Théâtre des Champs-Elysées; in 1917, he worked in the Church of St. Paul at Geneva; in 1924, he decorated the cupola of the Petit Palais in Paris; and in 1928, he painted the staircase in the Senate building. Between 1936 and 1939, he did a number of decorative panels for the League of Nations at Geneva.

In addition to his work as a painter, Denis was one of the most prominent theoreticians of the time. His articles on contemporary art, published in various magazines, were later collected in *Théories* (1912) and *Nouvelles théories* (1922).

Portrait of Marthe Denis, the Artist's Wife

1893. Oil on canvas. 45 × 54 cm. (17¾ × 21¼ in.)
The Pushkin Museum, Moscow

Martha and Mary

1896. Oil on canvas. 77 × 116 cm. (30⅜ × 45½ in.)
The Hermitage, Leningrad

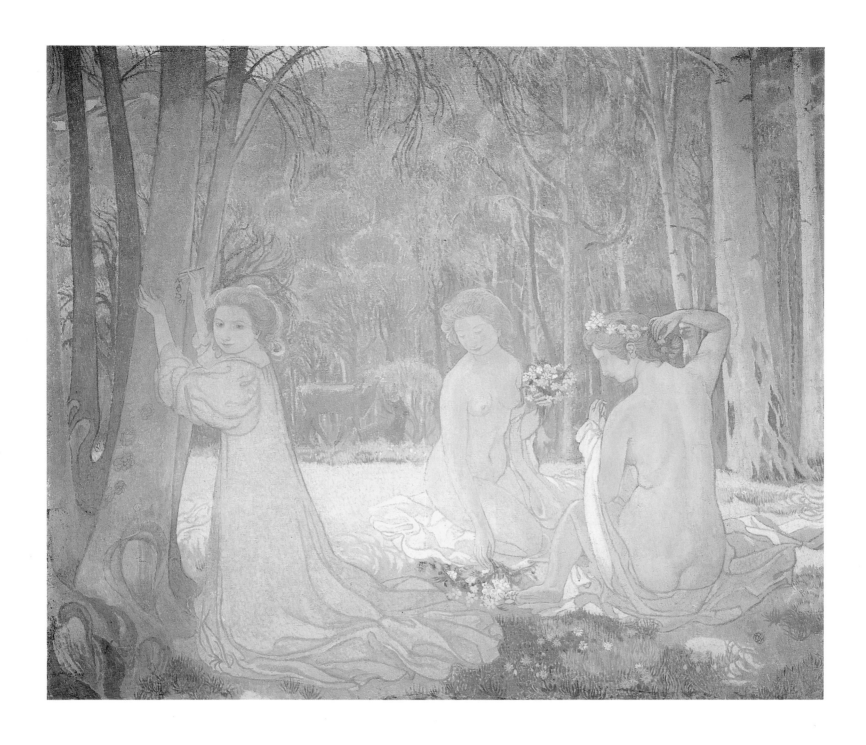

Figures in a Spring Landscape (Sacred Grove)

1897. Oil on canvas. 157 × 179 cm. (61¾ × 70½ in.)
The Hermitage, Leningrad

MAURICE UTRILLO
1883–1955

MAURICE UTRILLO was the illegitimate son of Suzanne Valadon, who was an acrobat, a well-known figure in the art world of Montmartre, and a model for several artists, particularly Degas.

Forced to paint by his mother as a remedy for his alcoholism, Utrillo began to produce prolifically in 1902, without benefit of formal training yet with unpredictable power. From the start, he depicted the streets and buildings of Montmartre, creating a world that is almost without people but somberly impressive in its austere architecture, its beautifully textured walls, its modulations of whites and grays, and its desolate perspectives.

Despite his frequent stays in hospitals and nursing homes, Utrillo continued to paint with clarity and uncanny grace until 1935, when he married and gave up drinking. From 1909 on, he painted his cityscapes almost exclusively after picture postcards. This was the beginning of his so-called White period (1908–14), when he produced his best-known works, exhibited for the first time in the Salon d'Automne (1910), held his first one-man show (1912), and designed sets for the Diaghilev ballet *Barbara* (1913). After this period, Utrillo's work became thinner and brighter in color. He was made a Chevalier of the Legion of Honor in 1928.

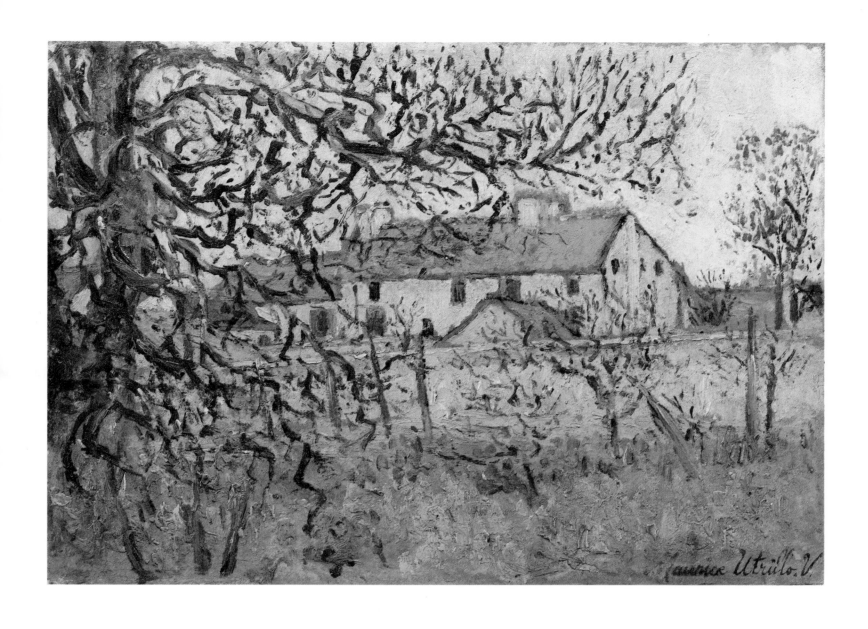

Landscape, Pierrefitte

c. 1907. Oil on cardboard mounted on wood. 25.1 × 34.5 cm. (9⅞ × 13⅝ in.)
Ailsa Mellon Bruce Collection, National Gallery of Art, Washington

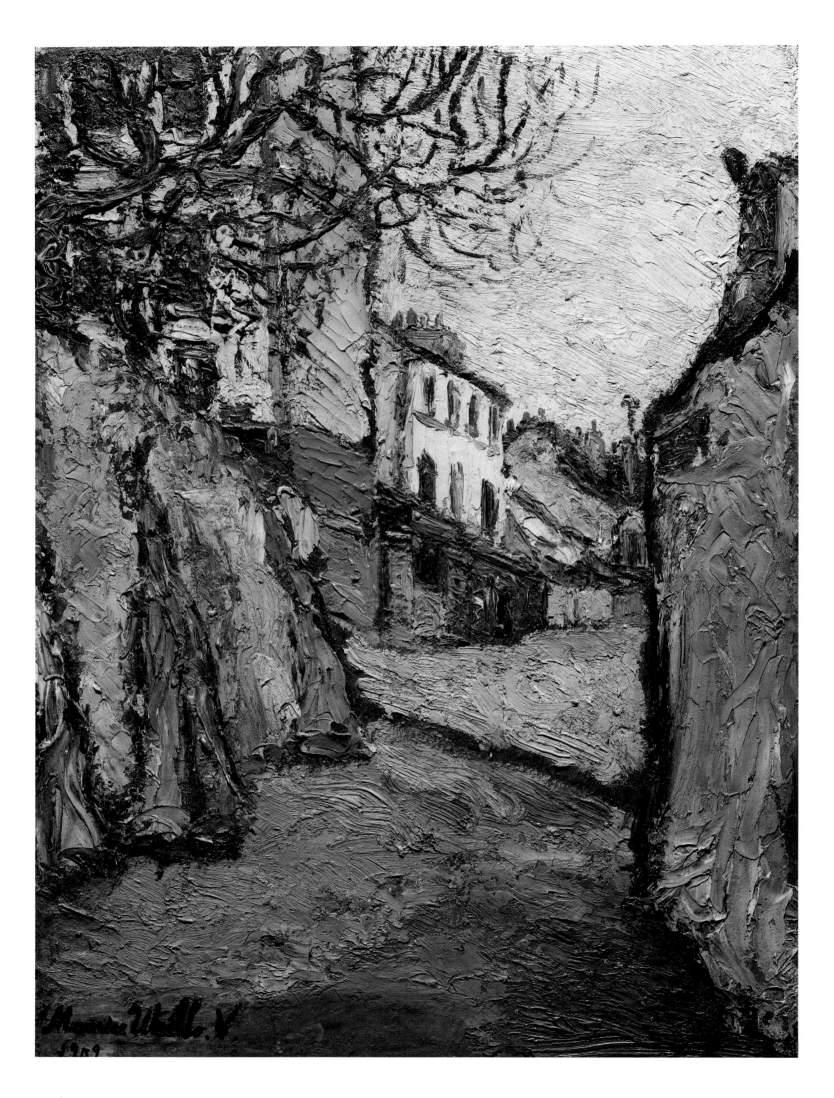

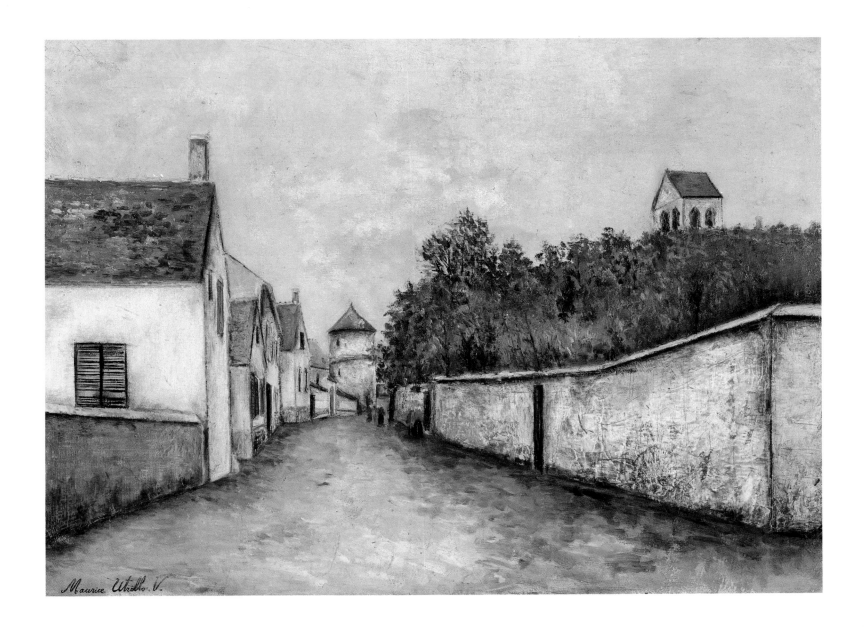

Marizy-Sainte-Genevieve

c. 1910. Oil on canvas. 59.7 × 81 cm. (23½ × 31⅞ in.)
Chester Dale Collection, National Gallery of Art, Washington

OPPOSITE:

Rue Cortot, Montmartre

1909. Oil on cardboard. 45.7 × 33.6 cm. (18 × 13¼ in.)
Ailsa Mellon Bruce Collection, National Gallery of Art, Washington

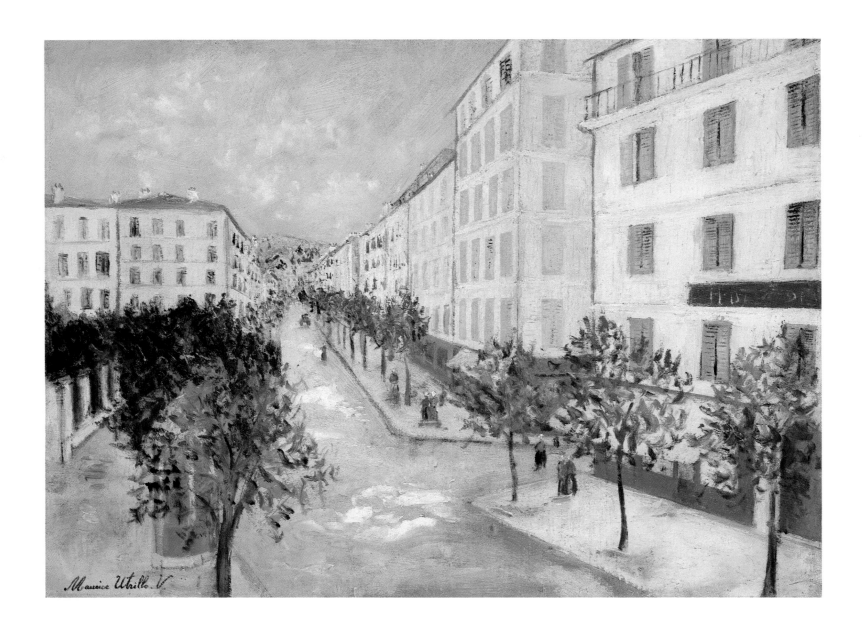

Street at Corte, Corsica

1913. Oil on canvas. 60.8 × 80.7 cm. (24 × 31¾ in.)
Ailsa Mellon Bruce Collection, National Gallery of Art, Washington

OPPOSITE:

The Church of Saint-Severin

c. 1913. Oil on canvas. 73 × 54 cm. (28¾ × 21¼ in.)
Chester Dale Collection, National Gallery of Art, Washington

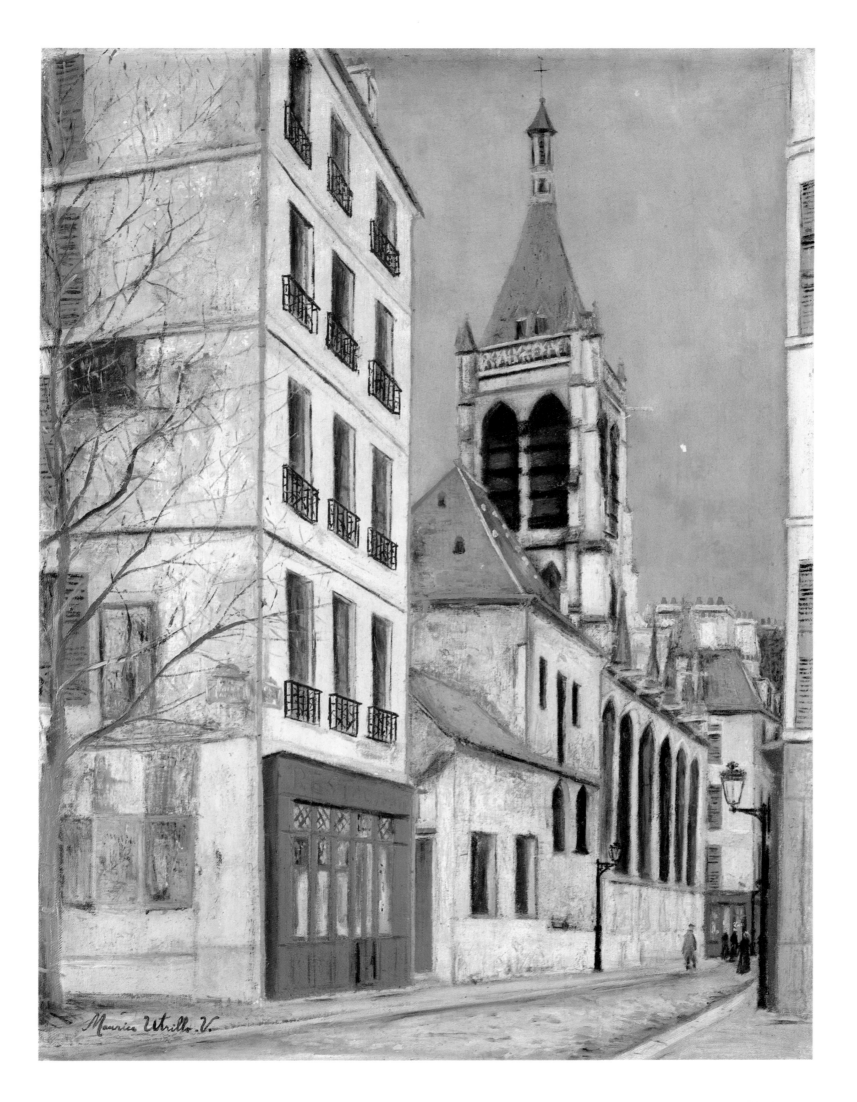

GEORGES ROUAULT
1871–1958

GEORGES ROUAULT, the son of a cabinet maker, was born and lived all his life in Paris. At fourteen, he was apprenticed to Hirsch, a stained-glass painter, and worked on the restoration of medieval windows. Several years of mastering this craft developed in him a taste for large, iridescent, colored planes encircled with a vigorous black line, a taste which to a certain extent shaped his painterly manner. During his apprenticeship, Rouault attended evening courses at the Ecole des Arts Décoratifs. In 1891, he entered the Ecole Nationale des Beaux-Arts, where his teachers were Delaunay and, later, Gustave Moreau. He became a close friend of Moreau and in 1898, after his teacher's death, was appointed keeper of the Musée Gustave Moreau.

When studying with Moreau, Rouault painted compositions on religious themes. One of them, *Christ among the Teachers* (1894), was awarded the Prix Chenavard. The peculiarity of Rouault's artistic manner was first reflected in sombre, dramatic landscapes done in the late 1890s, works already free from academic influence. But it was only in 1904–5 that his art, exhibited at the Salon d'Automne, revealed the features which were to distinguish his subsequent works: the tragic interpretation of images, the generalized manner of painting, the black contours, and the luminous colors. His judges, strolling acrobats, and prostitutes produced in the 1910s demonstrate all these characteristics. Rouault painted in oils, watercolors and gouaches and devoted much time to ceramics.

His art developed apart from the two major movements of the time, Fauvism and Cubism, though he constantly associated with Matisse and other painters of his circle. Rouault's searchings had much in common with the aspirations of the German Expressionists.

In 1917, Rouault undertook an extensive series of etchings to illustrate *Les Réincarnations du Père Ubu, Le Cirque de l'Etoile Filante, Les Passions*, and Baudelaire's *Les Fleurs du Mal*. For many years, he did a suite of engravings, *Miserere et Guerre*, its title derived from the first words of the Fifty-first Psalm. Though finished in 1927, the suite was published by Vollard only in 1948. These plates are executed in an individual and novel technique and are accompanied by captions of a highly expressive and imaginative character.

In 1928, he created the settings and costumes for Diaghilev's production of *Le Fils prodigue* to the music by Prokofiev.

From 1932 onwards, the artist concentrated on oil paintings. During his last ten years, Rouault painted, besides landscapes, numerous compositions with clowns and Pierrots.

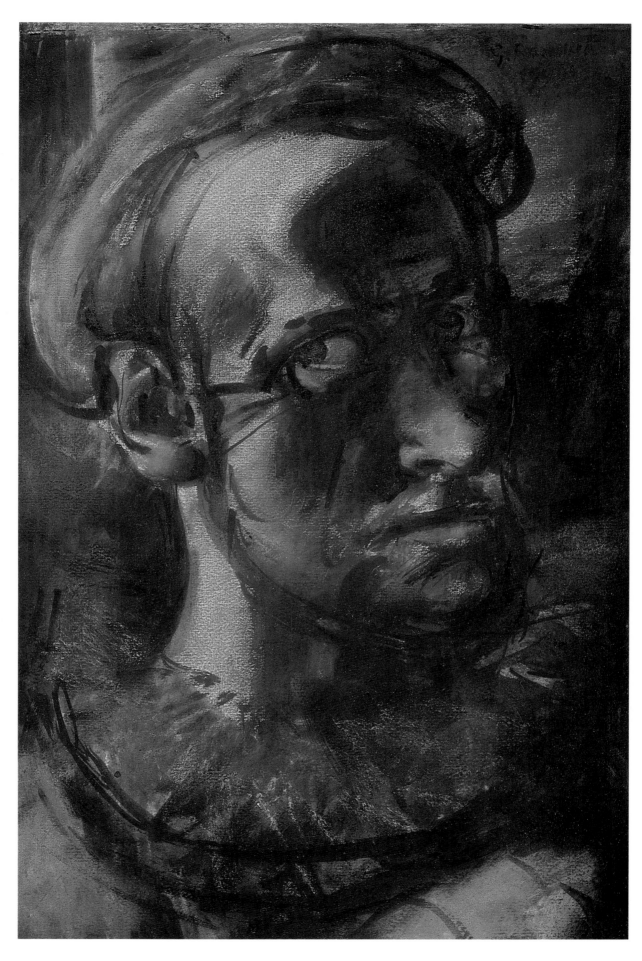

Head of a Clown

1904. Pastel, gouache, and watercolor on paper mounted on cardboard.
43 × 27 cm. (17 × 10⅝ in.) The Pushkin Museum, Moscow

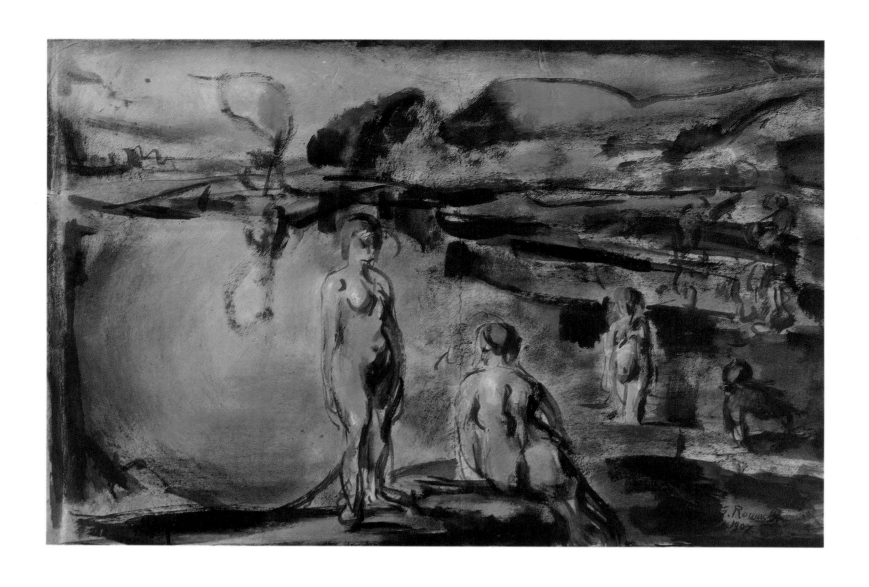

Bathing in a Lake

1907. Watercolor and pastel on paper. 65 × 96 cm. (25⅝ × 37¾ in.)
The Pushkin Museum, Moscow

OPPOSITE:

Nude with Upraised Arms

1906. Gouache on paper. 62.8 × 47.6 cm. (24¾ × 18¾ in.)
Chester Dale Collection, National Gallery of Art, Washington

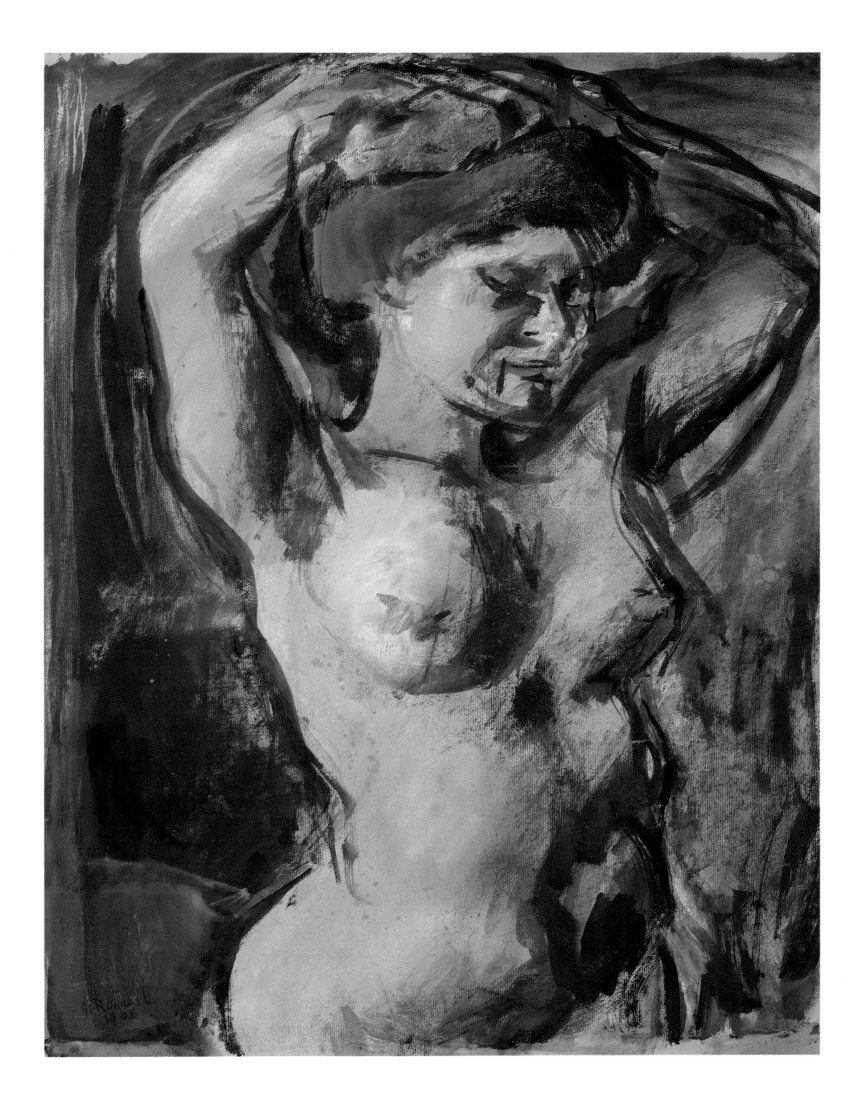

HENRI MATISSE
1869–1954

HENRI MATISSE was born at Le Cateau-Cambrésis in the north of France. He planned on a legal career and in 1889 was employed as a clerk in a solicitor's office. It was in 1890 that he was first attracted to painting. There followed the long years of learning: in 1891, Matisse studied with W.A. Bouguereau at the Académie Julian and in 1892 was accepted at the Ecole des Beaux-Arts as a student of Gustave Moreau—at the same time attending the Ecole Nationale des Arts Décoratifs.

In 1896, he made a successful début at the Salon de la Société Nationale des Beaux-Arts and a year later displayed there his large canvas *La Desserte*, which showed the influence of the Impressionists. After Moreau's death in 1898, he studied briefly with Cormon, left the Ecole des Beaux-Arts, and entered the Académie Carrière, where he met Derain and Puy and attended sculpture classes.

During his pre-Fauvism period (1899–1904), Matisse participated in a 1902 group exhibition at Berthe Weil's Gallery, painted townscapes in Paris, spent the summer of 1904 working with Signac and Cross at Saint-Tropez, and in 1905–6 painted views of Collioure.

In 1905 and 1906, Matisse, his talent now fully developed, headed the Fauvist group (a critic dubbed them "Les Fauves"), exhibiting at the Salon d'Automne and the Salon des Indépendants. At this time, he displayed a tendency towards monumental, decorative compositions. If in 1900 it was only to earn some money that he took on the task of painting a frieze for the World Exhibition at the Grand Palais, in 1907 he worked with enthusiasm on a ceramic triptych, *Nymph and Satyr*, for Osthaus' mansion in Hagen, Westphalia. In 1908, Matisse painted the monumental canvas *The Red Room*, and in 1909–10 executed the large decorative panels, *The Dance* and *Music*.

Sculpture, too, began to occupy a significant place in Matisse's artistic endeavor and was exhibited for the first time in 1912 in New York. At this time, Matisse set forth the theoretical basis for his art in his *Notes d'un peintre* (1908) and expounded his views on painting in the studio-school he had organized. Yet, as teaching weighed heavily on the artist, he withdrew to Issy-les-Moulineaux.

In 1911, Matisse visited Moscow on the invitation of S. Shchukin, and, at the end of that year, Tangier. From 1914 to 1918, he divided his time between Collioure, Paris, and Nice. In 1918, a Matisse–Picasso exhibition opened at the Guillaume Gallery; it was to a certain extent indicative of the role of these two painters in contemporary art.

In 1920, Matisse created sketches for the costumes and décors for Diaghilev's ballet *Le Chant du Rossignol* (to Stravinsky's music), and in 1939 for Léonide Massine's ballet *Rouge et Noir* (to the music of Shostakovich's First Symphony). In 1931–33, he illustrated Mallarmé's *Poésies*.

During the Second World War, Matisse lived in the south of France—Bordeaux, Ciboure, Nice. In 1941, he underwent a serious operation. Confined to bed, he turned his attention to book design and illustration. He designed and illustrated Baudelaire's *Les Fleurs du Mal*, Mariana Alcaforado's *Lettres Portugaises*, and Reverdy's *Visages* in 1946 and Ronsard's *Amours* in 1948. His unique book *Jazz*, published in 1947, contained the facsimile reproduction of the text written in the artist's own hand and twenty color illustrations executed in gouache after Matisse's *papiers collés*.

It was only after the end of the war that Matisse turned anew to monumental compositions. He executed sketches for the stained-glass panel representing St. Dominique in the church at Assy (1948), the entire decoration of the Chapelle du Rosaire at Vence (1948–51), and sketches for the stained-glass panel *Rose* for the Uniate Church in New York (1954). In his last years, he devoted much of his time to cut-outs and brush drawings.

The Musée Matisse was opened in 1952 at Le Cateau-Cambrésis, the birthplace of the artist. Matisse died on November 3, 1954.

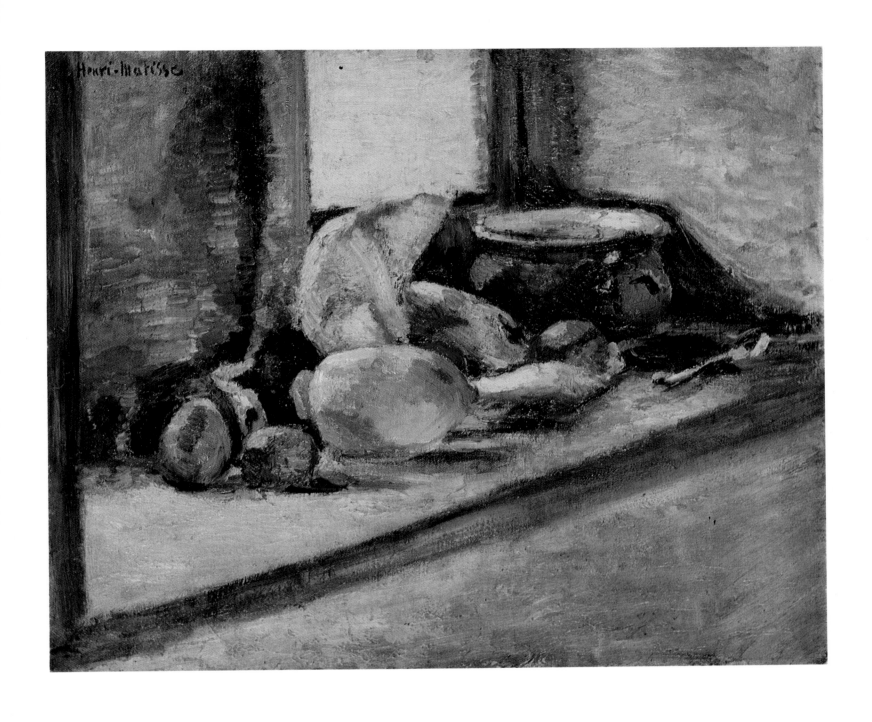

Blue Pot and Lemon

c. 1896–97. Oil on canvas. 39 × 46.5 cm. (15⅜ × 18⅜ in.)
The Hermitage, Leningrad

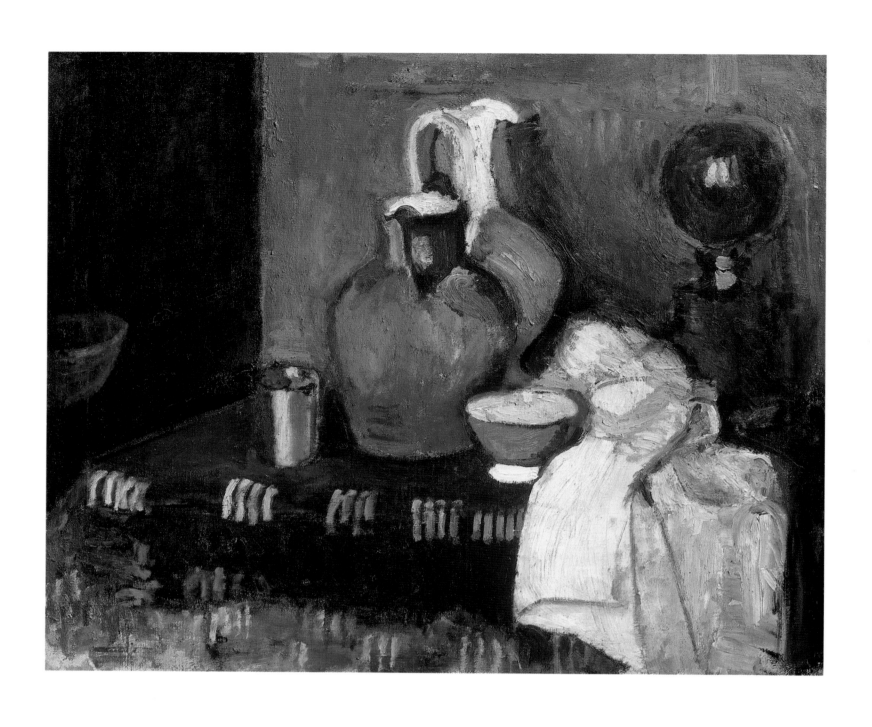

Blue Jug

c. 1899–1901. Oil on canvas. 59.5 × 73.5 cm. (23½ × 29 in.)
The Pushkin Museum, Moscow

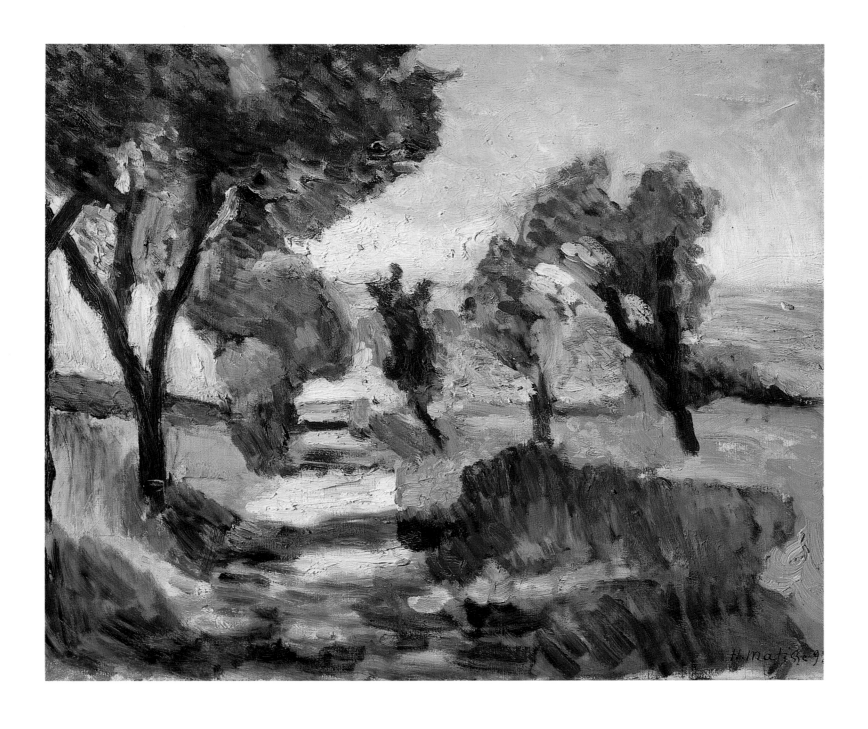

Corsican Landscape: Olive Trees

1898. Oil on canvas. 38 × 46 cm. (15 × 18⅛ in.)
The Pushkin Museum, Moscow

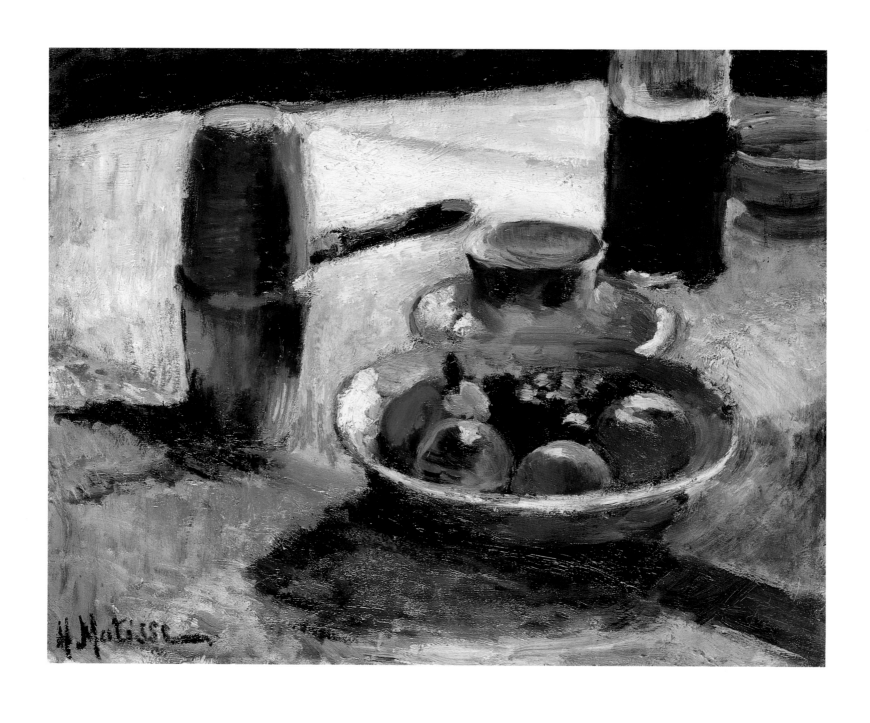

Fruit and Coffeepot

c. 1899. Oil on canvas. 38.5 × 46.5 cm. (15 × 18⅜ in.)
The Hermitage, Leningrad

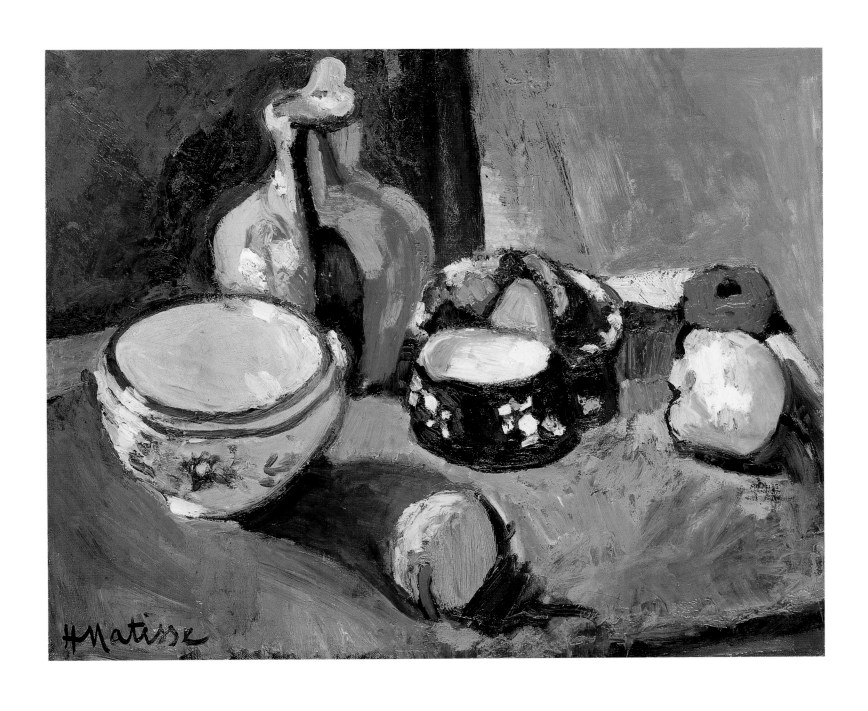

Dishes and Fruit

1901. Oil on canvas. 51 × 61.5 cm. (20 × 24¼ in.)
The Hermitage, Leningrad

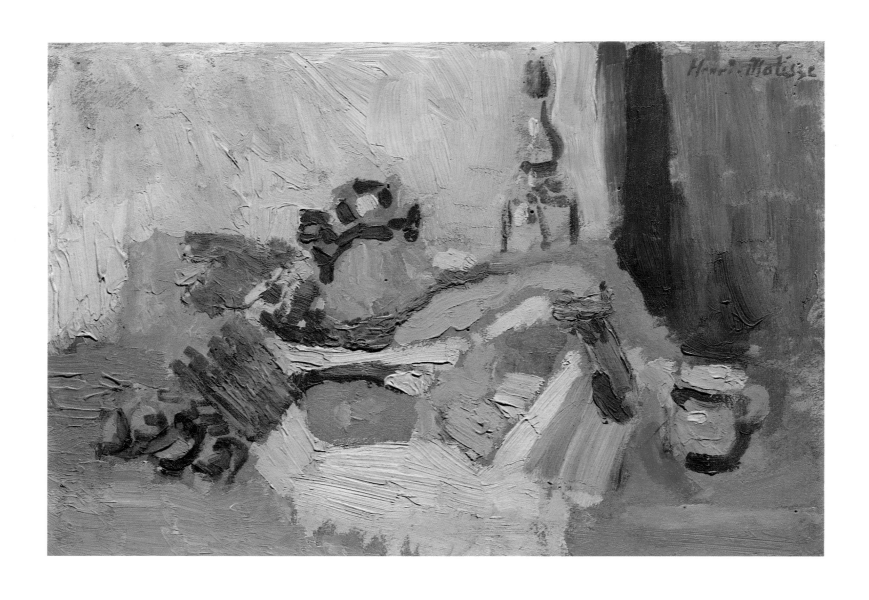

Still Life

c. 1905. Oil on cardboard mounted on wood. 17 × 24.8 cm. (6¾ × 9¾ in.)
Ailsa Mellon Bruce Collection, National Gallery of Art, Washington

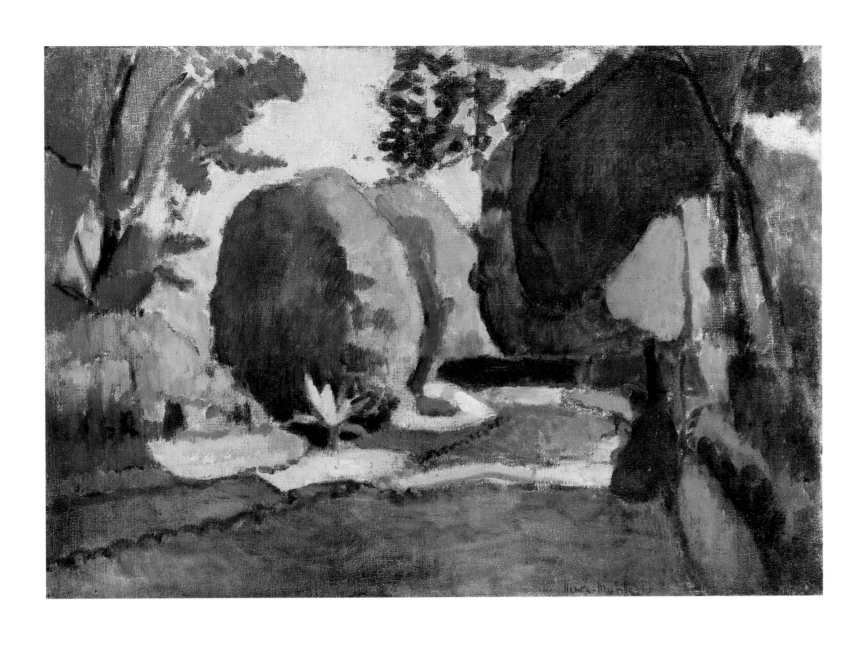

The Luxembourg Gardens

c. 1901–1902. Oil on canvas. 59.5 × 81.5 cm. (23½ × 32 in.)
The Hermitage, Leningrad

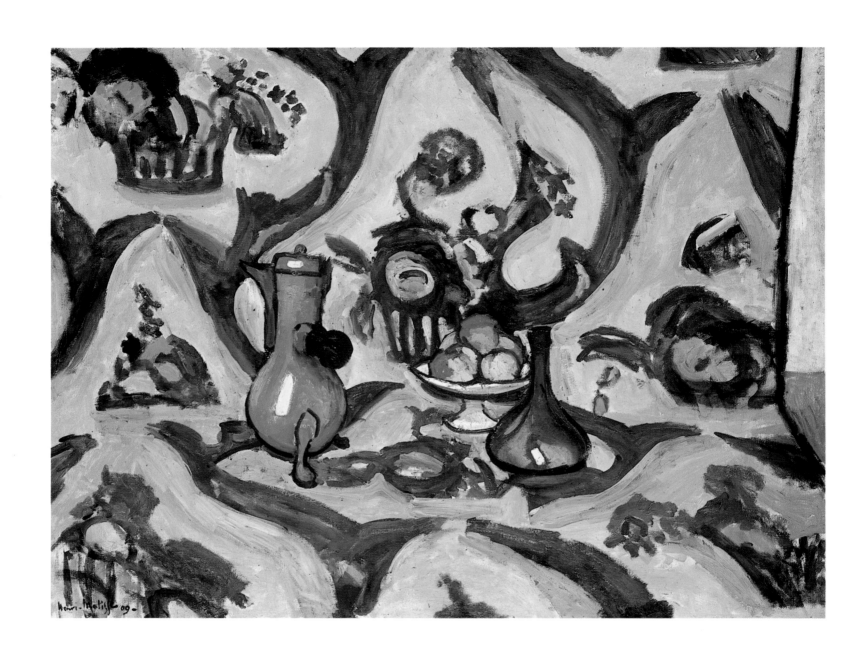

Blue Tablecloth

1909. Oil on canvas. 88 × 118 cm. (34⅝ × 46½ in.)
The Hermitage, Leningrad

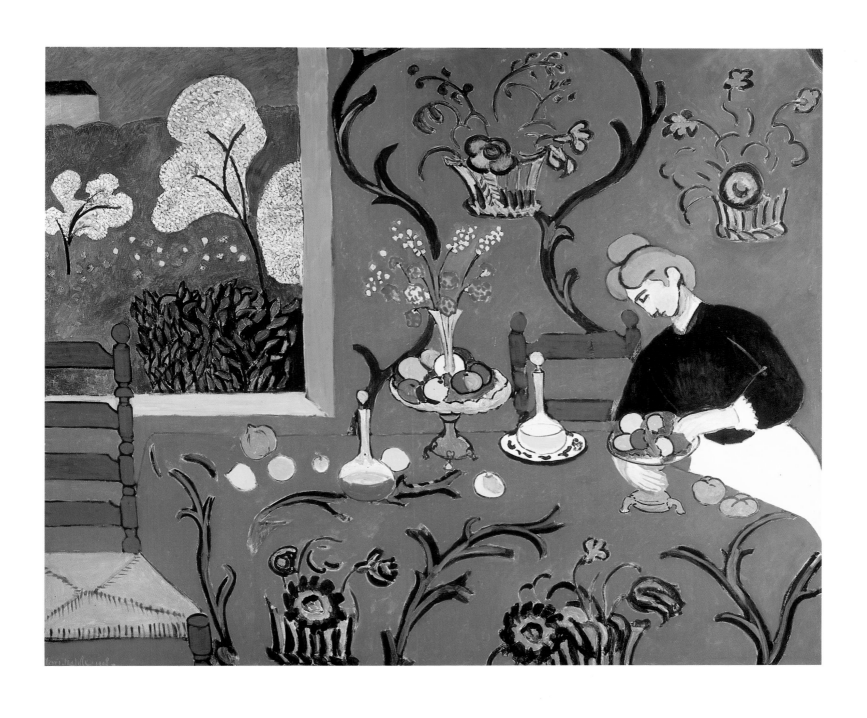

The Red Room

1908. Oil on canvas. 180 × 220 cm. (70⅞ × 86⅝ in.)
The Hermitage, Leningrad

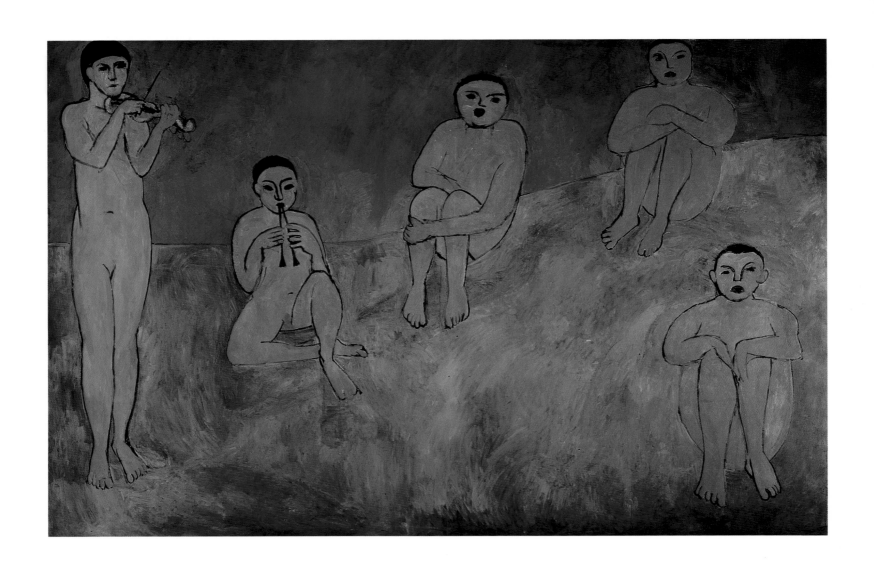

Music

1910. Oil on canvas. 260 × 389 cm. (102⅜ × 153⅛ in.)
The Hermitage, Leningrad

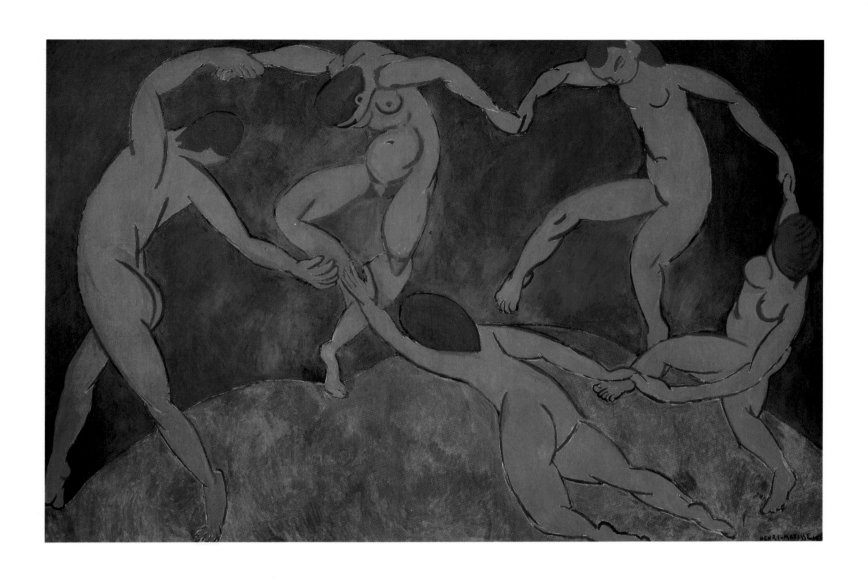

The Dance

1910. Oil on canvas. 260 × 391 cm. (102⅜ × 154 in.)
The Hermitage, Leningrad

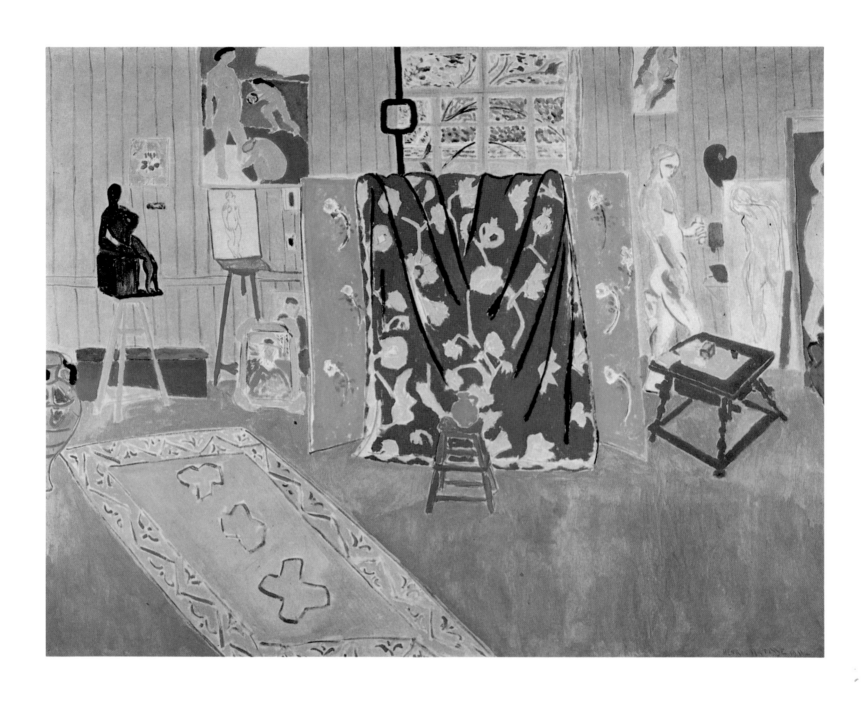

The Artist's Studio

1911. Oil on canvas. 179.5 × 221 cm. (70⅝ × 87 in.)
The Pushkin Museum, Moscow

OPPOSITE:

Goldfish

1911. Oil on canvas. 146 × 97 cm. (57½ × 39 in.)
The Pushkin Museum, Moscow

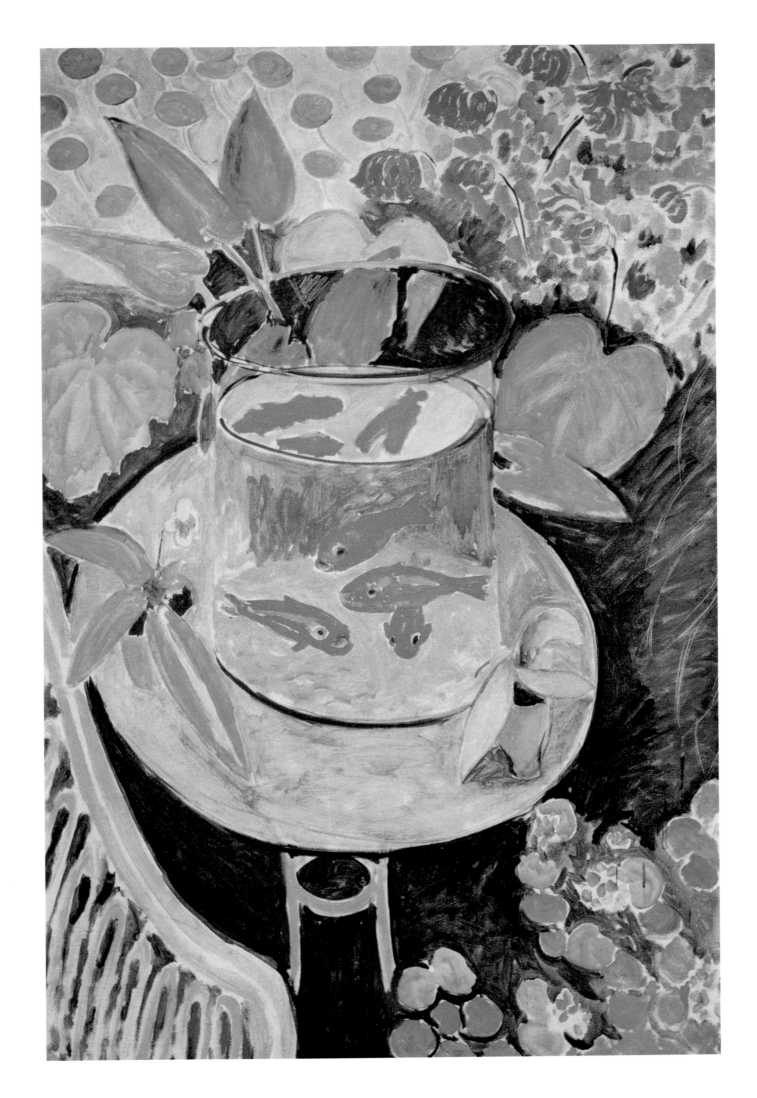

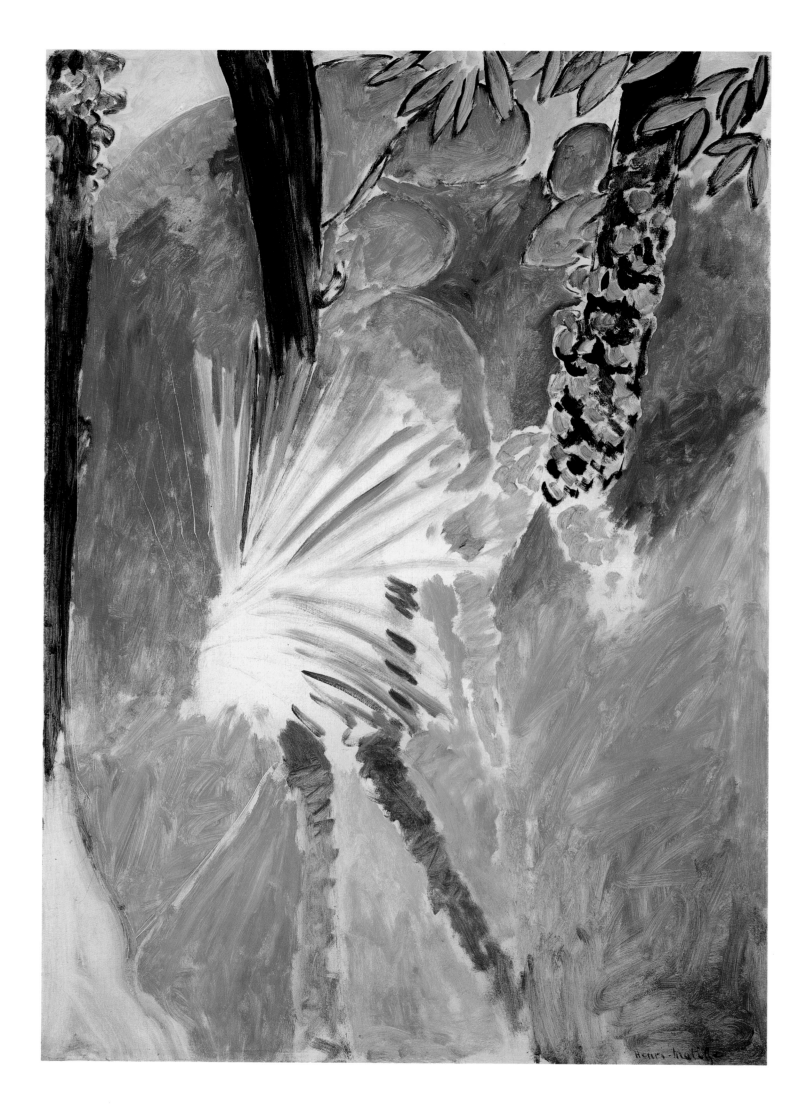

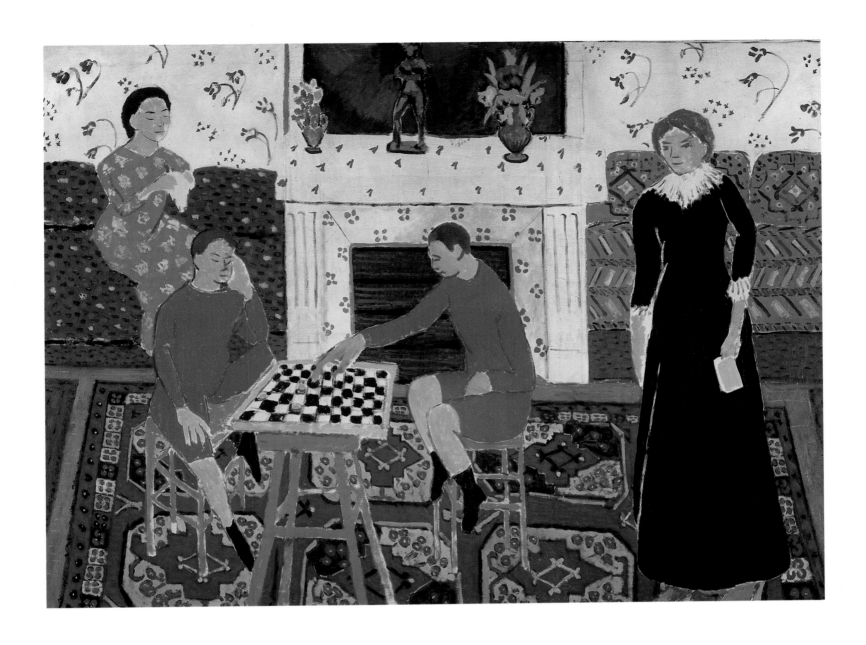

The Artist's Family

c. 1911. Oil on canvas. 143 × 194 cm. (56¼ × 76⅜ in.)
The Hermitage, Leningrad

OPPOSITE:

Palm Leaf, Tangier

1912. Oil on canvas. 117.5 × 81.9 cm. (46¼ × 32¼ in.)
Chester Dale Fund, National Gallery of Art, Washington

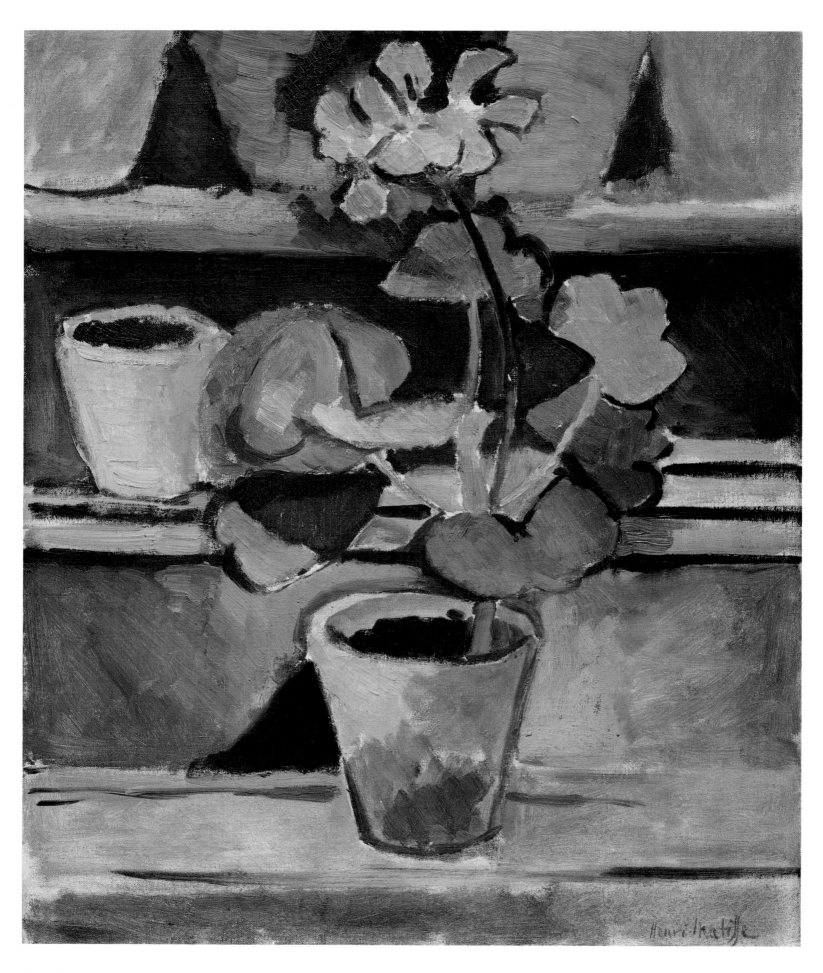

Pot of Geraniums

1912. Oil on canvas. 41.3 × 33.3 cm. (16¼ × 13⅛ in.)
Chester Dale Collection, National Gallery of Art, Washington

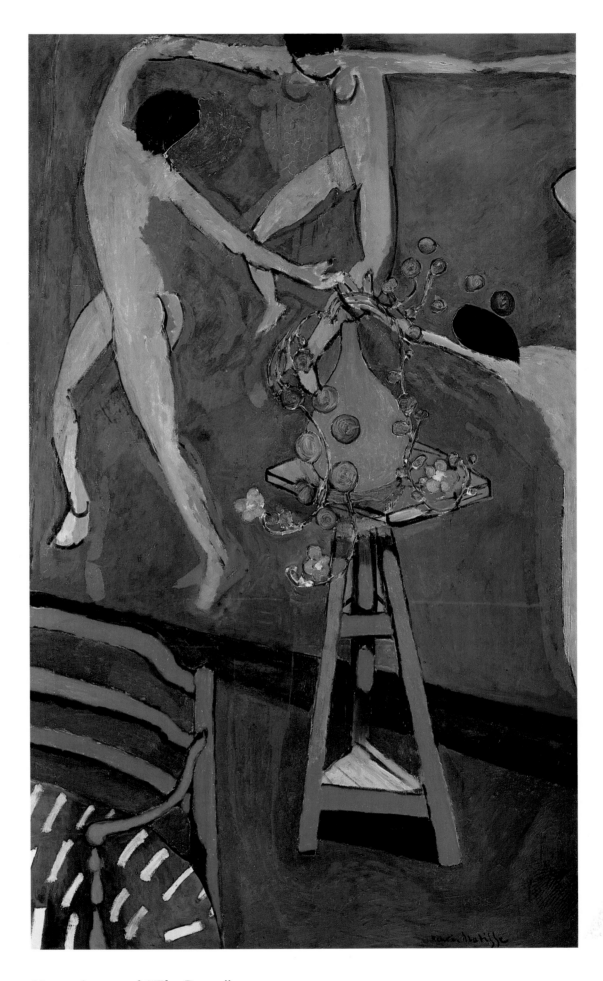

Nasturtiums and "The Dance"

1912. Oil on canvas. 190.5 × 114 cm. (75 × 45 in.)
The Pushkin Museum, Moscow

PABLO PICASSO
1881–1973

PABLO PICASSO, a Spaniard by birth, was born in Málaga and was first trained by his father, José Ruiz Blasco, a professor of drawing at the School of Arts and Crafts in Málaga (from 1895 he taught in Barcelona). At sixteen, Picasso entered the San-Fernando Academy in Madrid. In 1897, his *Knowledge and Mercy,* painted in the style of classical art, won him a gold medal at an exhibition in Málaga. However, the young artist was not satisfied with academic success. In 1899, he joined the circle of Barcelona artists and poets who met at the cabaret "The Four Cats," and he took part in their exhibition. In October of the same year, he first came to Paris, where he finally settled in 1904. He established himself in Montmartre, in the Bateau-Lavoir, 13 rue Ravignan, a house inhabited by young artists and writers. It was here, in an atmosphere of friendly contact and lively discussions with Apollinaire, Matisse, Derain, Jacob, and Braque, that the artistic idiom of the young Picasso took shape. His Blue period (1901–4, Barcelona and Paris) was followed by the Rose period (1905–6, Montmartre) with its recurrent theme of acrobats and harlequins. Then he embarked on a new quest, turning to the art of the primitive peoples of Africa—the Primitive period (1907–8)—evolved a new concept of space and form called Analytical Cubism (1909–11) and elaborated the

principles of Synthetic Cubism (1912–14). In the décor and designs for Diaghilev's ballet *Parade* (1917), he evinced an interest in the interrelationship of planar and spatial elements. His Neo-Classical period lasted from 1921 to 1924; to this time belong, besides his Cubist canvases, several works influenced by the painting of Ingres. Between 1925 and 1935, Picasso was attracted to the problems being tackled by the Surrealists. During these years, he worked on sculpture, drawings and paintings, and he wrote poetry. In 1937, he created his monumental composition *Guernica,* a great memorial to the victims of Fascism.

During the Second World War, Picasso lived in Paris, aiding the French Resistance movement. In 1944, he joined the French Communist Party. From 1948 on, he took an active part in various peace congresses throughout Europe. In the 1950s, Picasso divided his time between Antibes and Vallauris; he worked at decorative ceramics, painted the large canvases *War* and *Peace*, and produced a number of graphic and sculptural pieces.

In 1961, Picasso moved to his estate in Mougins (Alpes Maritimes) and lived there till his death. In 1963, the Pablo Picasso Museum was inaugurated in Barcelona. To this city, where his career had begun, Picasso donated 994 of his works.

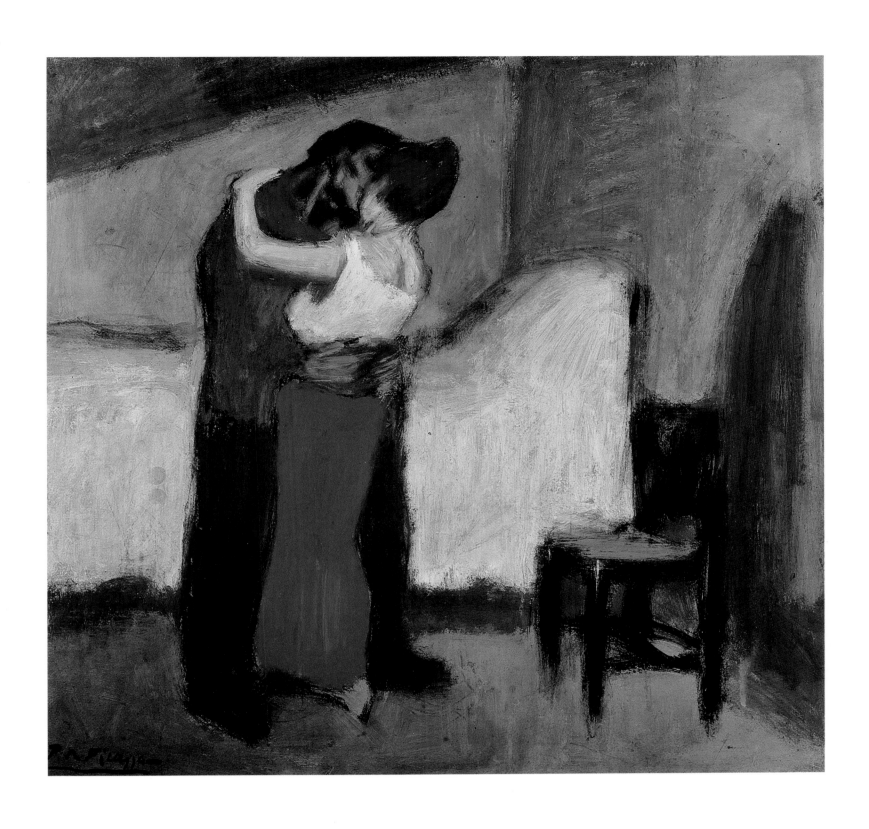

The Embrace

c. 1900. Oil on cardboard. 52 × 56 cm. (20½ × 21¼ in.)
The Pushkin Museum, Moscow

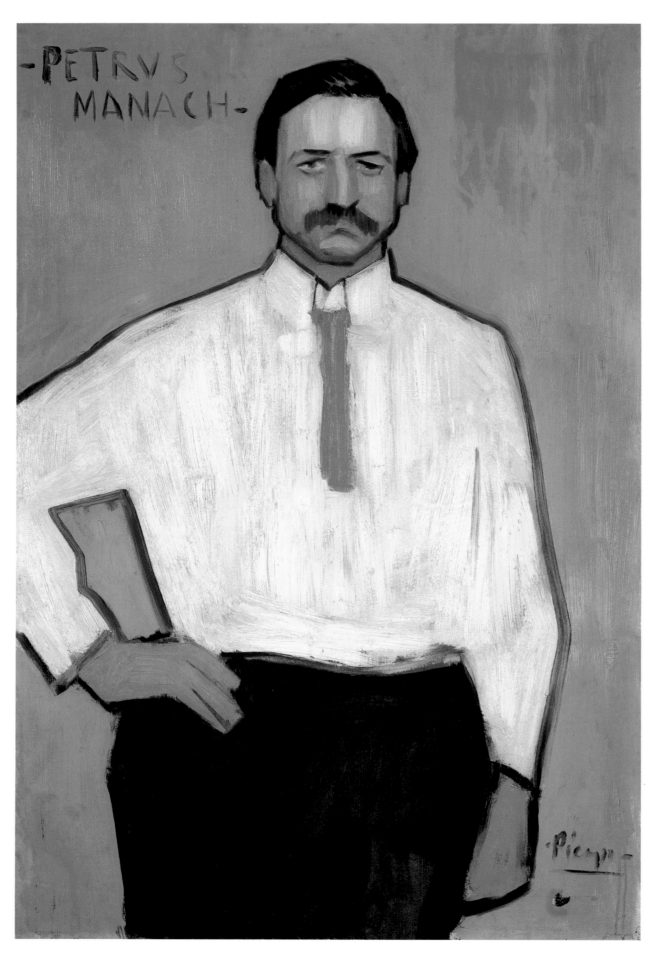

Pedro Manach

1901. Oil on canvas. 105 × 67 cm. (41½ × 27½ in.)
Chester Dale Collection, National Gallery of Art, Washington

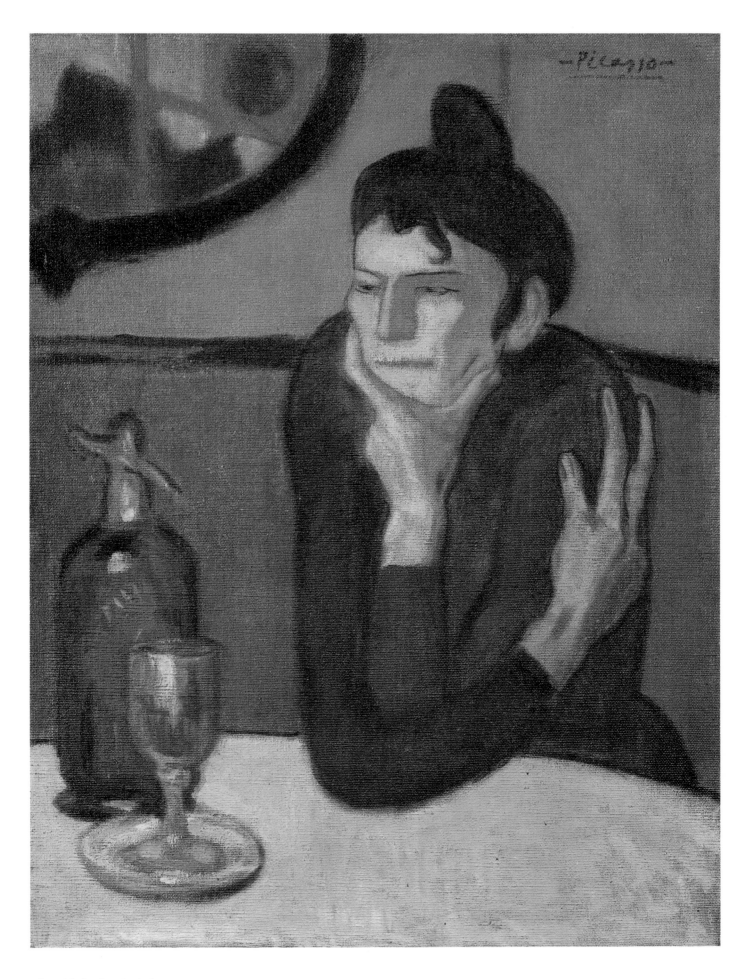

The Absinthe Drinker

c. 1901. Oil on canvas. 73 × 54 cm. (28¾ × 21¼ in.)
The Hermitage, Leningrad

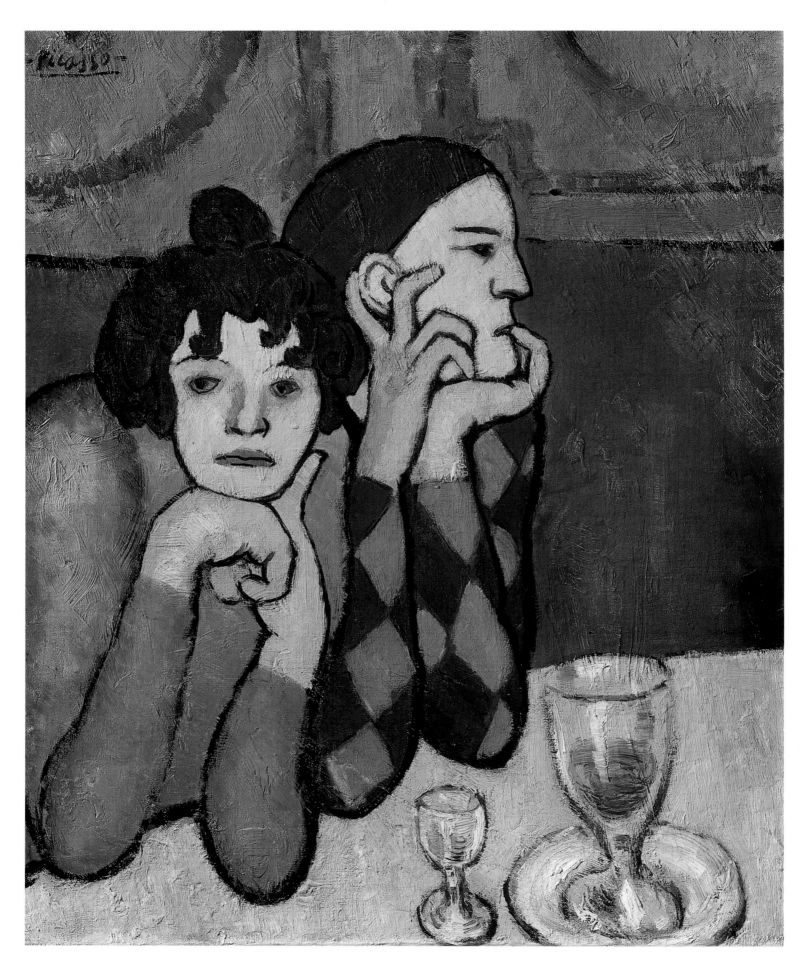

Harlequin and His Companion

c. 1901. Oil on canvas. 73 × 60 cm. (28¾ × 23½ in.)
The Pushkin Museum, Moscow

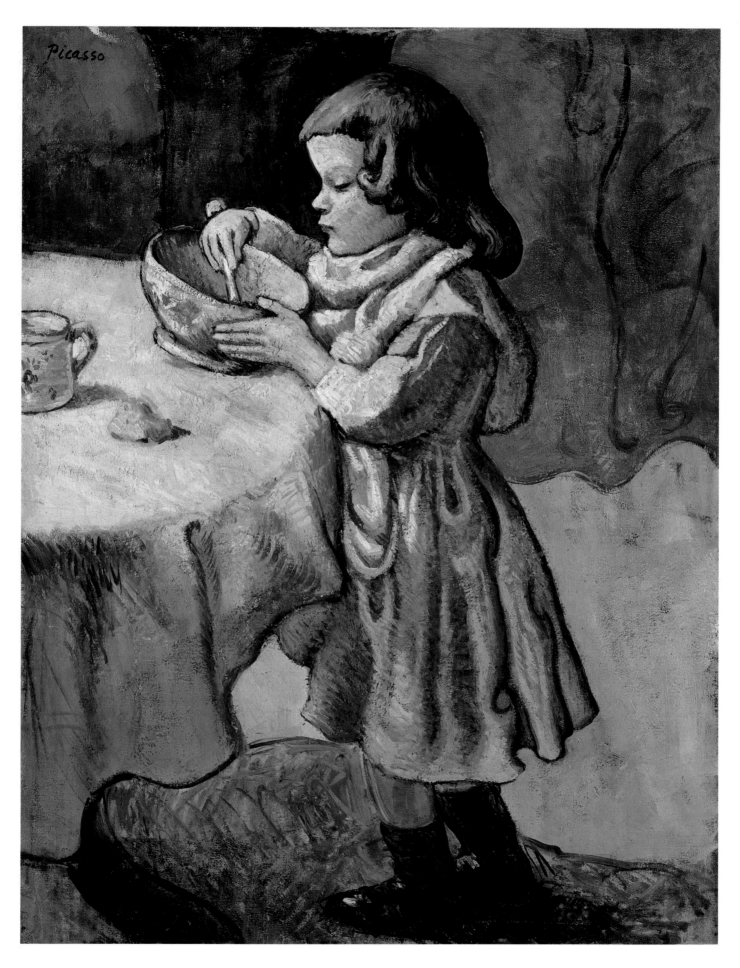

Le Gourmet

1901. Oil on canvas. 92.8 × 68.3 cm. (36½ × 26⅞ in.)
Chester Dale Collection, National Gallery of Art, Washington

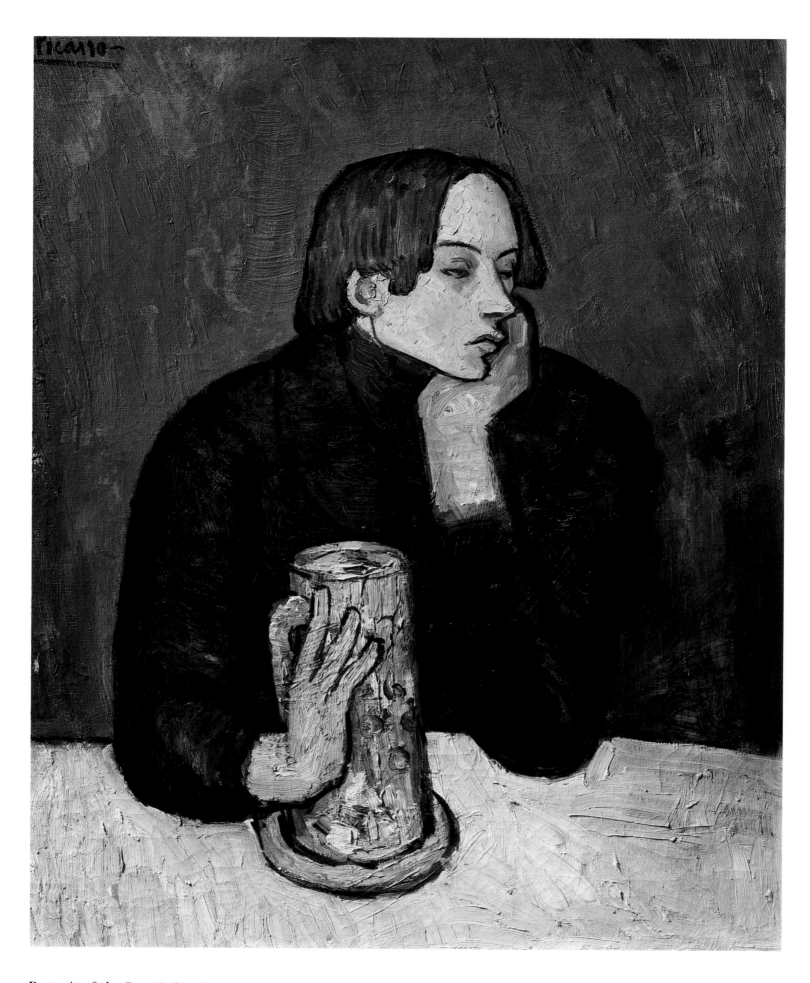

Portrait of the Poet Sabartés

c. 1901. Oil on canvas. 82 × 66 cm. (32¼ × 26 in.)
The Pushkin Musuem, Moscow

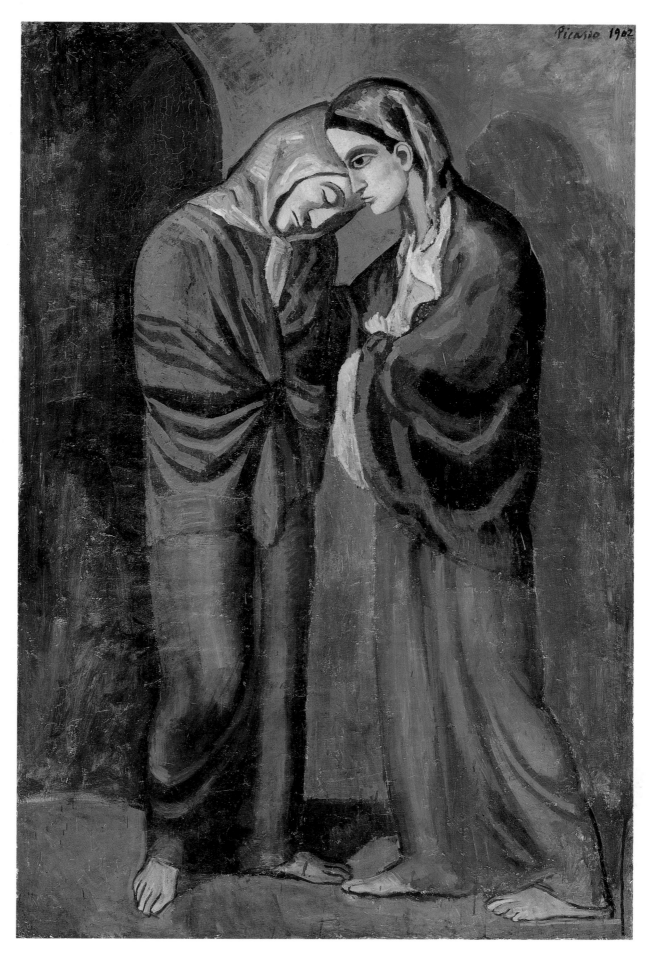

The Visit (Two Sisters)

1902. Oil on panel. 152 × 100 cm. (59⅞ × 39⅜ in.)
The Hermitage, Leningrad

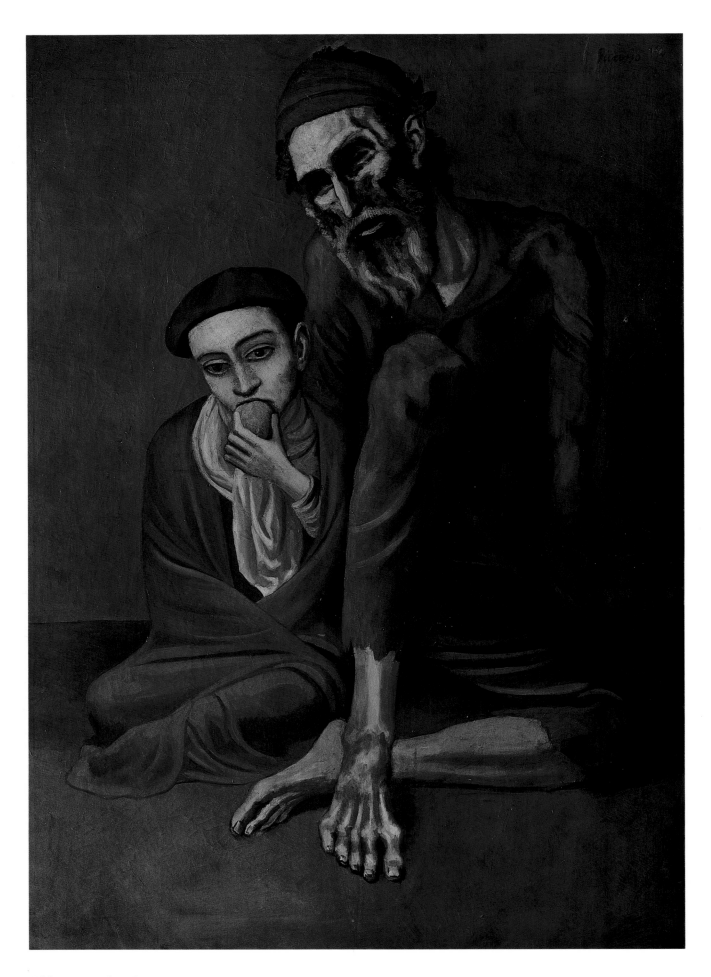

Old Jew and a Boy

c. 1903. Oil on canvas. 125 × 92 cm. (49¼ × 36¼ in.)
The Pushkin Museum, Moscow

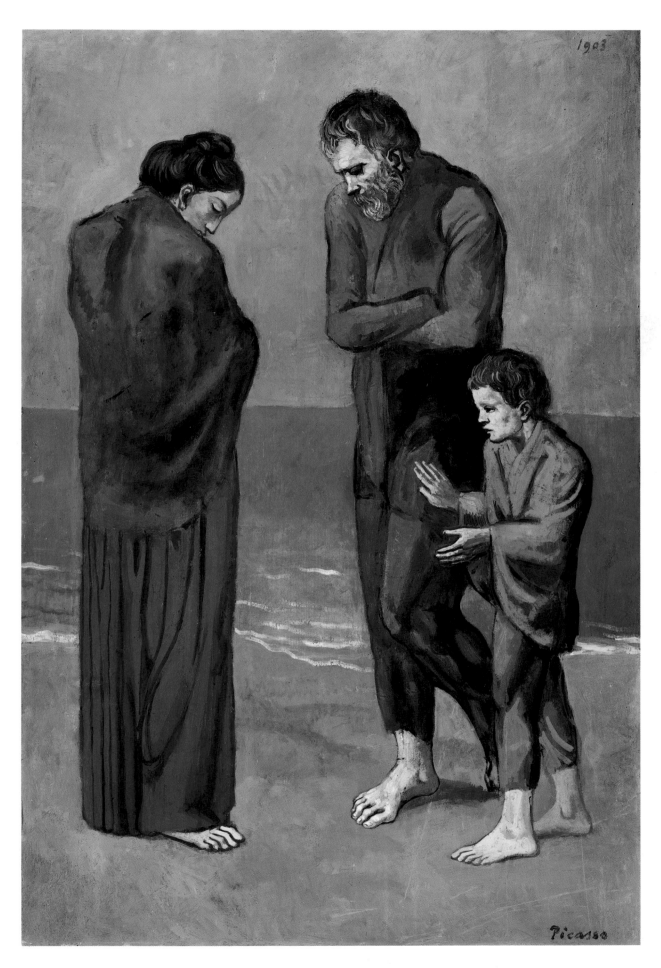

The Tragedy

1903. Oil on wood. 105.4 × 69 cm. (41½ × 27⅛ in.)
Chester Dale Collection, National Gallery of Art, Washington

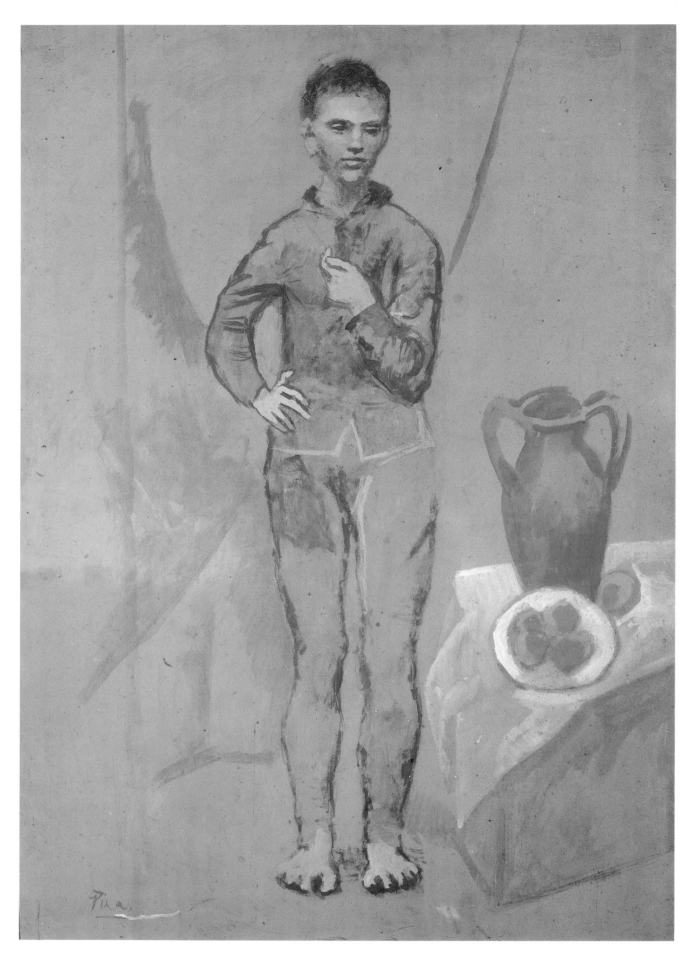

Juggler with Still Life

1905. Gouache on cardboard. 100 × 69.9 cm. (39⅜ × 27½ in.)
Chester Dale Collection, National Gallery, of Art, Washington

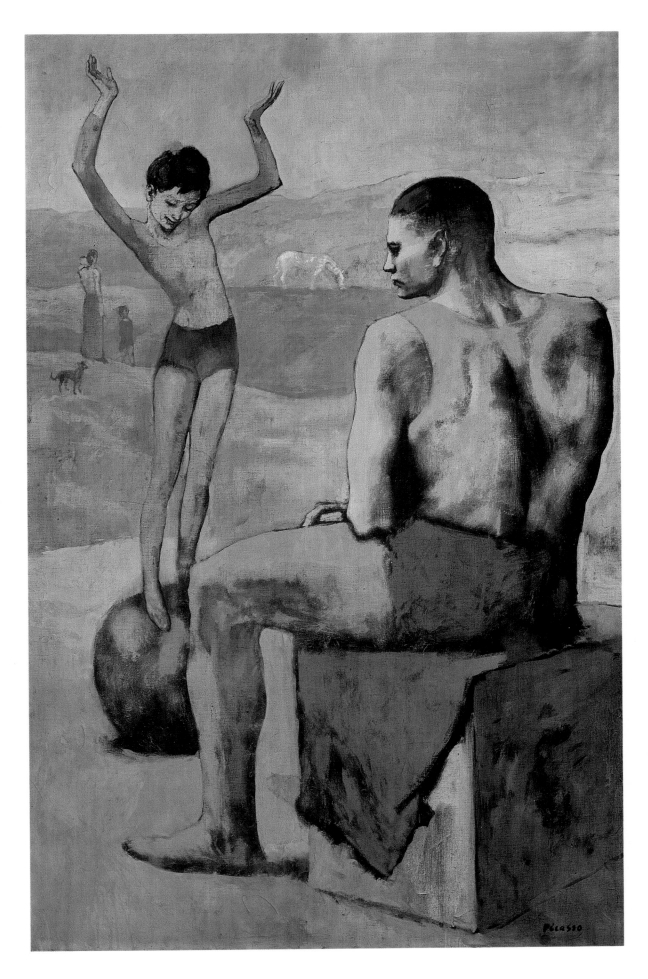

Girl on a Ball

c. 1905. Oil on canvas. 147 × 95 cm. (57⅞ × 37½ in.)
The Pushkin Museum, Moscow

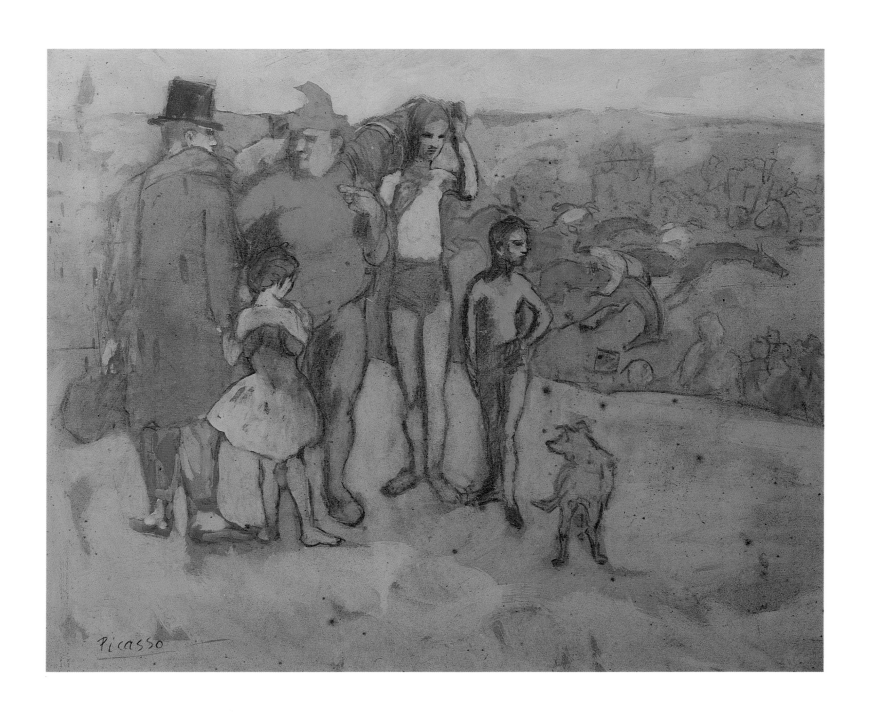

Family of Saltimbanques

c. 1905. Gouache and charcoal on cardboard. 51.2 × 61.2 cm. (20 × 24 in.)
The Pushkin Museum, Moscow

OPPOSITE:

Spanish Woman from Mallorca

c. 1905. Tempera and watercolor on cardboard. 67 × 51 cm. (26 × 20½ in.)
The Pushkin Museum, Moscow

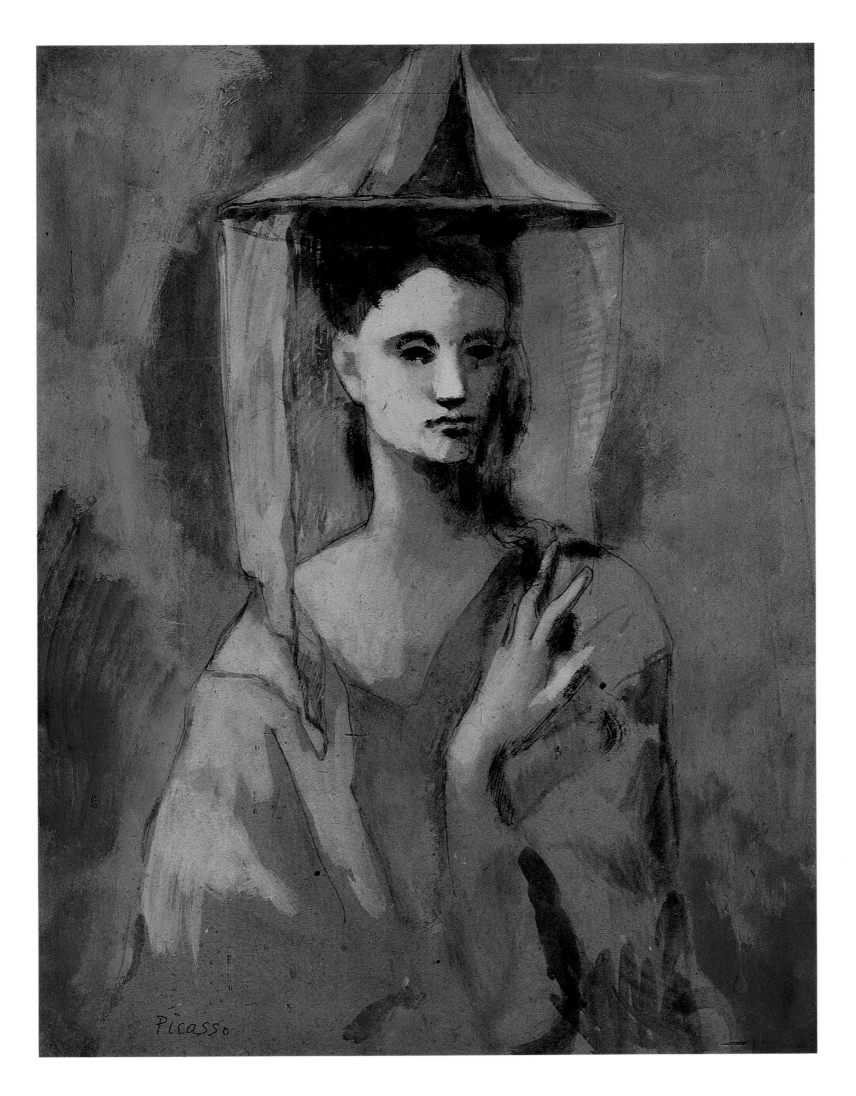

Picasso

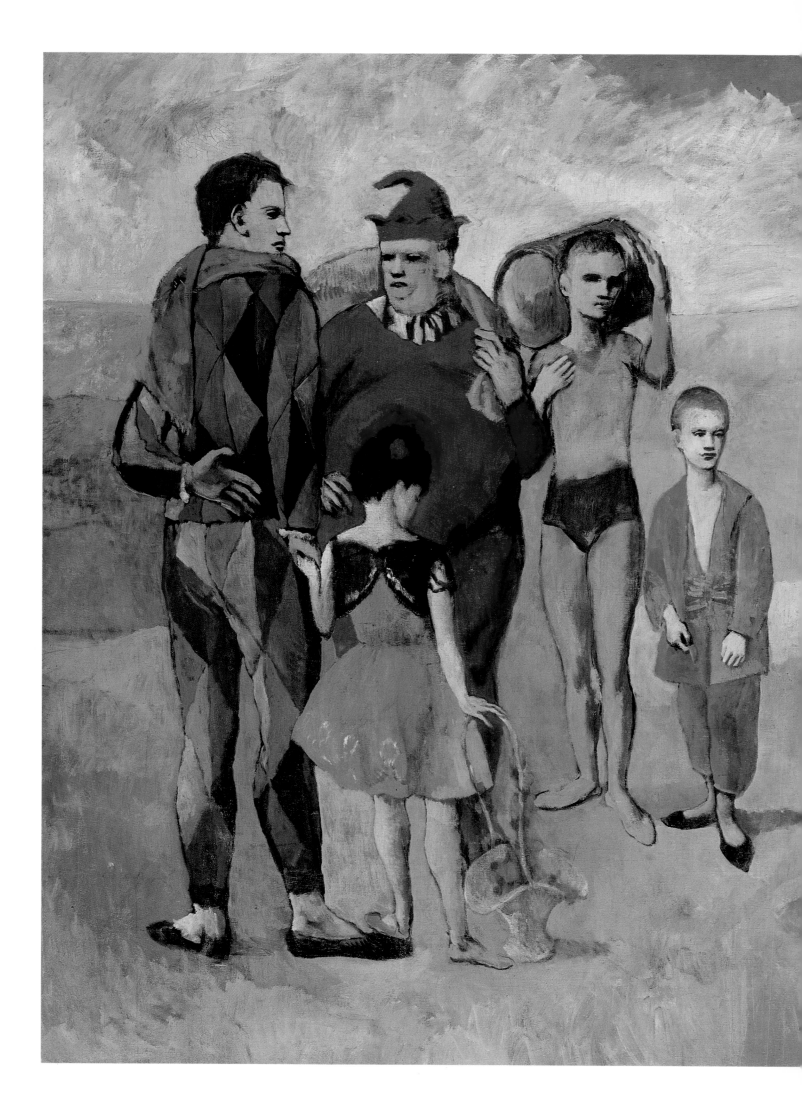

Family of Saltimbanques

1905. Oil on canvas. 212.8 × 229.6 cm. (83¾ × 90⅜ in.)
Chester Dale Collection, National Gallery of Art, Washington

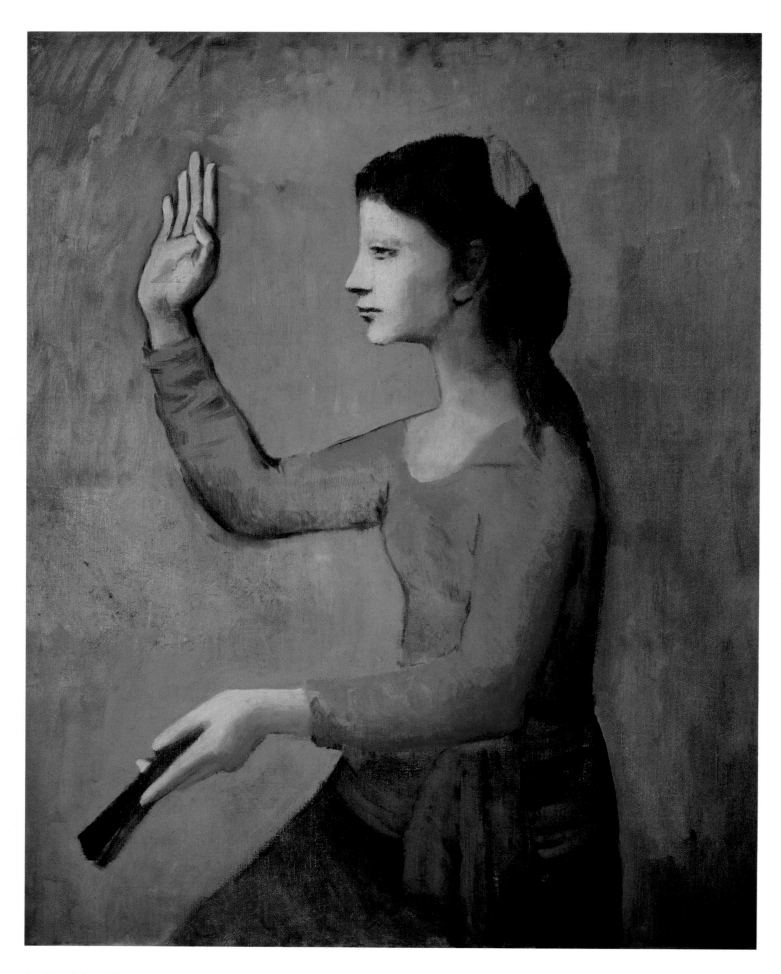

Lady with a Fan

1905. Oil on canvas. 100.3 × 81.2 cm. (39½ × 32 in.) Gift of the W. Averell Harriman Foundation, in memory of Marie N. Harriman, National Gallery of Art, Washington

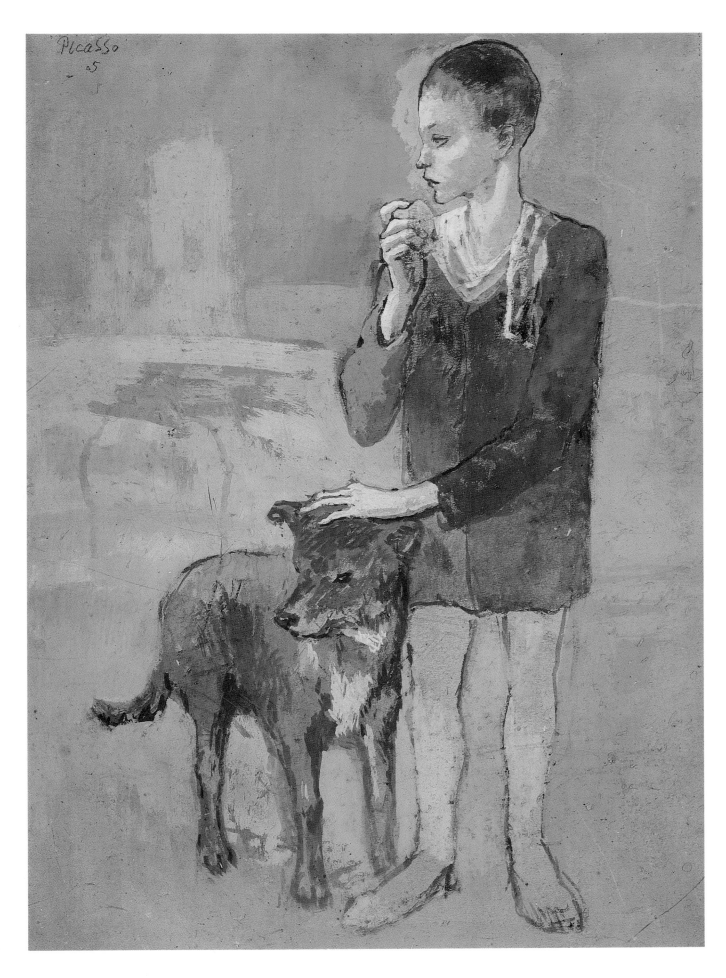

Boy with a Dog

c. 1905. Gouache on brown cardboard. 57 × 41 cm. (22½ × 16 in.)
The Hermitage, Leningrad

Index

Sisley

Renoir

c. Pissarro

Seurat

Claude – Monet

Cross

Degas

E. Boudin

Berthe Morisot

Maurice

Vincent

P. Cezanne